THE PENGUIN CLASSICS

FOUNDER EDITOR (1944–64): E. V. RIEU

EDITORS:
Robert Baldick (1964–72), Betty Radice

CHARLES-PIERRE BAUDELAIRE was born in Paris in 1821, the only son of an elderly father and a young mother. His father died before he was six and his new step-father, Col. Aupick, was regarded by him as an interloper and enemy. He was sent to boarding schools but, unhappy and rebellious, ended up being expelled from the Lycée Louis-le-Grand in 1839. Later that year he enrolled as a law student at the University of Paris, having already contracted the venereal disease from which, indirectly, he was to die. His step-father, alarmed by his recklessly 'Bohemian' life, sent him on a sea-voyage (1841) which he did not complete; it nevertheless made a great impact on his life and art, and he took a coloured mistress on his return. In 1842 he came into his fortune but his family, again taking fright at his life style, transferred the control of it to the notary Ancelle. For the rest of his life Baudelaire was surrounded by debts. His first publication was *Le Salon de 1845*, a review of the annual Paris art exhibition; and after his attempted suicide in 1845 there followed a productive period. The revolution of 1848 provoked him to almost socialist fervour and he edited two short-lived Republican journals. However, with the political disillusion of December 1851 he came increasingly under the influence of Edgar Allan Poe, in whom he saw a 'twin soul'; he was also involved amorously and poetically with two women. In 1857 he brought out *Les Fleurs du mal*, which he had worked on during the previous two years. As the result of a court order a new edition of *Les Fleurs du mal* was published in 1861, which included additional poems. He continued with his writings and essays; *L'Imprévu* (1863) seemed to mark a return to the orthodox Catholic fold. He was taken ill in Belgium after giving a disastrous series of lectures, transferred to Paris and he died in 1867.

P. E. CHARVET was born in 1903 and lived in Paris until 1916. He was educated at Clifton and Corpus Christi College, Cambridge. He is a Fellow of Corpus Christi and until his retirement in 1963 was a University Lecturer in French. His publications include a book on France and volumes V and VI of *A Literary History of France*.

D0775514

BAUDELAIRE:

SELECTED WRITINGS ON
ART AND ARTISTS

*Translated with an Introduction
by P. E. Charvet*

PENGUIN BOOKS

Penguin Books Ltd, Harmondsworth, Middlesex, England
Penguin Books Inc., 7110 Ambassador Road, Baltimore, Maryland 21207, U.S.A.
Penguin Books Australia Ltd, Ringwood, Victoria, Australia

—

This translation first published 1972

—

Copyright © P. E. Charvet, 1972

—

Made and printed in Great Britain by
Richard Clay (The Chaucer Press) Ltd, Bungay, Suffolk
Set in Monotype Bembo

Contents

★ Extracts.

Introduction

To his contemporaries, Charles Baudelaire (1821–67) may well, at any rate in earlier years, have appeared more important as a critic and journalist than as a poet. When his first 'Salon' appeared (May 1845), his poetic production was still slight; a year later, the second and much more significant 'Salon' could only have strengthened that first impression. A few poems, scattered here and there in different periodicals, and not all of them signed, could have done little to modify it, in spite of the announcement, which accompanied the 1846 'Salon', of a forthcoming volume of poetry (*Les Lesbiennes*) by the same author.

In the next few years, Baudelaire's publications, both in prose and in verse, were few. The wave of revolution in 1848 swept him along with it; in February he appeared on the barricades, and in the 'June Days' he was still actively helping the insurgents. But his demagogic enthusiasm quickly receded, and the year 1850 saw the beginnings of his most creative period, in both poetry and prose. *Les Lesbiennes* had, in the interval, changed its title to *Les Limbes*, which was announced in that year and again in 1851. When at last the book appeared as *Les Fleurs du mal*, in June 1857, Baudelaire the poet enjoyed a *succès de scandale*, if no other. Writing to his mother, Madame Aupick, on 9 July, Baudelaire says:

As for the poems, you know I have never thought of literature and the arts as having any aim other than disconnected with morality, and that the beauty of the idea and the style are enough for me. But this book, whose title, *Les Fleurs du mal*, says all that needs to be said, is clothed in a sinister and cold beauty; it was created in moods of savage anger and patience combined. Moreover the proof of its positive value lies in all the abuse it has aroused. The book makes

people wild . . . They refuse to give me credit for any creative gift or even knowledge of the language. I have the greatest contempt for all these fools . . .[1]

There can be little doubt about the impact upon the public of the day. The worthy bourgeois of the period were scandalized. Everything about the work seemed deliberately designed to offend their susceptibilities, from the rather absurd title – Baudelaire was not averse from the pleasure of deliberately shocking those he despised – to the frank sensuality of some of the poems. Then again, the great emphasis upon sin, almost the delectation in sin, and the evident belief in suffering, in both sin and suffering as the underlying realities of life, these attitudes were unlikely to find favour with the Positivist generation, which preferred to shift its gaze from the bleakness of today to the brightness of tomorrow, when material progress would inevitably ensure the reign of human happiness.

Without a doubt Baudelaire was a scandal, and when *Les Fleurs du mal* came before the courts (August 1857), public opinion probably decided that he had got what he deserved. Rare, in the late 1850s and the 1860s, were the *cognoscenti* prepared to see something more in Baudelaire, the poet, than an eccentric oddity. One of these, be it said to his credit, was Barbey d'Aurevilly (1808–89), novelist and critic, but he too was an isolated figure in his generation; in England, Swinburne was enthusiastic; and another admirer would appear to have been Victor Hugo: 'Your *Fleurs du mal* shine and dazzle like stars', he writes to Baudelaire (30 August 1857), and in a subsequent letter (6 October 1859) comes the well-known phrase: 'You give us a new kind of shudder'.

But Hugo's poetic vision and his philosophy were so different from Baudelaire's that we may be permitted to wonder how discerning these words of praise really were, whether they were more than the flattered condescension of the Guernsey exile, in response to the dedication of two

poems[2] to him and the author's avowed imitation, in one of them, of Hugo's manner.

Sainte-Beuve, on the other hand, was not one of the select band, and his malevolent playfulness at the expense of Baudelaire[3] no doubt evoked responsive echoes in the minds of the numerous readers who sought weekly guidance on matters literary in the *Nouveaux lundis*.

The Positivist age merged into Naturalism, which, with its ponderous and pretentious emphasis on science as the mainspring of literature, could scarcely be in sympathy with Baudelaire. But Naturalism, in its turn, weakened under the impact of new philosophic influences – Schopenhauer in particular, and, close in his wake, Bergson and Nietzsche. By 1890, Zola and Maupassant notwithstanding, the revolt against science and its much trumpeted promises had begun. The truth about life and the human situation must be sought on deeper levels than the superficial level of phenomena – mere representations of an underlying, hidden reality; the external world is merely a vast collection of symbols, beneath which the mysterious forces that shape our ends lie hidden.

The new intellectual climate promoted an abundant reflowering of poetry, which, released from the marmoreal weight of Parnassianism, abandoned rigid outline and precise definition in favour of delicate suggestion, atmosphere; apprehension, rather than comprehension, was the ideal. Schopenhauer had chosen music as the supreme art because of its power to penetrate immediately to the soul; poetry should emulate music – 'De la musique avant toute chose'.[4]

At this point, Baudelaire, the enemy of Positivist materialism and of the Idea of Progress, the defender (one of them) of 'uncommitted' art, the worshipper at the temple of beauty, the dandy, the believer in original sin, the decadent, the aesthete, the satanist, the champion of 'la sorcellerie évocatoire'[5] – evocatory witchcraft which poetry should be,

Baudelaire the prophet of Symbolism, comes triumphantly into his own.

From the days of Symbolism onwards, Baudelaire's reputation has scarcely faltered, but perhaps we may claim for our own time a more balanced assessment of his value than formerly obtained, an assessment less swayed by prevailing fashions and less eager to seize on this or that aspect of a many-sided genius. This we owe partly no doubt to the passing of time, and partly to Baudelairian scholars, who have given us complete and amply documented editions of his works,[6] so that, instead of the piecemeal impression earlier generations contented themselves with, we have a better opportunity of seeing him in the round: Baudelaire the man, as he appears in his letters and diaries, Baudelaire the poet in verse and in prose, Baudelaire the voyager into the dream-states and twilight world of the opium-eater, Baudelaire the translator and critical biographer (in miniature) of Edgar Allan Poe, Baudelaire the critic.

*

The articles here presented have been selected partly because of their intrinsic merit and partly to show the development of Baudelaire's critical ideas. Some – the articles on literary subjects, for example – are given *in extenso*, either because they are short or because they deal with one author only; Baudelaire's one excursion into the sphere of music – his article on Wagner – also appears in full because of its importance in the poet-critic's final aesthetic position; the 'Salons', on the other hand, have suffered some abridgements. Reporting on art exhibitions inevitably entails making critical comments on a large number of artists in many fields. Baudelaire could not avoid this necessity, and, though his comments are often pungent, amusing and no doubt much to the point, so many of the artists mentioned have since sunk into oblivion, even though their canvases may still adorn or encumber provincial museums or dusty attics, that to cut out sections dealing with

them was not harmful to the main purpose of this book. Only those passages of the 'Salons' are given where Baudelaire is discussing great artists – a Delacroix, an Ingres – or well-known artists of the second rank – Horace Vernet, Decamps, Corot, for example – or, alternatively, where Baudelaire rises from the work of given individuals to general ideas, valuable both in themselves and in relation to his ideas on art in general. Indeed, not the least interesting aspect of the 'Salons' is the manner in which Baudelaire succeeds in turning to good account the servitude just mentioned of the art critic's jottings on the canvases exhibited, and in using these as stepping-stones to cross over into more nourishing pastures, as fresh today as they ever were.

Of the three essays on artists given in full, the two on the caricaturists are short and therefore required no abridgement, and the final one in this selection, namely the one on Constantin Guys, 'The Painter of Modern Life', though long, is of cardinal importance, not only as an eloquent expression of Baudelaire's admiration of a contemporary artist, but as a reflection of certain characteristic ideas of the author on art, beauty and life.

*

Reading Baudelaire's critical writings is a stimulating and enriching exercise. An immediate impression we receive from his first 'Salon' is his forthrightness: 'M. Delacroix is decidedly the most original painter of both ancient and modern times. That is the simple truth . . .' Prudent critics, accustomed to cover themselves against attack by hedging their opinions about with diverse attenuating phrases – 'perhaps's and the like – could be forgiven for regarding this tone of assured mastery in a young man of twenty-four, doing battle for the first time, as youthful arrogance; but the modern reader, whether he shares Baudelaire's stoutly proclaimed opinion or not, will note the discerning way in which the critic defends his position as he comments on the pictures Delacroix

had sent to the salon of that year, and the technical under-
standing, worthy of a professional artist, with which he dis-
cusses, for example, the relationship between drawing, colour
and modelling.

Baudelaire's passionate admiration of Delacroix is a theme
he will return to again and again; the 'Salon' of 1846 provided
him with an opportunity he was to grasp with avidity, but
first let it be noted that, in the year that had elapsed, Baude-
laire had evidently been pondering on the function of the
critic and the nature of criticism. Criticism, to be valuable, he
tells us, must be '. . . partial, passionate, political . . .' Passionate,
we understand; Baudelaire was nothing if not passionate; nor
is the passionate man likely to be anything but partial: he will
have a clear-cut point of view – and rightly; but why political?
One suspects that the alliterative combination of the words
must have attracted Baudelaire, as giving emphasis to his
contention; but that thought alone scarcely does him justice.
The politician, to be worth his salt, must have a belief, must
defend it and act on it passionately; and, like him, the critic,
as Baudelaire goes on to explain, must adopt an exclusive
point of view, though he adds significantly that this point of
view must be a broad and flexible one: fervour – yes; fanati-
cism, to the point of unintelligent narrowness – no. And what
are the qualities this 'partial, passionate, political' critic is to
demand of the artist? The answer is two-fold: the artist must
have what Baudelaire calls naïveté, that is, he must sincerely
obey the impulses of his own temperament – whoever lacks
temperament, he tells us incidentally, is unworthy of painting
pictures; secondly, the artist must be 'romantic', by which
Baudelaire, following here, as in other passages, in the wake of
Stendhal,[7] means modern; the artist must express the spirit of
his own age, and, in Baudelaire's view, the spirit of the age, the
romantic spirit, implies: '. . . Intimacy, spirituality, colour,
yearning for the infinite . . .'

For any art student, and indeed for anyone interested in

painting, section III of the 1846 'Salon', on colour, is worth pondering; it and the previous definition of romanticism lead Baudelaire naturally back to Delacroix, the great colourist and romantic, whose pictures and large decorative works are a subtle harmony of tones, miracles of technical skill, full of movement, a permanent invitation to deep and melancholy reverie on suffering and on the cruelty of man to man. In contrast stands Ingres, the superb draughtsman; Baudelaire freely recognizes that great gift, but this being said, his attitude to Ingres here is, and in subsequent articles was to remain, unenthusiastic.

This 'Salon' also contains an attack on the painters Baudelaire dislikes, two notably: Horace Vernet, the materialist painter *in excelsis*, utterly lacking in imagination, and Ary Scheffer, utterly lacking personal convictions of any kind, the king of doubters, inevitably, therefore, the pallid apostle of eclecticism. As a schoolboy, Baudelaire, in a letter[8] to Colonel (future General) Aupick, his stepfather, speaks in praise of some pictures by Horace Vernet he has seen in the picture gallery at Versailles. He takes the precaution of adding that he does not know anything about painting, so we may assume that between the date of that letter (July 1838) and the writing of the 1846 'Salon', or indeed the 'Salon' of the previous year, where he remarks unfavourably in passing on the crudity of Horace Vernet's colours, Baudelaire had made immeasurable strides in his knowledge and appreciation of painting.

After praising the technical skill of many lesser exhibitors and bemoaning their profound lack of originality, betrayed in their servility to moribund classical tradition, Baudelaire concludes by raising the question: how is art to build anew? His answer is, by being resolutely modern. The classical tradition was a form of beauty which, like all forms of beauty at any time, was a synthesis, composed partly of an eternal element and partly of a transient one; the former has no real

existence, it is an abstraction, an idealization, drawn from the
material conditions of a given society, in this case, of the
Ancients; the latter derives from the passions characteristic of
the life of the time. We, the moderns, also have our charac-
teristic passions, our 'modern heroism', as Baudelaire calls it,
and accordingly the artist, instead of clinging to a classical
tradition that no longer has any contact with modern life,
must create a new synthesis, which shall combine the idealized
eternal element and the transient, that is the characteristic
passions and attitudes of our own day; Parisian life, to go no
further afield, can yield an abundant harvest of poetry for
those with eyes to see:

> Dans les plis sinueux des vieilles capitales,
> Où tout, même l'horreur, tourne aux enchantements . . .[9]

How well Baudelaire was to apply in *Les Fleurs du mal* his own
principle, as set out in the last section of the 1846 'Salon'!

But, it may be asked, does the theory square with Baude-
laire's unswerving admiration of Delacroix, who, being
essentially a literary painter, as the poet-critic will later point
out,[10] and whose canvases were inspired largely by literary
subjects, appears to turn his back on 'modern heroism'? The
answer is that subjects themselves do not necessarily have to be
contemporary; it is the attitude of the artist, the impact his
works make, that are important, and on this point Baudelaire,
as we have seen, had equated romantic with modern; Dela-
croix is modern, because romantic.

Another trait, amongst many, in Delacroix's talent that
particularly commends itself to Baudelaire is his selective
attitude towards nature. It must be mentioned here because
already at this early date comes the significant idea, which
Baudelaire was subsequently to attribute to Delacroix himself
and to develop[11]: nature, for that great painter, was, we are
told, like a vast dictionary, the pages of which he consulted
with a penetrating eye.

Baudelaire can be as forthright in condemnation as in praise – Horace Vernet and Ary Scheffer would have less than cordially agreed; so, no doubt, would that occasional but, whenever he invokes the muse, always pedestrian versifier, Émile Augier, playwright and pillar of the so-called 'School of Good Sense', knight in drab armour of moralizing literature, 'committed literature' of a kind, in today's parlance (and what, one wonders, might Baudelaire have said about that?). The short article on 'Virtuous Plays and Novels' provides a stimulating example of Baudelaire in the role of avenging angel, wielding a flaming sword in defence of true art.

As a movement in revolt against romanticism, at least as Baudelaire understood the term, the 'School of Good Sense' could evidently expect no favour from him, in any circumstances, but its particular vices in his eyes were its fundamentally materialist attitudes and the distortion, whether deliberate or unwitting, of realities to provide a moral lesson. Does material success in life inevitably reward the efforts of the virtuous, as Augier would have us believe in *Gabrielle* (1849)? Assuredly not, and a work purporting to show that it does is dishonest. That crime, moreover, is compounded; such prudential, calculating attitudes lead to the contemptible belief that material successes in life are a proof of virtue – false morality indeed, leading inevitably to debased art. Can art be useful? Yes, it can, Baudelaire maintains, but only so long as it remains faithful to its proper function – the pursuit of beauty; and beauty cannot be established on fraudulence.

In 1852, the March and April numbers of the *Revue de Paris* carried an article by Baudelaire on Edgar Allan Poe. This was the original and less developed version of 'Edgar Allan Poe, his Life and Works', which appeared as a preface to Baudelaire's translation (1856) of Poe's *Tales of Mystery and Imagination*. It was followed a year later by 'Further Notes on Edgar Poe', which served as a preface to a further translation of Poe's stories.

The 1852 article marks an important moment in the development of Baudelaire's critical ideas, under the influence of the poet's spiritual contact with Poe, and it is convenient therefore to speak at this point of the two prefaces, both of which are included in this volume.

Baudelaire probably first discovered Poe in 1847; and he published a translation from him in 1848. It is easy to understand why the American poet and critic, whose life and whose ideas on art and contemporary society afford a striking parallel with Baudelaire's own, made such an impact on him. Like Baudelaire, Poe had to struggle incessantly with financial difficulties, in a society that was highly materialistic and wedded to the gospel of progress; materialism and the idea of progress – 'an ecstasy for mugs . . .'[12] – were anathema to Poe, as they had so quickly become to Baudelaire; like Baudelaire, Poe believed in the doctrine of original sin, denounced democracy with its idea of man's natural goodness, and was disdainfully aristocratic in attitude, a dandy in fact, according to the Baudelairian formula. The price of all that, for Poe, had been a sense of spiritual isolation; Baudelaire's letters to his mother and to other people bear moving testimony to a similar situation in his own case. 'Do you see now', he writes to his mother,[13] 'why, in the hideous solitude that surrounds me, I have been able to understand so well the genius of Edgar Poe, and why I have written his wretched life so well?'

Apart from the biographer's evident and natural sympathy for his subject, particularly striking in the earlier, mainly biographical, of the two prefaces, are, first, Baudelaire's apologia for suicide, one of the forgotten rights of man, one that, back in 1845, he had come close to exercising himself,[14] and secondly his apologia for Poe's drunkenness. The commonplace explanation, that it was a periodic escape from the troubles and difficulties which beset him – a temporary refuge in oblivion – may be good enough as far as it goes, but it is not wholly satisfying. With such scattered bits of evidence as he

can marshal, Baudelaire builds the theory that Poe's drinking habits were, sometimes at least, a deliberate method of work. A relationship exists between given physical experiences and certain mental states, desirable in themselves and propitious for creative art. Thus for Poe the state of drunkenness may have had its own flow of reveries, of such surpassing beauty or strangeness, its own chains of reasoning, of such intricacy, that, for the sake of his poetry or merely as a euphoric relaxation, he may well have had recourse to the magical if ultimately destructive hallucination of alcohol, in the belief or the knowledge that he would thereby induce a mental state favourable to the conjuring up of previous paradisiac visions. The incantatory powers of wine are a theme dear to Baudelaire, the poet, himself:

> En toi, je tomberai, végétale ambroisie,
>
> . . .
>
> Pour que, de notre amour, naisse la poésie
> Qui jaillira vers Dieu comme une rare fleur.[15]

In the first preface Baudelaire has little to say about Poe the writer; he is concerned rather to paint Poe the man, at odds with a hostile world. His analysis of Poe's aesthetic and literary ideas comes mainly in the second preface. On Poe's purely literary opinions – his belief that poetry flows from an exaltation of soul, which is a fleeting experience, and his preference therefore for the short poem, because longer poems get, so to speak, out of breath, short of inspiration, and tend to become a string of short poems, losing thereby the one vital unity, which is the unity of impression, of impact; his insistence on the importance of rhyme; his objection to the poet's relying purely on inspiration in his compositions, and the importance he attaches to formal perfection; his hatred of all forms of didacticism in poetry; his praise of the short story because of its dramatic potential – again impact – on all these points Baudelaire's ideas and practice are parallel with Poe's.

More significant are the indications Baudelaire gives of
certain of Poe's general ideas on art: the exquisite sense of
the beautiful, which is 'an immortal instinct, deep within the
spirit of man'; the three divisions in 'the world of mind' –
pure intellect, taste, and the moral sense – and the respective
functions of these; vice as a moral deformity, and, because a
deformity, an offence to harmony and therefore to beauty.
With such notions Baudelaire is also in full accord. Closely
interwoven with his exposition of Poe's ideas, as expressed in
The Philosophy of Composition and *The Poetic Principle*, are
certain ideas that are thereafter to be at the very core of his
own aesthetic attitudes: the vital role of imagination as the
queen of the faculties, and the belief that, through our
immortal instinct of beauty, because of our longing for the
beyond, we are led to see this world as a kind of faint off-print
– *correspondance* is Baudelaire's vital word – of paradise.

In one particular, Poe's ideal of beauty seems far removed
from Baudelaire's. In spite of what Baudelaire claims for her
in Poe's poetry, the latter's muse knows not passion, 'the
excitement of the heart' as we mortals – and Baudelaire
himself – understand it; wan, ethereal, she lives in a rarefied
atmosphere; she will presently reappear in Pre-Raphaelite
studios, inspire Rossetti, and sit for Burne-Jones. We can
picture her with unnaturally golden hair, elongated neck, and
pale as lard. A generation later, coming down from her lofty
perch, she will be joining W. S. Gilbert's 'greenery-yallery,
Grosvenor Gallery, foot-in-the-grave young man', and
swoon with him in exquisite contemplation of a lily. But
Baudelaire's muse is of the earth, is made of mortal clay, knows
all about temptation, sin, suffering; she wins our sympathy.

In the opening chapter of the article on the Fine Art Section
of the Universal Exhibition of 1855, Baudelaire returns after
nine years to the problem of criticism; he demands from the
critic an open mind and a cosmopolitan attitude in the strict
sense. Nor is this cosmopolitan critic in conflict with the

ideal critic he had spoken of in his 'Salon' of 1846, the critic who must be partial, passionate and political; he is contrasted with those who wish to confine critical judgement within a rigid, narrow aesthetic system on classical lines; truth is too complex for that. Can we really believe Baudelaire when he confesses to having more than once, but always unsuccessfully, tried to adopt a water-tight system of critical judgement? (If so, where do these efforts occur in his critical writing?) In any case he has now, he tells us, decided that feeling and naïveté – again that keyword from the 1846 'Salon' – are the only sure guides.

'Correspondances' – another vital Baudelairian word – reappears in the striking image of dry-as-dust, system-ridden academism, whose stiff fingers can no longer run lightly up and down the immense keyboard of nature's correspondences.

Another important quality that Baudelaire ascribes here to his ideal of beauty is the quality of strangeness, to be understood not as a deliberate, self-conscious effort by the artist to draw attention to himself, but as the peculiar quality giving distinction, uniqueness, to a work of art, as it does to the personality of the artist. Not for nothing had Baudelaire spent some years in the spiritual company of Edgar Allan Poe.

Nor must we omit to draw attention to Baudelaire's vigorous attack, in this first section of the article, on the idea of progress – this brain-child of modern fatuity. Disastrous enough in the material world, it achieves the proportions of a grotesque absurdity when transferred to the sphere of the imagination.

How far Baudelaire has moved from his original position in 1845 as Salon reporter! The usual technical commentary, wrapped in the jargon of the studio, and covering a large number of works, is dismissed as a valueless form of critics' exhibitionism ('See, gentle reader, how well I know my stuff!') at the expense of the artists. For his part, he tells us, feeling, morality, pleasure are to be his guides; it is as though the

critic will not be looking outward so much as inward, with a
view to examining the impact of the canvas on that most sensi-
tive and responsive instrument, his own soul. The word moral-
ity may seem strange here from the pen of Baudelaire. Can he
have had a change of heart since his vigorous attack on Augier
and company? Surely not; we must be careful to distinguish
between the moralizer and the moralist. The former believes
in goodness and badness, the latter in righteousness and sin;
the former is a materialist, the latter holds to spiritual values;
the former is odious to Baudelaire – and not only, one may
hope, to him – the latter, Baudelaire assuredly is, with his con-
viction that belief in original sin is the true foundation for all
human attitudes to life and art. The moralist's attitude ensures
an unflinching gaze at life, admits of pity but not of senti-
mentality in human relationships, cuts at the root of cant, of
false values in creative work and critical judgement, strives, at
least, to strike dead all human vanities. Baudelaire appears to
sum up his own attitude on this question in a letter to Swin-
burne[16]:

Allow me, however, to tell you that you have taken your defence
of me a little far. I believe simply (as you do, no doubt) that any
poem, any work of art, well made, suggests naturally and inevitably a
moral. It is a matter for the reader. I even have a very marked hatred
for any exclusive moral intention in a poem.

After this vital first section, we can scarcely be surprised, as
we walk, so to speak, into the exhibition itself, in the wake of
Baudelaire, to find that we are to 'see' nothing of minor
exhibitors; Ingres and Delacroix alone are to engage our
attention, and, if Baudelaire's gaze has become more search-
ing over the years, his views on the two giants of the age in
French art, who in a contemporary cartoon are shown fighting
it out on horseback with paint brushes, have not altered.
Ingres is a powerful genius, but his art is cold and static, for
imagination is lacking; Delacroix, on the other hand, has that

quality in abundance: imagination, nourished by wide reading (for Delacroix, as we noted earlier, draws his inspiration largely from literary sources), combines with the skills of the colourist to inspire in the viewer an idea of harmony and melody, notwithstanding the frequently violent or tragic nature of the subjects depicted.

'Of the Essence of Laughter' appears originally to have been conceived as part of a work also to have included the studies on French and foreign caricaturists. If other proofs of Baudelaire's belief in original sin were wanting, here we have one. Apart from that music of happiness which is the laughter of children, the phenomenon of laughter, so Baudelaire tells us, is the physiological effect of our conviction of superiority over what makes us laugh; it is a form of vanity, in fact, *ergo* sin. The fountain of all righteousness, God, is recorded (in the Old Testament) as having been wrath on occasion, but laugh he never did; laughter is satanic. Baudelaire's analysis of laughter introduces us into the realm of the comic, thus preparing us eventually, under his guidance, to look at a number of artists, French and foreign, that have exploited this specialized form of art.

Fascinating as Baudelaire's analysis of the comic is, with its absolute and relative or significative divisions, as he calls them, and the sub-categories of these, followed by his discussion of the characteristic contributions different nations have made to man's comic heritage, it lies outside the main stream of his aesthetic ideas; it is an attractive by-way, one of the many to be found in these articles.

In the short article on *Madame Bovary*, Baudelaire provides us with an excellent example of his interpretative skill, his skill at seeing into the mind of a fellow-artist. What more reliable witness of that could we have than the author of the book himself? 'Your article has given me the greatest pleasure', Flaubert writes to Baudelaire.[17] 'You have penetrated into the arcana of the work, as though my brain were

yours. What you say shows that you have felt and understood it all thoroughly.'

The much longer article on Théophile Gautier shows Baudelaire as a persuasive advocate in a no more than moderately good cause, but the cause of a friend dedicated, as Baudelaire was himself, to art. No one would deny Gautier's standing, in his day, as an art critic, nor his skills, both metrical and linguistic, that ensure the survival of *Émaux et camées* (1852), but Baudelaire's admiration seems ready to put Gautier on a par with Hugo as a poet, and to hail him, into the bargain, as a great short-story writer. With the best will in the world, one cannot accept these claims, though from Baudelaire the first one at least is understandable. His attitude to Hugo may appear shifting and hesitant, but the fact remains that there is in Hugo's poetry a strong vein of moralizing and didacticism which Baudelaire could not be expected to stomach, in spite of what he may have said in an earlier article on the 'committed' poetry of his friend Pierre Dupont.[18] Furthermore, even if we sieve out all the didactic dross from Hugo's poetry, the pure metal that remains, generous in quantity though it is, is of a solid kind, firm in descriptive outline and detail, like drawings that tend to leave no part of a subject for the imagination of the viewer to fill in. Baudelaire's well argued rejection of the facile comparison, so often made in his day, between Delacroix and Hugo[19] as the two giants of romanticism, hits the nail well on the head, but if his discerning attitude to Hugo in the passage concerned reflects his true opinion, we are the more surprised at his praise of Théophile Gautier's poetry.

In 1859 Baudelaire was again commissioned – this time by Jean Morel, editor of the *Revue Française* – to report on the Salon of the year. Flat! Mediocre! Such was the opinion of it expressed by another well-known contemporary critic (Théophile Gautier, perhaps). For Baudelaire a few canvases by Delacroix (and there were some) would save any exhibition

from shipwreck, but in general he agrees with his unnamed colleague, and groans at the platitude and fatuity displayed. The reader of today, however, has reason to be grateful to the mediocrities of 1859, since to them no doubt he owes it that much of Baudelaire's account, in the form of letters to Morel, leads him into a number of those by-ways, previously alluded to, which are not the least valuable part of his articles.

How out of sympathy he is with some aspects of the art world of his day! Poor canvases betray poor painters, 'spoilt children' in their generation that they are! Skilful enough, to be sure, in the technique of the trade; but of culture and imagination not a trace! Hence the ludicrous fashion, much in evidence in this Salon, of pictures with joke or pun or conundrum-type titles, a fashion which is an effort to draw the attention of the viewer by means that lie outside art altogether. Equally disastrous for art is the new invention of photography – of immense value for any human activity where exact records are necessary, but not to be identified with art. Contrary to prevailing beliefs, painting, unlike photography, should not strive to be an exact reproduction of nature; if it does, it falls into the most deplorable enslavement.

With what relief does Baudelaire turn from all the poverty of mind displayed before him, fitting product of a Positivist age, to extol imagination; the passage is aflame with fervour; we are reminded of St Paul on charity, or Portia on mercy. With no less joy does Baudelaire return to the subject of Delacroix, recalling the latter's attitude to nature. The great artist, quoth Delacroix, consults nature for the elements of his work, as a writer may consult a dictionary for the elements of his; neither nature nor the dictionary can be equated with the finished composition. Follows an analysis of Delacroix as a colourist, and of his methods of creating a picture, and a passionate defence of the painter, who, despite his commanding position, remained isolated and often misunderstood in a materialist age.

Delacroix's death in August 1863 gave Baudelaire the opportunity to make a general reappraisal of the man and his art; a man of ardent will, a cultivated man, a man of courtesy and kindliness, loyal in friendship, generous on occasion but prudent by material necessity (a necessity cruelly familiar to Baudelaire himself). In mind and attitudes, Baudelaire opines, Delacroix recalls Stendhal and Mérimée, aloof, sceptical, aristocratic, the perfect dandy. The dandy! – another keyword in the Baudelairian scheme of things, denoting an attitude to life, and consequently to art; burning passions, hidden beneath a surface of ice; the will controlling the imagination, the rider in control of his mount.

Delacroix the artist has those very qualities; a powerful imagination, nourished by scholarship, passions in full flood, yet under the control of a mind fully able, thanks to an iron will and incomparable technical abilities, to organize them into efficient work for the maximum impact on the viewer.

This article, in which certain passages of the 1859 'Salon' are incorporated, is not only an effort to perpetuate the memory of a man, to review the art of a genius; it provides an invaluable insight into Baudelaire's own aesthetic ideas. It and the two remaining articles in this selection form a triumphant statement of his final position, before disease caught up with him, and silenced him for ever.

The long article on Constantin Guys, though the last in date of Baudelaire's critical articles, may well have been mostly written in 1860. It is, in the first instance, as close a scrutiny of an artist's work as any undertaken by Baudelaire, evoking for his readers Guys' pictorial record – a vast output, ranging from London to the Levant. Nor are our critic's descriptions gratuitous, since, as Baudelaire proceeds with these, he also brings out vividly the characteristics and the skills of the artist; Guys' passionate interest in the life about him, be it in war or peace, be it amongst the soldiery or in the 'snob' world of carriage folk, or in the brothel, be it at the

play or in the park; everywhere Guys' impressionable eye and photographic memory combined to produce what Baudelaire calls Guys' mnemonic art, a highly selective technique that suggests rather than defines, that has as its main purpose to be a distillation of modernity in the contemporary scene, that indispensable transient element which combines, in subtle and indefinable proportions, with the permanent to produce beauty.

Already in the 1846 'Salon' Baudelaire had alluded to the dual nature of beauty; here he returns to the theme. In his obituary on Delacroix he had spoken of that artist as a dandy; here he devotes a section to the phenomenon, because Guys had so unerringly seized the peculiar characteristics in dress and attitude of the dandy as a distinguishable social species, the last heroic adornment of decadent ages, a form of male artificial beauty, triumphant over nature, just as female beauty in the modern world is, and should be, an artificial product, triumphant over nature, with fashion, dress and make-up as essential spiritualizing ingredients; for nature, in itself, is vile, brutish; virtue, and beauty also, are rational, artificial constructions for which nature provides only the raw materials.

Baudelaire's article on 'Wagner and *Tannhäuser*', though smaller in scope than the article on Constantin Guys, is no less important. No better proof of Baudelaire's percipience as a critic could be found. With no technical knowledge of music, having heard only parts of *Tannhäuser* and *Lohengrin*,[20] Baudelaire reveals nonetheless a clear awareness of the magical power of suggestion in Wagner's music; the poet of *Correspondances*,[21] the believer in 'the complex and indivisible totality' of God's creation, had an instinctive affinity for organized sound, so full of colour, so descriptive of sensuous experience, so evocative of images, so capable of inspiring reverie or suggesting character.

Instinctive sympathy was duly transformed into the superior joy of understanding through a study of Wagner's

own writings on music and drama; his revolutionary aims, founded on the study of ancient Greek drama, the appeal to the German mythology, the skill of the composer-poet in co-ordinating the complementary functions of words and music to delineate character and paint the conflict of human emotions within the vast framework of the *Gesamtkunst*[22] conception, all this was revealed to Baudelaire and interpreted by him with rare insight. At a time when, in France, the understanding of Wagner had scarcely dawned, Baudelaire had appreciated his music, seen its significance and understood the immense potential of his ideas for art in general.

*

Of all literary genres, what more ephemeral than criticism, and therefore than critics? Confronted with such a crowd of ghosts, we might be tempted to develop the paradox that criticism as an art, retaining its resonance, its stimulating quality beyond the narrow limits of a single generation, is more difficult than creative writing, were it not that the crowd of ghosts in the sphere of creative writing must be at least as large.

But it remains true that great critics are rare; in English literature, Dryden, Lamb, Coleridge, Ruskin, Pater come to mind; in Germany, Lessing; in France, Boileau, Diderot, Sainte-Beuve.

If we ask ourselves what elixir has given these critics the power to survive, the answer surely is, not that they were more percipient and intelligent than others, for without these qualities no critic could make an honest living, but that they were more than merely interpretative critics, in the forefront perhaps, but nonetheless amongst the reading public at the receiving end of literature; they were also representative of an age and its values, like Boileau and Dryden, or responsible for discovering some hitherto unsuspected insights, like Lamb on the Elizabethans, or like Ruskin and Pater, champions, both,

of the religion of art; or again, a critic may have initiated some new movement, like Lessing, who, by loosening the hold of the French classical tradition, gave German literature the chance to breathe some invigorating native air; in France, Diderot played much the same role by his experiments and exploration in the field of drama; he has a further claim in his having virtually created art commentary, by the freshness and vigour of his 'Salons', which were to be an example to Baudelaire and to stimulate in the latter the wish to outdo his eighteenth-century predecessor in that genre. Nor must we forget those critics who, besides the range and abundance of their critical work – a Sainte-Beuve for instance – or their philosophical distinction – Coleridge springs to mind – have perhaps a greater claim by their stature as scholars. In short, all of these, one way or another, have a recognizable character, make an impact, and are, to that extent at least, creative.

Baudelaire's critical writings, too, are creative in a number of ways. Apart from the great intelligence and perceptiveness that lie behind them, the reader will quickly see that, if the first, the 1845, 'Salon' be excepted, Baudelaire is concerned to move from particular instances to general considerations on art and beauty. His purpose is not to create a water-tight system of aethetics; his condemnation of the narrow academism of pedagogues is forthright[23]; cosmopolitanism, in the best sense, is divine[24]; 'the mind of the critic', he writes, 'must be open to all kinds of beauty',[25] with feeling and pleasure as his guides, for 'a system is a kind of damnation'.[26]

On this basis, Baudelaire's criticism is a stimulating exploration into selected fields of literature, painting, sculpture and even music, to discover beauty in its great variety of forms. In a manner reminiscent of Poe, he marks out the respective boundaries of art, science and ethics[27]; the purpose of art is to create beauty, science pursues truth, ethics are concerned with goodness and morality. Communication between the three is not excluded, and it may be that, inspired by imagination,

an artist will have a vision of the peaks where dwells the all-embracing divine. But on the human level the aims of the three activities must remain distinct; if art, losing its direction, pursues truth, as the Positivist age requires, it becomes enslaved either to the banal representation of external reality or to a vain and mawkish depiction of inward saintliness; if didacticism becomes its aim in a moralizing effort to defend morality, it falls at once into dishonesty.

Baudelaire perceived and condemned many artists about him who vainly tried to capture attention, make an impact, by means that have nothing to do with art, either because they had misunderstood the fundamental principles enunciated above, or because they lacked creative imagination; usually both.

On the other hand, the artists, the writers, the musician that Baudelaire selects to write about in depth – Delacroix, Guys, Poe, Flaubert, Gautier, Wagner – are not only admirably studied in themselves, but are also of particular significance for certain qualities in them that he regards as fundamental to the creation of great art: disinterested dedication, imagination, controlled passion, spirituality and reverie, strangeness, modernity, dandyism, the appreciation of the unity of the arts, each art helping to develop the potential of the others, the feeling for the close connection of the visible and invisible worlds, the correspondence of the one to the other.

In his article on Wagner, where he stresses the combination in the German poet-composer of the man of order and the man of passion, he admits that where art is concerned he, Baudelaire, is not opposed to excess – 'moderation has never appeared to me to be the hall-mark of a vigorous artistic nature'[28] – and if we were to cast about for a word that would best indicate the general character of Baudelaire's art, both creative and critical, could we not choose 'intensity'?

Judged on the evidence of his letters, that intensity was certainly to be found in his own nature and temperament.

No mere aesthetic ideas held by the poet and critic could provide it had it been lacking in the man. Intensity is surely the word that describes Baudelaire's human experience, as it appears to us in his letters; intensity on every level, from that of suffering to that of personal relationships with his mother, his mistresses, his friends, to the intellectual level of judgement and attitudes. On all these levels, Baudelaire's intense sensibility was as taut as a tightly strung racket. What more natural, then, than for him to have a conception of beauty informed with that vital quality?

The decay and downfall of classical idealism in the course of the eighteenth century had brought down in ruins the belief in objective standards of beauty. A work of art was not to be judged on how far it conformed to objective standards of proportion, but by the impact it made on the subject. But how is the impact to be achieved, if not by intensity in some form or other? Intensity of colour in painting (Delacroix), intensity of controlled evocative sound (Wagner), intensity, exciting the emotions, stimulating the intellect, penetrating the soul, inducing reverie.

To develop this power of impact, reliance on academic tradition, as Ingres relies on it, or on technical skill, like Horace Vernet for example, or on complete submission to the object, like Courbet, is not enough; the artist must above all have imagination. All this is of the essence of romanticism, and Baudelaire is first and foremost a romantic. But, unlike so many romantics of the earlier generation, who believed that direct communication of their emotions was enough to ensure an equivalent response in the reader, viewer or hearer, Baudelaire understood that beauty was something more than emotion given form. Of *Les Fleurs du mal* he said to his mother that the book had been created 'in . . . savage anger and patience'; we may interpret these as intense emotion and control – the very qualities he saw in the painting of Delacroix and the music of Wagner. Without control, the artist will

not succeed in communicating, in making his impact; the emphasis here is on form, and art, be it remembered, is concerned with form, not with morality, which is the business of ethics, nor with truth, which is the domain of science; form, beauty (for what is beauty without form?), is the domain of art. Here Baudelaire is immediately seen as a late romantic, a worshipper at the altar of art. Sharing with the Parnassians the cult of form and the loathing of contemporary materialism, he is yet not of them; they strove to bring science into poetry. The poetry of Leconte de Lisle or Hérédia is essentially a learned poetry, a poetry built on data, the materials of objective truth; and objective truth is the aim of science, not of poetry, which is concerned with beauty, the cult of form.

But how is art to achieve its purpose to the fullest extent, to ensure its maximum impact? Unlike Leconte de Lisle or Hérédia or even his friend Théophile Gautier, all of whose conceptions of beauty are static, Baudelaire's answer is 'la sorcellerie évocatoire' – evocatory witchcraft. An artist's sensuous experience, rooted in human passions, and often in suffering, but emptied of its direct personal elements, and clothed in formal beauty, will find an echo in a reader's recollected experience and call forth a powerful response; expressed in words, depicted in paint, suggested in music, the phenomena of the seen world and the fine distillation of the poet's own experience may provide symbols to stimulate the reader's or the viewer's or the listener's imaginative mechanisms; they will adapt what the artist gives them to their own natures and experience, or to their aspirations, evoking in their own mind, by the interplay of 'correspondances', paradisiac visions of the world unseen: a secondary creative process perhaps, but creative nonetheless, and all the more effective because it is their own. By playing, as Baudelaire puts it, 'sur l'immense clavier des correspondances',[29] the artist launches the reader into the infinite on the wings of reverie, as the drugs of *Les Paradis artificiels* do and – so Baudelaire, and

many others after him, thought – as the music of Wagner does.

At this point, Baudelaire has left the romantic fold, and is pointing the way to the Symbolists; they will exploit the vein uncovered by Baudelaire, more musically perhaps, but less profoundly, and less passionately.

The reader will have noticed that we appear in the foregoing paragraphs to have shifted our ground from Baudelaire the critic to Baudelaire the poet – deliberately, for poet and critic are indeed inseparable in him, and if, on the one hand, Baudelaire's writings are creative as criticism, because so rich in stimulating ideas on art generally, they are equally creative because an integral part of his own poetry. The opponents of Wagner the theorist had refused to believe him capable of being a great composer either; his operas, said they, could be no more than experiments to prove a theory. Nonsense! retorts Baudelaire; even if the facts were not there to show that Wagnerian theory and practice evolved together, the truth about art would itself refute his enemies; a mere critic becoming a great poet must be a rare phenomenon indeed, but every artist carries within him a critic, who, sooner or later, will appear to explain how the creative mystery of his other and greater self evolved; thus Wagner, so Baudelaire.

If Baudelaire's is the criticism of a poet, the same is abundantly true of its form; the language, the style are those of a poet. Forthright, incisive, amusing; simple and eloquent; ornate and passionate; elusive and allusive, Baudelaire's style is all these things by turns, changing rapidly from one register to another and always in a manner appropriate to his theme. As a result, the translator's path is at times a thorny one. Can this translator claim to have been faithful to the translator's threefold allegiance: fidelity to his author's text, fidelity to his author's thought and intentions, fidelity to his own, the translator's, tongue – three steeds that do not always trot on easily together? The reader alone can judge, but as 'a doorkeeper

in the house' of Baudelaire, this translator will feel richly rewarded if he may be the means whereby an even greater company than now enters the shrine, the shrine of a prophet 'not without honour save in his own' . . . time.

Looking back over the literary and artistic landscape of Baudelaire's day, we may justifiably feel much sympathy for his having had, as a critic, to feed on such stony pastures, where compromise and lack of strong convictions (eclecticism, he called it), unimaginative, unselective realism, weighed down with pious moralizing (Schools of Good Sense, Positivists, photographers and the like!), effete classical traditions (in the wake of the great but bizarre Ingres), all these were to be met with – lean kine indeed. Would that he had lived to see the second flowering that was to come a little later in the century; the explosions of light in the canvases of the Impressionists, the vibrating colour of a Seurat, the resolute modernity of a Toulouse-Lautrec, a Degas or a Renoir, the mysterious symbolism of an Odilon Redon; would he not have understood and welcomed these? Or again, Mallarmé's faun, struggling in the torrid heat to recapture his erotic vision, and Debussy's music that the faun inspired, and, since we have mentioned music, what of the powerful evocations of northern landscapes, lakes and forests in the music of Sibelius? The list could be prolonged to include the work of Proust and the Surrealists. Idle speculation no doubt, but tempting, for these riches of the last hundred years, where dwells imagination, that 'queen of the faculties', may well be claimed as a part of Baudelaire's domain, which in his day still lay, but only just, in the shadows.

In conclusion, the translator desires to record his great debt of gratitude to his friend Mr John Walter Lucas, whose knowledge, sagacious advice and time have been put at his disposal, unsparingly; and to Mr Geoffrey Woodhead, for the two classical references on pp. 117 and 420.

P. E. CHARVET

1. The Salon of 1845[1]

I. A FEW WORDS OF INTRODUCTION

WE are entitled to claim with at least as much accuracy as a well-known writer about his little books: the papers would not dare print what we say. Does that imply that we are going to be very cruel and censorious? Not at all; on the contrary, impartial. We have no friends – that is a great advantage – and no enemies. M. G. Planche[2] was as ruggedly honest as an uncouth peasant, but since his imperious and learned eloquence has been silent, to the great regret of all sane minds, the newspapers' critical columns, sometimes silly, at other times angry, but never objective, have by their lies and shameless favouritism disgusted the layman with those useful hints for the ignorant known as Salon reviews.*

And to begin with, on the subject of that impertinent designation 'the bourgeois', we hereby let it be known that we do not at all subscribe to the prejudices of our important colleagues, with art at their finger-tips, who for several years now have been doing all they can to hurl anathemas at the inoffensive being, who would ask for nothing better than to appreciate good painting, if the gentlemen in question knew the art of making him understand it and if the artists showed him good painting more often.

This word, which stinks a mile away of studio slang, ought to be deleted from the dictionary of criticism.

There are no more bourgeois, now that the bourgeois himself uses this insulting epithet – a fact that shows his

*One splendid and honourable exception to be noted is M. Delécluze,[3] whose opinions we do not always share but who has always safeguarded his right to his forthright opinions, and who without trumpet blasts or pomposity has often had the merit of spotting young and unknown talents.

willingness to become art-minded, and listen to what the columnists have to say.

Secondly, the bourgeois – since in fact he does exist – is highly respectable; for we must please those by whom we hope to earn a living.

And finally, there are so many bourgeois amongst artists themselves that it behoves us to suppress a word that describes no particular vice of any social class, since it can be applied equally to those who ask for nothing better than to deserve it no longer, and to others who have never suspected that they deserved it.

It is with the same contempt for all systematic opposition and shrill complaints, both of which have become frequent and commonplace,* and with a similar sense of order, and love of common sense, that we have set our face against any discussion in this little pamphlet either of selection panels in general and the painting hanging committees in particular, or of the reform, which, so they say, has become necessary, of the method of appointment to selection panels, or of the style and frequency of exhibitions, etc. . . . To start with, a selection panel is essential; that is obvious. And as for the annual round of exhibitions, which we owe to the enlightened and liberally paternal attitude of a king[4] to whom public and artists owe the enjoyment of six museums (the Gallery of Drawings, the additional wing of the French Gallery, the Spanish Gallery, the Standish Museum,[5] the Versailles Museum and the Nautical Museum), any fair-minded man will always see that a great artist only stands to gain by it, in view of his natural creative power, while the second-rater gets no more than the punishment he deserves.

We shall speak of everything that attracts the eyes of crowd and artists alike; the duty of our calling compels us to. Everything that pleases has a reason for pleasing, and pouring

*The protests may be justified, but their systematic nature makes them tiresomely shrill.

scorn on the crowds that mistakenly gather here or there is not the way to bring them back to where they ought to be.

Our method of procedure will consist simply in dividing work into: paintings of historical subjects and portraits; genre pictures and landscapes; sculpture; engravings and drawings; and in arranging the artists according to the order and rating assigned them by public favour.

II. PAINTINGS OF HISTORICAL SUBJECTS

DELACROIX[6]

M. Delacroix is decidedly the most original painter of both ancient and modern times. That is the simple truth, like it or not. None of M. Delacroix's friends, even the most enthusiastic, has dared to say that, simply, baldly, impudently, as we are saying it now. Thanks to time's tardy justice, which softens feelings of rancour, astonishment, ill-will, and which slowly bears away every obstacle to the grave, the time is past when reactionaries crossed themselves if the name of M. Delacroix was mentioned, and when his name was a standard around which all forms of opposition, intelligent or not, rallied. Those good old days have gone. M. Delacroix will always to a certain extent remain a subject of dispute, just enough to add some further radiance to his crown of glory. And so much the better! He has the right to be for ever young, because he, for one, has not deceived us, or lied to us like some of the ungrateful idols we have carried into our temples of fame. M. Delacroix is not yet a member of the Academy, but morally he belongs to it; he said everything long ago, everything that needs to be said in order to be first. That is agreed; nothing remains for him to do (miraculous feat of a genius for ever in quest of something new) but to go forward in the path of excellence, the path he has always trodden. M. Delacroix has sent four pictures this year:

1. La Madeleine dans le désert. The picture, which is in a very narrow frame, is of the upturned head of a woman. In the top right-hand corner a small bit of sky or rocks – something blue; Mary Magdalene's eyes are closed, her mouth is soft and languid, her hair dishevelled. Without seeing the picture, no one can imagine the feelings of intimate, mysterious and romantic poetry the artist has succeeded in imparting to this simple head. It is painted almost entirely with straight brush strokes, as many of M. Delacroix's pictures are; the tones, far from being bright or strong, are very soft and very subdued; the impression is almost grey but perfectly harmonious. This picture reveals a truth we have long suspected, which is still more evident in another picture we shall speak of presently, namely that M. Delacroix is more skilful than ever, and on a path of progress for ever renewed; in other words he is more than ever a harmonist.

2. Dernières Paroles de Marc-Aurèle. Marcus Aurelius is depicted entrusting his son to the care of the stoics. Lying partly uncovered on his death-bed, he is presenting the young Commodus, pink, soft, voluptuous, and apparently bored, to his austere friends grouped about him in attitudes of deep sorrow.

A splendid picture, magnificent, sublime, misunderstood. A well-known critic lavished praise on the artist for having placed Commodus, the future in other words, in full light, the stoics, or the past, in shadow – how perceptive! But apart from two figures in chiaroscuro all the characters have their share of light. This recalls to our mind the admiration of a republican man of letters congratulating the great Rubens for having depicted Henry IV[7] with a down-at-heel jack-boot and stocking in one of his official pictures in the Medici Gallery[8] – evidently the satirical thrust of an independent mind, a liberal's dig at the king's debauchery. Rubens as a *sans-culotte*![9] Oh criticism! Oh critics!

This picture gives us Delacroix in full; in other words, we have before our eyes one of the most complete examples of what genius can achieve in painting.

The colour shows incomparable knowledge: not a single mistake, and yet the picture is full of feats of skill, feats of skill invisible to the inattentive eye, for the harmony is subdued and deep; the colour, far from losing its stark originality in this new and more complete science, remains gory and terrible. This balancing of the green and the red goes to our very soul. M. Delacroix has even introduced into this picture, at least we think so, some tones he had not hitherto made a habit of using. They set each other off. The background has the appropriate seriousness for such a subject.

In conclusion, let us add, for no one mentions it, this picture is perfection in drawing and modelling. Does the layman really appreciate the difficulty of getting the effect of shape and depth with paint? The difficulty is twofold. Modelling with one tone is the equivalent of using a drawing stump, the problem is simple; to achieve the same effect with colour means that the artist, in the midst of his rapid, spontaneous and complex brushwork, must first understand the logical interrelation of the shadows and light and then find the corresponding tone and its harmonious range; in other words, if the shadow is green and a source of light red, the artist must at once find a harmony of green and red, the former dark and the latter luminous, with which to render the effect in the round of a monochrome object.

This picture is impeccable in its drawing. With regard to this enormous paradox, this impudent blasphemy, must we repeat, re-explain, what M. Gautier[10] took the trouble to explain in reference to M. Couture[11] in one of his articles last year – for, when works suit the temperament and the education of the man of letters he is, M. Th. Gautier comments well on the things he feels are right – namely that there are two types of drawing, the drawing of the colourists and the

drawing of the draughtsmen? The technique in each case is the opposite of the other. But it is quite possible to draw with a high-key colour, just as one may be able to build up harmonious masses of colour, and yet remain essentially a draughtsman.

Thus, when we say that this picture is well drawn, we do not mean to convey that it is drawn like a Raphael; we mean that it is drawn in a manner full of spontaneity and wit; that this type of drawing, which has some analogy with that of all the great colourists, Rubens for example, renders effectively, renders perfectly, the movement, physiognomy, the illusive and delicate character of nature, all things that the draughtsmanship of Raphael never renders. We know of only two men in Paris who draw as well as M. Delacroix – the one in an analogous manner, the other adopting a contrary method. The one is M. Daumier,[12] the caricaturist; the other M. Ingres,[13] the great painter, the cunning admirer of Raphael. Now that is a statement likely to astonish friends and enemies, devotees and antagonists alike; but by dint of slow and studious attention, anyone may see that these three types of drawing have this in common, that they render perfectly and wholly the aspect of nature they choose to portray, that they say accurately what they want to say. Daumier draws better than Delacroix perhaps, if, that is, we choose to prefer healthy and robust qualities to the striking powers of a great genius, sick with genius. M. Ingres, so fond of detail, draws better, perhaps, than either of the other two, if we like painstaking delicacy better than a well-proportioned whole, and a composition studied bit by bit rather than seen and rendered as a whole, but . . . let us love them all three.

3. Une Sibylle qui montre le rameau d'or. Here again we have beautiful and original colour – the painting of the head has something of the same, charming hesitancy of outline as the Hamlet series of drawings.[14] The plasticity conveyed and the

impasto are incomparable; the bare shoulder is worthy of a Correggio.

4. *Le Sultan du Maroc entouré de sa garde et de ses officiers.* This is the picture we were referring to just now when we said that M. Delacroix had made progress in the knowledge of colour harmonies. Indeed, has anyone ever at any time displayed a greater musical coquetry? Was Veronese ever more magical? Who has succeeded in making colours on a canvas sing more capricious melodies, in finding more prodigious, new, unknown, delicate, delightful chords of tones? We appeal to the honesty of anyone familiar with the Louvre to quote an example of a picture by a great colourist where the colours display as much originality as that of M. Delacroix. We know we shall be understood only by a few people but that is enough. This picture is so harmonious, in spite of its tonal splendour, that the impression is grey, grey like nature, grey like the atmosphere in summer when the sun spreads, as it were, a mantle of shimmering dust on everything. As a result the picture does not immediately strike the visitor; it is overpowered by its neighbours. The composition is excellent; there is something unexpected about it, because it is true and natural . . .

P.S. People say that praises from some people are compromising, and that it is better to have a wise opponent . . . etc. For our part, we simply do not believe that genius can be compromised by being explained.

HORACE VERNET[15]

This African scene[16] is colder than a fine winter's day. Everything in it has a disastrous whiteness and clarity about it. Unity, nil; instead, a host of interesting little anecdotes; the whole vast panorama is fit for the walls of a tavern. Usually these sorts of decorative composition are divided into separate

compartments or acts, so to speak, by a tree, a great mountain, a cave, etc. M. Horace Vernet has adopted the same method and thanks to this method, which is that of the serial writer, the spectator's memory finds signposts to cling to: a tall camel, a group of hinds, a tent, etc. Really, how painful it is to see an intelligent man wallowing in the horrible. Could it be that M. Horace Vernet has never set eyes on the works of Rubens, Veronese, Tintoretto, Jouvenet[17] – great heavens! . . .

. . .

DECAMPS[18]

Let us approach them without further ado, for paintings by Decamps excite curiosity in advance; we always promise ourselves a surprise; we expect something new; this year M. Decamps has prepared a surprise that surpasses all those he worked at for so long with such love, even *Les Crochets* and *Les Cimbres*.

M. Decamps has done something in the manner of Raphael and Poussin, 'pon my word he has!

Let us hasten to say, in order to correct what may seem exaggerated in the foregoing remark, that never was an imitation better concealed or more skilful; imitations of that order are legitimate, even praiseworthy.

Frankly, in spite of all the pleasure we may get from tracing in an artist's work the various stages of his art and the successive ideas that have occupied his mind, we are inclined to miss the old Decamps a little.

With unerring choice, which is characteristic, he has hit upon that one of all biblical subjects that suited best the nature of his talent, namely the strange, weird, epic, fantastic, mythological story of Samson, the man saddled with impossible tasks, the man who rocked houses with his shoulder as he brushed past, that biblical cousin of Hercules and of the Baron von Münchhausen.[19] The first of these drawings – the

appearance of the angel in a broad landscape – has the disadvantage of recalling too many over-familiar things; that harsh sky, those rock faces, those horizons of granite have long been the stock in trade of the young school, and, although it is true to say that M. Decamps was M. Guignet's teacher, we do not enjoy being reminded of the latter when we are looking at a Decamps.

A number of these compositions have, as we have already said, a markedly Italian character, and this mixture of the spirit of the old and great schools with the spirit of M. Decamps, who in some ways is very close to the Flemish outlook, has produced a most curious result. For example, next to figures that look exactly, and deserve to look, like figures from great pictures, will be found an open window sketched in, with sunlight flooding in and lighting up the parquet floor in a manner to gladden the heart of the most meticulously detailed Flemish painter. In the drawing that depicts the destruction of the temple, a drawing composed in the grand manner of a great picture, with gestures and attitudes from the story, the peculiar genius of Decamps appears, pure and unadulterated, in the shadowy flying figure of the man jumping several steps at a time, who remains for ever suspended in the air. What crowds of other artists would never have thought of this detail, or at least would have depicted it in another way! But M. Decamps likes to catch nature in the act by showing its most sudden and unexpected glimpses, where its fantastic and real sides appear together.

The best of them all is, without a doubt, the last; the broad-shouldered, the invincible Samson is condemned to turn a mill-stone; his head of hair or rather his mane has gone, his eyes are pierced; the hero bends to his labour, like a draught animal; cunning and treachery have overcome that fearsome strength of his that might have disrupted the laws of nature. Splendid! Here we really have Decamps at his truest and best; here at last we come back to the ironic, the fantastic

– I nearly said the comic – elements that we missed in the first drawings. Samson is dragging a mill-stone round like a horse; he walks heavily and bowed, with uncouth simplicity, the simplicity of a dispossessed lion, the resigned melancholy and almost the brutishness of the king of the forests condemned to pull a cesspool emptier or a butcher's cart with lights for cats.

A supervisor, a jailer no doubt, in attentive attitude and seen in outline against a wall in shadow in the foreground is watching him work. What more complete than these two figures and the mill-stone? What more interesting? There was even no need to include the group of curious onlookers behind the bars of an aperture – the study was beautiful enough as it was.

To sum up, M. Decamps has produced a magnificent illustration and some impressive vignettes to accompany this strange Samson poem. Although some walls and a few objects, done in excessive detail, and the crafty, over-careful mixing of paint and pencil might be criticized, this series of drawings, because of the new aims that so luminously appear in it, is one of the best surprises that this prodigious artist has given us; no doubt others will follow.

ACHILLE DEVERIA[20]

A great name, that, a noble and true artist, in our opinion.

Critics and journalists have passed the word round to intone a charitable *de profundis* on the departed talent of Eugène Deveria. Every time the mood takes this hoary romantic celebrity to appear in the light of day, they bury him reverently in the shroud of *La Naissance de Henri IV*,[21] and light a few candles at the shrine of the old ruin. All right! At least all this shows that these gentry love beauty conscientiously; it does credit to the warmth of their hearts. But why is it that to none of them does the idea occur of casting a few sincere

blooms or of weaving a garland of honest articles in favour of
M. Achille Deveria? What ingratitude! For many years now
M. Achille Deveria has been drawing on his inexhaustible
fund of inventiveness to delight us with ravishing vignettes,
charming little interiors, elegant scenes of high life, such as no
autograph album, in spite of newcomers' claims, has pub-
lished since. He had the art of applying colour to the lith-
ographer's stone; all his drawings were full of charm and
distinction; they breathed an indefinable spirit of agreeable
reverie. All his coquettish and delicately voluptuous women
were the ideal representations of those desirable creatures to be
met with of an evening at concerts, at the Bouffes, the Opera
or in fashionable drawing rooms. These lithographs, bought
by the dealers for three sous a piece and sold by them for a
franc, are the faithful mirrors of that elegant and fragrant
Restoration life, over which hovers, like a protecting angel,
the fair romantic phantom of the Duchesse de Berry.[22]

What ingratitude! Today his name is never mentioned, and
all our anti-poetical treadmill donkeys have turned lovingly
to the asinine virtue-exuding rubbish of M. Jules David or the
pedantic paradoxes of M. Vidal.

We would not go so far as to say that M. Achille Deveria
has painted an excellent picture – but he has produced a
picture in his *Sainte-Anne instruisant la Vierge* that deserves
attention particularly by its elegance and skilful composition –
true, it is more a medley of colour than a picture, and in these
days when the critics talk of 'pictorial criticism', 'catholic
art', and 'bold brushwork', such a work must inevitably look
naïve and out of place. But if the works of a well-known man
who once was the joy of your life now seem naïve and out of
place to you, well, at least bury him with a becoming orches-
tral accompaniment, you herds of egotists, you!

CHASSÉRIAU[23]

Le Kalife de Constantine suivi de son escorte. The composition accounts for this picture's immediate impact. This procession of horses and powerful horsemen has an air about it that recalls the bold simplicity of the Old Masters. But for those that have followed attentively M. Chassériau's studies, it is evident that this young man's mind is seething with new ideas and that the conflict between them is far from over.

The position he wants to create for himself, between Ingres, whose pupil he is, and Delacroix, from whom he is seeking to pilfer, creates a feeling of equivocation in the public mind and is embarrassing for him personally. That M. Chassériau should find what he wants in Delacroix, what more natural; but that in spite of his great talent and the precocious experience he has acquired, he should show it so obviously, that is the trouble. And so, this painting has its contradictions. In certain parts colour reigns, in others we still have mere coloured drawing – and yet the whole effect is pleasant, and the composition, we are pleased to repeat, is excellent.

Already in his illustrations for *Othello* everyone had noticed the artist's evident concern to imitate Delacroix. But with such distinguished tastes and such an active mind, M. Chassériau will, we have every reason to hope, become a genuine and an eminent painter.

. . .

V. LANDSCAPES

COROT[24]

At the head of the modern landscape school stands M. Corot. If M. Théodore Rousseau[25] would only exhibit, Corot's supremacy would be in doubt: M. Théodore Rousseau has, in addition to a simplicity and an originality at least equal to

that of Corot, a greater charm and a surer technique. It is indeed simplicity and originality that together make up the worth of M. Corot. Clearly this artist has a sincere love of nature and knows how to study nature with as much intelligence as love. The qualities that shine forth in him are so emphatic – because they are rooted in his soul and his nature – that the influence of M. Corot can now be detected in almost all the paintings of the young landscape artists, especially of a few who had already had the wisdom to follow in his footsteps and draw advantage from his manner before he became well-known and before his reputation had extended beyond the artists' world. From the depths of his modesty, M. Corot has had an impact on a host of minds. Some have applied themselves to choosing in nature themes, views, colours, dear to the Master, to cherishing the same subjects; others have even tried to *copy* his clumsiness; and whilst on the subject of the supposed clumsiness of M. Corot, it seems to us that there is a slight preconception that needs pointing out. Having conscientiously admired a painting by Corot, and having sincerely paid him their tribute of praise, all the wiseacres give it as their opinion that the painting in question is weak in technique, and are at one in declaring confidently that M. Corot does not know how to paint. Oh, the worthy fellows! unaware, to begin with, that a work of genius, or, if the expression be preferred, a work of deep sincerity, where all the component parts have been accurately seen, well studied, well understood, well pictured in the mind, is always well executed, so long as it is sufficiently executed; further, that there is a world of difference between a 'completed' subject and a 'finished' subject and that in general what is 'completed' is not 'finished' and that a thing 'finished' in detail may well lack the unity of the 'completed' thing, that the value of an amusing, significant and well placed touch of colour is enormous, etc., etc.; from all of which it follows that M. Corot paints like the great masters. As an example we need look no further than his

picture[26] in last year's Salon, the impact of which was even more tender and melancholy than usual; that green country-side, where a woman sits playing a violin; that pool of sunlight on the grass in the middle ground, imparting to it a tonal value different from that of the foreground, was certainly a bold stroke and a very successful one. M. Corot is no less the master this year than in former years; – but the eye of the public has been so accustomed to shining neat offerings, conscientiously polished, that the same criticism is always levelled at him.

What further confirms M. Corot's mastery, in technique alone, to go no further, is that he knows how to be a colourist with a tone-range of little variety – and that he always achieves harmony even when using fairly crude and bright tones. His composition is always perfect. Thus in his *Homère et les Bergers* no detail is unnecessary, nothing could be cut out; not even the two little figures walking away along the path, talking as they go. The three little shepherds with their dog are delightful, much like those excellent bits of bas-relief to be found sometimes on the pedestals of ancient statues. The Homer of the picture is perhaps too much like Beli-sarius.[27] Another picture full of charm is *Daphnis et Chloe*; its composition, like all good compositions, as we have often pointed out, has the merit of the unexpected.

2. The Salon of 1846[1]

TO THE BOURGEOIS

YOU are the majority, in number and intelligence; therefore you are power; and power is justice.

Some of you are 'learned'; others are the 'haves'. A glorious day will dawn when the learned will be 'haves', and the 'haves' will be learned. Then your power will be complete and nobody will challenge it.

Until such time as this supreme harmony is ours, it is just that the mere 'haves' should aspire to become learned; for knowledge is a form of enjoyment no less than ownership.

The governance of the state is yours, and that is as it should be, because you have the power. But you must also be capable of feeling beauty, for just as not one of you today has the right to forgo power, equally not one of you has the right to forgo poetry. You can live three days without bread; without poetry, never; and those of you that maintain the contrary are mistaken; they do not know themselves.

The aristocrats of thought, the distributors of praise and blame, the monopolists of spiritual things have denied you the right to feel and enjoy – they are pharisees.

For you hold the power in a city where the public is cosmopolitan, and you must be worthy of the task.

Enjoyment is a science, and the exercise of the five senses demands a special initiation that can be achieved only by willingness to learn and by need.

And you need art, make no mistake.

Art is an infinitely precious possession, a refreshing and warming drink that restores the stomach and the mind to the natural balance of the ideal.

You perceive its usefulness, you worthies – legislators or tradesmen – when the chimes of the seventh or eighth hour incline your weary heads towards the glowing embers in the grate and the wings of your armchairs.

A keener desire, a more active reverie, will at such moments prove a relaxation from your daily strivings. But the monopolists have tried to keep you away from the fruits of knowledge, because knowledge is their counter and their shop, to be guarded jealously. If they had denied you the power of creating works of art or of understanding the techniques used in their creation, they would have been proclaiming a truth that you would not have taken offence at, because public business and trade absorb three quarters of your day. As for the leisure hours, they must therefore be used for enjoyment and pleasure.

But the monopolists have decreed that you shall not have the right to enjoyment, because you lack the technical knowledge of the arts, although possessing that of the law and business.

Yet it is only right, if two thirds of your time is taken up by techniques, that the other third should belong to feeling, and it is by feeling alone that you are to understand art; – and that is how the balance of your spiritual forces will be built up.

Truth, though many-sided, is not double; and just as you have extended men's rights and benefits in your political life, so you have established in the arts a greater and more abundant communion.

Bourgeois – be you king,[2] law-giver or merchant – you have established collections, museums, galleries. Some of these, which sixteen years ago[3] were accessible only to the monopolizers, have opened their doors to the masses.

You have entered into partnership, formed companies, issued loans, to realize the idea of the future in all its diverse forms, political, industrial and artistic forms. In no noble enterprise have you ever left the initiative to the protesting

and suffering minority, which, moreover, is the natural enemy of art.

For to allow oneself to be forestalled in art or politics is to commit suicide, and a majority cannot commit suicide.

What you have done for France you have done for other countries too. The Spanish Museum has recently contributed to the volume of general ideas that you must possess on art; for you are well aware that, just as a national museum is a communion whose delicate influence softens men's hearts and makes their will less rigid, so a museum devoted to foreign art is a place of international communion where two peoples, observing and studying each other more at their ease, achieve mutual understanding and fraternize without argument.

You are the natural friends of the arts, because some of you are rich and others learned.

Having given society your knowledge, your industry, your work, your money, you demand payment in the form of bodily, intellectual and imaginative enjoyment. If you recover the quantity of enjoyment necessary to restore the balance of all the parts of your being, you will be well filled, happy and kindly, just as society will be well filled, happy and kindly when it has found its general and absolute equilibrium.

And so it is to you, bourgeois, that this book is naturally dedicated; for any book that does not appeal to the majority, in numbers and intelligence, is a stupid book.

1 May 1846

I. WHAT IS THE GOOD OF CRITICISM?

What is the good of it? The large and frightening question mark seizes the critic by the scruff of the neck at the very first step he wants to take in his first chapter. The artist's first grudge against criticism is that it can teach nothing to the bourgeois, who wants neither to paint nor to versify, nor has it anything to teach art, whose offspring it is.

And yet how many artists of today owe to it alone their poor little reputations! That perhaps is the chief reproach to be made to it.

You must have seen Gavarni's[4] drawing of a painter, bending over his canvas, and behind him a personage full of gravity and dryness, stiff as a poker and with a white cravat, in his hand the latest of his newspaper articles. 'If art is noble, criticism is holy. Who says that? – The critics!' If the artist so easily assumes the chief part, that is no doubt because the critic is as humdrum as so many of his fellow-critics.

As for techniques and processes, as seen in the works them-selves,* neither public nor artists will find anything about them here. Those things are learned in the studio and the public is interested only in the results.

I sincerely believe that the best criticism is the criticism that is entertaining and poetic; not a cold analytical type of criticism, which, claiming to explain everything, is devoid of hatred and love, and deliberately rids itself of any trace of feeling, but, since a fine painting is nature reflected by an artist, the best critical study, I repeat, will be the one that is that painting reflected by an intelligent and sensitive mind. Thus the best accounts of a picture may well be a sonnet or an elegy.

But that type of criticism is destined for books of poetry and for readers of poetry. As to criticism proper, I hope philosophers will understand what I am about to say: to be in focus, in other words to justify itself, criticism must be partial, passionate, political, that is to say it must adopt an exclusive point of view, provided always the one adopted opens up the widest horizons.

Exalting the merits of line to the detriment of colour, or exalting colour to the detriment of line, doubtless that is

*I am well aware that contemporary criticism makes more exalted claims; thus it stresses the importance of drawing to colourists, and of colour to draughtsmen – an attitude both highly reasonable and highly sublime.

adopting a point of view; but that point of view is neither very broad nor particularly valid; moreover it reveals in the critic a great ignorance of individual destinies.

You do not know in what proportions nature has combined in every mind the taste for line and the taste for colour, nor by what mysterious alchemy she produces the fusion between them, the result of which is a picture.

Thus a broader point of view will be a well thought-out individualism, which demands of the artist naïveté and the sincere expression of his temperament, aided by all the means his craft gives him. He who has no temperament is not worthy of creating pictures, and – as we are tired of imitators and especially eclectics – let him become a workman in the service of a painter rich in temperament. I shall prove my point in one of my later chapters.[5]

Once armed with a reliable criterion, drawn from nature, the critic must do his duty with passion; for critic though he may be, he is a man nonetheless, and passion draws men of like temperaments together and raises reason to new heights. Stendhal[6] says somewhere: 'Painting is essentially a system of moral values made visible!' Whether you interpret the words 'moral values' more or less broadly, the same may be said of all the arts. Since they are always beauty expressed by every individual's feeling, passion, and dreams, in short variety in unity, or the multiple facets of the absolute, criticism verges constantly on metaphysics.

Since every century, every people has achieved the expression of its own beauty and system of moral values, and if the word romanticism may be defined as the most up to date and the most modern expression of beauty, then, in the eyes of the reasonable and passionate critic, the great artist will be he who combines with the condition laid down above, namely naïveté, the greatest degree of romanticism possible.

II. WHAT IS ROMANTICISM?

Few people today would willingly give this word a real and positive sense; but will they dare maintain that a whole generation would consent to go on fighting a battle for several years to defend a flag without symbolic power?

If we recall the polemics of recent years,[7] we shall see that, if few romantics remain, the reason is that few of them found romanticism; yet all of them were sincerely and loyally in quest of it.

Some applied themselves merely to the choice of subjects; they were not endowed with the temperament for the subjects they chose. Others, still believing in the existence of a catholic society, sought to reflect catholicism in their works. To call oneself a romantic and to fix one's gaze systematically on the past is contradictory. Another group, in the name of romanticism, blasphemed the Greeks and the Romans: but it is possible to make romantics of Romans and Greeks, if one is a romantic oneself. – Truth in art and local colour are slogans that have misled many others. Realism had existed long before that great battle, and, moreover, to compose a tragedy or paint a picture for M. Raoul Rochette[8] means running a risk of being contradicted by the first comer, if he be more learned than M. Raoul Rochette.

Properly speaking romanticism lies neither in the subjects an artist chooses nor in his exact copying of truth, but in the way he feels. Where artists were outward-looking, they should have looked inward, as the only way to find it.

For me, romanticism is the most recent, the most up-to-date expression of beauty.

There are as many forms of beauty as there are habitual ways of seeking happiness.[9]

The philosophy of progress explains this clearly; thus, just as there have been as many ideals as there have been, for all peoples, ways of understanding moral systems, love, religion,

etc., so romanticism consists, not in technical perfection, but in a view of art, analogous to the moral attitudes of the age.

Because some people identified romanticism with technical perfection, we have had a kind of rococo romanticism, quite certainly the most insufferable of all.

Therefore, above all we must know the different aspects of nature and the human situation, which the artists of the past either disdained or did not know about.

Romanticism and modern art are one and the same thing, in other words: intimacy, spirituality, colour, yearning for the infinite, expressed by all the means the arts possess.

It follows from this that there is an evident contradiction between romanticism and the works of its principal devotees. That colour plays a most important role in modern art, is there anything to be astonished at in that? Romanticism is a child of the North, and the North is a colourist; dreams and fairy tales are children of the mist. England, that homeland of out-and-out colourists, Flanders, half of France are plunged in fogs; Venice herself bathes in the lagoons. As for Spanish painters, their effects are by contrast rather than colour.

The South, on the other hand, is naturalistic, for there nature is so beautiful, so clear, that man, having nothing to wish for, finds nothing more beautiful to invent than what he sees; there, art in the open air, and a few hundred miles northwards, dreams lost in the depths of the infinite but dreamed in the studio, and the eye of fantasy lost in the grey horizons.

The South is brutal and positive like a sculptor in his most delicate compositions. The North, in suffering and anxiety, takes comfort in imagination, and its sculpture, when it takes to that, will more often be picturesque than classical.

Raphael, pure though he be, remains for all that a materialist, always seeking to express solid mass; but that old rascal Rembrandt is a strong idealist, who invites us to dream and peer into the beyond. The one composes fresh and virginal

creatures – Adam and Eve – whilst the other shakes his rags before our eyes, and tells of human suffering.

And yet Rembrandt is not a pure colourist, but a harmonist; how original the effect would be, how adorable the romanticism, if a powerful colourist were to express our feelings and our most precious dreams in colours appropriate to the subjects!

Before coming to discuss the man who until now is the most worthy representative of romanticism, I propose to put down a series of reflections on colour that will not be without value for the complete understanding of this little book.

III. OF COLOUR

Let us imagine a beautiful expanse of nature where the prevailing tones are greens and reds, melting into each other, shimmering in the chaotic freedom where all things, diversely coloured as their molecular structure dictates, changing every second through the interplay of light and shade, and stimulated inwardly by latent heat, vibrate perpetually, imparting movement to all the lines and confirming the law of perpetual and universal motion. Beyond, a vast expanse, sometimes blue and very often green, stretches to the horizon; it is the sea. The trees are green, the grass is green, the moss is green; green meanders in the tree trunks, the unripe stalks are green; green is nature's basic colour, because green marries easily with all the other colours.* What strikes me first of all is that everywhere – poppies in the grass, garden poppies, parrots etc. – red is like a hymn to the glory of the green; black, when there is any – a solitary and insignificant zero – begs for help from blue and red. Blue, the sky in other words, is cut into by light white flakes or by grey masses, which pleasingly soften its

*Except with its parent colours, yellow and blue; but I am speaking here only of pure tones. For this rule is not applicable to the supreme colourists, who are masters of the science of counterpoint.

monotonous harshness, and since the seasonal haze, winter or summer, bathes, softens or engulfs the outlines, nature resembles a top, which, when spinning at high speed, looks grey, although it incorporates all colours within itself.

The sap rises and, itself a mixture of elements, flowers in a mixture of tones; the trees, the rocks, the granites cast their reflections in the mirror of the water; all the transparent objects seize and imprison colour reflections, both close and distant, as the light passes through them. As the star of day moves, the tones change in value, but always they respect their mutual sympathies and natural hatreds, and continue to live in harmony by reciprocal concessions. The shadows move slowly and drive before them or blot out the tones as the light itself, changing position, sets others vibrating. These mingle their reflections, and, modifying their qualities by casting over them transparent and borrowed glazes, multiply to infinity their melodious marriages and make them easier to achieve. When the great ball of fire sinks into the waters, red fanfares fly in all directions, a blood-red harmony spreads over the horizon, green turns to a deep red. But soon vast blue shadows chase rhythmically before them the crowd of orange and soft rose tones, which are like the distant and muted echoes of the light. This great symphony of today, which is the eternally renewed variation of the symphony of yesterday, this succession of melodies, where the variety comes always from the infinite, this complex hymn is called colour.

In colour we find harmony, melody and counterpoint.

Now examine the detail within the detail in an object of medium dimensions – a woman's hand, for example, slightly reddish in tone, rather thin and with skin as delicate as silk; you will see the perfect harmony between the green tracery of the prominent veins and the blood-red tones of the knuckles; the pink fingernails contrast with the first joint where a few grey and brown tones are discernible. In the palm, the life lines of a darker rose or wine colour are separated from each

other by the intervening system of green or blue veins. The study of the same object under a magnifying glass will show in however small an area a perfect harmony of tones, grey, blue, brown, green, orange and white, warmed with a touch of yellow, a harmony which, with the interplay of the shadows, produces the sense of structure in the work of colourists, different in nature from that of the draughtsmen, whose problems amount to no more than those of copying from a plaster cast.

Colour, then, means the balance of two tones. A warm tone and a cold tone, the contrast between them constituting the whole theory, cannot be defined absolutely; they exist only in relation to each other.

The eye of the colourist is the magnifying glass. I do not mean to conclude from all this that a colourist should build up his picture by the minute study of the intermingled tones in a very limited space. For if we were to admit that each molecule were endowed with a particular tone, matter would then have to be infinitely divisible; moreover, art being only an abstraction and a sacrifice of detail to the whole, the important thing is to concentrate attention particularly on masses. What I was concerned to show was that if such a thing were possible, the tones, however numerous they might be, provided always they were in logical juxtaposition, would merge naturally, in virtue of the law that governs them.

Chemical affinities are the reason why nature cannot make mistakes in the arrangement of these tones; for in nature form and colour are one.

Nor can the true colourist make mistakes; he may do anything he likes because he knows by instinct the scale of tones, the tone-value, the results of mixing, and the whole science of counterpoint, and, as a result, he can create a harmony of twenty different reds.

This is so true, that if for example some anti-colourist land-owner had the notion of repainting his country house in some

absurd way and with a discordant scheme of colours, the thick and transparent glaze of the atmosphere and the trained eye of a Veronese would between them restore harmony and produce a satisfying canvas, conventional no doubt, but logical. That explains why a colourist can be paradoxical in his way of expressing colour and why the study of nature often leads to a result quite different from nature.

The air plays such a big part in the theory of colour that, if a landscape artist were to paint the leaves of a tree as he sees them, he would get a wrong tone, because there is a much narrower air space between a man and the picture he is looking at than between him and nature.

Falsehoods are constantly necessary even to get *trompe-l'œil* effects.

Harmony is the basis of the theory of colour. Melody means unity of colour, in other words, of a colour scheme.

A melody needs to be resolved, in other words, it needs a conclusion, which all the individual effects combine to produce.

By this means a melody leaves an unforgettable memory in the mind. Most of our young colourists lack melody.

The right way of knowing whether a picture is melodious is to look at it from far enough away to make it impossible for us to see what it is about or appreciate its lines. If it is melodious, it already has a meaning, and has already taken a place in our collection of memories.

Style and feeling in colour come from choice, and choice comes from temperament. Tones may be gay and playful, or playful and sad, or rich and gay, or rich and sad, commonplace, melancholy or original.

Thus, Veronese's palette is calm and gay, Delacroix's is often melancholy and that of M. Catlin[10] is often awe-inspiring.

For a long time, I had opposite my windows a tavern painted half in green and half in a harsh red, a mixture which

for my eyes was a source of exquisite pain. I do not know whether any analogist has drawn up a well authenticated scale of colours and their corresponding feelings, but I remember a passage in Hoffmann[11] that exactly expresses my idea and will please all who sincerely love nature:

Not only in dreams and in the free association of ideas (which phenomenon often comes just before sleep) but also when fully awake, listening to music, I find an analogy and a close union between colours, sounds and scents. I have the impression that all these things have been created by one and the same ray of light, and that they are destined to unite in a wonderful concert. The scent of brown and red marigolds especially produces a magical effect on my being. I fall into a profound reverie and then hear as though from afar the solemn, deep notes of the oboe.*

The question is often asked whether the same man can be both a great colourist and a great draughtsman?

Yes and no; for there are different sorts of drawing.

The essential quality of a pure draughtsman is delicacy, and delicacy excludes characteristic touch; now touches can often be felicitous, and the colourist, whose destiny it is to express nature in colour, would often stand to lose more by sacrificing felicitous touches than he would gain by seeking greater astringency in drawing.

Colour assuredly does not exclude great draughtsmanship, that of Veronese for example, who always sees his subject as a whole and by masses; but colour does exclude the drawing of details, of shapes in a section of a picture studied by themselves, because a bold touch always swallows up line.

The love of atmosphere, the choice of subjects in movement demand the technique of a disjointed multiplicity of lines.

Pure draughtsmen work on the opposite and yet analogous system. With a keen eye for line, eager to detect its most subtle curves, they have no time to observe atmosphere and light, or more precisely their effects, indeed they deliberately

Kreisleriana.

try not to see them in order not to harm the principle of their school.

And so it is possible to be both a colourist and a draughtsman, but only in a certain sense. Just as a draughtsman can be a colourist by broad masses, so a colourist can be a draughtsman by a logical understanding of lines as total shape, but one of these two qualities will always absorb the detail of the other.

Colourists draw like nature; their figures are naturally outlined by the harmonious conflict of colour masses.

Pure draughtsmen are philosophers and distillers of quintessentials.

Colourists are epic poets.

IV. EUGÈNE DELACROIX

Romanticism and colour lead me straight to Eugène Delacroix. I have no idea whether he is proud of being a romantic; but his place is there because the majority of the public have long since, indeed from his very first work, dubbed him leader of the *modern* school.

As I come to this part of my work, my heart is full of serene joy, and I am picking out my newest quills with deliberation, such is my wish to be transparently clear, such is my pleasure in tackling the subject most dear to me and, at the same time, the one I feel myself to be in greatest sympathy with. In order that the conclusions of this chapter may be fully grasped, I must go back somewhat in the history of our times and submit to the attention of my readers a number of key documents in the case, already invoked by former critics and historians, but essential to my whole argument. In any case, the dedicated admirers of Eugène Delacroix will enjoy rereading an extract from the *Constitutionnel* of 1822, drawn from the 'Salon' by M. Thiers,[12] journalist.

In my opinion, no picture gives a clearer indication of the future

of a great painter than M. Delacroix's *Le Dante et Virgile aux enfers*. There, supremely, the viewer can observe that gushing of talent, that impulse of superiority of a leader in the making, that revives our hopes, drooping a little at the sight of the over-moderate merits of all the others.

Dante and Virgil, ferried by Charon, are shown crossing the infernal river, clearing a way with difficulty through the crowd surrounding their craft and trying to climb into it. Dante, supposedly a living man, has the ghostly colour of the infernal place; Virgil, crowned with a sombre laurel, has the colour of death. The unhappy souls, condemned for ever to yearn for the opposite bank, cling to the boat; one catches hold in vain, and his sudden movement flings him backwards into the waters again; another enfolds the boat with his arms, and kicks away others, trying like him to climb aboard; two others are shown trying vainly to hold on with their teeth. The egoism of mental agony, the despair of hell are abundantly evident. The subject the artist has chosen could easily fall into exaggeration, yet he has shown an austere taste, a sense of what effects are appropriate to the scene, so to speak, which brings out the power of the design, and which severe judges, ill-advised in this case, might criticize as lacking in dignity. The brush-work is broad and bold, the colour simple and powerful, though a little crude.

Besides that poetic imagination which painters and writers hold in common, the creator of this picture has the true painter's imagination, which could perhaps better be called the draughtsman's imagination, and which is quite different from the other. He throws his figures on the canvas, places them and twists them as he likes, with the boldness of a Michelangelo and the fecundity of a Rubens. What reminiscence is it of the great masters that overwhelms me at the sight of this picture? Here once more I can see the wild, glowing, but natural power that yields without effort to its own momentum . . .
. . .

I do not think I am mistaken: to M. Delacroix genius has been given; let him stride forward with assurance, let him undertake those vast works that are the indispensable condition of talent; and what should give him still more confidence is that the opinion I am here expressing about him is held by one of the great masters of the school.

A. T. . .RS

These enthusiastic lines are truly astonishing, as much for their precociousness as for their boldness. If, as one is entitled to assume, the chief editor of the newspaper had claims to some knowledge of painting, young Thiers must have seemed to him a bit cracked.

To get a good idea of the deep turmoil that the picture *Dante et Virgile* must have caused in the minds of people at the time, the astonishment, the stupefaction, the anger, the chorus of insults, the enthusiasm, the guffaws of insolent laughter that greeted this fine picture, signal if ever there was one of a revolution, it must be remembered that in the studio of M. Guérin,[13] a man of great talent, but a despot and narrow like his master David,[14] there was only a handful of outcasts who bothered about the forgotten old masters and who dared, albeit timidly, to conspire under the aegis of Raphael and Michelangelo. There was as yet no question of Rubens.

M. Guérin, gruff and severe towards his young pupil, looked at the picture only because of the furore it was causing.

Géricault,[15] who had but lately returned from Italy, and who had, so they say, renounced a number of his almost original qualities at the sight of the great Roman and Florentine frescoes, was so full of praises for the new and still shy painter that the latter was almost overcome with confusion.

It was either when he saw this painting, or a little later on, at the sight of *Les Pestiférés de Scio*,* that Gérard[16] himself, who, it seems, was more wit than painter, exclaimed: 'A painter has been revealed to us, but he is a man who runs over the roof-tops!' To run over the roof-tops, a man must be sure-footed and guided by the inner light.

Let glory and justice be rendered to Messrs Thiers and Gérard!

No doubt there is a big interval between the *Dante et*

*I say *Pestiférés* instead of *Massacre* to explain to the scatter-brained critics the 'flesh-tones' so often criticized.

Virgile and the paintings in the House of Peers, and the Chamber of Deputies, but the biography of Eugène Delacroix is fairly uneventful. For such a man, endowed with such courage and such passion, the most interesting struggles are those that have to be fought out within himself; horizons need not be broad for the battles to be important; revolutions and the strangest events take place under the skies of the cranium, in the narrow and mysterious laboratory of the brain.

Now that the man had been duly revealed and was revealing himself more and more (the allegorical picture *La Grèce*, the *Sardanapale*, *La Liberté*, etc.), and now that the contagion of the new gospel was getting worse from day to day, academic disdain itself could do no other than take notice of this new genius. One fine day M. Sosthènes de La Rochefoucauld, the director of Fine Arts, sent for Eugène Delacroix, and after a preliminary barrage of compliments, said to him how distressing it was to see a man with such a rich imagination and so fine a talent, a man the Government was disposed to help, unwilling to put a little water in his wine; he asked him if he could not once and for all modify his style. Astounded beyond measure by this odd request and these ministerial counsels, Eugène Delacroix replied in a burst of almost comic anger that if he painted as he did, the thing must be accepted as inevitable and that he could paint in no other manner. The result was that he fell entirely out of favour, and for seven years received no official commissions. He had to wait until 1830. M. Thiers had in the interval written another and most laudatory article in the *Globe*.

A journey Delacroix undertook to Morocco seems to have made a profound impression on his mind; there he had the opportunity to study at leisure man and woman in their independence and original native way of life, and to understand the beauty of the classical form thanks to seeing a people untainted by any racial admixture, enhanced by healthy physique

and free muscular development. The creation of the *Femmes d'Alger* and a host of sketches probably belongs to this period.

Until now people have been unjust to Eugène Delacroix. The critics have been bitter towards him and shown their ignorance; with a few noble exceptions, even the praises he received must have had something offensive about them for him. In general and for most people, the very name Eugène Delacroix at once suggests to their minds some sort of vague idea of ill-directed passion, of turbulence, of haphazard inspiration, even of disorder; and for these gentry, who constitute the majority of the public, chance, that worthy and obliging bondman of genius, plays an important part in his most successful compositions. In the unhappy period of revolution I was speaking about just now, and of which I have recorded the countless mistakes, Eugène Delacroix was often compared with Victor Hugo.[17] The romantic poet had come, the painter was awaited. That urge to find at all costs counterparts and analogies in the different arts often produces queer blunders, and this one serves to confirm how little people really understood the position. Quite certainly the comparison must have seemed painful to Eugène Delacroix, perhaps to both of them; for if my definition of romanticism (inwardness, spirituality, etc.) places Delacroix at the head of romanticism, it naturally excludes M. Victor Hugo. The parallel has remained a part of the stock in trade of commonplaces, and these two preconceptions still encumber fuddled heads. Let us put an end once and for all to these bits of schoolboy nonsense! Will all those who have felt the need to create for their own use a certain type of aesthetic doctrine, and to deduce causes from results, kindly make a careful comparison between the productions of these two artists.

M. Victor Hugo, whose noble and majestic image I have no desire to diminish, is a craftsman, much more adroit than inventive, a worker, much more formalist than creative. Delacroix

is sometimes clumsy, but essentially creative. M. Victor Hugo
displays in all his descriptions, lyrical and dramatic, a
system of uniform alignment and contrasts. Eccentricity itself
takes on symmetrical forms with him. All rhyme effects, all
the resources of antithesis, all the deceits of apposition, he has
them all at his finger-tips, and uses them with cold calculation.
He is a composer in a period of decadence or transition, who
employs his tools with a truly admirable and strange dexterity.
M. Hugo was by nature an academician before he was born,
and if we still lived in the days of legendary miracles, I would
willingly believe that, as he passed by the affronted sanctuary,
the green lions of the Institut[18] must often have whispered,
with a prophetic voice, in his ear: 'Some day you will be in
the Academy, my boy!' For Delacroix, justice is taking her
time. His works, in contrast, are poems, and great poems,
naïvely conceived,* and executed with the customary
insolence of genius. – In Hugo's works, nothing is left to the
imagination, for he takes such pleasure in showing off his skill
that he does not leave out a single blade of grass or the
reflection of a street lamp. Delacroix, in his works, creates
deep avenues for the most adventurous imagination to
wander down. The former enjoys a certain quietude, or,
better, a certain spectator's egotism, which imparts to the
whole of his poetry an indefinable coldness and moderation –
which the tenacious and splenetic passion of the latter, in con-
flict with the patience imposed by his craft, does not always
allow him to keep.

The one starts from detail, the other from an intimate
understanding of his subject; with the result that the former
goes only skin-deep, while the latter tears out its vitals. In his
fondness for material things and his attention to the super-
ficial aspects of nature, M. Victor Hugo has become a painter

*By the naïveté of genius we must understand technical mastery combined
with the *gnoti seauton* (know thyself), but a technical mastery that is humble
and leaves the big part to temperament.

in poetry; Delacroix, with his fidelity to his ideal, is often, and without knowing it, a poet in painting.

As for the second preconception, that of chance, it has no more value than the first. Nothing is more impertinent or more stupid than to talk to a great artist like Delacroix, who is both scholar and thinker, of the debt he may owe to the god of chance. It is enough to make one shrug one's shoulders in pity. There is no such thing as chance in art any more than in mechanics. A happy idea is no more than the consequence of sound reasoning, though sometimes the intervening steps in the argument may have been omitted, just as a mistake arises from a faulty principle. A picture is a mechanism all the working parts of which are grasped by the expert eye, where every detail has its justifying cause, if the picture is a good one; where a given tone is always there to bring out the value of another; where an occasional detail of bad drawing is sometimes necessary in order to avoid sacrificing something more important.

The intervention of chance in Delacroix's painting is all the more improbable because he is one of the few men who retain their originality after having borrowed from all the genuine sources, and whose unconquerable individuality has been successively under the sway, later thrown off, of all the greater masters. Quite a number of people would be surprised to see a study by him after Raphael, a patient and laborious masterpiece, and few people remember nowadays the lithographs he has done from medallions and intaglios.

Here are a few lines from Heinrich Heine that explain rather well Delacroix's method, a method which is, as with all men of vigorous stamp, the direct result of his temperament:

In matters of art, I am a supernaturalist. I believe that the artist cannot find in nature all his models and that the most striking are revealed to him in his soul, as the innate symbolic of innate ideas, and at the same instant. A modern teacher of aesthetics, author of

Recherches sur l'Italie, has tried to bring back to favour the old principle of the imitation of nature, and to maintain that the plastic artist should find all his models in nature. In thus expounding his ultimate principle of the plastic arts, this worthy man had merely forgotten one of these arts, one of the very earliest, I mean architecture, for which subsequent efforts have been made to find forms in the boughs of forest trees or rock caves: but these forms were not visible in nature, they were quite certainly in the human soul.[19]

Delacroix, then, starts from the principle that a picture must first and foremost be the reflection of the innermost thought of the artist, who dominates the model just as the creator dominates his creation; and from that principle a second follows, which appears at first sight to contradict the first, namely the vital need for the artist to exercise care with the material means of execution. Delacroix professes a fanatical respect for the cleanliness of his tools and for the preparation of the elements of the work. How right! For since painting is an art that springs from close reasoning and demands the concurrent action of numerous qualities, the importance needs no stressing of the hand's having as few obstacles as possible to contend with when it starts work, and of its carrying out with swift obedience the divine commands of the brain; otherwise the ideal takes wing and vanishes.

If the elaboration of this great artist's idea is slow, painstaking and methodical, the execution is compensatingly rapid. We may add that speed is a quality he shares with the artist of whom public opinion has made his opposite, M. Ingres. Bringing to birth is not the same thing as conception, and these great lords of painting, endowed with apparent indolence, display a wonderful agility in covering a canvas. The *Saint-Symphorien* was wholly repainted several times, and at the outset it contained fewer figures.

For Eugène Delacroix, nature is a vast dictionary, and he turns and consults its pages with a sure and penetrating eye; and his painting, which flows largely from the memory,

appeals largely to the memory. The impact produced on the soul of the viewer is in direct relation to the means the artist uses. A picture by Delacroix, *Dante et Virgile* for example, always leaves a deep impression, the intensity of which is increased by distance. Delacroix is always ready to sacrifice detail to the whole; he is careful to avoid weakening the vitality of his thought by weariness from neater and more meticulous workmanship, and he possesses fully an indefinable originality, which goes to the very heart of a subject.

A dominant note can exercise its mastery only at the expense of the rest. An overriding taste demands sacrifices, and masterpieces are nothing if not so many extracts from nature. That is why we have to suffer the consequences of a great passion whatever it may be, accept a talent with all its potential, and not bargain with genius. That is what has never occurred to people who wax sarcastic about Delacroix's drawing; especially the sculptors, prejudiced and one-eyed folk beyond bearing, whose judgement is worth at most half that of an architect. Sculpture, for which colour is meaningless, and any expression of movement difficult, can have no claim to the attention of an artist particularly dedicated to movement, colour and atmosphere. These three elements necessarily require shapes that are not too clearly defined, lines that are light and hesitant, and bold touches of colour. Delacroix is the only artist today whose originality has not been impaired by the cult of straight lines; his figures are always in movement, and his draperies fluttering. From Delacroix's standpoint, the line does not exist; for however fine it be, a teasing geometrician can always suppose it thick enough to contain a thousand others; and for colourists, who seek to render the eternal restlessness of nature, lines are as in the rainbow, nothing but the intimate fusion of two colours.

Besides, there are several styles in drawing, just as there are several ranges of colour – the exact or stupid style, the physiog-

nomical and the imaginative. The first is negative and in-
accurate, by its slavish copying, natural but absurd; the second
is a naturalist style, but idealized, the style of a genius who
knows how to select, organize his subject, how to correct,
divine, scold nature; and lastly the third style, which is the
noblest and the strangest, can afford to neglect nature; it
depicts another nature, which reflects the mind and the tem-
perament of the artist.

Physiognomic drawing is usually characteristic of sen-
sualists like M. Ingres; creative drawing is the privilege of
genius.*

The hall-mark of drawings by the supreme artists is truth of
movement, and Delacroix never transgresses that natural law.

Let us pass on to the examination of even more general
qualities. One of the principal characteristics of the great
painters is universality. An epic poet, Homer or Dante for
example, can with equal facility write an idyll, a story, a
speech, a description, an ode etc.

Similarly, Rubens, if he paints fruit, will paint more
beautiful fruit than any specialist whatsoever.

Eugène Delacroix is universal; he has painted genre
pictures full of intimacy, historical subjects full of grandeur.
He alone, perhaps, in this century of unbelievers has conceived
religious pictures that were neither empty and cold, like
competition works, nor pedantic, mystical or neo-christian,
like those of all the philosophers of art who transform religion
into an archaic science and think that, to touch the religious
chord and make it vibrate, the first essential is for them to
understand the symbolics and the primitive traditions.

Delacroix's success in religious pictures is easy to under-
stand if we bear in mind that, like all great masters, Delacroix
is an admirable mixture of knowledge – that is to say a
complete painter – and naïveté – that is to say a complete man.
Go and see, at the church of Saint-Louis in the Marais,[20] that

*It is what M. Thiers calls the draughtsman's imagination.

Pieta, where the majestic queen of sorrows holds on her knees the body of her dead son, her arms outstretched horizontally in utter despair, a mother's uncontrollable sorrow. One of the two figures that comfort and soften her grief is weeping like the most tragic figures in his *Hamlet*, with which this work moreover has more than one trait in common. Of these two holy women, the first is dragging herself convulsively along the ground, still adorned with jewels and other signs of luxury; the other, fair and golden-haired, is sinking down more gracefully under the enormous weight of her despair.

The group is spread out and arranged entirely against a background of a uniformly dark green, which could just as well be piled-up rocks as a storm-lashed sea. This background is remarkably simple, and Eugène Delacroix, like Michelangelo, has doubtless suppressed all accessory details in order to avoid damaging the clarity of his idea. This masterpiece leaves a deep furrow of melancholy in the mind. Nor was this the first time that he had tackled religious subjects. The *Christ aux Oliviers* and the *Saint Sébastien* had already borne witness to the seriousness and deep sincerity he can impart to them.

But to explain the statement I was making just now, namely that Delacroix alone can create religious feeling, I would draw the viewer's attention to the fact that if his most interesting pictures are almost always those where the subject is of his own choosing, in other words, subjects of pure fantasy, nonetheless the gravity and sadness of his talent eminently suits our faith, a faith that is profoundly sad, a faith of universal suffering, and one which, because of its very catholicity, leaves complete freedom to the individual, and asks for nothing better than to be proclaimed in the language of any one of us – if he know the meaning of suffering and if he be a painter.

I remember that a friend of mine, a lad full of merit, be it

said, and a colourist already in fashion – one of those pre-
cocious young men who constantly raise one's hopes all their
lives, and much more academically-minded that he himself
suspects – called this painting: cannibal painting!

It is certainly true that neither in the odd assortment of an
overcrowded palette nor in the book of rules will our young
friend be able to find this bloody and wild desolation,
scarcely balanced by the dark green of hope!

This awesome hymn to suffering had the same effect upon
his classical imagination as the redoutable wines of Anjou,
Auvergne and the Rhine have on a stomach accustomed to the
pale violets of Médoc.

Universality of feeling therefore – and now universality of
knowledge!

Painters had long since unlearnt, so to speak, so-called
decorative painting. The amphitheatre at the Academy of
Fine Arts is a puerile and clumsy work[21] that betrays an
evident conflict of intentions and resembles a collection of his-
torical portraits. The *Plafond d'Homère*[22] is a fine picture but as
a ceiling piece it is poor. Most of the church decorations of
recent date, all of them commissioned from pupils of M.
Ingres, have been executed in the manner of the Italian
primitives; in other words they strive to achieve a sense of
unity by cutting out all effects of light and substituting a
scheme of subdued colours on a vast scale. This manner is no
doubt a more rational one, but it avoids the difficulties. Under
Louis XIV, Louis XV and Louis XVI, the painters covered
walls with decorative pieces that hit the eye but lacked unity of
colour and composition.

Eugène Delacroix received some decorative commissions
and found the answer to the great problem. He found how to
achieve a sense of unity in composition without damaging his
technical skill as a colourist.

The Chamber of Deputies is there as a witness to this
remarkable feat. Light effects, sparingly distributed, play on

all the figures, without catching the eye too insistently.

The circular ceiling of the Luxembourg Library is a still more astonishing piece of work. Here the painter has succeeded, not only in producing a still softer and more unified effect, without sacrificing any of the qualities of colour and light that are peculiar to all his pictures, but also in appearing under a new guise: Delacroix, a landscape painter!

Instead of painting Apollo and the Muses, which is the invariable decorative subject for libraries, Eugène Delacroix gave way to his irresistible liking for Dante, whom only Shakespeare perhaps can rival in Delacroix's mind, and he has chosen the passage where Dante and Virgil meet the principal poets of antiquity in a mysterious place:

We continued on our way, as he spoke; but we were still going through the forest, the impenetrable forest of spirits, I mean. We were not far from the entry of the abyss, when I saw a fire gleaming through a hemisphere of darkness. We were still a few paces away from it, but I could already see that a number of spirits crowned with glory had their abode here.

'Oh thou that honourest every science and art, who are these spirits to whom such honour is paid that they are separated from the fate of the other spirits?' He replied: 'Their great renown that echoes in thy world above finds grace in heaven, who distinguishes them from the others.'

Meanwhile a voice was heard to proclaim: 'Honour the sublime poet; his shade, which was gone, is coming back to us.'

The voice was still, and I saw coming towards us four tall shades; they appeared neither sad nor joyous.

The good master said to me: 'Look at the one that walks, sword in hand, in front of the three others, like a king; it is Homer, the sovereign poet; the one immediately behind him is Horace the satirist; Ovid is the third, and the last is Lucan. As each of them shares with me the name acclaimed by all with one voice, they do me honour, and do well to.'

Thus did I see gathered together the noble school of this master of sublime song, who soars over all others like the eagle. As soon as they

had talked together for a while, they turned to me with a gesture of salutation, which drew a smile from my guide. And they did me still more honour, for they received me into their midst, so that I became the sixth amongst so many geniuses . . .*

I shall not insult Eugène Delacroix with fulsome praise of his skill in overcoming the concavity of his canvas and in placing straight figures on it. His talent is above such things. I am concerned particularly with the spirit of this painting. To convey in mere prose the spirit of blessed peace that it breathes and the profound harmony that informs its atmosphere is impossible. It calls to mind the most verdant pages of *Télémaque*,23 and evokes all the memories that our minds have stored up from the stories of the elysian fields. The landscape, notwithstanding its being only an accessory, is, from the point of view I was adopting just now, namely the universality of the great masters, a most important thing. The circular landscape, which occupies an enormous space, is painted with the assurance of a history painter and the delicacy and loving care of a landscape painter. Clumps of laurel and quite large areas of shade give it a harmonious pattern; pools of steady soft sunlight slumber on the expanses of grass; mountains, blue or girt with woods, give an ideal horizon for the eye's delight. As for the sky, it is blue and white, a surprising thing in Delacroix's work; the tenuous clouds, drawn hither and thither like torn pieces of gauze, are of wonderful lightness, and this blue dome, deep and luminous, fades into prodigious heights. Even Bonington's water-colours are less transparent.

This masterpiece, superior, in my opinion, to the best Veronese, needs great peace of mind and a soft light, if it is to be thoroughly understood. Unfortunately the brilliant light that will flood in from the great window of the façade as soon as it has been freed of builders' sheets and scaffolding, will make the task more difficult.

*Dante, *The Inferno*, Canto IV.

This year the paintings exhibited by Delacroix are *L'Enlèvement de Rebecca* from *Ivanhoe*, *Les Adieux de Roméo et de Juliette*, *Marguerite à l'église*; and *Un Lion* in water-colour.

The particularly admirable thing about *L'Enlèvement de Rebecca* is the perfect scale of colour values, of great intensity, tightly packed together in logical sequences that ensure a powerful impact. In the work of almost all painters who are not colourists, vacuums are always noticeable, in other words, great holes produced by tones that are not on a level of quality with the others, so to speak; Delacroix's painting is like nature, it has a horror of a vacuum.

Roméo et Juliette – on the balcony, in the cold light of morning – embrace with almost religious fervour. In this passionate good-bye, Juliette, her hands laid on her lover's shoulders, throws her head back, as though to breathe, or in instinctive pride and passionate joy. This unusual posture – for almost all painters depict the lovers clasped mouth-to-mouth – is nonetheless very natural; that vigorous movement of the neck is peculiar to dogs and cats enjoying a caress. The violet-tinted haze of dawn-twilight envelops the scene and the romantic landscape, which completes the picture.

The popularity of this painting, the interest it arouses, fully confirm what I have said elsewhere, that Delacroix is popular whatever painters may say, and that all that is needed for him to be as popular as second-rate painters is for the public not to be prevented from seeing his works.

Marguerite à l'église belongs to that already numerous class of delightful genre pictures by which Delacroix seems to want to explain to the public his lithographs, which have been so bitterly criticized.

The water-colour of the lion has special merit for me, apart from the beauty of the drawing and posture, and that is its carefree execution. Water-colour as an art is here fulfilling its modest role, not striving to puff itself up to the size of oils.

To complete this analysis, it remains for me to stress a final quality of Delacroix, the most remarkable of all, the one that makes of him the true nineteenth-century painter; I refer to that strange and persistent melancholy which pervades all his work, and which his choice of subject, the expressions on his faces, the gestures and the colour key all alike reveal. Delacroix is an admirer of Dante and Shakespeare, two other great painters of human suffering; he knows them thoroughly and can interpret them freely. To look with penetrative attention at the whole series of his pictures is to feel as though we were present at the celebration of a tragic rite; *Dante et Virgile*, *Le Massacre de Scio*, *Sardanapale*, *Le Christ aux Oliviers*, *Saint Sébastien*, *Médée*, *Les Naufragés*, and *Hamlet*, so scorned and so little understood. In several of them, by the operation of some indefinable but repeated chance, a figure is to be found, more harrowed, more weighed down than others, a figure in whom all the surrounding suffering is expressed; thus, for example, in the *Croisés à Constantinople*, the woman with her hair thrown forward, kneeling in the foreground, or the aged woman, so wrinkled and dejected, in *Le Massacre de Scio*. This sense of melancholy even informs a picture like the *Femmes d'Alger*, of all his pictures the most appealing and most winsome. As eloquent as a poem, this interior, full of rest and quietude, hung with gorgeous fabrics and cluttered with trivial aids to beauty, suggests the heavily scented atmosphere of the brothel, which quite quickly leads us down to the unplumbed depths of sadness. Generally speaking he does not paint pretty women, not at least as society people understand the term. Most are sickly, and glow with an inner beauty. He expresses strength not by depicting powerful muscles but by nervous tension. He excels in expressing not only suffering but especially – and therein lies the prodigious mystery of his painting – moral suffering. That exalted and grave sense of melancholy shines forth with a bleak brilliance, even in his choice of colours, applied in broad simple harmonious masses,

like those of all the great colourists, but striking a deep plaintive note like a melody of Weber.

Each one of the old masters has his kingdom, his province, which he is often obliged to share with famous rivals. Raphael has form, Rubens and Veronese colour, Rubens and Michelangelo imaginative composition. One part of the empire remained, where Rembrandt alone had made some incursions – the drama, the natural, the living drama, the terrible and melancholy drama, often expressed by colour, but always by gesture.

In the matter of sublime gestures, Delacroix has rivals only outside his art. I know only Frédérick-Lemaître[24] and Macready.[25]

It is because of this wholly modern, wholly new quality that Delacroix is the latest expression of progress in art. He is not only the inheritor of the great tradition, or in other words of the abundance, the nobility and power in composition, but, worthy successor that he is of the great masters, he has, in addition to their gifts, the mastery of suffering, passion, and the sense of gesture! That in particular is what confers importance on his greatness. If the baggage of one of the old masters were to be lost, almost always a kindred spirit could be found to explain and interpret his genius to the mind of the historian; but remove Delacroix, and the great chain of history is broken, falls to the ground.

In an article that more nearly resembles a prophecy than a critical study, what would be the value of pointing out mistakes of detail and microscopic blemishes? The whole is so beautiful that I have not the courage to do that. Moreover the thing is so easy, and so many others have done it! Is it not more original to see people by their good side? The defects of M. Delacroix are sometimes so obvious that they strike even the most inexpert eye. Open any paper you care to name at random, where for a long time the critics have persisted, in contrast to my method, in refusing to see the brilliant qualities

that make up his originality. It is a well known fact that great geniuses never commit mistakes by halves, and that they have the privilege of extravagance in every direction.

Amongst Delacroix's pupils, some have successfully made their own such elements of his talent as can be appropriated, that is to say, some parts of his method, and have already won some sort of reputation for themselves. But their colour has in general this defect, that it aims at the picturesque and at achieving an effect; the ideal is not within their compass, although they willingly set nature aside, without having conquered that right, as the master did, by dint of courageous study.

. . .

VII. OF THE IDEAL AND THE MODEL

Since colour is the most natural thing and the most visible, the colourist party is the most numerous and the most important. Analysis, which makes the artist's means of execution easier, has divided nature into colour and line, and before proceeding to discuss the men who compose the second party, I think it will be useful here for me to explain some of the principles that guide them, even though sometimes they may not know it.

The title of this chapter is a contradiction, or rather a resolution of opposites; for the drawing of a great draughtsman must be the combined expression of the ideal and the model.

Colour is composed of colour-masses made up of an infinity of tones, the harmony of which makes the unity; similarly line, which also has its masses and its general statements, subdivides into a multitude of particular lines, each one of which relates to a characteristic trait of the model.

The circumference, which is the ideal of the curve, is comparable to an analogous figure composed of an infinite

number of straight lines and destined to merge with the ideal circumference, its interior angles becoming ever more obtuse.

But since no perfect circumference exists, the absolute ideal is a piece of nonsense. The exclusive taste for simplification leads the fathead sort of artist to repeated imitations of the same type. Poets, artists, and the whole human race would be most unhappy, if the ideal, that absurdity, nay impossibility, were to be discovered. What would each of us do thereafter with his poor ego, his broken line?

I have already noted that memory is the great criterion of art; art is a kind of mnemotechny of beauty; and slavish imitation interferes with memory. There is a class of atrocious painters for whom the smallest wart is a great piece of luck; not only would they not dream of leaving it out, but they must needs make it four times life-size: no wonder they are the despair of lovers, and a people that commissions the portrait of its sovereign is like a lover.

Too much attention to detail or too much generalization alike interfere with memory; rather than the *Apollo Belvedere* or the *Gladiator*, give me the *Antinous*, for this statue is the idealized image of the charming Antinous.

Although the universal principle is one, nature provides no example of something absolute nor even of something complete*; around me I see only individuals. Every animal within its own species differs in some particular from its neighbour, and of the thousands of specimens of a given fruit from the same tree not two identical ones could be found, for they would be the same specimen; and duality, which is a contradiction of unity, is also its consequence.†

The human race, in particular, possesses variety to an

*'No example of something absolute' – this makes nonsense of the search for the ideal measurements with a pair of compasses; 'nor even of something complete' – thus it is up to the artist to complete what is incomplete in nature, and to find the ideal hidden within the real.

†I say 'contradiction' and not 'contrary'; for contradiction is a human invention.

infinite and awesome degree. Setting aside the main types that nature has distributed in the different climes of the globe, I can see, every day, passing below my window, a number of Kalmucks, red-skins, Indians, Chinese and ancient Greeks, all more or less parisianized. Each individual is a harmony; for it must have happened to you to turn round at the sound of a familiar voice, and find to your amazement a stranger standing there, a living reminder of some other person, with similar voice and gestures. So true is this that Lavater has made a list of noses and mouths that look wrong on the same face, and found a number of mistakes of this kind in the works of the old artists, who sometimes gave religious or historical personages a cast of countenance out of keeping with their character. That Lavater made mistakes in detail is very possible; but his idea was sound in principle. A given type of hand demands a given type of foot; every skin produces its own type of hair, and so every individual has his own ideal.

I would not go so far as to claim that there are as many original ideals as there are individuals, because one mould gives a number of casts, but in an artist's soul there are as many ideals as individuals because a portrait is a model complicated by an artist.

Thus the ideal is not that vague thing, that boring and intangible dream floating on the ceilings of academies; an ideal is the individual modified by the individual, rebuilt and restored by brush or chisel to the dazzling truth of its own essential harmony.

It follows therefore that the first quality of a draughtsman is the slow and sincere study of his model. Not only must he have a deep intuitive understanding of the character of the model; he must also generalize his model somewhat, and exaggerate deliberately certain details in order to give greater emphasis to the cast of countenance and bring out its characteristic expression.

How interesting it is to observe that, guided by this prin-

ciple, namely that the sublime must eschew details, art on its quest for perfection is returning to the days of its infancy. For the earliest artists also did not express details. The great difference is that in creating all in one piece the arms and legs of their statues, it was not they that were running away from the details, but the details that were running away from them; for selection requires knowledge.

Drawing is a struggle between nature and the artist, and the better the artist understands nature's intentions, the easier will be his triumph over her. For him no question arises of copying; it is a matter of interpreting in a more simple and luminous language.

The introduction of portraiture, in other words of the idealized model, into historical or religious subjects or subjects of pure invention demands, to start with, a delicate choice of model; it may indeed rejuvenate modern painting and give it new life, for modern painting, like all our arts, is too inclined to be satisfied with slavish imitation of the past.

Whatever else I could say on ideals seems to me to be incorporated in a chapter by Stendhal, the title of which is as clear as it is insolent:

How to beat Raphael at his own game?

In all touching scenes produced by the passions, the great painter of modern times, if ever he appear, will give each of his characters the *ideal beauty drawn from the temperament*[26] best suited to feel with the greatest intensity the effect of that passion.

Werther will not be indifferently full-blooded or melancholic; Lovelace, phlegmatic or irascible. The kindly Parson Primrose, the amiable Cassio will not have choleric temperaments; but on the other hand the Jew Shylock, the gloomy Iago, Lady Macbeth, and Richard III will; the sweet and pure Imogen will be rather phlegmatic.

The creator of Apollo Belvedere must have worked in accordance with his first observations. But will he resort to giving cold copies of the Apollo each time he wants to create the image of a young and beautiful god? No, he will show a relationship between the action

and the kind of beauty. Apollo delivering the earth from the serpent Python will be given greater strength, Apollo striving to please Daphne will be given more winning features.*

VIII. OF SOME DRAUGHTSMEN

In the foregoing chapter I have not spoken of imaginative or creative drawing, because this is usually the privilege of colourists. Michelangelo, who, from a certain point of view, is the inventor of the ideal amongst the moderns, is unique in having possessed to the highest degree the gift of imaginative drawing without being a colourist. Pure draughtsmen are naturalists, endowed with one excellent sense; but their drawing is a rational exercise, whereas that of the colourists is a matter of feeling, an almost unconscious process. Their method is like nature; they draw because they apply colour, and the pure draughtsmen, if they wanted to be entirely logical and true to their profession of faith, would content themselves with a black pencil. Nonetheless they apply themselves to colour with unbelievable ardour, and without noticing the contradictions that result. They begin by establishing the outlines of the objects in a harsh and absolute manner, and then proceed to fill these areas. This double process constantly hampers their efforts and gives all their productions an indefinable bitterness, something laboured and conflicting. They are for ever at odds with themselves, they are a wearisome duality. A draughtsman is a failed colourist.

So true is this that M. Ingres, the most illustrious representative of the naturalistic school in drawing, is for ever in pursuit of colour. Oh! admirable and unfortunate obstinacy! It is the old, old story of people who would sell the reputation they deserve for one they cannot get. M. Ingres adores colour like a milliner. It is mixed pain and pleasure to observe the trouble he goes to to choose and marry his colour-tones. The

Histoire de la peinture en Italie, Chapter CI. Such ideas were being printed in 1817!

result, which is not always discordant, but bitter and crude, often pleases corrupted poets; and yet when their weary minds have long enjoyed the sight of these dangerous conflicts, they insist upon turning to a Velasquez or a Lawrence for restful contemplation.

If M. Ingres occupies the most important place after Eugène Delacroix, the reason lies in his very special quality of drawing, the mysteries of which I was analysing just now, and which sums up, better than any other so far, the ideal and the model. M. Ingres draws outstandingly well, and he draws quickly. His sketches are by nature idealist; his drawing, often reduced to essentials, is made up of not many strokes; but each one expresses an important contour. Compare his work and the drawings of those journeymen painters, often his pupils; they begin by stating minutiae, and that is why they delight the vulgar herd, who, in every sphere, have eyes only for little things.

In a way, M. Ingres draws better than Raphael, the popular king of draughtsmen. Raphael decorated enormous wall surfaces, but he would not have done such a good portrait as Ingres of your mother, your friend or your mistress. The boldness of Ingres is of a peculiar kind, and it is combined with such cunning that no kind of ugliness or oddity daunts him: M. Molé's[27] frock-coat and Cherubini's[28] cape; in his Homer ceiling – a work aiming to be idealist more than any other of his – he has introduced a blind man, a one-eyed man, a man with one arm, and a hunchback. Nature rewards him generously for this pagan adoration. He could even make something sublime of Mayeux.[29]

Cherubini's beautiful Muse[30] is really another portrait. It is fair to say that if M. Ingres, lacking as he does the gift of imaginative drawing, cannot produce pictures, at least on the grand scale, his portraits are almost pictures, in other words intimate poems.

His is a miserly talent, pitiless, irascible and ailing; it is a

singular mixture of contrary qualities, all pressed to the service of nature; nor is its strangeness the least of its attractions; he recalls the Flemish school in his execution, he is individualist and naturalist in his drawing, looks backward to antiquity in his sympathies and is idealist by reason.

To harmonize so many conflicting elements is no easy task; and it is, therefore, not without good reason that he has chosen for his pictures a cold unnatural light, the better to display the sacred mysteries of his draughtsmanship and the better to bring out the subtleties of his thought, a light resembling the dawn-twilight when nature, still only half awake, seems pale and harsh and when the landscape takes on a weird and gripping aspect.

A peculiar and, I believe, as yet unnoticed fact about the talent of M. Ingres is that he seems to prefer painting women; he paints them as he sees them, loving them too much, it would seem, to want to change them in any way; he concentrates on the smallest details of their beauty with the keenness of a surgeon; his eye follows the most delicate curves in their outlines with the slavishness of a lover. *Angélique*, the two *Odalisques*, the portrait of Madame d'Haussonville are profoundly voluptuous works. But all of them are bathed in a light that is almost frightening, for it is neither the golden atmosphere that envelops the fields of the ideal, nor the moderate steady light of the sub-lunary regions.

The works of M. Ingres, which are the product of excessive attention, demand an equal degree of attention to be understood. Daughters of suffering, they engender suffering, the reason being, as I was explaining just now, that his technique is not one and simple, but rather a succession of different techniques.

Around M. Ingres, whose teaching appears to enjoy an authority that makes fanatics, a few men have gathered, the best known of whom are Messrs Flandrin, Lehmann and Amaury-Duval.

But what a distance between master and pupils! M. Ingres is still alone of his school. His method is the result of his nature, and however strange and obstinate it may be, at least it is sincere, and, so to speak, involuntary. Passionately in love with antiquity and the sitter of the moment, respectful servant of nature, he paints portraits that rival the best Roman sculptures. But these gentlemen have coldly, deliberately and pedantically transformed into a system the displeasing and unpopular aspects of his genius; for what characterizes them particularly is pedantry; what they have seen and studied above all in the master is his curiosity and his erudition. That explains why they affect leanness, pallor and other ridiculous conventional effects, adopted without examination or good faith. They have wandered far, far back into the past, imitating with childish servility a number of deplorable mistakes, and voluntarily denying themselves all the technical means of successful execution which the experience of centuries offered them.

. . .

IX. OF PORTRAITURE

There are two ways of understanding portraiture: history and fiction.

The first consists of reproducing faithfully, rigorously, minutely, the contour and modelling of the sitter. This process does not exclude idealization, which for the enlightened naturalist will consist in choosing the most characteristic attitude – the one, that is, that reveals better than any other the sitter's attitudes of mind – and, in addition, in being able to give to every important detail a reasonable emphasis, to bring out whatever is naturally prominent, accentuated and dominant, and to neglect or merge into the whole whatever is insignificant or the effect of some accidental flaw.

The leaders of the historical school are David and Ingres;

the best examples are the portraits by David that were to be seen at the Bonne-Nouvelle Exhibition,[31] and those by M. Ingres, for example the portraits of M. Bertin and Cherubini.

The second method, the one characteristic of the colourists, consists in making a picture out of a portrait, a poem with its accessories full of space and reverie. This form of the art is more difficult, because it is more ambitious. The artist must know how to bathe a head in the soft light of a warm atmosphere or bring it out from the depths of 'chiaroscuro'. Here imagination plays a greater part, and yet, just as fiction is often truer than history, so a sitter may be more clearly interpreted by the rich and skilful brush of a colourist than by the pencil of a draughtsman.

The leaders of the fictional school are Rembrandt, Reynolds, Lawrence. Well-known examples are *The Lady with the Straw Hat* and the young *Lambton*.

Broadly speaking, the work of Messrs Flandrin, Amaury-Duval and Lehmann has the excellent quality of well observed and delicate modelling. It is well thought out in detail and carried through with visible ease and all in one go; but often their portraits are marred by pretentious and clumsy affectation. Their pronounced taste for effect constantly plays them tricks. They are known for the admirable bonhomie they display in their search for what they regard as 'effective' tones, in other words tones which, with more intensity, would clash like the devil and holy water, like marble and vinegar; but as they are applied excessively thinly and administered, so to speak, in homoeopathic doses, their effect is rather more surprising than painful; that is their great triumph!

Effect in drawing means sharing the prejudices of prim little persons, dabbling in prurient literature, who have a horror of small eyes, big feet, big hands, little foreheads, and cheeks aglow with joy and health – all of which can be very beautiful.

This pedantry in colour and drawing always impairs the works of these gentlemen, however much they are to be commended otherwise. Thus, as I looked at the 'blue' portrait by M. Amaury-Duval and a lot of other 'Ingrested' or 'Ingresized' portraits of women, I was reminded by some association of ideas or other of the wise words of the dog Berganza,[32] who avoided 'blue-stockings' with as much ardour as these gentlemen display in seeking their company: 'has Corinna never seemed insufferable to you? . . . The very thought of her as a living person coming near me gave me the feeling of being oppressed by a painful sensation and of being incapable of keeping my calmness and my independence of mind in her company . . . However beautiful her arms or her hands, never could I have borne her caresses without a sense of repugnance, an internal shiver which usually deprives me of my appetite. Naturally I am speaking here only in my capacity as a dog!'

I have experienced the same sensation as the witty Berganza in front of almost all the portraits of women (both previously executed portraits and those now hung) by Messrs Flandrin, Lehmann and Amaury-Duval, in spite of the beautiful hands, really well painted, which they know how to give their sitters and certain flattering details. Dulcinea[33] herself, the Tobosan maid, were she to tarry as a sitter in the studios of these gentlemen would emerge thence as diaphanous and prudish as an elegy, and reduced in weight by a diet of aesthetic tea and butter.

And yet – we must say the same thing over and over again – it is not like this that M. Ingres understands things, great master that he is!

. . .

X. OF 'CHIC' AND 'PONCIF'

Chic, this hideous and bizarre word, coined in our own day, which I do not even know how to spell* but am obliged to use because the artists' confraternity has adopted it to express a modern monstrosity, denotes: painting without reference to a model or to nature. *Chic* is the abuse of memory; *chic* means rather memory of the hand than memory of the brain; for there are artists endowed with a retentive memory for characters and shapes – Delacroix, Daumier – who have no truck with *chic*.

Chic may be compared with the work of those skilled calligraphers, writing a beautiful hand with a nib designed for the cursive script, who can trace, with their eyes shut, the head of Christ or the Emperor's hat in a bold flourish.

The meaning of the word *poncif* has much in common with that of the word *chic*. But it applies more particularly to carriage of the head and to attitudes. Anger can be 'poncified', so can astonishment (for example, astonishment expressed by a horizontal arm with thumb upwards).

There are in life and in nature a number of things and beings that are *poncif*, in other words, that are the epitome of the vulgar and commonplace ideas we have of these things and beings; as a result great artists detest them.

Everything that is conventional and traditional is related to the *chic* and the *poncif*.

When a singer puts his hand on his heart, that usually means: 'I shall love her for ever.' If, on the other hand, he clenches his fist, as he glares at the prompter or the boards, that implies: 'He shall die, the dastard.' Such is *poncif*.

XI. OF M. HORACE VERNET

Such are the rigorous principles that guide the steps of this eminently national artist in his quest for beauty, whose com-

*H. de Balzac spells it *Chique* somewhere.

positions adorn the cottage of the humble villager, and the garret of the merry student, the sitting-rooms of the most sordid brothels and the palaces of our monarchs. I know well enough that this man is a Frenchman and that a Frenchman in France is a holy and sacred thing – abroad too, so they say; but that is precisely why I detest the fellow.

In the most generally adopted sense, who says 'French' means 'frivolous', and a frivolous type is the man who is attacked by vertigo at the sight of Michelangelo and by brutish stupor at that of Delacroix, much as certain animals are at the sound of thunder. Everything that is profound, either in height or in depth, puts him to prudent flight. The sublime always puts him in mind of a riot, and if he takes up his copy of Molière, it is with trepidation, and only because he has been persuaded that Molière is a light author.

And so all decent folk, except M. Horace Vernet, hate the Frenchman. Ideas are not what this turbulent people needs, but facts, stories from history, a rhyming couplet or so and *Le Moniteur*! That is all: never anything abstract. It has done great things, but without thinking. It was forced to do them.

M. Horace Vernet is a soldier who busies himself with painting; I hate this art thought up to the beat of drums, these canvases daubed at the gallop, this painting fabricated by pistol-shot, just as I hate the army, armed power and anyone who clanks weapons noisily around in a peaceful place. This enormous popularity, which, moreover, will last no longer than war itself, and which will fade away as nations find other ways of amusing themselves, this popularity, I repeat, this *vox populi*, *vox Dei*, simply oppresses me.

I hate this man because his pictures are not painting but a sort of agile and frequent masturbation, an irritation of the French epidermis – just as I hate a certain other great man,[34] whose austere hypocrisy dreamed up the Consulate and who rewarded the people for their affection with nothing but bad verse, verse which is not poetry; contorted, badly built verse,

full of blunders and solecisms, but also full of civic spirit and patriotism.

I hate him for being born with a caul★ and because art for him is as clear as glass, and offers no problems. But he records your glory for you, and that is the great thing. And of what importance, pray, is that to the enthusiastic traveller with a cosmopolitan outlook, who prefers beauty to glory?

To define M. Horace Vernet clearly, he is the antithesis of the artist; he substitutes *chic* for drawing, a medley for colour, and episodes for unity; he fabricates Meissoniers[36] on a vast scale.

Moreover, to carry out his official mission, M. Horace Vernet is endowed with two eminent qualities, one negative, the other positive: absence of all passion and a memory like an almanac.† Who better than he knows how many buttons there are on every sort of uniform, what a gaiter or a boot battered by hard marches looks like, where exactly on the leather shoulder-pads the rub of the gun-metal makes its verdigris-coloured mark? And so, what an immense public! As many categories of admirers as there are categories of trades required to manufacture uniforms, shakos, swords, rifles and guns! And all these trades, united in admiration of Horace Vernet by a common love of glory! What a spectacle!

★The expression is M. Marc Fournier's,[35] and it applies to almost all the fashionable novelists and historians, who are scarcely more than serial writers, like M. Horace Vernet.

†True memory, considered from a philosophical angle, consists, I suppose, only in a very lively imagination, easy to stimulate and, in consequence, able to evoke in support of every sensation the scenes of the past, endowing them, as if by magic, with life and character appropriate to each; at least I have heard the thesis developed by one of my former teachers, who had a prodigious memory, although he could not remember a single date or a single proper name. My teacher was right, and doubtless for words and addresses that have penetrated deeply into the soul, the intimate mysterious meaning of which we have been able to grasp, the position is different from that of words merely learnt by heart[37] (Hoffmann).

I was one day twitting some Germans on their liking for Scribe and Horace Vernet; their reply was: 'We admire Horace Vernet profoundly, as the most complete representative of his century.' Hooray! The story goes that M. Horace Vernet one day called on Pierre de Cornelius and larded him with compliments. But he had to wait a long time for the response, for Pierre de Cornelius congratulated him only once during the whole interview, on the quantity of champagne he could imbibe without feeling any ill effects. True or apocryphal, the anecdote has poetic verisimilitude.

Will anyone still have the face to maintain that the Germans are a naïve people!

Many people who believe in the indirect approach in savage criticism, and who have no more love than I for M. Horace Vernet, will upbraid me for clumsiness. But to be blunt, and to go straight to the point, is not being incautious, when the 'I' of every sentence really stands for 'We', an innumerable, silent, invisible 'We' – 'We', a whole new generation, enemy of war and nationalist nonsense, full of health because young, already impatiently waiting at the end of the queue, elbowing its way forward and making its impact, a generation, earnest, ironical and threatening!*

. . .

XII. OF ECLECTICISM AND DOUBT

As you see, here we are in the infirmary of painting, with its sores and its ailments before us, and this ailment is not the least strange or the least contagious of them.

In the present century, as in past centuries, now as formerly, the strong men, healthy in both body and mind, share out amongst themselves, each man according to his tastes and

*Thus in front of every canvas by M. Horace Vernet may be sung:
 You have but a short time to live,
 Friends, live it gaily.[38]
An essentially gallic gaiety.

temperament, the various territories of art, and they work away there in complete freedom, in accordance with the inescapable law of natural attraction. Some gather an easy and abundant harvest in the vineyards of colour, bathed in golden autumnal light; others till patiently and cut the deep and difficult furrow of drawing. Each of these men knows that his dominion implies a sacrifice, and that on that condition only he may continue to reign securely up to the frontiers that mark its limits. Each of them has a standard with his crown; and the words emblazoned on it are clear for all to read. None of them doubts his claim, and it is in that imperturbable conviction that their glory and serenity reside.

M. Horace Vernet himself, that odious representative of *chic*, has the merit of not being a doubter. He is a man of a happy and frolicsome disposition; he inhabits an artificial country, where the actors and the scenery are all made of cardboard, but he reigns supreme in his kingdom of parade and entertainment.

Doubt, which today is the main cause of all morbid maladies in the moral sphere, and the ravages of which are greater than ever, results from certain major causes, which I shall analyse in the last chapter but one, entitled 'Of Schools and Journeymen'. Doubt has engendered eclecticism, for the doubters were eager to find salvation.

Eclecticism in every age has always considered itself greater than the traditional philosophies, because, being last in the line, it could survey the most distant horizons. But this impartiality shows the impotence of the eclectics. People who allow themselves so much time for reflection are not whole men; they lack a passion.

The eclectics have not noticed that, the narrower the attention is, and the more it limits its own field of observation, the keener it is. To grasp all is to lose all!

It is especially in the arts that eclecticism has had the most obvious and tangible consequences because, to be deep, art

demands a constant process of idealization, achieved only at the price of sacrifice – an involuntary sacrifice.

However skilful an eclectic may be, he is a weak man; for he is a man without love and therefore without an ideal, without a conviction; neither star nor compass.

He will unite four different techniques, with a dark, negative effect.

An eclectic is a vessel with sails set to the four winds at once.

A work executed from an exclusive point of view, however great its defects, always has great charm for those endowed with temperaments akin to the painter's.

The work of an eclectic makes no lasting impression on the memory.

An eclectic does not know that an artist's first job is to substitute man for nature and to protest against her. This protest is not the result of a cold rational decision, like a code of rules or a figure of rhetoric; it is rash and artless, like vice, like passion, like appetite. An eclectic, therefore, is not a man.

Doubt has led certain artists to invoke the help of all the other arts. Experiments with contradictory methods, the encroachment of one part upon another, the importation of poetry, of wit and sentiment into painting, all these trivialities of our day are vices peculiar to eclectics.

XIII. OF M. ARY SCHEFFER[39] AND OF THE APES OF SENTIMENT

A disastrous example of this method, if absence of method may be called by that name, is M. Ary Scheffer.

After he had modelled himself on Delacroix, and aped the colourists, the draughtsmen of the French School, and the neo-Christian school of Overbeck,[40] it dawned on M. Ary Scheffer, a little late no doubt, that he was not a painter born. From that moment there was nothing for it but to have

recourse to other means; and so he asked for help and protection from poetry.

A ridiculous error for two reasons; first, poetry is not the immediate aim of painting; when it happens to be mingled with painting, a work is all the better for it, but poetry cannot hide a picture's weaknesses. To make a point of straining after poetic effect in the conception of a picture is the surest way not to find it. It must come without the painter's being aware of it. It is the result of painting itself; for it lies deep in the spectator's soul, and genius consists in awakening it there. Painting is interesting only by colour and form; it resembles poetry only in so far as the latter awakens in the reader ideas of painting.

Secondly, and this is a consequence of what I have just written, it is noticeable that the great painters, whose instincts are always a sure guide, have borrowed from poets only highly coloured and image-making subjects. Thus they prefer Shakespeare to Ariosto.

Now to choose a striking example of the imbecility of M. Ary Scheffer, let us examine the subject of the painting entitled *Saint Augustin et Sainte Monique.* A worthy Spanish painter, with the twin pieties of art and religion, would, in his simplicity, have done his best to portray the general idea in his mind of St Augustine and St Monica. Here no such thing; the aim is to express the following passage, with brushes and paints: 'We sought between us what might be the nature of that life eternal, which *the eye has not seen, the ear has not heard and which the heart of man cannot rise to.*'[41] This is the height of absurdity. It suggests to me a dancer executing a step in mathematics!

Time was when the public was kindly disposed towards M. Ary Scheffer; his poetical paintings recalled the most cherished memories of the great poets and that was enough. The fleeting vogue M. Ary Scheffer enjoyed was a homage to the memory of Goethe. But painters, even those possessed

of only meagre originality, have for a long time now been showing the public genuine painting, executed with a sure hand and according to the simplest rules of art; as a result, the public has slowly lost its taste for invisible painting, and today, like all publics, shows itself heartless and cruel towards M. Ary Scheffer. Upon my word, they are right.

Furthermore, these works are so cheerless, so mournful, so neutral, and so muddy that many people have mistaken pictures by M. Ary Scheffer for those by M. Henry Scheffer,[42] another Girondin[43] of painting. To me, they look like the pictures by M. Delaroche washed out by heavy rain.

A simple way of finding out the range of an artist is to see what public he attracts. Eugène Delacroix has the painters and the poets on his side; M. Decamps has the painters; M. Horace Vernet, the garrison troops; M. Ary Scheffer, the troop of aesthetically-minded ladies who revenge themselves for their leucorrhoea by playing religious music.*

The apes of sentiment are in general bad artists. If it were otherwise they would do things other than produce sentiment.

The best of them are those who do not understand anything beyond prettiness.

Just as sentiment is an infinitely variable and multi-sided thing like fashion, the apes of sentiment belong to different categories.

The ape of sentiment leans heavily on the catalogue. We may note to begin with that the title of the picture never reveals the subject; especially is this true of artists who by a delicious mixture of horrors mingle sentiment with wit. By developing this method you get to the sentimental rebus.

For example, suppose you see in the catalogue: *Pauvre*

*To those who may sometimes have felt scandalized by my bouts of rightous wrath I commend Diderot's 'Salons'. Amongst a number of examples of well-founded charity, they will learn of this great philosopher's attitude in the case of a painter who had been recommended to his attention because he had a number of mouths to feed. Quoth he: 'Either pictures or the family must be abolished.'

fileuse! Well, the picture might represent a female silk-worm, or a caterpillar squashed by a child, that heartless age!

Aujourd'hui et demain. What might that be? Could it be the white flag and the tricolour; or perhaps a newly-elected deputy in joy, and the same fellow kicked out? Not at all; behold a youthful maiden, promoted to the dignity of a 'loose lizzie', playing with jewellery and roses, and then faded and hollow-cheeked, with straw for a bed, suffering the consequences of her flighty conduct.

L'Indiscret. Guess, please! The picture shows a gentleman surprising two blushing young ladies with an album of licentious drawings.

This picture belongs to the category of pictures in the Louis XV spirit, which slipped into the Salon in the wake of *La Permission de dix heures.* As will be seen, we have here a quite different order of feeling; these are much less mystical.

In general, sentimental pictures are drawn from the most recent book of poetry by some blue-stocking or other, full of foggy melancholy; or they are the pictorial translation of the whinings of the poor against the rich, the protesting kind; or they are borrowed from the wisdom of nations, the witty kind; sometimes from the works of M. Bouilly,[44] or from Bernardin de Sainte-Pierre,[45] the moralizing kind.

And here are a few more examples of the sentimental pictures: *L'Amour à la campagne*, happiness, peace and quiet, and *L'Amour à la ville*, cries, disorder, chairs and books thrown around: this is metaphysics within the reach of simple minds.

La Vie d'une jeune fille en quatre compartiments. A warning to those with a leaning towards motherhood!

L'Aumône d'une vierge folle. She gives her mite, earned by the sweat of her brow, to the proverbial chimney-sweep, mounting guard at the entrance to Félix's. Inside rich men of the day are filling their faces with good things. That picture evidently comes from the *Marion Delorme*[46] sort of literature, which consists of extolling the virtues of murderers and harlots.

How witty Frenchmen are and what lengths they go to to fool themselves! Books, pictures, drawing-room ditties, nothing is useless, no means are neglected by this charming people when self-deception is involved.

. . .

XV. OF LANDSCAPE

In landscape, as in portraiture and history painting, classification may be made according to the different methods used; thus there are landscape colourists, landscape draughtsmen, and imaginative landscapists; naturalists, who idealize unconsciously, and partisans of the *poncif*, who busy themselves with one most peculiar genre, called historical landscape.

At the time of the romantic revolution, landscape artists, following the example of the greatest Flemish masters, devoted themselves entirely to the study of nature; that is what saved them, and gave particular brilliance to the modern landscape school. Their talent consisted essentially of the unfaltering adoration of visible creation in all its aspects and all its detail.

Others, more philosophically and rationally inclined, concerned themselves particularly with style, in other words with the harmony of the dominant lines, with the architecture of nature.

As for the purely imaginative landscape, which is the expression of human reverie, of human egotism, substituted for nature, it was not greatly cultivated. This strange genre, of which Rembrandt, Rubens, Watteau[47] and a few English illustrated gift-books offer the best examples, and which is, on a small scale, analogous to the beautiful scenery of the Opera, is the product of a natural need of the marvellous. It is imaginative drawing imported into landscape; fairy-land gardens, vast horizons, streams more limpid than nature makes them and running against the laws of topography, huge rocks, built in ideal proportions, floating haze as diaphanous as a

dream. Imaginative landscape has had few enthusiasts in France, either because this fruit was not very French, or because the school needed above all to steep itself once more in nature's unadulterated springs.

As for historical landscape, about which I have a few words to say as a kind of office for the dead, it is neither unfettered fantasy nor the admirable verisimilitude of the naturalists; it is applying a moral law to nature.

What a contradiction and what a monstrosity! Nature has no moral law other than fact, because nature is itself morality; and yet the aim here is to rebuild nature, and to order her in accordance with healthier and purer rules, which are not to be found in the pure enthusiasms of the ideal, but in strange codes, which the devotees never show anyone.

In the same way, tragedy – that type of drama forgotten of men, and of which only a few examples survive at the Comédie-Française, the most deserted theatre in the world – tragedy consists in cutting out certain eternal patterns, which are love, hatred, filial devotion, ambition, etc., suspending them on wires, and making them walk, bow, sit down and talk according to a recondite and sacred code of manners. Never, even with the help of wedges and mallets, will you be able to drive into the head of a tragic poet the idea of the infinite variety of things; and even by belabouring him to death, you will not succeed in persuading him that different codes of morals are necessary. Have you ever seen characters of tragedy eat or drink? Evidently such characters have taken a high moral line on the subject of the body's natural needs and have created their own temperament, whereas the majority of men are the slaves of theirs. I have heard a poet-in-ordinary to the Comédie-Française say that the novels of Balzac filled him with feelings of depression and distaste; that, as far as he was concerned, he found it impossible to conceive that lovers could live on anything but the scent of flowers and the tear-drops of the dawn. It is high time, in my view, that the govern-

ment took a hand in this; for if men of letters, who all have their dreams and labours, and for whom there is no such thing as Sunday, do not, in the nature of things, fall into tragedy's net, there are people that have been persuaded that the Comédie-Française is the sanctuary of art, and whose admirable good will is swindled once a week.[48] Is it sensible to allow a number of citizens to become stupefied and get false ideas? But it seems that tragedy and historical landscape are stronger than the gods.

You are now in a position to understand what a good tragic landscape is. It is an arrangement of stereotyped patterns of trees and fountains, of tombstones and funeral urns. The dogs are cut out on a certain pattern of historical dog; a tragic shepherd cannot, on pain of dishonour, have any other kind of dog. Any immoral tree which had the cheek to grow independently and according to its own nature is necessarily cut down forthwith; any pond full of toads and tadpoles is mercilessly filled in. Painters of historical landscapes, if assailed by pangs of conscience for some trifling natural peccadillo, imagine hell to be like a real landscape, with a pure sky and a free luxuriant growth: an open plain, for example, or a virgin forest.

Messrs Paul Flandrin, Desgoffes, Chevandier and Teytaud are the men who have shouldered the glorious task of struggling against the taste of a nation.

I do not know what is the origin of the historical landscape. One thing is sure, namely that it did not have its source in Poussin[49]; for in comparison with these gentlemen he is a corrupt and debauched spirit.

. . .

XVI. WHY SCULPTURE IS A BORE

The origin of sculpture is lost in the night of time; it must therefore be an art of the Caribbees.

And sure enough we find all races carving fetishes very skilfully, long before they tackle painting, which is an art demanding deep thought and one that requires a special initiation merely to be enjoyed.

Sculpture is much closer to nature, and that is why our very peasants, who are delighted at the sight of a piece of stone or wood industriously worked, stand unmoved in front of the finest painting. Here is a peculiar, impalpable mystery.

Sculpture has a number of disadvantages that are the consequences of the means at its disposal. Brutal and forthright like nature, sculpture is at the same time vague and elusive, because it displays too many facets at one and the same time. Vainly does the sculptor try to adopt one point of vision; the viewer who walks round the figures can choose a hundred different positions without finding the right one; and it often happens, and this is humiliating for the artist, that a chance ray of light or the play of lamplight throws into relief a beautiful effect not intended by the artist. A picture is nothing but what it intends to be. There is no way of looking at it except in its own light. Painting has only one point of view; painting is exclusive and despotic, and, in consequence, the painter's message is much more forceful.

That is why a good judge of sculpture is as rare as a bad sculptor. I once heard the sculptor Préault[50] say: 'On Michelangelo, Jean Goujon,[51] Germain Pilon,[52] I know what I am talking about, but as for sculpture I know nothing about that.' Evidently he was referring to the sculpture of primitive carvers, in a word of the Caribbees.

When sculpture had emerged from its primitive period and attained its most magnificent development, it still remained only a complementary art. Its aim was no longer to chip away at shaping portable figures but to become the humble associate of painting and architecture and to serve their aims. The cathedrals soar skywards, and crowd their thousand depths with sculptures that are as one flesh and body with the edifice;

painted sculpture, be it noted, whose colours, simple and pure, but arranged in accordance with a special scale, blend with the whole, and complete the poetic effect of the great structure. Versailles is peopled with statues, sheltering in shaded bowers, which serve as background to them, or in watery grottoes, where fountains scatter about them a thousand sparkling diamonds of light. In all great epochs sculpture is a complement; in its primitive stage and in its later days, it is an art apart.

As soon as sculpture consents to be seen from close at hand, the sculptor will risk all manner of trivial details and puerilities that triumphantly outstrip any pipes or fetishes. When sculpture has become a drawing-room or bedroom art, the Caribs of lace, like M. Gayrard, and the Caribs of the wrinkle, the hair and the wart, like M. David,[53] at once appear.

Then come the Caribs of the andiron, the clock, the writing table and so on, like M. Cumberworth, whose *Marie* is a maid-of-all-work, at the Louvre and Susse's shop, statue or candelabra; or like M. Feuchère, who has a gift of universality that drives viewers to despair: colossi, matchboxes, goldsmith's designs, busts and low relief, he can turn his hand to anything. The bust he has done this year, which is of a well-known actor, is no more like the model than last year's. They are nothing but rough approximations. Last year's resembled Jesus Christ, this year's, gaunt and mean in appearance, does not at all recapture the striking, angular, mocking and mobile features of the model. But it would be wrong to think that these artists lack knowledge of their art. They are as erudite as writers of vaudevilles and academicians; they plunder every period and every art form; they scrape the barrel of every school. They would willingly make the tombs of Saint-Denis[54] into cabinets for cigars or boxes for cashmere shawls, and all the Florentine bronzes into penny pieces. For further information on the principles adopted by this school of frolicsome butterflies, application should be made to M. Klagmann,[55] who is, I believe, the master of this vast workshop.

The best proof of the pitiful state sculpture is in today lies in the fact that M. Pradier[56] is its acknowledged master. At least he knows how to render flesh, and he has a peculiar delicacy of touch with his chisel; but he has neither the required imagination for large compositions nor the draughts-man's imagination. His is a cold academic talent. He has spent his life fattening up a few specimen torsos from antiquity, and adorning them with the hairstyles of kept women. His *La Poésie légère* is all the colder because so mannered; the exe-cution is less generous in its proportions than previous ones by M. Pradier, and seen from the back it is hideous. In addition he is showing two bronzes – *Anacréon* and *Sagesse* – which are impudent imitations of the ancients, and only go to show that but for this noble crutch M. Pradier would stumble at every step.

Busts are a genre that requires less imagination and more humble though no less delicate gifts than large-size sculpture. It is a more intimate art, narrower in compass; its successes are less public. As in the portrait done in the manner of the naturalists, it demands a thorough understanding of the salient traits of the sitter's character, and the expression of its poetic depths; for few sitters are wholly devoid of poetry. Nearly all M. Dantan's busts are done according to the best principles; they all have a particular stamp, and the detail does not exclude boldness and facility of modelling.

M. Lenglet's main fault, in contrast, is a degree of timidity and childishness, of meticulous sincerity in the modelling, which gives his work an appearance of dryness; but, on the other hand, no truer and more authentic character could be impressed on a human face. This little bust, compact, grave and puckered, has the splendid character of Roman works from the best period, the very kind of idealism from nature itself. Furthermore, M. Lenglet's bust suggests to me another trait characteristic of the faces of the Ancients, namely the concentrated air of attention they have.

XVII. OF SCHOOLS AND JOURNEYMEN

All of you whose casual curiosity has often drawn you into the thick of a street riot, have you felt the same joy as I, at the sight of some worthy custodian of the public slumbers, be he policeman or municipal guard (the real army), cudgelling a republican? And like me, you will have said in your heart: 'Whack on, whack a bit harder, whack again, oh! officer dear to my heart, for in this ultimate cudgelling, I adore thee and see thee as the equal of Jupiter, the great dispenser of justice. The man thou cudgellest is an enemy of roses and scents, a fanatic of utility; he is an enemy of Watteau, of Raphael, an arch enemy of luxury, of the fine arts and literature, a sworn iconoclast, a butcher of Venus and Apollo. He refuses to go on working, as a humble and anonymous journeyman, producing public roses and scents; he wants to be free, the ignorant boor, and he is not even capable of founding a workshop of new flowers and scents. Go on belabouring him devoutly, on his back, the anarchist!'*

In the same way, philosophers and critics must belabour without mercy 'artistic' apes, emancipated journeymen, who hate the strength and sovereignty of genius.

Just compare this age with past ages; when you leave the Salon or a recently decorated church, go and rest your eyes in a museum and analyse the differences. In the former, conflict and hubbub of styles and colours, cacophony of tones, colossal trivialities, vulgarity of gesture and attitudes, conventional dignity, clichés of every kind, and all this, staring you in the face, not only in pictures hung side by side, but even in the same picture; in short, a complete lack of unity producing a dreadful feeling of fatigue for the mind and the eyes.

*I often hear people complaining of the modern theatre; it lacks originality, they say, because there are no longer any types. But what of the republican! What do you make of him, pray? Is he not a necessary element in any comedy that aims to be amusing, and is he not a character that has graduated to the state of a 'Marquis'57?

In the latter, you find an air of reverence that makes even children take their hats off, and grips the soul, just as the dust of tombs and vaults grips the throat. That is the effect, not of yellow varnish and of the filth of ages, but of a sense of unity, profound unity. For a great Venetian painting conflicts less with a neighbouring work by Giulio Romano[58] than some of your modern pictures (and not necessarily the worst) clash amongst themselves.

The splendour of costume, the nobility of movement, often mannered yet grand and haughty, the absence of mean little tricks and contradictory techniques are qualities that are all implied in the expression: the great tradition.

Then – schools, and now – emancipated journeymen.

Even under Louis XV, schools still existed; under the Empire there was one, a school, that is to say, a faith, that is to say, the impossibility of doubt. There were pupils, united by commonly held principles, obedient to the word of a powerful master, and helping him in all his labours.

Doubt, or the absence of faith and naïveté, is a vice peculiar to this age, for no one is obedient nowadays; and naïveté, which means the dominance of temperament in the manner, is a gift from God, possessed by very few.

Few men have the right to rule, for few men are inspired by a powerful passion.

And as everyone today wants to rule, no one knows how to govern himself.

Now that every man is abandoned to his own devices, a teacher has a crowd of faceless pupils, for whom he is not responsible; and his muted and involuntary sway extends far beyond his studio to places where his thought cannot be understood.

Those who are nearer the master's word and action preserve the doctrine unadulterated, and, by obedience and tradition, they do what the master does by the imperatives of his nature.

But outside this family circle stands a whole crowd of

mediocrities, apes of different races and cross-breeds, a loosely-knit nation of mongrels, who move daily from one country to another, carrying away with them from each those customs that suit them, and try to build up a character for themselves by a system of contradictory borrowings.

There are some people quite ready to lift a fragment from a picture by Rembrandt and introduce it into a painting inspired by a different idea, without modifying or assimilating it, and without finding the right gum to stick it on with.

Others change over from white to black in a single day: yesterday they were *chic* colourists, colourists without passion or originality; tomorrow they will be sacrilegious imitators of M. Ingres, without finding more taste or faith there.

Whoever nowadays belongs to the category of even the most skilful apes is and will always be a mediocre painter; in the old days he would have been an excellent journeyman. And so he is a dead loss both to himself and to us all.

That is why it would have been better, in the interests of their salvation and even of their happiness, for the lukewarm to have been subjected to the ferule of a vigorous faith; for strong men are rare, and nowadays you have to be a Delacroix or an Ingres to come to the top and be seen on the chaos of an exhausting and sterile freedom.

The apes are the republicans of art, and the present state of painting is the result of an anarchic liberty that glorifies the individual, however weak, to the detriment of groups, in other words schools.

In the schools, which are nothing else but the organized force of invention, the individuals really worthy of the name absorb the weak; and that is justice as it should be, for a massive production is merely one mind served by a thousand arms.

This glorification of the individual has necessitated the infinite sub-division of the territory of art. The absolute and divergent liberty of everyone, the division of effort and the

dispersal of the human will have brought about this state of weakness, of doubting, and poverty of invention; a few sublime and long-suffering eccentrics cannot fully compensate for this swarming disorder of mediocrities.

Individuality – this right of small property – has eaten up collective originality; and just as a celebrated chapter of a romantic novel[59] has shown that printing has killed stone edifices, so we can say that for our time the painter has killed painting.

XVIII. OF THE HEROISM OF MODERN LIFE

Many people will attribute the decadence of modern painting to the decadence of manners. This studio prejudice, which has been current amongst the public, is a poor excuse put about by artists themselves. For they were keen on constantly depicting the past, which is an easier task and appeals to the lazy.

It is true that the great tradition is lost and that the new one is as yet unformed.

What was that great tradition if not the ordinary and customary process of idealizing life in antiquity: a robust and warlike kind of life with every man ready to defend himself, a state that gave him the habit of deliberation in his movements, of noble or violent attitudes? Add to that the public pomp and circumstance reflected in private life. The ancients loved public ceremony; life was organized to please the eye, and this everyday paganism did great service to the arts.

Before trying to isolate the epic quality of modern life and to show, by giving examples, that our age is no less rich than ancient times in sublime themes, it may be asserted that since every age and every people have had their own form of beauty, we inevitably have ours. That is in the order of things.

All forms of beauty, like all possible phenomena, have within them something eternal and something transitory – an absolute and a particular element. Absolute and eternal

beauty does not exist, or rather it is nothing but an abstract notion, creamed off from the general surface of different types of beauty. The specific element of each type of beauty comes from the passions, and just as we each have our particular passions, so we have our own type of beauty.

With the exception of Hercules on Mount Oeta, Cato of Utica and Cleopatra, whose suicides are not in the modern manner,★ what suicides are depicted in ancient art? In all pagan lives, devoted to satisfaction of material appetites, you will find no example of Jean-Jacques's suicide,[60] or even of the strange and marvellous suicide of Raphael de Valentin.[61]

As for the frock-coat, that outer skin of the modern hero, although the day has long since gone when every little dauber dressed himself up like the grand Turk and smoked like a chimney, the studios and society are still full of people who would like to poeticize Antony[62] by clapping him in a Greek mantle or in motley.

And yet has it not got its own beauty and native charm, this much abused frock-coat? Is it not the inevitable uniform of our suffering age, carrying on its very shoulders, black and narrow, the mark of perpetual mourning? And observe that the black frock-coat and the tail-coat may boast not only their political beauty, which is the expression of universal equality, but also their poetic beauty, which is the expression of the public soul – an immense procession of undertakers' mutes, political mutes, mutes in love, bourgeois mutes. All of us are attending some funeral or other.

A uniform livery of grief is a proof of equality; as for the eccentrics, who used to be easily distinguishable by their violent contrast of colour, they content themselves nowadays much more with discreet differences of design and cut than of

★The first killed himself because the pain from his burning tunic had become unbearable; the second because he could do nothing more for the cause of liberty; and the voluptuous queen because she had lost her throne and her lover; but none of them destroyed himself to change skins, as metempsycosis promised.

colour. Those grimacing folds, which play like serpents about mortified flesh, have they not got a mysterious grace?

M. Eugène Lami[63] and M. Gavarni, who are not, after all, superior geniuses, have understood all this clearly – the former, the poet of official dandyism; the latter, the poet of happy-go-lucky and bargain-basement dandyism! If the reader will reread M. Jules Barbey d'Aurevilly's[64] *Du Dandysme* he will see at once that dandyism is a modern phenomenon and owes its existence to a wholly new set of causes.

Let the race of colourists hold their indignation in check; for the task, though more difficult, is all the more glorious. Great colourists know the secret of creating colour with a black frock-coat and a white cravat and a grey background.

But to come to the main and essential question, which is to examine whether we have a specific kind of beauty, inherent in new forms of passion, I have noticed that the majority of artists who have tackled modern subjects have contented themselves with public and official subjects, our victories and our political heroism. Even so, they do it with an ill grace and only because they are at the beck and call of the government that pays them. But there are private subjects that are much more heroic than these. Scenes of high life and of the thousands of uprooted lives that haunt the underworld of a great city, criminals and prostitutes, the *Gazette des Tribunaux* and the *Moniteur* are there to show us that we have only to open our eyes to see and know the heroism of our day.

Take for example the case of a minister goaded by impertinent questions from the Opposition into expressing, once and for all, in tones of lofty and sovereign eloquence, so characteristic of him, his contempt and distaste for every sort of ignorant and waspish opposition; then, depend upon it, that evening on the Boulevard des Italiens you will overhear chance talk such as this: 'Were you in the House today? Did you see the Minister? Ye gods . . . ! How good-looking he was! I have never seen a prouder mien!'

So there is a modern type of beauty and heroism!

And then a little later: 'They say K. – or F. – has been commissioned to engrave a medal on the incident – but he will never be able to do it; he is not capable of understanding things like that.'

So there are artists more or less capable of understanding modern beauty.

Or else: 'Sublime old B. . . . ! Byron's pirates are less great and less scornful. Would you believe it, he pushed Abbé Montès[65] aside and threw himself at the guillotine exclaiming: "Do not shake my courage!"'

These words allude to the funereal boasting of a criminal, of a great protester, sound in wind and limb, whose fierce courage did not falter at the foot of the engine of death.

All these words that escape your lips bear witness to your believing in a new and particular species of beauty that is neither that of Achilles nor that of Agamemnon.

Parisian life is rich in poetic and wonderful subjects. The marvellous envelops and saturates us like the atmosphere; but we fail to see it.

The nude, this subject so dear to artists, this indispensable element of success, is as prevalent and necessary as in the life of antiquity – in bed, in the bath, in the medical theatre. The technical means and the themes of painting are equally numerous and varied; but there is a new element, which is modern beauty.

For the heroes of the *Iliad* do not so much as reach up to your ankles, oh! Vautrin, oh! Rastignac, oh! Birotteau,[66] and thou, oh! Fontanarès,[67] that hast not dared to tell the public thy sorrows, clad in the funereal and ragged tail-coat we all put on today; and you, oh! Honoré de Balzac, you the most heroic and the most remarkable, the most romantic and the most poetical of all the characters you have drawn from your heart.

3. Of Virtuous Plays and Novels[1]

FOR some time now a veritable frenzy of virtue has seized hold of stage and novel alike. The puerile excesses of the so-called romantic school have produced a reaction that may well be accused of shocking clumsiness, in spite of the pure intentions it seems informed with. Virtue is no laughing matter to be sure, and no writer in his senses has ever thought of taking the line that works of art ought to run counter to the great moral laws. The question at issue therefore is to determine whether the so-called virtuous writers are tackling successfully the problem of inspiring love and respect for virtue, whether virtue is satisfied with the way her cause is being served.

Two examples occur to me as I write. One of the most puffed-up upholders of middle-class virtue, one of the knights errant of common sense,[2] M. Émile Augier,[3] has produced a play, *La Ciguë*,[4] in which the rampageous, loose-living and hard-drinking young hero, a complete epicurean, falls at the end for the charms of an innocent girl. Cases of notorious debauchees casting all their luxury to the winds and seeking in asceticism and poverty bitter and unsuspected joys are not unknown. The theme, though commonplace enough, could have its beauty. But it would lie beyond the virtuous powers of the public catered for by M. Augier. I think he wanted to show that in the end a man must take to the 'straight and narrow . . .', and that virtue is only too glad to pick up the crumbs from the profligate's table.

Listen to Gabrielle,[5] the virtuous Gabrielle, reckoning with her virtuous spouse how long a spell of virtuous avarice they will need to undergo, at compound interest on their money, for them to enjoy an investment income of ten to twenty

thousand francs a year. Five years, ten years, or whatever it was, I forget the poet's figures. 'Then,' exclaim the virtuous pair, 'WE SHALL BE ABLE TO AFFORD THE LUXURY OF A SON'!

By the horns of all the devils of lust! By the souls of Tiberius and the divine Marquis,[6] what will they be up to all that time?

Must I soil my pen by mentioning all the vices they will have to resort to to accomplish their virtuous programme? Alternatively, does the poet hope to persuade his public of common or garden folk that the couple are going to live in perfect chastity? Would he perchance want to induce them to take lessons from the thrifty Chinese and Malthus?

Frankly it is impossible to write conscientiously a line of verse so pregnant with turpitude. However, M. Augier has erred, and his error brings its own punishment. He has spoken the language of the counting house, the language of society people, thinking that he was speaking the language of virtue. I am told that amongst the writers of this school,[7] passages of merit, some good lines, and even occasional verve are to be found. Of course! Where would be the excuse for their popularity, if there were nothing there of value?

But reaction is winning the day, reaction in its uninhibited stupidity. The brilliant preface of *Mademoiselle de Maupin*[8] poured scorn on asinine bourgeois hypocrisy, and now the school of *bon sens*, with smug impertinence, is getting its own back for all the violence of the romantics. Alas, yes! revenge is at the bottom of it. *Kean ou désordre et génie*[9] had appeared to suggest that between 'disorderliness' and 'genius' a necessary link exists, and Gabrielle, in revenge, calls her husband a poet!

'O, poet! I love you!'

And he a notary, if you please! Just imagine this virtuous dame, cooing with love on the shoulder of her man, and making languorous eyes at him, as they do in the novels she

has read. Just imagine all the notaries in the auditorium acclaiming the author, who has put himself on their level, and who is avenging them on all those debt-laden cads who believe the poet's craft to consist in expressing the lyrical emotions of the soul in rhythms controlled by tradition! Such is the key to many a success.

People began by describing all this as 'the poetry of the heart'! That is how the French language declines, and how unworthy literary passions destroy its precision.

In passing we may with advantage note a parallelism of stupidity in the fact that the same eccentricities of language are to be found in all extreme literary schools. There is, for example, a whole crowd of poets, befuddled by pagan voluptuousness, who are for ever using the words 'saint' (in both genders), 'ecstasy', 'prayer', etc. to describe things and beings that have nothing saintly or ecstatic about them, far from it, and, in the process, pushing the adoration of woman to the point of the most disgusting impiety. One of these, in a gush of 'saintly' eroticism, has gone so far as to exclaim: 'O my beautiful catholic!' As well foul an altar with excrement. All this is the more ridiculous in that poets' mistresses are as a rule passably ugly sluts, the least unagreeable being those who can cook and do not keep another lover.

On the fringe of the *École du bon sens*, with its types of oh! so proper, stuck-up bourgeois, a sickly crowd has grown up and pullulated: sentimental skivvies, who also bring God into their little affairs; Lizzies who get everything forgiven them by 'Gallic naughtiness'; prostitutes, who have somehow, somewhere, preserved an angelic purity, etc. Another type of hypocrisy.

The *École du bon sens* could now be called the *École de la vengeance*.*

* The origin of the name *Ecole du bon sens* is as follows. Some years ago in the offices of the *Corsaire-Satan*, one of the editors, referring to the success of a play produced by a member of the School, exclaimed in a moment of literary

How are we to explain the success of *Jérôme Paturot*,[10] that odious imitation of Courtille,[11] where poets and scholars are pelted with mud and flour by the most prosaic ragamuffins? The pacific Pierre Leroux,[12] whose numerous works constitute a veritable dictionary of human beliefs, has written some sublime and moving pages, which the author of *Jérôme Paturot* has perhaps not read. Proudhon[13] is a writer whom Europe will always envy us. Victor Hugo has after all written a number of fine verses; nor do I see that the learned M. Viollet-le-Duc[14] is an architect worthy of ridicule. Revenge! Revenge! The rank-and-file public must be allowed to relieve its feelings. The works I have mentioned are so many servile caresses destined to the passions of angry slaves.

There are certain awe-inspiring words that constantly recur in literary polemics: Art, the beautiful, the useful, morality. A grand scrimmage is in progress, in which, owing to a lack of philosophical wisdom, each contestant grabs half the flag and says the other half is valueless. I would not dream of making a show of philosophical pretentions in so short an article, nor do I want to bore people with efforts to establish absolute aesthetic principles. I prefer to go straight to the most urgent question and I speak the language of ordinary simple folk. It is painful to observe that similar errors are to be found in two opposing schools: the bourgeois school and the socialist school. 'Let us moralize! Let us moralize!' both sides exclaim, with the feverish ardour of missionaries. Of course, the one preaches bourgeois morality and the other socialist morality, and, as a result, art is a mere question of propaganda.

Is art useful? Yes. Why? Because it is art. Is there such a

indignation: ' 'Pon my word! there are people that seem to think that common sense is what is needed for producing comedies!' He meant 'Common sense alone is not enough, etc. . . .' The chief editor, who was a very simple man, thought the remark so uproariously funny that he insisted on its being published. From then on the *Corsaire-Satan*, and soon other journals, used the term as an insult, and the young members of the said school picked it up as a banner, just as the *sans-culottes* had done.

thing as a pernicious form of art? Yes! The form that distorts
the underlying conditions of life. Vice is alluring; then show it
as alluring; but it brings in its train peculiar moral maladies
and suffering; then describe them. Study all the sores, like a
doctor in the course of his hospital duties, and the good-sense
school, the school dedicated exclusively to morality, will
find nothing to bite on. Is crime always punished, virtue
rewarded? No; and yet if your novel, if your play is well put
together, no one will take it into his head to break the laws
of nature. The first necessary condition for the creation of a
vigorous art form is the belief in underlying unity. I defy
anyone to find one single work of imagination that satisfies the
conditions of beauty and is at the same time a pernicious work.

A young writer who has written some good things, but
who, on this occasion, was carried away by socialist sophistry,
recently attacked Balzac, in an article in *La Semaine*, on the
question of morality. Balzac, for whom the bitter recrimi-
nations of the hypocrites were very hurtful and who attached
great importance to this subject, seized the opportunity to
disculpate himself in the eyes of twenty thousand readers. I do
not propose to reproduce here what he wrote in his two
articles, both admirable for their lucidity and sincerity. He
treated the subject exhaustively. He began, with naïve and
comic bonhomie, to tot up the number of his virtuous
characters and the number of his villains. The balance was in
favour of virtue, in spite of the perversity of society, which,
quoth he, 'I have not made.' He then proceeded to show that
there are few arch-villains whose ugly souls have no redeem-
ing feature. After enumerating all the punishments that attend
closely upon evil-doers who break the moral law and envelop
them in a hell on earth, he apostrophized the faint-hearted
and those who are easily led, in a manner that is not without
either its sinister or its comic side: 'Woe betide you, good
sirs, if the fate of the Lousteaus or the Luciens[15] fills you with
envy!'

Yes indeed! Either vice must be depicted as it is or it must not be seen at all. And if the reader does not have within him a philosophic and religious guide as he reads, so much the worse for him.

I have a friend who for several years now has been assailing my ears with the name of Berquin.[16] Now there's a writer for you. Berquin! A charming author, kind, consoling, a do-gooder, a great writer! – unknown to me, since I had, as a child, the good or bad luck to read weighty tomes for adults. One fine day, when my brain was all gummed-up with this problem, so fashionable today: morality in art, the providence of writers thrust a volume of Berquin in my hands. The first thing I saw in it was that the children all talked like grown-ups, like a book, and that they were for ever preaching to their parents. This is fraudulent art, I said to myself. And as I read on, I noticed that wisdom was constantly rewarded with sugar, wickedness invariably shown up as ridiculous, under the lash of punishment. If you are good, you shall have goodies – such is the basis of this moral code. Virtue is the condition SINE QUA NON of success. One really begins to wonder whether Berquin was a Christian at all. That settles it, thought I, this is pernicious art. For the disciple of Berquin, on the threshold of society, will quickly reverse the terms: success is the condition SINE QUA NON of virtue. Moreover the label 'crime pays' will deceive him, and with the help of the master's precepts he will go and lodge at the hostelry of vice, thinking himself to be at the inn of morality.

Well then! Berquin, M. de Montyon,[17] M. Emile Augier, and countless other honourable persons, they are all tarred with the same brush. They do virtue to death, just as M. Léon Faucher[18] has delivered a death blow to literature with his satanic decree in favour of virtuous plays.

Prizes bring bad luck. Academic prizes, prizes for virtue, decorations, all these inventions of the devil encourage hypocrisy, and freeze the spontaneous upsurge of a free heart.

When I see a man asking for a decoration, it is as though I could hear him saying to the sovereign: 'I have done my duty, it's true, but if you don't spread it abroad, I swear not to do it again.'

Who is to prevent two rogues from conspiring together to win the Montyon prize, the one pretending to be in the depths of poverty, the other full of charity? There is in an official prize something wounding to a man and to humanity, something that affronts the modesty of virtue. For my part, I would not want to make a friend of a man who had won a prize for virtue; I should be afraid of finding in him an implacable tyrant.

As for writers, their prize lies in the esteem of their fellow-writers and in the tills of the book-sellers. What the devil is the honourable minister meddling with? Does he want to create hypocrisy in order to have the satisfaction of rewarding it? From now on, unending sermons will be the order of the day along the boulevards. When an author owes a few quarters' rent he will dash off a moralizing play; if he is heavily in debt, the play will be angelic. Splendid idea, these prizes!

I shall return later to this theme, and I shall speak of the attempts made by two great French minds, Balzac and Diderot, to rejuvenate the theatre.[19]

4. The Universal Exhibition of 1855:
the Fine Arts[1]

I. CRITICAL METHOD

OF THE MODERN IDEA OF PROGRESS, APPLIED TO THE FINE ARTS. OF THE SHIFT OF VITALITY

FOR a critic, for a dreamer given to generalizations as well as to the study of detail and, to put it even better, to the idea of order and universal hierarchy, there can be few occupations more interesting, more absorbing, so full of surprises and revelations, than comparison between nations and their respective products. When I say hierarchy I do not mean to claim supremacy for one nation over another. Although there may be in nature divers plants that are more or less holy, certain forms that are more or less spiritual, animals that are more or less sacred, and although we may legitimately claim, from the thoughts inspired by the immense universal analogy, that certain nations – vast animals whose organisms are adequate to their environment – have been prepared and schooled by Providence for a specific purpose, a more or less exalted purpose, more or less close to heaven, I have no other desire than to proclaim their equal usefulness in the eyes of HIM, the indefinable, and the miraculous help they bring to each other in the harmony of the universe.

A reader whom solitude (much more effectively than books) has at all accustomed to contemplating such vast horizons can already guess what I am getting at; and to cut short all circumlocutions and hesitations of style by putting a question almost equivalent to a formula, I ask any man of good faith, provided always he has done a little thinking and travelling: what would a modern Winckelmann[2] (we are full

of them, the nation is bursting with them and lazy people adore them) – what, I say, would a modern Winckelmann do, what would he say, at the sight of a Chinese product, a strange product, weird, contorted in shape, intense in colour, and sometimes delicate to the point of fading away? And yet this object is a sample of universal beauty; but if it is to be understood, the critic, the viewer, must bring about within himself a transformation, which is something of a mystery, and, by a phenomenon of will-power acting on his imagination, he must learn by his own effort to share in the life of the society that has given birth to this unexpected bloom.

Few men have received – in full – the divine grace of cosmopolitanism; but all men may acquire it to a greater or lesser degree. The most richly endowed in this respect are the lone travellers who have lived for years in forest depths or in vast prairie solitudes, their gun as sole companion, contemplating, analysing, writing. No scholastic veil, no academic paradox, no pedagogic utopia has interfered with their vision of the complex truth. They know the admirable, the immortal, the inevitable relation between form and function. They are not ones to criticize; they contemplate, they study.

If instead of a pedagogue I were now to take a man of the world, an intelligent one, and were to transport him to a distant land, I feel sure that though his surprises on disembarking would be great, though his process of acclimatization might be more or less long, more or less difficult, his sympathy would sooner or later become so keen, so penetrating, that it would create in him a whole new world of ideas, a world that would become part and parcel of him and accompany him as memories till his death. Those odd-shaped buildings that began by offending his academic eye (every people is academic in judging others, every people is barbaric when being judged), that vegetation so disturbing for his memory, filled with images of his own native land, those women and those men whose muscle play is unlike the classic norms in his

own country, whose walk has a different rhythm from the one he is used to, whose gaze comes across with a different magnetic power, those scents that are not those of his mother's boudoir, those mysterious flowers whose deep colours strike the eye despotically, whilst their shape teases the attention, those fruits disconcerting and bewildering the senses by their different flavours, and revealing to the palate ideas belonging to the sense of smell, this whole world of new harmonies will slowly enter into him, penetrate him patiently like the steam of a scented bath house; all these unknown springs of life will be added to his own; some thousands of ideas and sensations will enrich his mortal's dictionary, and it may even happen that, overstepping the mark and transforming justice into revolt, he will do as the converted Sicambrian[3] did, and burn what he had adored, to adore what he had burned.

What, I repeat, would one of those modern self-appointed aesthetic pedants, as Heinrich Heine (that delightful character who would be a genius if only he turned more often to the divine) calls them, what would one of them say or write at the sight of unaccustomed phenomena? The witless doctrinaire of beauty would babble nonsense, no doubt; imprisoned in the blinding fortress of his system, he would blaspheme against life and nature; and his form of fanaticism, be it Greek, Italian or Parisian, would persuade him to forbid that insolent people to savour life, to dream, to think in any other modes than his own. Ink-smudged scholarship, a bastard taste, more barbarous than the barbarians, you who have forgotten the colour of the sky, the shape of plants, the movement and smell of animal life, and whose fingers, stiffened, nay paralysed, by writer's cramp, can no longer run nimbly up and down the vast keyboard of nature's correspondences!

Like all my friends I have tried more than once to lock myself inside a system, so as to be able to pontificate as I liked. But a system is a kind of damnation that condemns us to

perpetual backsliding; we are always having to invent another, and this form of fatigue is a cruel punishment. And every time, my system was beautiful, big, spacious, convenient, tidy and polished above all; at least so it seemed to me. And every time, some spontaneous unexpected product of universal vitality would come and give the lie to my puerile and old-fashioned wisdom, much-to-be-deplored daughter of Utopia. In vain did I shift or extend the criterion, it could not keep up with universal man, and it was for ever chasing multiform and multicoloured beauty, which dwells in the infinite spirals of life. Under the threat of being constantly humiliated by another conversion, I took a big decision. To escape from the horror of these philosophic apostasies, I arrogantly resigned myself to modesty; I became content to feel; I came back and sought sanctuary in impeccable naïveté. I humbly beg pardon of academics of every kind, who inhabit the different workshops of our art factory, for only there has my philosophic conscience found rest; and at least I can now declare, in so far as a man can answer for his virtues, that my mind now enjoys a more abundant impartiality.

Everyone can easily understand that, if the men whose function it is to express beauty were to conform to the rules laid down by the self-appointed pedagogues, beauty itself would disappear from the earth, since all types, all ideas, all sensations would merge into one vast monotonous and impersonal unity, as limitless as boredom and nothingness. Variety, that indispensable condition of life, would be expunged from life. So true is it that in the manifold productions of art, there is something always new, something that will eternally escape from the rules and the analyses of the school! Surprise, which is one of the greatest sources of enjoyment produced by art and literature, derives from this very variety of forms and sensations. The self-appointed pedant, a species of tyrant-mandarin, always reminds me of an impious wretch setting himself up as God.

I shall go even further, *pace* the sophists who in their overwhelming pride have culled all their wisdom in books, and, however subtle or difficult my idea may be to express, I do not despair of succeeding. Beauty always has an element of strangeness. I do not mean a deliberate cold form of strangeness, for in that case it would be a monstrous thing that had jumped the rails of life. But I do mean that it always contains a certain degree of strangeness, of simple, unintended, unconscious strangeness, and that this form of strangeness is what gives it the right to be called beauty. It is its hallmark, its special characteristic. Reverse the proposition and try to imagine a commonplace beauty! And how could this necessary, incompressible, infinitely varied strangeness, dependent upon environment, climate, habits, upon race, religion and the temperament of the artist, ever be controlled, amended, corrected by utopian rules, excogitated in some little temple or other of learning somewhere on the planet, without mortal danger to art itself? This element of strangeness which constitutes and defines individuality, without which there is no beauty, plays in art (and may the precision of this comparison excuse its triviality) the role of taste or flavouring in cookery; if the individual usefulness or the degree of nutritious value they contain be excepted, viands differ from each other only by the idea they reveal to the tongue.

I shall therefore strive, in this glorious chance I have of analysing this superb exhibition, so full of variety in its elements, so disturbing by its variety, so baffling for pedagogues, to avoid all kinds of pedantry. There will be others in plenty to speak the jargon of the studios, and to throw their weight about at the expense of the artists. Erudition often appears to me puerile and unconvincing by its nature. It would be child's play for me to descant with subtlety on symmetrical or balanced composition, on tone, on warm tones and cold tones, etc. O Vanity! I prefer to speak in the

name of feeling, of morality and pleasure; I hope that some people, learned without pedantry, will find my 'ignorance' in good taste.

The story is told of Balzac (who would not listen with respect to any anecdote, however trivial, concerning that great genius?) that he happened one day to be looking at a fine picture, a melancholy winter scene laden with hoar frost, a few hovels and wretched peasants dotted about the landscape. After looking attentively at a little house from which was rising a thin wisp of smoke he exclaimed: 'How beautiful it is! But what can they be doing inside that hovel? What can they be thinking about, what are their sorrows? Has the harvest been good? No doubt they have some bills to pay.' Laugh if you must at Balzac. I do not know the name of the painter who had the honour of making the great novelist's soul vibrate with conjecture and anxiety, but I think that in this instance, with his adorable simplicity, he has given us an excellent lesson in criticism. It will often happen to me to assess a picture solely by the sum of ideas or the day-dreams that it raises in my mind.

Painting is an evocation, a magical operation (could we but consult the souls of children about it!), and when the character evoked or the idea brought back to life has risen up, looked us in the face, we are not entitled to discuss – at least it would be the height of childishness to do so – the magician's evocatory formulas. I can think of no more confusing problem for the pedants and pseudo-philosophers than that of trying to discover in virtue of what law artists whose methods are wholly opposed to each other can evoke the same ideas and stir up similar feelings in us.

There is another error much in fashion today, which I propose to avoid like the plague. I refer to the idea of progress. This smoky beacon-light, a creation of current pseudo-philosophy, patented but without guarantee from Nature or the Divinity, this modern lantern sends out beams of darkness

over the whole domain of knowledge; liberty dies away, punishment vanishes. Whoever wants to understand the workings of history must first of all put out this treacherous beacon. This ludicrous idea, which has bloomed on the rubbish dump of modern vanity, has absolved every man from his duty, delivered every soul of its responsibility, released the will from all the bonds laid upon it by the love of beauty; and, if this distressing lunacy persists for long, all the declining races will fall into doting slumbers of decrepitude on the pillow of fatalism. This infatuation is the symptom of an already too obvious decadence.

Ask any good Frenchman who reads his favourite newspaper every day, in his favourite café, what he understands by progress, and his answer will be: steam! electricity! gas lighting ! – miracles unknown to the Romans; he will say that these discoveries are ample proof of our superiority over the ancients; such is the depth of darkness that exists in this poor mind, such the weird confusion there between the material and the spiritual order of things. The poor man has been so americanized by his zoocratic and industrial thinkers that he has quite lost sight of the notion of the differences that mark the phenomena of the physical and the moral worlds, the natural and the supernatural.

If, today, a nation has a more delicate sense in moral questions than in the previous century, there is progress; that is clear. If an artist produces this year a work that displays greater knowledge or imaginative powers on his part than he showed last year, he has unquestionably made progress. If foodstuffs are of better quality and cheaper today than yesterday, that is an undeniable case of progress in the material order. But where, I ask you, is the guarantee that this progress will go on tomorrow? For that is how the disciples of the steam and sulphur-match philosophy understand it; an unending series. Where is that guarantee? It exists, I declare, only in your credulous fatuity.

I am leaving out of account the question whether, in making humanity more sensitive in proportion as it adds to the sum of possible enjoyment, unending progress would not be humanity's most ingenious and cruel form of torture; whether by this process, which is a stubborn negation of itself, progress would not be a constantly renewed form of suicide, and whether, imprisoned within the flaming circle of divine logic, progress, this eternal *desideratum*, which is humanity's eternal despair, would not be like the scorpion which stings itself with its own deadly tail.

Certain audacious minds, hot-heads of logic, have tried to transplant the idea of progress into the world of the imagination, where it stands like a monument of absurdity, a grotesque joke rising to horrific heights. The proposition is no longer defensible; the facts are too palpable, too well known. They laugh this piece of sophistry to scorn, and confront it with equanimity. In the realm of poetry and art, the great discoverers rarely have precursors. Every flowering is spontaneous, individual. Is Signorelli[4] really the generator of Michelangelo? Did Perugino[5] contain Raphael? The artist owes nothing to anyone but himself. To future ages he holds out no promises but his own works. He is a guarantor for no one but himself. He dies without offspring. He has been his own king, priest and God. It is in such wonders of Nature that Pierre Leroux's famous and stormy formula[6] finds its true application.

The same applies to those nations that cultivate the arts of the imagination joyfully and successfully. Present prosperity is assured, alas!, only for a very short time. Time was when the dawn was in the East, then light moved down towards the South, and now it springs from the West. France, to be sure, by her central position in the civilized world, seems destined to gather in all her neighbours' ideas and poetic works, and to hand them on to other peoples, beautifully worked and fashioned. But never let it be forgotten that nations, those vast

collective beings, are subject to the same laws as individuals. Like babes they wail, gurgle, fill out and grow. Like youths and mature men they produce works full of boldness and wisdom. Like the aged they fall asleep on their heaped-up riches. Often enough the very principle of their strength and development brings about their decline, especially when that principle, vitalized by all-conquering zeal, has become a kind of routine for the majority. Then, as I was adumbrating just now, the vital spark moves elsewhere to other lands and races; nor should we think that the newcomers inherit the whole estate from previous generations and that they receive from the latter a ready-made doctrine. It often happens (it happened in the Middle Ages) that the loss is total, and a new start has to be made.

Any visitor to the Universal Exhibition who came with the preconceived idea that he was going to find in the Italian room the children of Leonardo, of Raphael and of Michelangelo, the spirit of Albrecht Dürer in the German room, the soul of Zurbarán and Velazquez in the Spanish, would get an avoidable surprise of his own making. I have neither the time nor, perhaps, enough knowledge to find out what are the laws that determine this shifting of artistic vitality, and why God despoils nations, sometimes for a time, sometimes for all time; I must content myself with establishing this very frequent event in history. We live in an age when certain commonplace truths need to be repeated, in a vainglorious age that believes itself to be immune from the misadventures of Greece and Rome.

The English section is very fine, exceptionally fine, and worthy of a long and careful study. I had intended beginning with a eulogy of our neighbours, of this people so marvellously rich in poets and novelists, of the people that can boast of Shakespeare, Crabbe and Byron, Maturin and Godwin; of the fellow-citizens of Reynolds, Hogarth and Gainsborough. But I want to study them further; I have an

excellent excuse; it is out of extreme politeness that I am putting off so pleasant a task. My delay will enable me to do it better.

I am therefore beginning with an easier assignment; I propose to deal in quick succession with the great masters of the French school, and analyse the elements of progress or the seeds of decay it contains.

II. INGRES

The French section is so extensive and is for the most part composed of items so familiar, their freshness having largely faded under the curiosity of the Parisian public, that criticism's task must be to try and explore to its innermost depths each artist's temperament and the motives that inspire him, rather than to analyse or describe every painting minutely.

When that ice-cold star David, attended by his historical satellites Guérin and Girodet,[7] abstractors of quintessence in their respective ways, rose above the artistic horizon a great revolution took place. This is not the place to discuss the objective they set themselves, to say whether they were right or wrong in doing so, or whether they overstepped the mark; let us rather state quite simply that they had an objective, a great objective, namely to start a reaction against the excesses of gay and amiable frivolity,[8] which I do not propose to assess or define either; that they stuck to their objective steadfastly, and that they went forward under the light of their artificial sun with a candour, a firmness and unity worthy of true party men. By the time the stark idea had softened and become caressing with the brush of Gros,[9] it was already a lost cause.

I remember very clearly the prodigious respect with which in the days of our childhood all those figures, fantastic without meaning to be, all those academic spectres were regarded; and I myself could not look without a kind of religious awe at all those great heteroclite oafs, all those solemn-faced, elegant,

lovely boys, all those prudishly chaste and classically volup-
tuous women, the former shielding their modesty behind
antique swords, the latter shielding theirs beneath pedantically
transparent draperies. All these people, truly beyond the
natural order of things, moved, or rather posed, beneath a
greenish light, which was a queer rendering of the true light
of the sun. But these masters, too revered in their own day,
too despised in ours, did have the great merit, if we are willing
to overlook their technique and their weird principles, of
reviving in the French character the taste for heroism. The
constant contemplation of Greek and Roman history was after
all bound to have a salutary stoic influence; but they were not
always as Greek and Roman as they made themselves out to
be. It is true that David never ceased to be the heroic, the
inflexible David, the despotic teacher. As for Guérin and
Girodet, both incidentally much preoccupied, like the prophet
himself, with the spirit of melodrama, it would not be difficult
to discover in them a few small specks of corruption, a few
sinister and amusing symptoms, of the coming onslaught of
romanticism. Look at that *Dido* there in her oh! so precious
and theatrical attire, lying languorously in the setting sun, like
a relaxed Creole; she has more affinity with the early visions
of Chateaubriand than with the conceptions of Virgil; and her
tearful eye, lost in misty contemplation after the keepsake[10]
manner, is almost like an early promise of certain Parisian
heroines of Balzac. Girodet's *Atala*,[11] in spite of what certain
wags, who will soon be very dated, may care to think, is a
dramatic portrayal far superior to a whole lot of insipid
modern confectionery, unworthy of mention.

But today we stand facing a man of immense and un-
questionable fame, whose work is very much more difficult
to understand and explain. Just now, when I was discussing
those poor illustrious painters, I most disrespectfully ventured
to use the word 'heteroclite'. No one therefore can complain
if, in order to describe the feelings aroused by the works of

M. Ingres in some types of artistic temperament, I were to say that they feel they are confronted with a much more mysterious and complex 'heteroclitism' than that of the masters of the republican and the imperial schools[12] which none the less were its starting point.

Before coming to the real heart of the matter, I want to record a first impression felt by many people, one that they will inevitably recall as soon as they go into the holy of holies set aside for the works of M. Ingres. This impression is not easy to describe; it has some connection, but in unknown proportions, with disquiet, boredom and fear; it reminds one vaguely and involuntarily of the feeling of faintness due to lack of air, or to the atmosphere in a chemical laboratory, or to the awareness of being in a world of phantasms, or rather one that imitates such a world, a world of automatons, confusing to our senses because too obviously and palpably extraneous to us. This is no longer the childlike respect I was speaking about just now, the respect that took hold of us when we were looking at the *Sabines*, *Marat*[13] stabbed in the bath, the *Déluge*[14] or the melodramatic *Brutus*.[15] The sensation is a powerful one, it is true – why try to deny the power of M. Ingres? – but it belongs to a lower order, an almost ailing order. It is almost a negative sensation, if it were possible to speak of such a thing. Indeed, it must be confessed at once, this well-known and, in his own way, revolutionary painter has such indisputable merits, even charm, the force of which I propose to investigate presently, that it would be childish, here, not to note a gap, a missing something, a slowing down in the mechanism of his spiritual faculties. The imagination which sustained the earlier masters, led astray as we have seen by their academic gymnastics, the imagination, that queen of the faculties, has vanished.

No more imagination; hence no more movement. I would not push disrespect and ill-will to the point of saying that this is tantamount to an act of resignation by M. Ingres.

I think I understand his character well enough to believe that for him it is a heroic immolation, a sacrifice on the altar of those faculties he sincerely regards as vastly more noble and important.

However outrageous the paradox, the fact is that in this way he comes close to a young painter whose remarkable debut[16] recently produced something like an insurrection. Like M. Ingres, M. Courbet[17] is a mighty man of work, endowed with a fierce unrelenting will; and the results he has achieved, which for some minds have already more charm than those of the great champion[18] of the Raphaelesque tradition, no doubt because of their positive solidity and their amorous shamelessness, have the same peculiarity as the latter, namely that they show a sectarian spirit, a slaughterer of the establishment. Politics and literature also produce men of this same vigorous stamp, real protestants, anti-supernaturalists, whose sole justification is their spirit of reaction, which is sometimes salutary. The providence responsible for the affairs of painting has given them, as accomplices, all those whom the reigning party with opposite ideas had wearied or oppressed. But the difference is that, whilst M. Ingres makes his heroic sacrifice in honour of tradition and the idea of the beautiful according to Raphael, M. Courbet makes his in favour of the immediate impact of external material nature. In their war on imagination they are prompted by different motives; but their two contrary forms of fanaticism lead them to offer up the same sacrifice.

And now, to take up again the main thread of our analysis, what is the purpose M. Ingres has set himself? It certainly is not the translation of feelings, of passions, and of the variations of these passions and feelings; nor is it the representation of great scenes from history (in spite of its italianate – too italianate – beauties, his *Saint-Symphorien*, italianized down to the very crowding of the figures, certainly conveys no idea of the sublimity of a Christian martyr or the savage and

indifferent bestiality of the conservative heathen). What then can M. Ingres be looking for, what dream is he pursuing? What message has he come into this world to impart? What new appendix does he wish to add to the Gospel of painting?

I could easily persuade myself that his is a kind of ideal consisting half of physical health and half of placidity, I almost said indifference, something akin to the ideal of the Ancients, to which he has added the peculiarities and minutiae of modern art. It is this combination that often confers on his works their bizarre charm. Enamoured as he is of an ideal which unites, in a provokingly adulterous way, the calm solidity of Raphael and the affectations of a call girl, M. Ingres was evidently made to succeed in portraiture; and it is in fact this genre that has given him his greatest and most legitimate successes. But of course M. Ingres is not one of those hirelings by the hour, one of those vulgar portrait daubers, to whom the commonest mortal can go, purse in hand, and commission a likeness of his unbecoming face. M. Ingres chooses his sitters and, it must be admitted, he chooses, with wonderful perceptiveness, the sitters best suited to bring out his talents: beautiful women, amply-endowed, generous natures, characters bursting with serene and flourishing health, these are his triumph and his joy.

At this point, however, a much debated question arises, one that is always worth coming back to. What is the quality of M. Ingres' drawing? Is it supremely good? Is it an absolutely intelligent type of drawing? I shall surely be understood by all those who have made a comparative study of the drawing styles of the principle masters of the art when I say that the drawing of M. Ingres is the drawing of a man with a system. He believes that nature must be corrected, amended; that cheating, if skilful, agreeable and done to please the eye, is not only a right but a duty. Hitherto the saying was that nature was to be interpreted, translated in its totality and with all its logic; but in the works of the master we are discussing, fraud,

ruse and violence are not uncommon, and sometimes he resorts to cheating, and shabby tricks. Look for example at that host of fingers, all too uniformly tapered like spindles, their tips, their narrow tips, constricting the fingernails, which Lavater, on inspection of that broad bosom, that muscular forearm and the rather virile impression of the whole figure, would have declared should have been square, and symptomatic of a mind turned to masculine occupations, to the symmetry and the laws of art. Or look at those delicate faces, those shoulders of simple elegance, associated with arms too robust, too full of Raphaelesque succulence. But there, Raphael liked fleshy arms, and the first thing to do was to obey and please the master. Or again, what of this navel wandering off towards the ribs or that breast pointing too far towards the armpit; and here – a less excusable thing (for generally speaking the sort of cheating I have referred to has a more or less plausible excuse, and is always easy to discern wherever the liking for style is unrestrained) – here, I repeat, we are entirely disconcerted by a leg scarcely worthy to be called such, emaciated, devoid of muscle and shape, and without so much as a fold behind the knee (*Jupiter et Antiope*).

Let us not forget, either, that, carried away by his almost pathological attention to style, the painter often effaces the modelling, or reduces it to the point of being invisible, in the hope thereby of giving more emphasis to contours; the result is that his figures look like very accurately drawn dressmaker's patterns, stuffed with lifeless lard, and quite foreign to the human organism. Every now and then the eye lights upon charming areas of painting, impeccably full of life; but then the wicked thought flashes through our mind that it is not M. Ingres that has pursued nature, but nature that has violated the painter, and that the high and puissant dame has subjugated him by her irresistible ascendancy.

From all the foregoing, the reader will easily gather that M. Ingres may be regarded as a man endowed with exalted

qualities, an eloquent lover of beauty, but quite devoid of that vigorous temperament that makes the fatality of genius. His dominant preoccupations are the taste for antiquity and the respect for the school. He has in fact an easily aroused admiration, an eclectic disposition, like all men who lack that fatality. And so we see him wandering from one archaism to another; Titian (*Pie VII tenant chapelle*), the Renaissance enamellers (*Vénus Anadyomène*), Poussin and the Carracci (*Vénus* and *Antiope*), Raphael (*Saint-Symphorien*), the German primitives (all the little anecdotal, illustration-type of pictures), the curios and colour medleys of Persian or Chinese paintings (the little *Odalisque*) are for ever in conflict for his allegiance. His love of antiquity and its influence upon him are all-pervading in his work; but, for me, M. Ingres and antiquity stand in the same relationship as good form, with its capricious changes, and natural good manners, which stem from the sense of dignity and the charity of the individual.

It is particularly in the *Apothéose de l'Empereur Napoléon I*, the painting from the Hôtel de Ville, that M. Ingres has revealed his taste for the Etruscans. And yet the Etruscans, great simplifiers though they were, did not push simplification to the point of not harnessing their horses to their chariots. But these supernatural horses (and what, by the way, are they made of, these horses, which look as though they were of some polished, hard substance like the wooden horse that captured Troy?), do they possess a magnetic force enabling them to draw the chariot behind them without reins or harness? As for the figure of the Emperor Napoleon I am strongly tempted to say that I see no trace there of that epic and fatal beauty generally ascribed to him by his contemporaries and by historians; that it is painful to me not to find the exterior, legendary character of great men being preserved; and that the common people, who agree with me in this, do not picture their favourite hero except in ceremonial trappings, or in the historic iron-grey great-coat, which, whether

the frenzied lovers of *style* like it or not, would in no way be
out of place in a modern apotheosis.

But a more serious criticism could be levelled at this
picture. The essential characteristic of an apotheosis must be
the sense of the supernatural, the powerful ascent towards the
higher regions, a movement, an irresistible upswing towards
the skies, goal of all human aspirations and classic dwelling-
place of great men. Now this apotheosis, or rather this
equipage, is falling, falling with a speed proportionate to its
weight. The horses are dragging the chariot towards the
earth. The whole apparatus, like a deflated balloon which has
kept all its ballast, is going to crash to pieces inescapably on
the planet's surface.

As for the *Jeanne d'Arc*, which is conspicuous for the
pedantic attention to detail, I dare not discuss it. Little though
I can expect to please the Ingres fanatics, with my evident lack
of sympathy for him, I prefer to believe that even the most
exalted talent retains the right to make mistakes. In this work,
as in the *Apothéose*, there is no trace of feeling, no sense of
supernaturalism. Where, oh! where is that noble maid who,
according to the promise of the kindly M. Delécluze,[19] was to
avenge herself and us for the smutty jests of Voltaire.[20] To sum
up my views, I believe that, setting aside his erudition and his
intolerant, almost licentious taste for beauty, the faculty that
has made M. Ingres what he is, namely the powerful, the
unquestioned, the complete dictator, is his will-power, or
rather an immense abuse of will-power. In short, what he
is now, he was at the very beginning. Thanks to the energy
that is in him, he will stay like that to the end. Just as he has not
progressed, he will not grow old. His too passionate admirers
will always remain what they were, blinded by their love;
and nothing will have changed in France, not even the mania
for borrowing from a great artist certain bizarre qualities
which he alone is big enough to possess, and trying to imitate
the inimitable.

A thousand circumstances, lucky ones moreover, have combined to consolidate his powerful renown. High society folk were impressed by M. Ingres on account of his pompous love of antiquity and of tradition. To the eccentrics and to the blasé, to the host of the over-fastidious always in search of novelty, even if it is bitter, he appealed by his strangeness. But what was good, or at least attractive, in him has had a deplorable effect on the crowd of imitators; that is something I shall have more than one opportunity of showing.

III. EUGÈNE DELACROIX

Messrs Eugène Delacroix and Ingres share public favour and disfavour between them. It is a long time ago that opinion drew a ring round them, like two wrestlers. Without accepting this common and childish love of antithesis, we must begin by a study of these masters of the French school, since around and below them nearly all the individuals that make up our art world have clustered and ranged themselves.

The first idea that strikes the viewer, as he looks at M. Delacroix's thirty-five pictures, is that of a well-filled life, of a stubborn steadfast love of art. Which of these paintings is the best? It is impossible to pick it out. The most interesting? One hesitates to say. Here and there the eye lights on samples of what might be called progress; but if in fact some of the more recent paintings show that certain important qualities have been pushed to extremes, the impartially-minded viewer must recognize with amazement that from his earliest works, from his youth (*Dante et Virgile aux enfers* dates from 1822), M. Delacroix was a great painter. At times his work has shown greater delicacy, at others more strangeness, and at others again, it was more painterly, but always he has been great.[21]

. . .

Never has an artist been attacked more bitterly, more covered with ridicule, more hampered. But what do we care

for the hesitations of governments (I am speaking of the past), the shrill complaints of a few bourgeois drawing-rooms, the spiteful discourses of a few tavern academies, or the pedantries of domino players? The matter is proved to the hilt, the question is settled for all time, the result is there before our eyes, visible, immense, all aflame.

M. Delacroix has treated every genre; his imagination and his scholarship have wandered in every part of painting's domain. He has painted (and with what love and delicacy!) charming small pictures, full of intimacy and depth; he has decorated the walls of our palaces, filled our museums with vast compositions.

This year he has very legitimately taken the opportunity to show a fairly considerable portion of his life's work, and to make us, so to speak, review the documents of the case. The paintings have been chosen with great skill in order to furnish us with convincing and varied samples of his mind and talent.

Here to begin with is *Dante et Virgile*, that young man's picture, which was a revolution in itself, and one of the figures of which (the torso of the prone male figure) was for a long time wrongly attributed to Géricault. Among the big works we may well hesitate to choose between the *Justice de Trajan* and the *Prise de Constantinople par les Croisés*. The *Justice de Trajan* is so miraculously full of light and air, so full of tumult and pomp! The Emperor is so handsome, the crowd, swirling round the columns or moving with the procession, is so full of vitality, the weeping widow is so dramatic! This picture enjoys the distinction of having been the target of trivial jests about the pink horse from the pen of M. Karr, who seems to have taken leave of his common sense; as though there were no slightly pink horses, and as though in any case the painter had not the right to paint the horse that colour if he chose to.

On the other hand the *Croisés* is a symphony of storm and

gloom, which, quite apart from the subject itself, accounts for the picture's deep impact. Look at that sky and that sea! All is tumult and yet still, like the calm after a great event. Behind the Crusaders, who have just passed through it, the city stretches away into the distance, a miraculously true evocation; and, as always, glittering waving banners, their luminous folds unfurling and flapping in the clear atmosphere; as always, movement and anguish in the crowd, the clash of arms, the splendour of vestments, emphatic gestures, as gestures are in the great moments of life! Both these pictures have an essentially Shakespearian beauty about them. For after Shakespeare no one has excelled like Delacroix in forging a mysterious unity out of drama and reverie.

The public will find some old friends, pictures of stormy memory that recall revolts, struggles and triumphs; the *Doge Marino Faliero* (the Salon of 1827; how strange to note that *Justinien composant ses lois*, and *Le Christ au Jardin des Oliviers* belong to the same year), the *Évêque de Liège*, that admirable translation from Walter Scott, a crowd in ferment bathed in light, the *Massacre de Scio*, the *Prisonnier de Chillon*, *Le Tasse en Prison*, the *Noce Juive*, the *Convulsionnaires de Tanger* etc. etc. . . . But how are we to define that group of charming canvases, such as the *Hamlet* in the graveyard scene, the *Adieux de Roméo et Juliette*, which are so deeply moving and fascinating that our gaze is riveted once it has wandered into their melancholy little world, that our minds cannot escape them?

Et le tableau quitté *nous* tourmente et *nous* suit.[22]

This is not Hamlet as recently played by Rouvière,[23] with such brilliance: a bitter, unhappy, violent man, almost frantic with anxiety. That is exactly what we might expect from the romantic strangeness of this great tragic actor; but Delacroix, more faithful perhaps to Shakespeare, depicts a fastidious and pale Hamlet, with white, feminine hands, and

an exquisite but soft, rather indecisive nature with an almost vacant gaze.

And here is the familiar *Madeleine*, with her upturned head and strange, enigmatic smile; so supernaturally beautiful that we cannot tell whether the glory of death is shining upon her, or whether she is transfigured in a swoon of divine love.

The *Adieux de Roméo et Juliette* reminds me of an observation I wish to make, and which I believe to be important. I have so often heard people poking fun at the ugliness of Delacroix's female figures, without being able to understand that kind of fun, that I am taking this opportunity to attack the prejudice.

M. Victor Hugo shared it, so I am told. He deplored the fact – this, be it remembered, in romanticism's heyday – that the man whom public opinion placed on the same level of eminence as his own could commit such monstrous blunders where beauty was concerned. Frogs he has been known to call Delacroix's women. But M. Victor Hugo is a great sculptural poet whose eyes are closed to spirituality.

I regret that Delacroix's *Sardanapale* has not reappeared this year. That picture contains some very beautiful women, fresh, luminous rose-pink, at least so far as I can remember. Sardanapalus himself was as beautiful as a woman. Generally speaking Delacroix's women fall into two classes; on the one hand, the easy ones to understand, often mythological characters, and necessarily beautiful (the recumbent nymph, back view, in the ceiling of the Apollo Gallery); these are richly endowed, Junoesque, large-bosomed, opulent, and have a wonderful flesh transparency, and beautiful heads of hair.

As for the others, they are sometimes historical characters (Cleopatra looking at the asp), more often creatures of invention or from genre pictures (Marguerites, Ophelias, or Desdemonas, even Virgin Marys and Mary Magdalenes). I would willingly describe them all as being intimate women.

All of them seem to have in their eyes some secret suffering that cannot be locked away in the secret depths of the soul. Their pallor seems to betray their inner struggle. Whether it is the attractiveness of crime, or the odour of sanctity that lends distinction to them, whether their gestures are languid or violent, these women, sick at heart or in mind, have in their eyes a leaden look of fever, or the abnormal glint of their sickness, in their glance a supernatural intensity.

But always, and in spite of everything, they are distinguished women, essentially distinguished; in short, to sum it all up, M. Delacroix appears to me to be the artist best fitted to express the modern woman, especially the modern woman on the heroic level, whether satanic or divine. These women even have the modern physical type of beauty, an air of reverie, but an ample bosom, a rather narrow chest, a broad pelvis, charming arms and legs.

The new pictures as yet unknown to the public are the *Deux Foscari*, the *Famille Arabe*, the *Chasse aux lions*, a *Tête de Vieille Femme* (a Delacroix portrait is a rarity). These different paintings help us to appreciate the wonderful sureness achieved by the master. The *Chasse aux lions* is a veritable colour explosion (let the word be taken in the good sense). Never can colours more beautiful, more intense, have penetrated into the soul by way of the eyes.

From the first and cursory glance at these pictures as a whole, followed by a minute and attentive examination of each of them, a number of irrefutable truths emerge. First, it must be noticed, and this is most important, that, even seen from too far for the viewer to analyse or even understand the subject matter, a picture by Delacroix will already have made a strong impression, either happy or melancholy, on the soul. It is as though Delacroix's style of painting, like sorcerers and hypnotists, can project its thought at a distance. This strange phenomenon is accounted for by the power of the colourist, the perfect tone key and by the harmony (pre-established in

the painter's brain) between colour and subject. It really seems as though the colour – I hope I may be forgiven these linguistic subterfuges to express what are highly subtle ideas – is itself capable of thought, independently of the objects it clothes. Then, these wonderful colour chords of his often make one dream of musical harmonies and melodies, and the impression we carry away after looking at his pictures is often, as it were, musical. A poet has tried to express the subtle sensations in some lines of poetry, the sincerity of which may render their strangeness acceptable:

> Delacroix, lac de sang, hanté des mauvais anges,
> Ombragé par un bois de sapin toujours vert,
> Où, sous un ciel chagrin, des fanfares étranges,
> Passent comme un soupir étouffé de Weber.[24]

Lac de sang: red; *hanté des mauvais anges*: supernaturalism; *un bois toujours vert*: green, red's complementary colour; *un ciel chagrin*: the tumultuous and stormy backgrounds of his pictures; the *fanfares* and Weber: ideas of romantic music evoked by his colour-harmonies.

What should be said about Delacroix's drawing, so absurdly and stupidly criticized, if not that there are certain elementary and wholly misunderstood truths; that good drawing does not consist of hard, cruel, despotic, static lines, enclosing a figure like a straight-jacket; that drawing should be like nature, full of life and movement; that simplification in drawing is a monstrosity, like tragedy in the world of drama; that nature presents us with an infinite texture of curved, fleeting, broken lines, obedient to a faultless law of generation where parallelism is always uncertain and sinuous, where concavities and convexities are disposed in a balanced and fluent order; that M. Delacroix satisfies all these conditions to perfection and that, even if it were true that his drawing sometimes reveals weaknesses or exaggeration, he has at least the immense merit of being a constant and effective living protest against the

barbarous invasion of the straight line, that tragic and systematic line, the ravages of which at this present time, both in painting and in sculpture, are already enormous?

Another great and far-reaching quality of M. Delacroix's talent, a quality that makes of him the painter beloved of poets, is that he is essentially a literary painter. Not only has his painting explored, and always successfully, the field of the great literatures of the world, not only has it translated and frequented Ariosto, Byron, Dante, Walter Scott, Shakespeare, but it has the secret of revealing ideas of a higher, more delicate, more subtle order than the art of most modern painters. Nor should we omit to stress that never by distortions or trivial details or by tricks and fraudulence does M. Delacroix achieve this prodigious result; but by the general effect, by the deep and total harmony between his colour scheme, subject matter, drawing and the dramatic gestures of his figures.

Edgar Allan Poe says, I forget where, that the effect of opium on the senses is to endow the whole of nature with a supernatural interest that gives every object a deeper, a more deliberate, a more despotic meaning. Without recourse to opium, who has not experienced those ecstatic moments, true festivals of the brain, when a more acute perceptiveness enables the senses to receive more resounding sensations, when the blue of the sky acquires greater transparency, and plunges into a more infinite abyss, when sounds have a musical ring, when colours speak and scents bring with them worlds of ideas? Well, the painting of M. Delacroix seems to be the translation of these glorious moments of the spirit. It is clothed in intensity and its splendour is exceptional. Like Nature's impact upon ultra-sensitive nerves, it reveals the supernatural.

What will M. Delacroix mean to posterity? What will that righter of wrongs say of him? He has reached a point in his career when it is already easy to give the answer without fear

of over-much contradiction. Like us, posterity will say that he represents a unique combination of the most astonishing faculties; that he had like Rembrandt a remarkable feeling for intimacy and a profound magical quality, a sense of composition and decoration like Rubens and Lebrun,[25] a fairylike sense of colour like Veronese etc.; but that he also had a quality all his own, indefinable, yet defining the melancholy, passionate side of this age, something entirely new, which has made him into a unique artist, without a forerunner, without precedent, probably without a successor, a link so precious that none could be found to replace it; and if it were to be destroyed, assuming such a thing to be possible, then a whole world of ideas and sensations would vanish with it, and too big a gap would occur in the chain of history.

5. Of the Essence of Laughter, and generally of the Comic in the Plastic Arts[1]

I

I DO not propose to write a treatise on caricature; all I want to do is to impart to the reader a few reflections that have often occurred to me on this strange genre. These reflections had become a kind of obsession with me and I wanted to get rid of it. I have moreover made every effort to bring some order into what I had to say, and thus to make it easier to digest. This then is purely an article for the philosopher and the artist. Doubtless a general history of caricature, in its relations with all the political and religious events, grave or gay, which in the context of national attitudes or fashion have stirred humanity, would be a glorious and important undertaking. The work still remains to be done, for the essays published to date are no more than the raw materials; but I thought the work required a division of labour. Clearly a work on caricature thus conceived becomes a history of facts, an immense gallery of anecdotes. In caricature much more than in other branches of art, there are two categories of works, valuable and worthy of commendation for different and almost opposite reasons. The works in one group are valuable only for the facts they illustrate. They are doubtless entitled to the attention of the historian, the archaeologist and even of the philosopher; they must take their place in the national archives, in the biographical registers of human thought. Like the fly-sheets of journalism, they are blown away by the same gusts of wind that constantly bring us new ones; but the others, and it is of these that I particularly want to speak, have in them a mysterious, a durable, an eternal element, which

commends them to the attention of artists. Truly the intro-
duction of this intangible element of beauty, even into works
destined to show men their own moral and physical ugliness,
is a thing both curious and worthy of attention. And another
no less mysterious thing is that this lamentable spectacle never
fails to excite their undying and incorrigible hilarity. That
then is the true subject of this article.

But I have a sudden scruple. Should one reply by a clear
demonstration to a preliminary, a spiteful question, which will
no doubt be raised by divers unsmiling pedagogues, char-
latans of gravity, pedantic corpses who have risen from the
ice-cold subterranean burial grounds of the Institut,[2] and
come back to the land of the living, like those misers' ghosts,
for the purpose of extracting a few farthings from willing
ministries. To start with, they would ask, is caricature a
genre? No, their cronies would reply, caricature is not a
genre. I have heard similar heresies bruising my eardrums at
academicians' dinner parties. These were the worthy folk
who let the comedy of Robert Macaire[3] pass them by, with-
out seeing in it significant moral and literary symptoms. Had
they been contemporaries of Rabelais,[4] they would have dis-
missed him as a low and coarse buffoon. In truth, then, must
we really show that nothing that comes from man is frivolous
in the eyes of the philosopher? And certainly least of all this
deep and mysterious element, which no philosophic theory
has yet analysed thoroughly.

We are accordingly going to apply our thought to the
essence of laughter and to the constituent parts of caricature.
Later we shall perhaps examine some of the most remarkable
products in this genre.

II

The wise man laughs only with fear and trembling. From whose
authoritative lips, from whose wholly orthodox pen, comes

this strange and striking maxim? Does it come down to us from the philosopher king of Judea? Is it to be ascribed to Joseph de Maistre,[5] that soldier imbued with the Holy Spirit? I have a vague recollection of having read it in one of his books, but as a quotation, no doubt. That austerity of thought and style fits the majestic saintliness of Bossuet,[6] but the elliptical phrasing of the idea and its quintessential delicacy incline me to attribute the honour of having coined it to Bourdaloue,[7] that unflinching Christian psychologist. This singular maxim comes constantly to my mind since I had the idea of writing this article, and I wanted to deal with it at the outset.

Let us indeed analyse this strange proposition: the wise man, that is to say he who is filled with the spirit of the Lord, he who has a divine formulary at his finger-tips, does not laugh, does not let himself go to laughter without trepidation. The wise man trembles when he has laughed; the wise man is afraid to laugh, just as he is afraid of profane entertainments or concupiscence. He holds back on the brink of laughter, as though on the brink of temptation. Thus, according to the sage, there is some secret contradiction between his character as sage and the primeval character of laughter. Indeed, to do no more than refer in passing to very solemn memories, I will draw attention to the fact, which perfectly corroborates the officially Christian nature of this maxim, that the sage of all sages, the Incarnate Word, has never laughed. In the eyes of Him who knows and can do all things, the comic does not exist. And yet the Incarnate Word did know anger; he even knew tears.

And so, let us pay special attention to this: in the first place, here is an author – a Christian, no doubt – who considers it as quite certain that the sage scrutinizes things very closely before allowing himself to laugh, as though some indefinable sense of disquiet or anxiety would remain with him; and, in the second place, the comic disappears at the level of absolute

knowledge and power. Now, if the two propositions were reversed, the result would be that laughter is generally the attribute of madness, and that it always implies a greater or lesser degree of ignorance and weakness. I have no wish to launch out adventurously on to a theological sea, for which I would no doubt have neither suitable compass nor enough sail area; I must content myself with pointing out these strange horizons to the reader with my forefinger.

If we are willing to adopt the orthodox standpoint, it is certain that human laughter is intimately connected with the accident of an ancient fall, of a physical and moral degradation. Laughter and grief express themselves through the organs that have the control and the knowledge of good and evil, the eyes and the mouth. In the earthly paradise (whether we place it in the past or in the future, in memory or prophecy, according to the theologians or the socialists), in the earthly paradise, that is to say in the surroundings where it seemed to man that all created things were good, joy did not reside in laughter. As no sorrow afflicted him, man's countenance was simple and composed, and the laughter that nowadays shakes nations did not distort the features of his face. Neither laughter nor tears can show themselves in the paradise of bliss. They are equally the children of sorrow, and they came because enervated man lacked the bodily strength to control them. From the standpoint of my Christian philosopher, the laughter of his lips is a sign of as great a state of corruption as the tears in his eyes. God, who desired to multiply his own image, did not place lion's teeth in man's mouth – but man bites with his laughter; nor did He place, in man's eyes, all the fascinating duplicity of the serpent – but man seduces with his tears. And pray observe that it is also with his tears that man washes away man's sorrows, that it is with laughter that he sometimes softens man's heart, and draws it closer; for the phenomena produced by the Fall will become the means of redemption.

May I be allowed a poetic supposition which will help to verify the accuracy of these assertions, and which many people will doubtless consider to be vitiated by the *a priori* approach of mysticism. Since the comic is an element of damnation and of diabolic origin, let us try to confront with it an absolutely primitive soul, as given by the hands of Nature, so to speak. Let us take as our example the noble and typical character of Virginie,[8] who is a perfect symbol of absolute purity and simplicity. Virginie arrives in Paris still bathed in sea mists, and gilded by the tropical sun, her eyes full of majestic primitive scenes of waves, mountains and forests. Here she is swept into the turbulent, overflowing and noisome stream of civilization, the pure and rich scents of the Indies still clinging to her; her links with humanity are family and love, her mother and her lover, her Paul, as angelic as she is, and whose sex is, so to speak, indistinguishable from hers, in the unsatisfied ardours of a love unaware of itself. God she has known in the church of Les Pamplemousses, a modest and mean little church, in the immensity of the indescribable blue sky of the tropics, and in the immortal music of the forests and torrents. Virginie is most intelligent, to be sure; but a few images and a few memories are enough for her, just as a few books are enough for the sage. It happens that, one day at the Palais-Royal, or in a glazier's shop window, or was it on a table, or in some public place, Virginie happens, by chance and in all innocence, upon a caricature! For us a most alluring caricature, full of venom and spite, just the sort that a bored and perspicacious civilization has the secret of. Let us imagine some broad jest between prize fighters, some enormity from across the channel, with clots of blood liberally scattered, and well seasoned with monstrous 'goddams'; or if this pleases your eagerly curious imagination more, let us suppose our virginal Virginie's eye to have alighted upon some charming and suggestive indecency, a Gavarni[9] of that time and of the best quality, some insulting satire against some royal extrava-

gance or other, some well-designed diatribe against the Parc-aux-Cerfs[10] or the gutter origins of a chief favourite or the nocturnal escapades of the notorious Austrian woman.[11] The caricature is double: the drawing and the idea; the drawing is violent, the idea biting and veiled; tiresome complications of elements for a simple mind, accustomed to grasp intuitively things as simple as itself. Virginie has seen, and now she is looking. Why? She is looking at the unknown. Anyhow she scarcely understands, either what it means, or what its purpose is. And yet, have you noticed the sudden folding of wings, the shudder of a soul, veiling itself and wanting to escape? The angel has sensed that there is something shocking here. And, in truth, I declare that, whether she has understood or not, an indefinable uneasiness, something not unlike fear will linger in her mind. Doubtless if Virginie stays in Paris, and if knowledge comes to her, laughter will follow; we shall see why. But for the moment, as analyst and critic, who would certainly not dare to claim our intelligence to be superior to that of Virginie, we can note the fear and the suffering of the angel, unspotted from the world, when confronted with caricature.

III

The fact that would suffice by itself to show that the comic is one of the clearest marks of Satan in man, and one of the numerous pips in the symbolic apple, is the unanimous agreement of the physiologists of laughter on the primary reason for this monstrous phenomenon. Anyhow, their discovery is not all that profound and does not take us very far. Laughter, so they say, comes from superiority. I should not be surprised if, in face of this discovery, the physiologist himself were to burst out laughing at the thought of his own superiority. And so the way it should have been put is: Laughter comes from a man's idea of his own superiority. A

satanic idea if ever there was one! What pride and aberration! For it is a matter of common knowledge that all the inmates of our asylums harbour the idea of their own superiority developed to an inordinate degree. I have never heard of anyone mentally ill of humility. Note, moreover, that laughter is one of the most frequent and numerous symptoms of lunacy, and see how everything fits in; when Virginie, having stepped aside from the strict path of virtue, has come down a degree in purity, she will begin having the idea of her own superiority, she will be more sophisticated from a worldly point of view, and she will laugh.

I said earlier that there was a symptom of weakness in laughter; and indeed, what clearer sign of debility could there be than a nervous convulsion, an involuntary spasm, comparable to a sneeze, caused by the sight of another's misfortune? That misfortune is almost always a weakness in mind. Is there a more deplorable phenomenon than weakness delighting at weakness? But there is worse to come. The misfortune is sometimes of a very inferior kind, a weakness on the physical level. To take one of the most commonplace examples in life, what is there so particularly diverting in the sight of a man falling on the ice or on the road, or tripping on the edge of a pavement, that his brother in Christ should promptly double up uncontrollably, that the muscles of his face should suddenly begin to function like a clock at midday or a mechanical toy? The poor devil may at the very least have damaged his face, or perhaps have broken a vital limb. But the irresistible and sudden roar of laughter was unleashed. It is certain that if we want to explore this situation, we shall find at the very heart of the laugher's thought a certain unconscious pride. That is the start of the thing: 'I don't fall, I don't; I walk straight, I do; my footstep is steady and assured, mine is. You won't catch me being stupid enough not to see where the pavement ends, or that there is a pavingstone in my way.'

The romantic school, or more accurately, one of the sub-divisions of the romantic school, the satanic school, thoroughly grasped this primeval law of laughter; or, at least, if they did not all grasp it, all of them, even in their most outrageous extravagances and exaggerations, felt its force and applied it correctly. All melodrama's miscreants, cursed, damned, inevitably marked with a rictus running from ear to ear, are in line with the purest orthodoxy of laughter. Anyhow almost all of them are legitimate or illegitimate grandchildren of the celebrated traveller, Melmoth, the great satanic creation of Charles Robert Maturin.[12] What could be greater, what more powerful, in relation to poor humanity than this pale, bored Melmoth? And yet he has a weak, an abject, anti-divine and anti-luminous side to him. And so, how he laughs and laughs, as he constantly compares himself with human cater-pillars, he so strong, so intelligent, he for whom a certain number of the physical and intellectual laws that condition humanity no longer exist! And this laughter is the perpetual explosion of his wrath and his suffering. It is, be sure and understand me, the necessary product of his dual and contra-dictory nature, which is infinitely great in relation to man, infinitely vile and base in relation to absolute truth and righteousness. Melmoth is a living contradiction. He has left behind the fundamental conditions of life; his bodily organs can no longer support his thought. That is why this laughter of his freezes and wrings the guts. It is a laughter that never sleeps, like a disease for ever on its stealthy way, in execution of a providential command. And so, Melmoth's laughter, which is the highest expression of pride, is always fulfilling its func-tion, as it tears and scorches the lips of the laugher beyond hope of pardon.

IV

Now let us recapitulate a little, and establish more clearly the principle propositions which form a kind of theory of

laughter. Laughter is satanic; it is therefore profoundly human. In man it is the consequence of his idea of his own superiority; and in fact, since laughter is essentially human it is essentially contradictory, that is to say it is at one and the same time a sign of infinite greatness and of infinite wretchedness, infinite wretchedness in relation to the absolute being, of whom man has an inkling, infinite greatness in relation to the beasts. It is from the constant clash of these two infinites that laughter flows. The comic, the power of laughter, is in the laugher, not at all in the object of laughter. It is not the man who falls down that laughs at his own fall, unless he is a philosopher, a man who has acquired, by force of habit, the power of getting outside himself quickly and watching, as a disinterested spectator, the phenomenon of his ego. But cases of that sort are rare. The most comic animals are the most unsmiling: monkeys and parrots, for example. Moreover, imagine man removed from creation, there would be no comic, for the animals do not regard themselves as superior to the vegetables, nor the vegetables to the minerals. While laughter is a sign of superiority in relation to animals, and I include in that category the numerous outcasts of intelligence, it is a sign of inferiority in relation to the wise men, who, by the contemplative innocence of their minds, have something childlike about them. If, as we have the right to, we compare humanity to man, we can see that, like Virginie, the primitive nations cannot begin to conceive the idea of caricature, and have no comic drama (holy books, whichever nation they belong to, never laugh), and that, as they move slowly upwards towards the misty peaks of intelligence, or peer into the gloomy furnaces of metaphysics, nations begin laughing diabolically like Melmoth; and finally that if, in these self-same ultra-civilized nations, one intelligent being, driven on by a noble ambition, wants to break through the limits of worldly pride, and launch out boldly into pure poetry, that limpid poetry as profound as nature, laughter will not be there

any more than in the soul of the sage. As the comic is a mark of superiority, or of a man's belief in his own superiority, it is natural to believe that, before nations have attained the state of absolute purification promised by certain mystical prophets, they will see their wealth of comic themes increasing constantly in proportion as their superiority increases. But on the other hand the comic changes its nature. Thus the angelic element and the diabolical element operate in parallel. Humanity works its way up, and acquires a potential for evil and an understanding of evil, proportionate to the potential it acquires for good. That is why I do not find it surprising that we, children of a better covenant than the ancient religious laws, we, the cherished disciples of Jesus, should possess more comic resources than pagan antiquity. That fact may even rank as one condition of our general intellectual power. By all means let the sworn gainsayers quote the classic anecdote of the philosopher who died of laughing at the sight of a donkey eating figs, or even the comedies of Aristophanes and those of Plautus. My answer is that, apart from these epochs being essentially civilized and beliefs having already retreated considerably, the sense of the comic in question is not entirely like our own. It even has something barbaric about it, and we can scarcely grasp it fully except by a backward effort of mind which produces what is called 'pastiche'. As for the grotesque figures that antiquity has handed down to us, the masks, the bronze statuettes, the muscular representations of Hercules, the little Priapuses with bronze tongues curling upward and pointed ears, with prodigious brain boxes and phalli – as for the latter, on which the fair daughters of Romulus innocently ride astride, these monstrous mechanisms of generation, decked out with bells and wings, I believe all these things to have a deeply serious intention. Venus, Pan, Hercules were not figures of fun. They were laughed at only after the coming of Jesus, with the help of Plato and Seneca. I believe that antiquity was full of respect for

the drum majors and for all the circus acrobats with their various turns, and that all the extravagant fetishes I have just referred to are nothing but objects of adoration, or at most symbols of strength, and not at all intentionally comic figments of mind. Indian and Chinese idols are unaware of being laughable; the comic dwells in us Christians.

V

We must not run away with the idea that we have got rid of all our difficulties. Even the person least accustomed to these aesthetic subtleties would quickly counter with this insidious argument: laughter is diverse. Our mirth is not always caused by a misfortune or a weakness, some inferiority. Many sights that excite our merriment are very innocent, and not only what makes children laugh but also many things that provide a source of merriment to artists, have nothing to do with the spirit of Satan.

Certainly this argument has a certain semblance of truth about it. But first of all we must be careful to distinguish between joy and laughter. Joy exists of itself, but it has different manifestations. Sometimes it can hardly be detected; at others it expresses itself in tears. Laughter is merely a form of expression, a symptom, an outward sign. Symptom of what? That is the whole question. Joy is a unity. Laughter is the expression of a double or contradictory feeling: and it is for this reason that a convulsion occurs. Thus the laughter of children, which some people might vainly try to use as a counter-argument, is of a quite different nature, even in its physical expression, in its form, from the laughter of an adult attending the performance of a comedy, or looking at a caricature, or from the terrible laughter of Melmoth, of Melmoth, the social outcast, the outsider standing at the extreme limits of the human world and on the frontiers of the higher life, of Melmoth, always believing himself to be on

the point of escape from his compact with the devil, for ever hoping to exchange his superhuman power, cause of his misfortune, for the pure and undefiled conscience of a simple soul, which he envies. The laughter of children is like the blossoming of a flower. It is the joy of receiving, the joy of breathing, the joy of confiding, the joy of contemplating, of living, of growing up. It is like the joy of a plant. And so, generally speaking, its manifestation is rather the smile, something analogous to the wagging tail in a dog or the purring of cats. And yet, do not forget that if the laughter of children may, after all is said and done, be distinguished from the outward signs of animal contentment, the reason is that this laughter is not entirely devoid of ambition, and that is as it should be, in mini-men or in other words Satans of early growth.

There is a case where the question is more complex. I refer to the laughter of men, and I mean genuine laughter, guffaws of laughter, at the sight of things that are not marks of weakness or misfortune of fellow-humans. I refer of course to the kind of laughter provoked by what is grotesque. Fabulous creations, beings for whose existence no explanation drawn from ordinary common sense is possible, often excite in us a wild hilarity, excessive fits and swoonings of laughter. Evidently a distinction is called for here, as we are confronted with a higher form. From the artistic point of view, the comic is an imitation; the grotesque, a creation. The comic is an imitation mixed with a certain degree of creative capacity, or, in other words, of artistic ideality. Now, human pride, which always gets the upper hand and which is the natural cause of laughter in the case of the comic, also becomes the natural cause of laughter in the case of the grotesque, which is a creation, mixed with a certain faculty of imitating elements pre-existing in nature. I mean to say that, in this case, laughter is the expression of the idea of superiority, no longer of man over man, but of man over nature. This idea must not be thought too subtle; that would not be an adequate reason for

rejecting it. Find another plausible explanation if you can. If this one appears far-fetched and hard to accept, the reason is that laughter excited by the grotesque has in itself something profound, axiomatic and primitive, which comes much closer to the life of innocence and to absolute joy than the laughter aroused by the comic derived from social manners. Setting aside all considerations of usefulness, the same difference obtains between these two types of laughter as between the literature of involvement and the school of art for art's sake. Thus the grotesque looks down on the comic from a height of like proportions.

From now on I shall refer to the grotesque as the absolute comic, in contrast to the ordinary comic, which I shall call the significative comic. The significative comic speaks a language that is clearer, easier for the common man to understand, and especially easier to analyse, its element being obviously double: art and the moral idea; but the absolute comic, coming as it does much closer to nature, appears as a unity that must be grasped intuitively. There is only one proof of the grotesque, which is laughter, a burst of instantaneous laughter; confronted with the significative comic, we may be forgiven if ours is a delayed laughter; this does not detract from its value; it is simply a matter of quick analysis.

I have used the expression 'absolute comic', but we must be on our guard. From the point of view of the definitive absolute there is only joy. The comic can be absolute only relatively to fallen humanity, and it is in that sense that I am using the term.

VI

The exalted nature of the absolute comic makes of it the special preserve of superior artists who have in them the necessary receptivity for absolute ideas. Thus the man who until now has apprehended these ideas better than anyone

else, and who has exploited some of them in his purely aesthetic as well as his creative work is Theodor Hoffmann. He was always careful to distinguish between ordinary comic and the comic he called 'innocent comic'. He often sought to express in works of art the learned theories he had propounded didactically or given expression to in the form of inspired conversations or of critical dialogues; and presently I shall be borrowing, from those very works, the most brilliant examples, when the time comes for me to give a series of applications of the principles enunciated above, and to stick a sample under each category heading.

Moreover, in the absolute comic and the significative comic we find groups and sub-groups and families. The division between them may be drawn on different principles. It may in the first place be built on the law of pure philosophy, as I began by doing, or again on the artistic law of creation. The first division is produced by the primary separation between the absolute comic and the significative comic; the second is established on the type of special qualities each artist possesses. And finally, a classification of different types of comic may also be made on the basis of the climate and different national aptitudes. It must be noted that each term in each category may be completed or modified by adding a term from another, just as grammatical law teaches us to modify the substantive by the adjective. Thus, for example, such and such a German or English artist is more or less gifted for absolute comic, and at the same time he is more or less an idealizer. I propose now to try to give a choice of examples of both absolute and significative comic, and to describe briefly the comic spirit proper to a number of nations distinguished for their artistic qualities, before coming to the section in which I want to discuss and investigate at greater length the talent of the men who have made a study of the comic and devoted their lives to it.

By exaggerating the consequences of the significative

comic and driving them to their extreme limit, we get the ferocious comic; and, similarly, the synonymous expression of the innocent comic, with a degree more, is the absolute comic.

In France, the home of clear thought and demonstration, where art aims naturally and directly at utility, the comic is usually significative comic. Molière[13] was the highest French expression of this type; but as the basis of our national character is a dislike of all extremes, as one of the particular symptoms of any French passion, any French science or art is to avoid any excess, any absolute, any depth, little ferocious comic is, in consequence, to be found here; by the same token, our grotesque seldom rises to the absolute.

Rabelais, who is the great French master of the grotesque, even in the midst of his most colossal fantasies preserves a semblance of the useful and the reasonable. He is directly symbolic. His type of comic almost always has the transparence of the fable. In French caricature, in the plastic expression of the comic, we shall again find that spirit dominant. We have to confess that the prodigious poetic good humour necessary to the genuine grotesque rarely exists in France in a constant and equal flow. At distant intervals, the vein re-emerges; but it is not an essentially national one. In this genre mention must be made of a few interludes by Molière, too little read, unfortunately, and too rarely performed, amongst others those of the *Malade imaginaire* and the *Bourgeois Gentilhomme*,[14] and the carnivalesque figures by Callot.[15] As for the comic in Voltaire's *Contes*, so essentially French, it always draws its justification from the idea of superiority; it is entirely the significative variety of the comic.

Dreamy Germany will give us some excellent examples of absolute comic. There, everything is serious, profound, extreme. To find the ferocious and ultra-ferocious comic, we must cross the Channel and pay a visit to the misty kingdoms of the spleen. Carefree Italy, full of joy and noise, offers an

abundance of innocent comic. It is in the centre of Italy, at the heart of the Southern carnival, in the middle of the bustling Corso, that Theodor Hoffmann has judiciously placed the scene of that eccentric tale *Princess Brambilla*. The Spaniards are very gifted for the comic. They get to the cruel very quickly and their most grotesque inventions often contain something sombre.

I shall long remember the first English pantomime I saw performed. It was at the Théâtre des Variétés a few years ago. Few people will remember the occasion, no doubt, for very few people seemed to have a taste for this form of entertainment, and those unfortunate English mimes received a mighty poor welcome over here. The French public does not much care to lose its bearings; it has not got a very cosmopolitan taste, and changes of horizon blur its vision. For my part, I was greatly struck by this manner of understanding the comic. To account for the lack of success, it was being said by those most kindly disposed that the actors were a common and mediocre lot, in a word understudies; but this was beside the point. They were English, that is the important factor.

It seemed to me that the distinguishing mark of this type of the comic was violence. A few examples drawn from my memories will serve to prove it.

First the Pierrot was not the character as pale as the moon, as mysterious as silence, as flexible and mute as the serpent, as straight and tall as a gibbet, that artificial man, activated by strange springs, to whom the late lamented Deburau[16] had accustomed us. The English Pierrot rushed on to the stage like a whirlwind and fell down like a bundle of sacking; and when he laughed the whole house rocked; his laughter was like joyous thunder. He was short and stout, and had given dignity to his bulk by a costume adorned with ribbons, which gave to his jubilant personage the effect that feathers and down give to birds or fur to angora cats.

Two patches of pure red which he had crudely stuck to his

flour-covered face stood out without gradation, without transition. His mouth had been enlarged by a simulated prolongation of the lips with the help of two bands of carmine, so that when he laughed his mouth seemed to gape from ear to ear.

As for his character, at bottom it was the same as that of the Pierrot familiar to all of us: unconcern and detachment, and, in consequence, the satisfaction of every greedy and rapacious whim, at the expense now of Harlequin, now of Cassandra, now of Leander. But, where Deburau would have no more than dipped the tip of his finger to lick it, this Pierrot plunged in with both hands and both feet.

And everything in this singular piece was played with like excess; it was a giddy round of hyperbole.

Pierrot strolls past a woman busily scrubbing her doorstep; after having rifled her pockets, he tries to push into his own her sponge, her broom, her pail and even the water. As for his way of trying to express his love to her, anyone can imagine it by recalling his memories of watching the phanerogamous habits of the monkeys in their famous cage at the Jardin des Plantes. It must be added that the female role was played by a very tall, very thin man, whose affronted modesty expressed itself in piercing shrieks. It really was a riot of laughter, something both terrible and irresistible.

For some misdeed or other, Pierrot was to have his head chopped off at the end. Why the guillotine instead of hanging in England? I have no idea; doubtless to bring about what follows. There stood the instrument of death, on a French stage, very surprised at this romantic novelty. After struggling and bellowing like an ox that smells the slaughterhouse, Pierrot finally suffers his fate. His head came away from his neck, a big white and red head, rolling down with a thump in front of the prompter's box and exposing the bleeding neck, split vertebrae and all the details of a piece of butcher's meat, just cut up for the shop window. And then suddenly the

truncated torso, driven by the irresistible monomania of thieving, got up, triumphantly filched its own head, like a ham or a bottle of wine, and, being cuter than the great St Denis,[17] rammed it into his pocket!

Set down with the pen, the whole thing seems pale and chill. How could the pen rival pantomime? Pantomime is the distillation of comedy; its quintessence; it is the comic element pure, isolated, concentrated. Thus, what with English actors' special gift for hyperbole, all these bits of grisly slapstick took on a strangely gripping reality. Certainly, one of the most remarkable things in the way of absolute comic and of its metaphysics, so to speak, was the opening scene of this beautiful piece, a prologue of a high aesthetic design. The principal characters, Pierrot, Cassandra, Harlequin, Columbine, Leander, stand in front of the public, gentle and subdued as could be. They seem rational enough and not all that different from the worthy folk in the auditorium. The magic breath that will set them off in extraordinary movement has not yet passed through their little brains. A few jovial jests from Pierrot can give but a pale idea of what he will be up to presently. The rivalry between Harlequin and Leander has just come into the open. A fairy takes pity on Harlequin; she is the eternal protectress of the love-sick and the poor; she promises him her protection, and, to give him an immediate proof of it, she waves her wand in the air with a mysterious commanding gesture.

Like a flash the giddy intoxication is upon us, it is in the air, we breathe it in, it fills our lungs, and sends the blood coursing through the veins.

What is this intoxication? It is the absolute comic; it has taken hold of them all; Leander, Pierrot, Cassandra gesticulate wildly, thereby showing clearly that they feel they are being thrust forcibly into a new life. They do not appear displeased about it. They are preparing to meet the great disasters and the tumultuous fate that awaits them, like a man spitting

into his palms and rubbing them together before embarking upon a dramatic action. They wave their arms about, they look like windmills lashed by a storm. No doubt they are loosening up their joints; they will need all their suppleness. All this goes on to the accompaniment of loud guffaws, full of broad contentment; then they start a game of leapfrog, and once their agility and skill has been convincingly shown, comes a brilliant display of kicks in the pants, fisticuffs, and slappings that sound and flash like a battery of guns; but it is all in good part. All their gestures, their yells, their glances seem to say: the fairy has willed it, destiny is hounding us on, we don't give a damn! On with the dance! And off they rush into the fantastic action, which, to be precise, begins only at this point, or in other words on the borders of the marvellous.

Taking advantage of the general delirium, Harlequin and Columbine have fled, dancing as they go, lightfooted in quest of adventure.

To quote another example, here is one drawn from the pages of an unusual writer, a most universal mind, whatever may be said, who unites to the railing significative comic of the French the frolicsome, ebullient, extravagant gaiety of the lands of the sun, at the same time as the profound, germanic type of comic. I am again referring to Hoffmann.

In the story entitled *Daucus Carota, King of the Carrots* (which some translators call *The King's Betrothed*), nothing could be more beautiful to see than the arrival of the numerous troupe of carrots in the yard of the farmhouse where dwells the king's betrothed. All these little folk, as scarlet as an English regiment, with vast green plumes on their heads, like the outriders of a coach, prance and dance about on their little horses. The whole scene is one of surprising agility. They are all the more adroit, and it is all the easier for them to fall on their heads, because these are larger and heavier than the rest of their bodies, like toy soldiers made from elder-pith that have a little lead in their shakos. The poor girl, infatuated with

dreams of grandeur, is fascinated by this deployment of military might, but how different is an army on parade from an army in barracks, furbishing their weapons, polishing their equipment, or, worse still, snoring brutishly on their dirty smelly camp-beds! That is the reverse of the medal! For all the rest was nothing but a magic charm, a means of seduction. Her father, a prudent man and well versed in sorcery, wants to show her the underside of all this showy display. And so, at the time when all the vegetables are sunk in heavy sleep, far from suspecting that they could be discovered by the eyes of a spy, he half draws aside the flap of one of this magnificent army's tents; and then the poor little dreamer sees this mass of red and green soldiery in its dreadful undress, wallowing, sleeping in the earthy mire they came from. All that military pomp and circumstance in sleeping bonnets is transformed into an evil-smelling bog.

I could easily draw from the admirable Hoffmann a number of other examples of the absolute comic. If the reader wants to understand thoroughly what I mean he should read attentively *Daucus Carota*, *Peregrinus Tyss*, *The Crock of Gold*, and especially, first and foremost, *Princess Brambilla*, which is a veritable catechism of high aesthetics.

What particularly distinguishes Hoffmann is the involuntary, and sometimes very voluntary, mixture of a certain element of the significative comic with the most absolute comic. His most supernatural fleeting comic conceptions, which often resemble the visions of a drunken man, have very evident moral implications; it is as though we were dealing with the profoundest of physiologists or psychiatrists, who was amusing himself by clothing his abstruse science in poetic forms, like a scholar speaking in fables and parables.

Take for example, if you will, the character of Giglio Fava, the actor in *Princess Brambilla*, a prey to a deep-seated form of schizophrenia. This character, one in body, changes from time to time his personality, and under the name of Giglio

Fava declares he is the sworn enemy of the Assyrian Prince Cornelio Chiapperi; and when he is the Assyrian Prince, he pours his profoundest and most regal contempt on his rival for the favour of the Princess, a miserable actor by the name, so they say, of Giglio Fava.

It must be added that one of the most distinctive signs of the absolute comic is to be unconscious of itself. That is to be seen, not only in certain animals like monkeys, in whom gravity is an essential element of their funniness, and in certain sculptural caricatures of the ancients I have already referred to, but also in those Chinese grotesque figures which we find so highly diverting, and which have much less of a comic intention than is generally believed. A Chinese idol, though an object of veneration, scarcely differs from a tumble-over, or a pot-bellied chimney-piece ornament.

And so, to make an end with all these subtleties, all these definitions, and to conclude, let me say once and for all that the dominant idea of superiority is to be found both in the absolute comic and in the significative comic, as I have – too lengthily perhaps – explained; that, in order for the comic, in other words an emanation, an explosion, an emergence of the comic, to exist, there must be two beings in the presence of each other; that it is particularly in the laugher, in the spectator, that the sense of the comic resides; but that, on the other hand, in regard to this law of unselfconsciousness, an exception must be made for those men who have made it their profession to foster in themselves the sense of the comic, and to draw it out of themselves for the enjoyment of their fellow-men, a phenomenon that belongs to the class of all artistic phenomena that show the existence in the human being of a permanent dualism, the capacity of being both himself and someone else at one and the same time.

And to come back to the definitions I started out from, and to express myself more clearly, I submit that when Hoffmann engenders absolute comic he is surely well aware of the fact;

but, equally, he knows that the essence of this type of comic is to appear to be unaware of oneself and to instil in the spectator, or rather the reader, the feeling of joy at his own superiority and the joy of man's superiority over nature. Artists create the comic; having studied and brought together the elements of the comic, they know that such and such a creature is comic, and that he is comic only on condition that he is unaware of his own nature; just as, by an inverse law, the artist is an artist only on condition that he is dual and that he is ignorant of none of the phenomena of his dual nature.

6. Edgar Allan Poe, his Life and Works

'Doubtless', said I, 'what it utters is its only stock and store,
Caught from some unhappy master whom unmerciful Disaster
Followed fast and followed faster till his songs one burden bore –
Till the dirges of his hope that melancholy burden bore
Of "never – never more".'

<div align="right">

EDGAR POE, *The Raven*, lines 62–6

</div>

Sur son trône d'airain le Destin qui s'en raille
Imbibe leur éponge avec du fiel amer,
Et la nécessité les tord dans sa tenaille.[1]

<div align="right">

THÉOPHILE GAUTIER, *Ténèbres*

</div>

I

RECENTLY a poor wretch appeared before the courts; his brow was inscribed with an unusual and curious piece of tattooing: 'No luck!' In this way his forehead carried, as a book its title, the motto of his life, and the interrogation he was subjected to showed that this strange inscription was the brutal truth. Literary history contains similar life stories, cases of real damnation – men who bear the words 'Ill luck' stamped in mysterious lettering in the sinuous folds of their foreheads. The blind angel of expiation has seized hold of them, and lashes them hard for the edification of others. In vain do their lives show them to have had talents, virtues, grace; society has a special kind of curse in reserve for them, holding them guilty of weaknesses, which are the result of its persecuting them. What did Hoffmann not do to placate fate, and what did Balzac not undertake to conjure good fortune? Can there then really be a diabolical Providence that sets misfortune in train from the cradle, that, with premeditation, casts spiritual and angelic natures into hostile surroundings, like martyrs into the circuses? Are there then consecrated

souls, destined for sacrifice, condemned to march towards death and glory, through the ruin of their own lives? Will the nightmare of 'Ténèbres' assail these elect souls for ever? Vainly do they struggle, vainly adapt themselves to this world, to its prudential ways, to its wiles; let them raise prudence to a fine art, cork up every aperture, bolster the windows against the slings and arrows of fortune, the Devil will yet get in by a keyhole; some element of perfection will be the chink in their armour, and an outstanding quality the seed of their perdition.

> L'aigle, pour le briser, du haut du firmament
> Sur leur front découvert lâchera la tortue,
> Cars *ils* doivent périr inévitablement.[2]

Their fate is writ large in their whole nature, it shines with a lurid brilliance in their eyes and gestures, it runs in their veins with every drop of blood.

A well-known writer[3] of our time has written a book to show that poets cannot hope to fit in, either in a democratic or an aristocratic society, in a republic or an absolute or constitutional monarchy. Has anyone been able to answer him convincingly? Today, I am in a position to furnish another tale in support of his case, I can add a new saint to his martyrology; I have to tell the story of one of these illustrious unfortunates, too loaded with poetry and passion, and born to suffer the harsh apprenticeship of genius here below amidst the crowd of mediocre souls.

The life of Edgar Poe – what a heartbreaking tragedy! His death – what a horrible ending to it, the horror increased by its triviality! All the documents I have read have lead me to the conclusion that the United States was nothing but a vast prison house for Poe, within which he moved in a state of feverish agitation, like someone born to breathe a sweeter air – nothing but a gaslit desert of barbarism – and that his inner spiritual life as a poet, or even as a drunkard, was a constant struggle to escape from the influence of this hostile atmosphere.

Public opinion in democratic societies is indeed a pitiless dictatorship; do not try to implore love or leniency or flexibility in the application of its laws to the numerous and complex cases of moral life. It seems almost as though the ungodly love of liberty has given birth to a new form of tyranny, the tyranny of beasts or zoocracy, which, in its savage insensitiveness, resembles the idol of the Juggernaut. A biographer – well-intentioned, worthy fellow – tells us in the gravest tones that, if Poe had only made an effort to bring order into his genius and to apply his creative faculties in a manner more appropriate to American soil, he might have become a moneyed author, 'A money-making author'[4]; another, a cynical simpleton this one, opines that, however fine Poe's genius, it would have been better for him if he had been merely talented, since talent is more easily negotiable than genius. Yet another, who has been a newspaper and review editor, and a friend of the poet's, admits that he was a difficult man to employ, and that one had to pay him less than others because his style was too far above the common herd. 'What a smell of trade,' as Joseph de Maistre[5] used to say.

A few were bolder, and with a mixture of gross misunderstanding of his genius and ferocious bourgeois hypocrisy competed in throwing insults at him; and, after his sudden death, they took the corpse to task most cruelly – particularly Mr Rufus Griswold, who, to recall the avenging words of Mr George Graham, was guilty then of an immortal piece of infamy. Possibly because he had a presentiment of a sudden end, Poe had entrusted to Messrs Griswold and Willis the task of putting his works in order, of writing his life, and of restoring his memory. This pedagogue-vampire defamed his friend at length, in an enormous, boring and venomous article placed at the head of the posthumous edition of Poe's works. Is there no bye-law in America to prevent dogs from entering cemeteries? As for Mr Willis, he showed, on the contrary, that kindliness and decency have always gone with true in-

telligence, and that charity towards our colleagues, which is a moral duty, is also prescribed by good taste.

If you talk to an American about Poe, he will perhaps recognize his genius, may even show himself proud of it, but with a sardonic and imperious tone, which betrays the matter-of-fact type, he will go on to tell you about the poet's disordered life, his alcoholic breath which would have caught alight in the flame of a candle, his wandering habits; he will tell you that Poe was an erratic and heteroclite being, a planet out of orbit, that he was constantly running off from Baltimore to New York, from New York to Philadelphia, from Philadelphia to Boston, from Boston to Baltimore, from Baltimore to Richmond. And, if these preliminary details of a heartbreaking story fill your heart with pity, moving you to hint that the man himself was not alone to blame, and that it must be difficult to think and write comfortably in a country where there are millions of sovereign units, a country without a capital, properly speaking, and without an aristocracy, then you will see his eyes open wide in astonishment and blaze with anger, the saliva of injured patriotism moisten his lips, and America, from his mouth, hurl insults at Europe, her aged mother, and at old-fashioned philosophy.

I repeat that, as far as I am concerned, I am persuaded that Edgar Poe and his mother country were not on a level. The United States is both a gigantic and a juvenile country, naturally jealous of the old continent. This newcomer in history, proud of his material development, which is abnormal to the point of being monstrous, has a childlike faith in the omnipotence of industry; he is convinced, like a few poor fellows amongst us, that it will in the end swallow up the Devil. Time and money have such immense value over there! Material activity, exaggerated to a kind of national mania, leaves very little room in the mind for things that are not of this world. Poe, who came of good stock, and who moreover was in the habit of saying that the great misfortune of his

country was to have no aristocracy of birth (since, in his view, amongst a people without aristocracy the cult of beauty can only be corrupted, diminished and die), who perceived in his fellow-citizens, not forgetting their showy and costly luxury, every symptom of bad taste characteristic of the self-made man, who thought that progress, that great idea of the modern age, was a kind of ecstasy for mugs, and who called housing 'improvements' scars and rectangular abominations, Poe was a strangely solitary mind over there. He believed only in the immutable, the eternal, the 'selfsame', and he possessed in a large degree – oh! cruel privilege in a society full of self-infatuation – that robust good sense, in the manner of Machiavelli, which goes before the man of wisdom like a column of light through the desert of history. What would he have thought, what written, poor man, if he had heard the female theologian[6] of feeling denying the existence of hell, for love of the human race; or the philosopher of numbers[7] suggesting an insurance system, a subscription, at a penny a head, for the suppression of war, and the abolition of the death penalty and spelling – two correlated follies! – and countless other crackpots 'Who have their ear keenly attuned to the wind', and spin round like weather-cocks, as they write nonsense as flatulent as the element that dictates them? If you add to this unerring vision of truth, truly a weakness in some circumstances, an exquisite delicacy of ear, tortured by a wrong note, a refinement of taste that everything apart from exact proportions shocked, an insatiable love of beauty, driven to a state of morbid passion, you will not be surprised that for such a man life became a torture, and that he should have come to grief in the end; you will merely be astonished that he could have lasted as long as he did.

II

Poe's family was amongst the most respectable in Baltimore. His maternal[8] grandfather had served as Quartermaster-

General in the War of Independence, and Lafayette[9] held him in great esteem and friendship. During his last trip to the United States, Lafayette asked to see the General's widow in order to express his gratitude for the services her husband had rendered to him. Poe's great-grandfather had married the daughter[10] of an English admiral, Admiral MacBride, who was related to England's most noble houses. David Poe, Edgar's father and son of the General, fell wildly in love with an English actress, Elizabeth Arnold, a celebrated beauty; he eloped with her and married her. In order that his own destiny should be the more closely intertwined with hers, he became an actor and appeared with his wife in different theatres in the principal cities of the Union. The couple died at Richmond almost at the same time, leaving three young children, Edgar being one of them, with no one to look after them, and in utter poverty.

Edgar Poe was born in Baltimore in 1813.[11] I give that date from what he says himself, in protest against Griswold, who places Poe's birth in the year 1811. If ever the spirit of romance, to use our poet's own expression, presided at a birth – sinister and stormy spirit! – then certainly it presided at his. Poe was assuredly the child of passion and adventure. A merchant in the town took a liking to the pretty child in distress, whom nature had endowed with a charming manner, and, being childless, he adopted him. And so thereafter the boy was called Edgar Allan Poe. He was thus brought up in the lap of luxury and in the legitimate expectation of one of those fortunes that confer a splendid sense of security on a man's character. His parents by adoption took him off with them on a trip they made to England, Scotland and Ireland, and before returning to their own country, they left him with a certain Dr Bransby, who kept a flourishing educational establishment at Stoke Newington, near London. Poe has himself described in *William Wilson* this strange old Elizabethan house and his schoolboy impressions.

He returned to Richmond in 1822, and pursued his studies in America under the guidance of the best teachers in the town. At the University of Charlottesville, which he entered in 1825, he distinguished himself not only by his miraculous intelligence but also by the almost sinister overflow of passions – a thoroughly American precociousness – which finally resulted in his expulsion.[12] We should note in passing that at Charlottesville Poe already showed a most remarkable talent for the physical sciences and mathematics. Later he was to put this to frequent use in his strange tales, and to draw most unexpected effects from it. But I have reason for thinking that this was not the form of composition he attached most importance to, and that – perhaps because of that very precocious talent – he was almost disposed to consider the tales as facile tricks, compared with the works of pure imagination. Some miserable gaming debts caused a momentary rift between him and his adoptive father, and Edgar – the fact, curious in itself, argues for the presence in his impressionable mind, in spite of what has been said, of a degree of chivalrousness – conceived the idea of taking part in the Greek War of Independence and going to fight the Turks. Accordingly he set out for Greece. What became of him in the Levant, what did he do there? Did he make a study of the classical shores of the Mediterranean? Why do we pick up his tracks again at St Petersburg, without a passport, involved in some trouble (and if so, what trouble?), forced to appeal to the American Chargé d'Affaires, Henry Middleton, to escape from the clutches of the law in Russia, and to be able to go home? No one knows the answers; there is a gap here, which he alone could have filled. The life of Edgar Poe, his youth, his adventures in Russia, and his letters have long been announced in the American press but have never appeared.

He was back in America in 1829; and then expressed the wish to enter the Military School of West Point. He did in fact gain admission there, and there as elsewhere he gave promise

of an admirably endowed but ungovernable intelligence, and after a few months he was struck off. At that very time, an event occurred in his adoptive family that was to weigh heavily on his whole life. Mrs Allan, for whom he appears to have felt a really filial affection, died, and Mr Allan married a quite young woman. A domestic quarrel took place at this point – a strange and obscure story which I am unable to relate because none of Poe's biographers explains it clearly. But it is scarcely surprising that he should have parted once and for all from Mr Allan, and that the latter, who had children of his own by his second marriage, should have cut him out entirely from his will.

Shortly after leaving Richmond, Poe published a small volume of poems: a brilliant dawn indeed. For those who have a feeling for English poetry, there is already a sense of other-worldliness here, of calm in melancholy, of pleasing solemnity, and precocious – I believe I was about to say 'innate' – experience, which are the hall-marks of great poets.

Poverty drove him to join up for a time, and it may be supposed that he used the long idle hours of garrison life to prepare the materials of his future works, strange works that appear to have been created to show that strangeness forms an integral part of beauty. Back in literary life, the only medium in which certain uprooted beings can breathe, Poe was in the direst poverty, from which he was rescued by a piece of luck. The proprietor of a review had just founded two prizes, one for the best short story, the other for the best poem. A singularly beautiful handwriting attracted the attention of Mr Kennedy, who was the president of the committee, and inspired him with the wish to see the manuscripts with his own eyes. It was then found that Poe had won both prizes; but only one was awarded to him. The president of the committee was curious to see the unknown prizewinner. The journal's publisher came, bringing with him a young man of striking good looks, in rags, his coat buttoned up to his chin, and with

the air of an aristocrat as proud as he was starving. Kennedy behaved well. He arranged for Poe to meet a certain Mr Thomas White, who was in process of launching the *Southern Literary Messenger* at Richmond. Mr White was a man of enterprise, but quite devoid of literary talent; he needed a helper, and so Poe, still quite young – he was twenty-two – found himself the director of a review, whose fate rested entirely on him. Its prosperity was his creation. The *Southern Literary Messenger* subsequently admitted that it was to this cursed eccentric, this incorrigible drunkard, that it owed its readers and its profitable celebrity. It was this magazine that published for the first time *The Adventure of one Hans Pfaall*, and several other short stories, which our readers will see passing before their eyes. For nearly two years Edgar Poe, with a marvellous ardour, astounded his public by a series of compositions quite new in character, and by critical articles which, with their liveliness, their precision, their reasoned severity, were well-designed to catch the eye. These articles dealt with books of all kinds, and the sound education the young man had equipped himself with was of no little help to him. It is well to know that this considerable labour was done for 500 dollars, that is to say, 2,700 francs a year. 'Immediately' – to quote Griswold (by which Griswold means: he thought himself rich enough, the fool!) – he married a beautiful, charming girl, of a sweet and heroic disposition, but '. . . without a penny to bless herself with,' adds Griswold, with a shade of disdain. It was Miss Virginia Clemm, his cousin.

In spite of the services rendered to his journal, Mr White quarrelled with Poe after about two years. The cause of this break must evidently be found in the poet's attacks of hypochondria and bouts of drunkenness – characteristic accidents that darkened his spiritual sky, like those threatening clouds that suddenly cast over the most romantic landscape an apparently irreparable air of melancholy. From now on we

see the unfortunate man folding his tent like a dweller in the desert, and carrying his meagre household gods to one after another of the big cities of the Union, directing reviews, or contributing to them brilliantly in every place. Critical and philosophical articles, tales full of magic, flow from his pen with dazzling rapidity, the latter appearing in collective form under the title of *Tales of the Grotesque and the Arabesque* – an intentionally startling title, for grotesque and arabesque elaborations have the effect of pushing the human figure into the background, and the reader will see that in many respects the writings of Poe are extra- or supra-human. Wounding and outrageous items of news inserted in the papers inform us next that Mr Poe and his wife are lying dangerously ill at Fordham and in complete destitution. Shortly after the death of Mrs Poe, the poet suffered the first attack of *delirium tremens*. Then another insertion – very cruel, that one – suddenly appeared in a newspaper, attacking his scorn and disgust of the world, initiating one of those whispering campaigns which are a veritable social indictment and which he was continually having to defend himself against – one of the most sterile and exhausting struggles imaginable.

True, he was earning money, and his literary work just about kept him alive. But I have proof that he was constantly having to grapple with odious difficulties. Like so many other writers, he dreamed of having his own review, he wanted to have a place he could call his own, and the fact is that he had suffered enough to make him desire ardently a permanent refuge for his thought. To achieve that end, to procure the necessary sum of money, he had recourse to lectures. We know well enough what such lectures are – a kind of speculation, the Collège de France[13] put at the disposal of writers generally, the author publishing his lecture only after he has extracted from it all the money that can be squeezed out of it. Poe had already given a reading from his cosmogonic poem *Eureka* in New York, and this had even aroused animated

discussions. He now hit on the idea of giving a series of lectures in his native Virginia. His intention, which he imparted to Willis in a letter, was to make a tour in the West and South, and he hoped to get the co-operation of his literary friends and his former acquaintances from his College and West Point days. He accordingly went the rounds of the main towns in Virginia, and Richmond saw once more the man it had known so young, so poor, so shabby. All those who had not seen Poe since the days of his obscurity came in crowds to set eyes on their illustrious compatriot, and they saw a handsome man, dressed with all the studied elegance of genius. I even believe he had so far pushed his condescension to public opinion as to gain admission to a temperance society. He chose a theme as broad as it was elevated: *The Poetic Principle*; and he developed it with the lucidity that was one of his peculiar gifts. True poet that he was, he believed the aim of poetry to be similar in nature to its essence; he believed the end it should have in view to be none other than itself.

The splendid welcome he received filled his poor heart with pride and joy; he was so delighted that he talked of settling down at Richmond for good, and ending his days in the surroundings that childhood had made so dear to him. But business matters called him to New York, and he set out on 4 October, although complaining of bouts of feverish shivering and faintness. On the evening of the 6th, he arrived at Baltimore, still feeling rather ill, and, having had his luggage carried to the departure platform for Philadelphia, he went into a tavern to take a stimulant of some sort. There, unfortunately, he fell in with some old acquaintances, and lingered with them. The next morning, in the pale shadows of early dawn, a corpse was found on the roadside – is that the right way to put it? No, the body of a man still with the breath of life in him but whom Death had already stamped with his royal seal. On this man, whose name was unknown, neither papers nor money were found, and he was taken to a

hospital. It was there that Poe died that very evening of Sunday, 7 October 1849, at the age of thirty-seven, vanquished by *delirium tremens*, fearful visitor that had haunted Poe's brain once or twice before. Thus disappeared from this world one of its greatest literary heroes, the man of genius who had written in the *The Black Cat* these fateful words: 'what disease is like Alcohol!'

Poe's death amounts almost to a suicide – a suicide long prepared. At any rate it caused a similar indignation. Great was the clamour, and 'virtue' gave rein to its pompous cant, freely and voluptuously. Even the most kindly disposed funeral oration could not avoid affording some space to the inevitable echoes of bourgeois morality, which eagerly seized such a splendid opportunity. Mr Griswold was slanderous; Mr Willis, in genuine sorrow, behaved more than merely fittingly. – Alas! The man who had climbed the most arduous heights of aesthetics, and plunged into the least explored abysses of the human mind, he who, in the course of a life which seemed like a storm without respite, had found new means, unknown techniques, to make an impact on man's imagination, to enchant all minds athirst for beauty, had just died within the space of a few hours, on a hospital bed – what a fate! And such loftiness of spirit, such misfortune, all to raise a whirlwind of bourgeois moralizing, all to become the food and topic of pious journalists!

Ut declamatio fias![14]

Such scenes are not new; rarely does a freshly covered and illustrious grave fail to become the meeting place for scandalous talk. Moreover, society has little sympathy for these luckless madmen, and, either because they disturb its festivities, or because it suffers naïvely from a bad conscience, whichever way it is, society is unquestionably right. Who will fail to remember the spate of declamatory comment at the time of Balzac's death,[15] in spite of his having died with due

decorum? and even more recently – exactly a year ago today, 26 January – when an admirably honest writer, of the highest intelligence, whose lucidity never deserted him, went discreetly, without disturbing anybody – so discreetly that his discretion seemed very like scorn – and released his soul in the darkest street he could find.[16] Oh! the disgusting sermonizings! – what a refined form of murder! A well-known journalist, to whom Jesus will never succeed in teaching generous courtesy, thought the incident diverting enough to mark the occasion with a ponderous pun.[17] Amongst the large number of the *Rights of Man*, which the nineteenth century, in its wisdom, so often enumerates with complacency, two quite important ones have been forgotten, namely our right to contradict ourselves, and our right to quit this life. But society regards the man who does quit as an insolent fellow, and would willingly punish certain mortal remains, like that unfortunate soldier suffering from vampirism, who was driven mad by the sight of a corpse. And yet, it may be said that sometimes, under the pressure of given circumstances, after a searching analysis of given incompatibilities, and with a strong faith in given dogmas, and metempsychoses, it may be said without pomposity, and without playing on words, that suicide is at times the most sensible action in life. And thus is formed a goodly company of ghosts which haunts us familiarly, each member coming to sing the praises of his present state of rest, and to whisper his persuasions in our ear.

We must admit, however, that the mournful end of the author of *Eureka* produced certain comforting exceptions, without which one would be driven to despair, and life would no longer be bearable. Mr Willis, as I said, spoke worthily, and even with feeling, about the happy relations he had always had with Poe. Messrs John Neal and George Graham recalled Mr Griswold to a sense of shame. Mr Longfellow, whose merit is all the greater because of his having been cruelly handled by Poe, praised, in a manner worthy of a

poet, Poe's great power, as both poet and prose writer. An anonymous writer declared that American literature had lost its most powerful mind.

But the really broken, torn, heart, the heart pierced with the seven swords, was that of Mrs Clemm. Edgar had been as son and daughter to her. Cruel had been the destiny, says Willis (from whom I borrow these details almost word for word), cruel the destiny she watched over and protected. For Edgar Poe was an awkward character; not only did he subject his own writing to the most fastidious standards, and express himself in a style 'too much above the ordinary intellectual level to be paid very highly', but also he was constantly battling with financial difficulties, and often he and his sick wife lacked the most indispensable things of life.

One day, as Willis was sitting in his office, who should come in but an old lady, with a sweet solemn countenance. It was Mrs Clemm. She was seeking work for her dear Edgar. The biographer says he was profoundly struck, not only by the impeccable way in which she spoke in praise of her dear son, and by her precise understanding of his talents, but also by her whole appearance, her sweet sad voice, her rather old-world, but beautiful and dignified manner. And for several years, he adds, this tireless handmaid of genius, poorly and insufficiently clad, was to be seen going from newspaper office to newspaper office, offering for sale now a poem, now an article. Sometimes she would say that 'he' was ill, that being the only explanation, the only reason, the invariable excuse, she would give when her son was momentarily afflicted by one of those crises of sterility experienced by highly-strung writers; nor would she ever allow a syllable to escape her lips that could be construed as expressing a doubt, a decline of confidence in the genius and will-power of the loved one. When her daughter died, she clung to the surviving partner in the disastrous battle with redoubled maternal devotion; she came to live under his roof, took care of him, watched over him, shielding him

against life and against himself. Assuredly, Willis concludes, with lofty and impartial reason, if a woman's devotion born of a first love, and fostered by human passion, glorifies and sanctifies its object, what does not a devotion such as this, pure, disinterested, and as holy as a guardian angel, say in favour of the man who inspired it? Poe's detractors ought indeed to have seen that there are some kinds of charm so powerful that they can only be virtues.

The terrible shock that the news was for the unhappy woman may easily be guessed. She wrote a letter to Willis, of which the following passage is an extract:

I learned this morning of my beloved Eddie's death . . . Can you give me a few details, some of the circumstances? . . . Oh! do not forsake your poor friend in this moment of bitter affliction. Ask M— to come and see me; I have a message for him from my poor Eddie . . . I need not ask you to announce his death, and to speak well of him. I know you will. *But be sure and say what an affectionate son he was to me,* his poor grieving mother.

This woman appears to me to be great, to compare favourably with the Ancients. Struck by an irreparable blow, she thinks only of him who was everything to her; nor is it enough, in her eyes, for him to be called a genius; people must know that he was dutiful and affectionate. Surely this mother, beacon and source of light, kindled by a beam from highest heaven, has been given as an example to us humans, too careless of devotion, of heroism, and of all that lies beyond the strict limits of duty. Was it not justice indeed to inscribe above the works of the poet the name of her who was the spiritual sun of his life? His glory will cast fragrance over the name of the woman who bathed his wounds with her tenderness, and whose image will for ever hover above the martyrology of literature.

III

Poe's life, his way of life, his manners, his physical stature, all the factors that, together, add up to the totality of his personality, produce on us an effect of sombre brilliance. His strangeness, his fascination, these are the hall-marks of his being, which, like his works, was stamped with an indefinable seal of melancholy. He was conspicuously gifted in every way. In his youth, he had shown unusual prowess in all kinds of physical exercise, and, although he was small, with feet and hands like a woman's, his whole being in fact bearing this character of feminine delicacy, he was remarkably tough, and capable of astonishing feats of strength. In his youth he won a bet as a swimmer which outstrips the normal limits of possibility. It would seem that nature endows those from whom it expects great things with an energetic temperament, just as it gives powerful vitality to those species of tree symbolizing mourning and grief. These men, though sometimes slight in appearance, are cast in an athletic mould, capable of drunken orgies and hard work, quick to fall into excess, and yet able to endure astonishing bouts of self-denial.

Certain points concerning Edgar Poe command general agreement, for example his great air of natural distinction, his eloquence, his physical beauty, about which, so it was said, he was not a little vain. His manner displayed an unusual mixture of *hauteur* and exquisite sweetness, together with an easy self-assurance. Expression, bearing, gestures, carriage of the head, everything about him, especially on his good days, marked him out as one of the elect. His whole being produced a penetrating sense of solemnity. Nature's finest stamp was truly upon him, like those passers-by who draw the observer's attention and linger in his memory. Griswold himself, that narrow and sour pedant, admits that, when he went to see Poe, and found him still pale and ill from the shock of his wife's illness and death, he was struck beyond measure, not

only by the perfection of his manners, but also by his aristo-
cratic features, and by the fragrant atmosphere of his dwelling,
modestly furnished in all conscience. Griswold is ignorant of
the fact that poets, more than any other type of men, enjoy
that wonderful privilege, attributed to Parisian and Spanish
women, of having the secret of dressing well with the poorest
trifles, and that Poe, lover of beauty in all things, would have
found the art of transforming a cottage into a palace of new
design. Did he not, in the most original and interesting way,
sketch out furnishing projects, designs of country houses and
gardens, landscape planning?

There exists a charming letter from Mrs Frances Osgood,
who was one of his friends; it provides us with the most inter-
esting details on his habits, his person, his family life. This
woman, herself a distinguished writer, bravely denies all the
vices and errors the poet has been charged with. 'His manner
towards men', she writes to Griswold,[18]

may have been such as you describe, and speaking as a man you may
be right. But I declare as a fact that towards women he was quite
different, and that no woman ever knew Mr Poe without feeling a
deep interest in him. To me, he never seemed anything but a model
of elegance, distinction and generosity . . .

The first time we met was at Astor House. Willis had passed over
to me, while we were sitting at luncheon, a copy of *The Raven*, about
which, so he said, the author desired to know my opinion. The
mysterious and supernatural music of this strange poem made such a
deep impact on me that when I learned that Poe wished to be intro-
duced to me, a strange feeling came over me, which much resembled
fear. There he was before me, with his beautiful, proud head, his dark
eyes sparkling with the light of the elect,[19] a light full of feeling and
thought, an outward manner that was an indefinable mixture of
pride and sweetness – he greeted me with a calm, serious, almost cold
air; but beneath this coldness vibrated a feeling of sympathy so
evident that I could not help being deeply impressed by it. From that
moment till his death we were friends . . . and I know that in his last
words I had my share of remembrance, that, before his reason was

toppled from its sovereign throne, he gave me a final proof of his fidelity in friendship.

It was particularly in his own home, so simple and full of poetry, that Edgar Poe appeared to me in his best light. Playful, affectionate, witty, now docile, now flying into a temper, like a spoilt child, he always had, even in the midst of his most tiring literary duties, a pleasant word, a kindly smile, gracious and courteous attentions for his young, gentle and adored wife, and for all his visitors. He spent long hours at his desk beneath the portrait of his *Lenore*, loved and dead, always diligent, always resigned, and committing to paper, in that beautiful handwriting of his, the brilliant fantasies that flashed through his remarkable brain, incessantly alert. I remember having seen him one morning happier and more light-hearted than usual. Virginia, his sweet wife, had bade me come and see them, and I could not resist her entreaties . . . I found him working on a series of articles, which he subsequently published under the title *The Literati of New York*. 'Look,' he said to me, with a triumphant laugh, as he unrolled several little rolls of paper (he used to write on narrow bands of paper, no doubt to make his copy conform with the lay-out of the papers), 'I am going to show you, by the differences of length, the various degrees of esteem in which I hold every member of your literary species. In each one of these papers, one of you is rolled up, and thoroughly discussed. Come here, Virginia, and help me!' And they unrolled all the bands, one by one. The last of all seemed interminable. Virginia walked backward, laughing as she did so, to a far corner of the room, holding it by one end, and her husband towards another corner, holding the other. 'And who is the lucky one', I asked, 'that you have judged worthy of such immeasurable kindliness?' 'Listen to her!' he exclaimed, 'as though her vain little heart hadn't already whispered to her that it is she herself!'

When I was obliged to travel for my health, I kept up a regular correspondence with Poe, in obedience, on this point, to the requests of his wife, who believed I could win a salutary influence and ascendancy over him. As for the love and trust that existed between his wife and him, which to me was delightful to see, I cannot speak of that with more conviction and enthusiasm than I do. I pass over certain poetic little episodes, into which his romantic temperament led him. I think she was the only woman he always truly loved . . .

In Poe's tales, love has no place. At least, *Ligeia* and *Eleonora* are not in the strict sense love stories, the main idea on which the work hinges being quite different in each case. Perhaps he thought that prose as a medium was unworthy of this strange and inexpressible feeling; for his poems, on the other hand, are strongly saturated with it. The divine passion figures there as magnificently as a starlit night, and always veiled in incurable melancholy. In his articles, he sometimes speaks of love, and even refers to it as something that makes his pen tremble. In *The Domain of Arnheim* he declares that the four essential conditions for happiness are: life in the open air, the love of a woman, the indifference to any feeling of ambition, and the creation of a new type of beauty. What corroborates Mrs Frances Osgood's idea about Poe's chivalrous respect for women is the fact that, in spite of his prodigious gift for the grotesque and the horrible, there is no single passage in the whole of his work that has anything to do with lubricity or even sensual pleasures. His portraits of women have, so to speak, a halo; they shine forth from a supernatural haze, and are painted with all the emphasis that an adoring lover would give them. As for 'the little romantic affairs', can it be a matter of surprise that such a highly-strung being, whose thirst for beauty was perhaps the essential trait of his character, should occasionally, with passionate ardour, have had a love affair, that volcanic and heavily scented flower for which the seething brain of poets is a much-favoured soil?

Of his remarkable personal beauty, mentioned by several biographers, the mind can, I think, get an approximate idea by summoning to its aid the vague yet characteristic notions contained in the word 'romantic', a word which usually serves to render the kinds of beauty that come from facial expression. Poe had a vast, dominating brow, certain protuberances of which revealed the overflowing abundance of the faculties they are held to denote – construction, comparison, causality – with, enthroned in their midst in Olympian pride, the sense of

ideality, which is the aesthetic sense pre-eminently. Yet, in spite of these gifts, or perhaps because of these outstanding privileges, this head seen in profile offered perhaps a none too agreeable aspect. As in all things that are excessive in one particular, a deficit could arise from abundance, poverty from a usurpation. He had large eyes, dark, and yet luminous at the same time, of an indeterminate and sombre colour, tending to violet, a fine, strong nose, a delicate and sad mouth, on which hovered the suggestion of a smile; his complexion was swarthy, his face usually pale, his expression rather dreamy, and faintly disguised by his habitual melancholy.

His conversation was most remarkable and essentially enriching. He was not what is called a fine talker – odious thing – and, moreover, his talk, like his pen, eschewed the commonplace, but his vast store of knowledge, his powerful command of language, his arduous studies and his impressions, gathered in a number of countries, ensured that all he said was worth listening to. His essentially poetic eloquence, very methodical, yet moving on a plane of method rarely entered by the ordinary run of minds, a prodigious skill in deducing, from some obvious and wholly acceptable proposition, unsuspected and novel points of view, in opening up surprising vistas, and, in a word, the art of enchanting, of stimulating thought, of inducing reverie, of uprooting souls from the mud of routine, such were the dazzling qualities that remain in many people's memories. But it sometimes happened – so at least it is said – that the poet, yielding to a capricious vein of destructiveness, would enjoy bringing his friends rudely down to earth by a distressing cynicism, thus brutally destroying the effect of spirituality he had previously conjured up. It must also be noted that he was not particular in the choice of his hearers, and I think the reader will have no difficulty in finding in history other great and original intellects who are at home in any company.[20] Certain types of minds, solitary amongst crowds, and sustained by their inner monologues, are quite

indifferent to any question of refinement in their audience. In effect, it would seem to be a fraternal attitude, founded on contempt.

Of his drunkenness – proclaimed and censured with an emphasis that could lead one to believe all writers in the United States, except Poe, to be angels of sobriety – speak we must. Several versions are plausible and not mutually exclusive. First and foremost, I must observe that Willis and Mrs Osgood both say that a minimal amount of wine or liquor was enough to disturb his organization. In any case, what could be easier than to suppose that a man so really solitary, so profoundly unfortunate, a man who may often have looked on the whole social system as a paradox and an imposture, and who, harassed by a pitiless fate, often declared that society was nothing but a crowd of scoundrels (it is Griswold that mentions this, scandalized as only a man can be who may think that very thing, but would never say it) – what more natural, I say, than to suppose that this poet, thrown, when still a child, into all the hazards of independence, his mind encircled by a harsh, unremitting labour, should sometimes have sought the pleasures of oblivion in the bottle? Literary grudges, metaphysical anguish, domestic griefs, the insults of poverty, Poe took refuge from them all in the dark abyss of drunkenness, as in a preliminary tomb. But good though this explanation may seem, I do not find it all-embracing enough, and I am suspicious of its deplorable simplicity.

I learn that he did not drink greedily but like a barbarian, with an energy and an economy of time characteristically American, as though he were accomplishing a homicidal act, as though he had within him something to kill, 'a worm that would not die.'[21] There is, moreover, a story according to which one day, as he was on the point of marrying again (the banns had been published, and, as people were congratulating him on a union that placed in his hands the chances of happiness and comfort, he had said: 'You may have heard the

banns of marriage being read, but take note of this: I shall not marry'), he went, and, in an appalling bout of drunkenness, scandalized the neighbourhood where the woman who was to be his wife lived, thus having recourse to his vice to free himself from an act of disloyalty towards the poor dead woman whose image lived on in him and whom he had so admirably sung in his *Annabel Lee*. I therefore consider that in a great number of cases the infinitely precious fact of pre-meditation is established as true.

Apart from this, I learn from a long article in the *Southern Literary Messenger*, the very review of whose early success he had been the architect, that never once had the purity, the finish of his style, never once had the precision of his thought or his ardour for work been diminished by this terrible habit; that the composition of most of his admirable pieces either preceded or followed one of these crises; that after the publication of *Eureka* he gave way deplorably to his inclination; and that in New York, on the very morning of *The Raven*'s appearance, whilst the poet's name was on everybody's lips, he was to be seen crossing Broadway, stumbling outrageously. Note that the words 'preceded or followed' imply that the state of drunkenness could be a stimulant as well as a rest.

Now, just as there are fleeting and striking impressions – all the more striking in their recurrence, the more fleeting they are – which sometimes follow immediately upon some external event or other, a kind of signal like the sound of a bell, a musical phrase, or a forgotten scent, and which are themselves followed by some event similar to a formerly experienced event, occupying the same position in a chain, previously revealed, just as strange periodic dreams come to us in sleep, so it is beyond dispute that in the state of drunkenness there exist, not only concatenations of dreams, but patterns of argument that require, if they are to re-form, the ambience that gave them birth. If the reader has followed me thus far without repugnance, he will already have guessed my conclusion:

I believe that in many cases, certainly not in all, Poe's drunkenness was a mnemonic means, a method of work, an energetic and deadly method, but one that fitted his passionate nature. The poet had learnt to drink just as a careful man of letters applies himself to the exercise of note-taking. He could not resist the desire to recapture the marvellous or terrifying visions, the subtle conceptions he had met with in the course of a preceding storm; they were old acquaintances that drew him on imperatively, and to make contact with them once more he took the most dangerous but the most direct road. A part of what is today the source of our enjoyment is what killed him.

IV

About the works of this strange genius, I have little to say; the public will make it plain what it thinks of them. For me, it would perhaps be difficult but not impossible to unravel his method, to explain his manner, particularly in that portion of his works where the main effect arises from a well-contrived analysis. I could lead the reader into the mysteries of his workmanship, expatiate at length on the element of American genius in him which leads to his delighting in a difficulty vanquished, an enigma solved, a feat of strength achieved, which drives him on to disport himself with a childlike and almost perverse relish in the world of probabilities and conjectures, and to invent cock-and-bull stories on which his subtle art has conferred an air of convincing probability. No one will deny that Poe is a wonderful entertainer, but I know that he particularly prized another part of his works, and, in any case, I have some more important, albeit brief, remarks to make.

It is not through these material miracles, despite his owing his reputation to them, that the admiration of thoughtful people will come to him, it is through his love of beauty, his

knowledge of the harmonic terms of beauty, through his poetry, both profound and melancholy, yet fashioned with the transparency and perfection of a crystal jewel, through his admirable style, at once pure and strange, tightly knit like chainmail, pleasing and scrupulous, whose most delicate effect has as its purpose to guide the reader gently towards a desired end, and, finally, through this very special genius, this unique temperament, which enabled him to evoke and explain, in an impeccable, gripping and terrible manner, the exceptional cases in the moral sphere. Diderot, to take one example in a hundred, is a full-blooded author; Poe is the writer of nervous tension, even of something more than that, and he is the best writer I know.

The opening passages of Poe's writings always have a drawing power without violence, like a whirlpool. His solemn tone keeps the mind on the alert. We feel at the very outset that something serious is afoot. Then slowly, little by little, a story unfolds, the whole interest of which is founded on an imperceptible deviation of intellect, on some bold hypothesis, on a risky dosage by nature in the mixture of the faculties. The reader, as though in the grip of vertigo, is impelled to follow the author in his inviting deductions.

No man, I repeat, has spun such magical tales about the exceptions of human life and of nature, the feverish curiosities that arise in convalescent states, the dying seasons, heavy with enervating splendours, warm days, sodden with damp mists, when under the soft caress of the south wind nerves are relaxed like the strings of an instrument and the eyes run over with tears that do not come from the heart, hallucination, at first leaving room for doubt, but soon following, like a book, its own line of reasoning with conviction, the absurd occupying the intelligence and governing it with its own hideous logic, hysteria usurping the throne of the will, conflict reigning between nerves and mind, and man so out of tune with himself as to express grief by laughter. He analyses the most

fleeting phenomena, he weighs up imponderables and describes, with that scrupulous and scientific manner, the whole impact of which is frightening, all the world of imaginary things that float about the nerve-ridden man and lead him to destruction.

The ardour with which he throws himself into the grotesque for the love of the grotesque, and into the horrible for the love of the horrible, is clear proof of the sincerity of his work, and the inner harmony between the man and the poet. I have noticed before now that, in a number of men, this sort of zest is often the result of a vast unexpended store of vital energy, sometimes of an unrelenting chastity, and also of a deep repressed sensibility. The supernatural thrill that a man may feel at the sight of his own blood flowing, all sudden, violent and unnecessary movement, loud cries uttered without the mind's having ordered the throat to work, all these are phenomena to be classed in the same category.

Thrust into this literature, where the air is thin, a reader may experience the sort of indefinable anguish, of fear dissolving quickly into tears, of unease of the heart that dwells in vast, unusual spaces. But admiration is stronger; and the skill, moreover, is so great! The backgrounds and the accessories are always appropriate to the feelings of the characters. The solitude of nature, the bustle of great cities, are all evoked tensely and fantastically. Like our own Eugène Delacroix,[22] who has raised his art to the height of great poetry, Edgar Poe loves to have his characters live and move against lurid backgrounds of mingled purple and green, which reveal the phosphorescence of decay and the smell of the storm. So-called inanimate nature participates in the nature of the living beings, and, like them, is seized with a supernatural and galvanic shuddering. Space is extended by opium[23]; opium confers a magical meaning on every tint, and gives a more significant resonance to every sound. Sometimes the landscapes open up and reveal magnificent horizons, full of light

and colour, where, sparkling in the sun's golden rain, oriental cities and divers buildings appear in the distant haze.

Poe's characters, or rather his one character, the man with heightened faculties, the man with distraught nerves, the man whose ardent yet patient will defies all obstacles, the man whose eyes are fixed with the rigidity of a sword on the objects that grow larger under his gaze, is Poe himself. And his women, bathed in light, feverish, dying of mysterious maladies, speaking in a voice like music, they also are himself, or, at least, by their strange aspirations, by their knowledge, by their incurable melancholy, they are endowed with a large share of their creator's nature. As for his ideal woman, his Titaness, she appears under different portraits, scattered in his all too few poems, portraits or rather modes of feeling beauty, which the temperament of the author brings together, and merges into a vague but perceptible unity, where dwells, in a more delicate form, perhaps, than elsewhere, that insatiable love of beauty which is his great claim, that is to say the sum total of his claims, to the affection and respect of all poets.

7. Further Notes on Edgar Poe

I

'A LITERATURE of decadence!' – empty words we often hear fall with a pompous yawn from the lips of the sphinxes without a riddle that guard the holy portals of classical aesthetics. Each time the irrefutable oracle thunders forth, it may safely be affirmed that the cause is a work more amusing than the *Iliad*, a poem or a novel evidently, all parts of which are skilfully arranged with a view to surprise, the style of which is splendidly ornate, where all the resources of language and prosody have been exploited by an impeccable hand. Whenever I hear the booming anathema, which, be it said in passing, usually falls on some favourite poet, I am always seized by the desire to reply: 'Do you take me for a barbarian like yourself, and do you think I can take my pleasures as dismally as you do?' Grotesque comparisons then begin to dance in my brain; I have the impression that two women are being introduced to me, one a rustic matron, bursting with rude health and virtuousness, with no style or expression, in short 'owing nothing but to nature unadorned'[1]; the other, one of those beautiful women who dominate and oppress our memories, adding to her own profound native charm the eloquent appeal of dress, knowing exactly how to walk with grace, aware of her regal poise, with a speaking voice like a well-tuned instrument and thoughtful eyes that reveal only what they want to. My choice is not in doubt, and yet there are pedagogue-sphinxes who would accuse me of offending against the honour of the classics. But setting aside these parables, I think I may be allowed to ask these wiseacres if they really understand all the vanity and all the uselessness of their wisdom. The phrase 'a literature of decadence' implies that

there is a scale of literatures, a literature in infancy, a literature in childhood, in adolescence, etc. I mean that the term presupposes an inevitable and providential process, like some inescapable decree; and what then could be more unjust than to reproach us for accomplishing the mysterious law? All the meaning I can extract from this academic pronouncement is that we ought, somehow, to feel ashamed of obeying this law with pleasure, and that we are guilty of rejoicing in our destiny. That sun which a few hours ago was crushing everything beneath the weight of its vertical, white light will soon be flooding the western horizon with varied colours. In the changing splendours of this dying sun, some poetic minds will find new joys; they will discover dazzling colonnades, cascades of molten metal, a paradise of fire, a melancholy splendour, nostalgic raptures, all the magic of dreams, all the memories of opium. And the sunset will then appear to them as the marvellous allegory of a soul, imbued with life, going down beyond the horizon, with a magnificent wealth of thoughts and dreams.

But the point these pundits have not thought of is that in the life process, some complication, some combination of circumstances, may arise which their schoolboy wisdom has not reckoned with. And then their inadequate language will be in default, as for example when a nation begins in decadence, and starts in fact where others end up – a phenomenon that may, perhaps, be repeated with variants.

If, in the vast colonial empires of the present century, new literatures should take shape, spiritual exceptions are sure to emerge, of a kind wholly puzzling to the minds of the schoolmen. Young and old at one and the same time, America chatters and drivels away with astonishing volubility. Who can count the number of her poets? They are legion. Her blue-stockings? They crowd out the reviews. Her critics? Be assured that she can boast pedants at least the equal of our own at ceaselessly calling artists back to antique beauty, at cross-

questioning a poet or a novelist on the morality of his aims and the quality of his intentions. Over there, as here, but even more than here, there are writers who dismiss spelling as a puerile and useless activity, compilers by the dozen, bores, plagiarists feeding on plagiarisms, critics on criticisms. In that ferment of mediocrities, in that world enamoured of material progress – a new kind of scandal that allows us to appreciate the greatness of idle peoples – in that society, hungry for new subjects of astonishment, in love with life but in particular with a life full of thrills, a man has appeared who was great, not only in his metaphysical subtlety, the sinister or ravishing beauty of his conceptions, and the rigour of his analysis, but great also, and no less great, as a 'caricature'. I must explain what I mean with some care; for, recently, as a means of disparaging Edgar Poe and of invalidating the sincerity of my admiration, an incautious critic used the word 'entertainer', which I had myself applied to this noble poet almost in praise.

From the midst of a society, insatiable in its materialistic appetites, Poe launched into a dream world. Smothered as he was by the American atmosphere, he wrote as epigraph to *Eureka*: 'I offer this book to those that have put their faith in dreams as the only realities!' He was therefore an admirable protest in himself; he both was one and made one after his own manner, in his own way. The author who, in his *Colloquy of Monos and Una*, releases floods of scorn and disgust over democracy, progress and so-called civilization, that author is the very same one who, to win over the credulous, to enchant the gaping idleness of his compatriots, proclaimed, with the utmost energy, the sovereignty of man, and spun most ingeniously elaborate hoaxes of the kind most flattering to the pride of modern man. Seen in that light, Poe appears to me like a helot who wants to shame his master. In short, to state my view beyond any peradventure, Poe was always great, not only in his noble conceptions, but also as a hoaxer.

II

For dupe he never was! – I do not believe that the Virginian
who, in the full tide of democracy, could calmly write: 'The
people have nothing to do with the laws but to obey them',[2]
can ever have been the victim of modern wisdom; and 'The
nose of a mob is its imagination; by this at any time it can be
quietly led',[3] and a hundred other passages where mockery
rains down, thick as shot and shell, and yet remains non-
chalant and haughty. The Swedenborgians congratulate him
on his *Mesmeric Revelation*, like those simpleton 'Illuminati',
who, at one time, looked suspiciously on the author[4] of *Le
Diable amoureux*[5] as a revealer of their mysteries; they pour out
their thanks to him for the great truths he has just proclaimed –
for they have discovered (oh! verifiers of what cannot be
verified!) that all the things he has stated are absolutely true;
although at first, these worthy folk confess, they did in fact
suspect that it was merely a simple piece of fiction. Poe replies
that, for his part, he has never had any doubts at all.[6] Need I
quote, in addition, this short passage which catches my eye,
as I turn over, for the hundredth time, the pages of his enter-
taining *Marginalia*, which are like the secret recesses of his
mind: 'The enormous multiplication of books in every
branch of knowledge is one of the great evils of this age;
since it presents one of the most serious obstacles to the
acquisition of correct information.'[7] Aristocrat by nature even
more than by birth, this Virginian, this man from the South,
this Byron lost in an evil world, always keeps his philosophic
calm, and, whether he be defining the mob's nose or flaying
the fabricators of religion with his irony, whether he be
poking fun at circulating libraries, he remains what the true
poet was and always will be – a truth clothed in a strange habit,
an evident paradox, refusing to be elbowed by the crowd, and
running off to the extreme easterly point when the fireworks
are being let off in the west.

But here is a more important point than any: let us take careful note that this author, the product of a self-infatuated age, the child of a nation more full of its own importance than any other, has seen clearly, has calmly proclaimed the natural wickedness of man. There is in man, he writes, a mysterious force that modern philosophy refuses to take into account; and yet without this unmentioned force, without this primeval tendency, a vast number of human actions will remain un-explained, inexplicable. These actions exercise a pull only because they are bad, dangerous; they have the lure of the abyss. This primitive, irresistible force is the natural perversity that results in man's being constantly, and at one and the same time, homicidal and suicidal, murderer and executioner; for, he adds, with a remarkably satanic subtlety, in the absence of an adequate, reasonable motive to account for certain evil and dangerous actions, we might be led to put them down to the promptings of the Devil, if experience and history did not teach us that God often uses them to establish order and to punish the scoundrel – after having used those very scoundrels as accomplices! That is, I confess, the notion that slips into my mind, as an unspoken thought, as perfidious as it is inevitable. But for the moment I want to take account only of the great forgotten truth – the primeval perversity of man – and not without a very real sense of satisfaction do I see a few fragments of ancient wisdom floating back to us from a country whence they were not expected. How good it is that a few old-fashioned truths should thus explode in the faces of all these flatterers of humanity, of all these mollycoddlers and opiate-pedlars who never stop repeating, with every possible variation of tone, 'I am born good, and you too, and all of us, we're all born good!', quite forgetting – no! pretending to forget, nonsensical egalitarians that they are – that we are all born branded with the mark of evil!

What lie could he have been victim of, he who at times, by the painful necessity of social pressures, handled lies so well?

What scorn for all mock philosophy, on his good days, on the days when, so to speak, he was illuminated! This poet, some of whose stories seem to have been written deliberately to confirm the supposed omnipotence of man, sometimes felt the need to purge himself. The day on which he wrote: 'Only in dreams is certainty to be found',[8] he was thrusting his own Americanism down into the regions of inferior things; at other times, taking the road of all true poets, doubtless obeying the inescapable truth that haunts us all like a demon, he heaved the ardent sighs of 'the fallen angel that remembers the skies'[9]; his nostalgic thought flew towards the golden age and the lost Eden; he mourned all that magnificence of nature 'shrivelling up under the hot breath of the furnaces'; and then he dashed off those admirable pages, *Colloquy of Monos and Una*, which would have enchanted and disturbed the impeccable de Maistre.[10]

He it was who said of socialism, at a time when socialism still had no name, or at least when the name was not yet widespread: 'The world is infested now by a new sect of philosophers, not yet recognized as forming a sect, and consequently as yet without a name. They are "the believers in old wives' tales" (as if one were to call them preachers of "old hat"). The high priest in the East is Charles Fourier[11] – in the West, Horace Greely[12]; and high priests they are for good reason. The only common bond in the sect is credulity; let us call it madness, and talk no more of it. Ask any one of them why he believes this or that and if he be conscientious (ignoramuses usually are) he will give you a reply not unlike the one Talleyrand[13] gave when he was asked if he believed in the Bible: "I believe in it," quoth he, "first because I am Bishop of Autun, and secondly because I do not understand one word of it." What these philosophers call an argument is their way of denying what is and of explaining what is not.'

Nor could progress, that grand heresy of decrepitude, escape him. The reader will see in a number of passages the

sort of terms he uses to describe it. It really seems, from the ardour of his denunciations, that it was his duty to take vengeance on it as a public nuisance, as a street pest. How he would have laughed, with that scornful laugh of the poet who never joins the crowd of idlers, if he had happened, as I did recently, upon this ineffable passage, which recalls the farcical and deliberate nonsense of the clowns, and which I found displaying itself perfidiously in a highly serious newspaper: 'The constant progress of science has quite recently enabled man to rediscover the lost and long-sought-for secret . . . (Greek fire, copper tempering, anything that has disappeared), the most successful applications of which go back to a barbarous and very ancient period'!!!14 – that surely is a sentence that deserves to be called a real find, a dazzling discovery, even in a century – 'of constant progress'; but I suspect that the mummy Allamistakeo15 would not have failed to ask, in a soft and discreet tone of superiority, if it was also thanks to 'incessant' progress, to the inevitable, irresistible law of progress, that this much vaunted secret had been lost. But, setting all jesting aside, in a subject as full of tears as of laughter, may we not claim it as a truly stupefying thing to witness a nation, several nations, the whole of humanity very soon, saying to its wise men, its magicians: 'I will love you and exalt you, if you can persuade me that we are progressing willy-nilly, inevitably – as we lie asleep; free us from responsibility, cast a veil for us over the humiliation of comparisons, turn history into sophistry, and you may call yourselves the wisest amongst the wise?' – Is it not a matter for astonishment that this oh! so simple notion does not flash in every brainbox, namely that progress (in so far as it exists) sharpens suffering in proportion as it refines sensual pleasure, and that, if the skins of peoples get ever more delicate, they are evidently pursuing nothing but an *Italiam fugientem*,16 a conquest lost again at every minute, a form of progress that is a constant negation of itself?

But these illusions (deliberately fostered, be it said) have their roots in a soil of perversity and falsehood – will-o'-the-wisps of the bog – that drive souls in love with the fire eternal, like Edgar Poe, to a sense of disdain, and they excite obscure minds, like Jean-Jacques,[17] for whom wounded and quickly rebellious feelings do duty for a philosophy. That the latter had right on his side against 'the depraved animal'[18] is indisputable; but the depraved animal is entitled to reproach him for having invoked simple nature. Nature creates only monsters,[19] and the whole thing turns on finding an agreed definition for the word 'savages'. No philosopher dare set up as models those miserable hordes, rotted with disease, victims of the elements, at the mercy of wild beasts, as incapable of making weapons as of conceiving the idea of a supreme spiritual being. But, if we compare modern man, civilized man, with the savage, or rather a so-called civilized nation with a so-called barbarous nation, that is to say a nation deprived of all the ingenious inventions that make it unnecessary for the individual to cultivate heroism, who will fail to see that all the credit lies with the savage? By his nature, of necessity, even, he is encyclopedic, whereas civilized man is confined within the very small limits of his specialism. Civilized man invents the philosophy of progress to console himself for his abdication and decline; whereas primitive man, a feared and respected husband, a warrior forced to be individually brave, a poet in moments of melancholy, when the declining sun incites him to sing of the past and of his ancestors, comes closer to the borders of the ideal. What omission may we dare to reproach him with? He has priests, sorcerers and medicine men. Nay more, he has the dandy,[20] that ultimate incarnation of the idea of beauty, transported into the business of living, the arbiter on matters of form and good manners. His clothes, his adornment, his weapons, his pipe, all display an inventive faculty that we have long since lost. Can we really compare our lazy eyes and our stopped-up

ears to those eyes that pierce the mist, to those ears that could hear the grass growing?[21] And what of primitive woman, simple, childlike soul, obedient and caressing animal, giving herself utterly, well aware of being only the half of a destiny, are we to say she is inferior to the American woman, whose praises M. Bellegarigue (editor of the *Moniteur de l'Épicerie*) thought he was singing, in calling her the ideal type of the kept woman? – the very same woman whose over-calculating attitudes to life led Poe – normally so courteous, so respectful of beauty – to write the following sad lines: 'These large purses, like giant cucumbers, which are in fashion amongst our belles are not, as is commonly thought, of Parisian origin; they are quite simply and wholly native. What would be the point of such a fashion in Paris, where a woman puts nothing in her purse but her money? But an American woman's purse! That must be capacious enough for her to be able to put her money, all her money – and her whole soul – into it!' As for religion, I shall not speak of Vitzilipoutzli[22] as lightly as Alfred de Musset has done; I own, without shame, that I much prefer the cult of Teutatès[23] to that of Mammon; and the priest who offers up to the cruel extortioner of human sacrifice victims who die honourably, victims who want to die, seems to me a quite gentle and humane being in comparison with the financier who sacrifices populations solely to his personal interest. At long intervals, a glimmer of understanding for these things is to be found, and I happened once, in an article by M. Barbey d'Aurevilly, on an exclamation of philosophic sadness that sums up exactly all I would like to say on this matter: 'Oh! you civilized peoples that are for ever pointing the finger of scorn at the savages, soon you will no longer be worthy even of being idolaters!'

Such surroundings – I have said it before, I cannot resist saying it again – are scarcely made for poets. The 'State', as understood by even the most democratically-minded Frenchman, would be an inconceivable conception to the mind of an

American. For every intelligence moulded in the Old World, a political State has a power-generating core, which is its brain and its source of light, it has old and glorious memories, ancient poetic and military annals, an aristocracy, to which poverty, that daughter of revolutions, can but add a paradoxical lustre; but that! that mob of buyers and sellers, that nameless thing, that headless monster, that exile overseas, that, a State! Agreed! – if a vast drinking saloon, thronged with consumers doing their business at dirty tables, against a background hubbub of coarse talk, may be compared to a 'salon', to what we used to call a salon, in times past, a republic of cultured minds, where beauty held sway!

It will always be difficult to pursue, at once nobly and profitably, the profession of man of letters, without laying oneself open to the slander and calumny of the impotent, to the envy of the wealthy – that envy which is their punishment! – to the revenge of bourgeois mediocrity. But what is difficult under a moderate monarchy or a regular republic becomes almost impossible in a sort of lumber room where every man, self-constituted policeman of opinion, does his own policing, to the benefit of his vices – or his virtues, it's all the same – where a poet or a novelist in a slave-owning community is perforce a bad writer in the eyes of an abolitionist critic; where it is impossible to say which offers the greater cause for indignation: disorderly cynicism or imperturbable biblical hypocrisy. Burning chained-up negroes, guilty of having felt their black cheeks tingle with the flush of honour, revolver-play in a theatre pit, legalizing polygamy in divers paradises of the Far West, which the savages (the word savours of injustice) had not hitherto disgraced with such shameful utopias, sticking bills on walls, doubtless to confirm the principle of limitless liberty, advertising the 'cure of nine-month maladies', such are a few of the outstanding traits, a few examples of morality from the noble country of Franklin, inventor of counting-house morality, the hero of a century

dedicated to materialism. It is a good thing to call attention, constantly, to these wonders of brutishness, at a time when Americomania has almost become a fashionable enthusiasm, to such an extent that an archbishop has felt himself able to promise, in all seriousness, that Providence would soon call us to enjoy this transatlantic ideal.

III

A social environment of this order is bound to produce corresponding literary errors. It is these errors that Poe battled against, as often as he could, and with all his might. We must therefore be in no way surprised that American writers, whilst recognizing his remarkable power as poet and story-teller, have always tended to challenge his value as a critic. In a country where the utilitarian idea, the most hostile in the world to the idea of beauty, takes first place and dominates all other considerations, the perfect critic will be the most 'respectable', that is to say, the critic whose instinctive attitudes and desires will come closest to the attitudes and desires of his readers; the one who, confusing faculties and types of production, will ascribe to them all one single purpose; the one who will seek in a book of poetry a means of perfecting the conscience. Naturally he will, to that extent, become less attentive to the real positive beauties of poetry; he will, to that extent, be less shocked by the blemishes and even the vices of form. Edgar Poe, on the other hand, divided the world of mind into pure intellect, taste and moral sense,[24] and he applied his criticism according to which of the three divisions the object of his analysis belonged to. Above all, he was sensitive to the degree of perfection in the structure, and to formal correction. He would take literary works to pieces like a defective mechanism (defective, that is, in relation to its avowed aims), noting carefully the faults in manufacture; and, when he came to examine a work in detail, in its plastic

form or, in a word, its style, he would, without omitting anything, sift the errors of prosody, the grammatical mistakes, and all that mass of surface scum which, in writers who are not artists, spoils the best intentions and distorts the most noble conceptions.

For Poe, the imagination was the queen of the faculties[25]; but by this word he understood something greater than what the ordinary run of readers understand by it. Imagination is not fantasy, nor is it sensibility, difficult though it would be to conceive of an imaginative man who was not sensitive. Imagination is a virtually divine faculty that apprehends immediately, by means lying outside philosophical methods, the intimate and secret relation of things, the correspondences and analogies. The honours and functions Poe confers on this faculty give it such value (at least when one has thoroughly grasped the author's thought) that a scholar without imagination seems no more than a false scholar, or at least an incomplete one.

In the domains of literature, where imagination can achieve the most interesting results, can reap, not the richest nor the most precious treasures (these belong to poetry), but the most numerous and the most varied, one was particularly dear to Poe: the short story. The short story has one immense advantage over the novel, with its large canvas, namely that its brevity adds to the intensity of its effect. Reading a short story, which can be accomplished at a sitting, leaves a far sharper imprint on the mind than an episodic reading, a reading often interrupted by the worries of business and the care of mundane interests. The unity of impression, the totality of impact, is an immense advantage that may give this type of composition a very special superiority, to the extent that a story that is too short (which is no doubt a weakness) is still worth more than a story that is too long. If skilful, the artist will not adapt his ideas to the incidents; but, having conceived, in leisured deliberation, an effect he intends to produce, he will then

invent incidents, link up a series of events, best suited to bring about the effect desired. If the first sentence is not written with the preparation of the final impression in view, the work is a failure from the start. In the whole composition, not a single word must be allowed to slip in that is not loaded with intention, that does not tend, directly or indirectly, to complete the premeditated design.

On one point the short story is superior even to the poem. Rhythm is necessary to the development of the idea of beauty, which is the greatest and noblest aim of the poem. But the artifices of rhythm are an insurmountable obstacle to that detailed development of thoughts and expressions whose purpose is truth. For truth may often be the aim of the short story, and reasoned argument, the best tool for the construction of the perfect short story. That is why this kind of composition, which does not occupy so exalted a position as pure poetry, can offer ordinary readers products more varied in nature and easier for them to appreciate. Moreover, the author of a short story has at his disposal a multitude of tones, shades of language, the reasoning tone, the sarcastic, the humorous, all of which poetry eschews, and which are like discords, affronts, to the idea of pure beauty. That, too, is why the author who pursues, in the short story, no aim other than beauty, labours only to his disadvantage, deprived as he is of the most useful instrument, rhythm. I know that in all literatures, attempts have been made, often successful, to create purely poetic short stories; Edgar Poe himself has written some very beautiful ones. But these strivings and efforts serve only to show the strength of the true means adapted to corresponding ends, and for my part I am almost persuaded that in some authors, the greatest one can find, these heroic efforts were born of despair.

IV

That poets (using the word comprehensively, as including artists in general) are a *genus irritabile*[26] is well understood, but the *why* seems not to be commonly seen. An artist is an artist only by dint of his exquisite sense of beauty, a sense affording him rapturous enjoyment, but at the same time implying or involving an equally exquisite sense of deformity, of disproportion. Thus a wrong – an injustice – done to a poet who is really a poet excites him to a degree which to ordinary apprehension appears disproportionate with the wrong. Poets *see* injustice, never where it does not exist, but very often where the unpoetical see no injustice whatever. Thus the poetical irritability has no references to 'temper' in the vulgar sense, but merely to a more than usual clear-sightedness in respect to all forms of falseness and injustice, this clear-sightedness being nothing more than a corollary to the vivid perception of right – of justice – of proportion – in a word of beauty. But one thing is clear, that the man who is not 'irritable' (to the ordinary apprehension) is *no poet*.[27]

Thus speaks the poet himself, preparing an excellent and irrefutable apologia for all members of his kin. Poe carried this sensitiveness into all questions of literature, and the great importance he attached to all matters touching poetry often led to his adopting a tone in which, in the eyes of the weaker mortals, the sense of his superiority was too obvious. I think I have already observed that several of the prejudices he had to fight against, the false notions and vulgar opinions that floated around him, have long since infected the French press. It will therefore not be without profit to give a short account of some of his most important views on poetic composition. The parallelism of error will make their application quite easy.

But first and foremost I shall say that, having allotted the due share to the natural poet, to innateness, Poe goes on to apportion another to knowledge, hard work, analysis, a share that will appear exorbitant to the pride of the unscholarly. Not only did he expend considerable efforts to subordinate the fleeting demon of the blissful moments to his will, to

recall at will his exquisite experience, his spiritual yearnings, his states of poetic well-being, so rare, so precious, that they could really be considered as miracles of grace, exterior to man, and as visitations; but also he subjected inspiration to the strictest method and analysis. The choice of means! He comes back to this constantly. He dwells, with informed eloquence, on making means correspond with effects, on the use of rhyme, on perfecting the refrain, on adaptation of rhythm to feeling. He was fond of saying that whosoever cannot grasp the intangible is no poet; that he only is a poet who is master of his memory, the master of words, the register of his own feelings, always ready to be opened and consulted. Everything for the final impact!, he often repeats. Even a sonnet needs a plan, and construction, the framework, so to speak, is the most important surety of the mysterious life that informs the works of the spirit.

In the article entitled *The Poetic Principle*, to which I naturally need to refer, I find at the very outset a vigorous protest against what in matters of poetry might be termed the heresy of length or size – the absurd value attributed to lengthy poems. 'I hold that a long poem does not exist. I maintain that the phrase "a long poem" is simply a flat contradiction in terms.' Indeed, a poem deserves its name only in so far as it excites, ravishes the soul, and the positive value of a poem is proportionate to that excitement, that ravishment of the soul. But by a psychological necessity all excitements are fleeting and transitory. This strange state, into which the reader's soul has, so to speak, been drawn by force, will surely not last as long as reading any poem that extends beyond such tenacious enthusiasm as human nature can muster.

That clearly condemns the epic poem. For a work of those dimensions can be considered poetic only in so far as we are prepared to sacrifice the vital condition of any work of art – unity. By this I mean, not unity of conception, but unity of impression, the totality of impact, a point I made when com-

paring the novel and the short story. The epic poem therefore appears to us, in aesthetic terms, a paradox. It may be true that ancient times did produce whole series of lyrical poems that were subsequently strung together by compilers of epic poems; but every epic intention is obviously the result of an imperfect artistic sense. The day of these artistic anomalies is past, and it is even highly dubious whether a long poem could ever have been really popular, in the full sense of the term.

It must be added that a poem that is too short, the poem that cannot provide enough pabulum for the excitement created, the poem that does not satisfy the reader's natural appetite, is also most defective. However brilliant and intense the effect, it will not last; the memory will not retain it; it is like a seal too lightly and too hastily applied, which has not had the time to impress its image on the wax.

But there is yet another heresy,[28] which, thanks to the hypocrisy, the dullness and the meanness of our minds, is far more dangerous, and has greater chances of lasting – an error far harder to kill; I refer to the heresy of didacticism, which includes, as inevitable corollaries, the heresies of passion, of truth and morality. A whole crowd of people imagine that the aim of poetry is some sort of lesson, that its duty is to fortify conscience, or to perfect social behaviour, or even, finally, to demonstrate something or other that is useful. Edgar Poe claims that the Americans, particularly, have fostered this heterodox notion; alas! there is no need to go as far as Boston[29] to come upon the heresy in question. Here, in this very place, we are besieged by it, and every day it batters a hole in the ramparts of true poetry. If we will even briefly look into ourselves, question our souls, bring to mind our moments of enthusiasm, poetry will be seen to have no other aim but itself; it can have no other, and no poem will be as great, as noble, so truly worthy of the name 'poem' as the one written for no purpose other than the pleasure of writing a poem.

Let there be no misunderstanding: I do not mean to say that poetry does not ennoble manners – that its final result is not to raise man above the level of squalid interests; that would clearly be absurd. What I am saying is that, if the poet has pursued a moral aim, he will have diminished his poetic power; nor will it be incautious to bet that his work is bad. Poetry cannot, except at the price of death or decay, assume the mantle of science or morality; the pursuit of truth is not its aim, it has nothing outside itself. The modes of demonstration of truth are other, and elsewhere. Truth has nothing to do with song. The things that go to make the charm, the grace, the compelling nature of a song would rob the truth of its authority and power. Cold, calm, unmoved, the proving humour rejects the diamonds and the flowers of the muse; it is therefore at the opposite pole from the poetic humour.

Pure intellect pursues truth, taste reveals beauty to us, and our moral sense shows us the path of duty. It is true that the middle term has intimate connections with the two extremes, and is separated from the moral sense only by such a narrow shade of difference that Aristotle did not hesitate to number some of its delicate operations amongst the virtues. This is why the thing that particularly exasperates the man of taste, as he looks on vice, is its deformity, its lack of proportion. Vice offends against accuracy and truth, disgusts intellect and conscience; but as an outrage to harmony, as dissonance, it will in particular hurt certain poetic spirits; nor do I think it shocking to regard any infringement of morality, of moral beauty, as a kind of offence against universal rhythm and prosody.

It is this admirable, this immortal, instinctive sense of beauty that leads us to look upon the spectacle of this world as a glimpse, a correspondence with heaven. Our unquenchable thirst for all that lies beyond, and that life reveals, is the liveliest proof of our immortality. It is both by poetry and

through poetry, by music and through music, that the soul dimly descries the splendours beyond the tomb; and when an exquisite poem brings tears to our eyes, those tears are not the proof of overabundant joy: they bear witness rather to an impatient melancholy, a clamant demand by our nerves, our nature, exiled in imperfection, which would fain enter into immediate possession, while still on this earth, of a revealed paradise.

Thus the poetic principle is strictly and simply the human longing for a superior form of beauty, and the manifestation of this principle lies in an enthusiasm, an excitement of the soul – an enthusiasm that is quite independent of passion, which is an intoxication of the heart, and of truth, which is a nourishment of reason. For passion is natural, too natural not to introduce a hurtful, jarring note into the realm of pure beauty; too familiar and too violent not to shock the pure desires, the sweet melancholies, the noble despairs, that dwell in the supernatural spheres of poetry.

This rare elevation, this exquisite delicacy, this element of immortality that Edgar Poe demanded of the muse, far from diminishing his attention to the practice of writing, drove him to sharpen ceaselessly his genius as a practitioner. Many people, especially those who have read that strange poem entitled *The Raven*, would be shocked if I were to analyse the article where our poet, with an appearance of ingenuousness but with a delicate impertinence I cannot disapprove of, minutely explained the building method he used, the adaptation of the rhythm, the choice of refrain – the shortest possible, the most easily applied to the various uses, and, at the same time, the most suggestive of melancholy and despair, adorned with the most sonorous rhyme of all ('nevermore'); the choice of a bird that can imitate the human voice, but a bird – the raven – stamped in popular imagination with the character of ill-omen and doom; the choice of the most poetic tone of all, the tone of melancholy; of the most poetic

sentiment of all, the love of a dead woman etc. . . . 'And I shall
not place the hero of my poem', he says, 'in poor surround-
ings, because poverty is a mean thing and contrary to the idea
of beauty. His melancholy shall have as its home a room
richly and poetically furnished.'30

The reader will discover in several of Poe's short stories
interesting traces of this pronounced taste for beautiful
forms, especially if they have an element of strangeness, for
ornate surroundings and oriental luxury.

I said that this article struck me as marked by a suspicion of
impertinence. The proponents of inspiration above all will not
fail to interpret it as an act of blasphemous profanity; but I
think it was for them that the article was written. Just as some
writers make a parade of negligence, aiming at a masterpiece
with their eyes shut, full of confidence in disorder, and
expecting letters thrown up to the ceiling to fall down again
as a poem on the floor, so Edgar Poe – one of the most
inspired men known to me – prided himself on hiding
spontaneity, on simulating cold deliberation. 'I think I may
boast', he writes with an amusing gust of pride, which I do
not find in bad taste, 'that no one point in its composition is
left to chance, and that the whole work advanced step by step
towards its goal with the precision and rigorous logic of a
mathematical problem.'31

Only believers in chance, I repeat, the fatalists of inspiration,
and the fanatics of blank verse, can find such *minutiae* odd.
There are no *minutiae* in matters of art.

Talking of blank verse, I would add that Poe attached
great importance to rhyme; and in his analysis of the mathe-
matical and musical pleasure that the mind derives from
rhyme, he took as much care, and displayed as much subtlety,
as in any subject concerning the craft of poetry. Just as he
showed that the refrain is capable of an infinite variety of
applications, he also sought to rejuvenate, redouble the
pleasure of rhyme, by adding a new element to it, strangeness,

which is like the indispensable condiment of all beauty. He often has an inspired way of using repetition of the same line or several lines, a persistent return of sentences that counterfeits the obsessions of melancholy or a fixed idea; of using the refrain, pure and simple, but introduced in various different ways; of the refrain variant that suggests nonchalant absence of mind; of double and triple rhymes, and also rhymes of a kind that brings into modern verse, but with greater precision and intention, the surprises of the leonine line.[32]

Evidently, the value of all these means can be tested only by their use; and to translate poems so deliberately composed, so concentrated, may be an enticing dream, but can be no more than a dream. Poe did not write much poetry; he used sometimes to express regret at his lack of opportunity to dedicate himself, not merely more often, but exclusively, to this kind of work, which he considered the noblest. But his poetry always makes a powerful impact. The fiery effusions of Byron, the soft, harmonious, well-bred melancholy of Tennyson, for whom, incidentally, he entertained an almost fraternal admiration, these will not be found here. What we do find is something deep and shimmering like a dream, the mysterious perfection of crystal. I assume that I do not need to add that American critics have often disparaged this poetry; quite recently, in an American biographical dictionary, I came upon an article which condemned it for its strangeness, expressed fear lest this muse so artfully attired should create a school in the glorious country of utilitarian morality, and, finally, regretted that Poe had not applied his talents to the expression of moral truths instead of squandering them in search of a bizarre ideal, and lavishing, in his verse, a form of pleasure admittedly full of mystery but also of sensuality.

We know only too well this type of fencing according to the rules for what it is. The attacks that bad critics make on good poets are the same in all countries. As I read that article, I had the impression that I was reading the translation of one

of those numerous indictments, from the pens of Parisian critics, of those amongst our poets who are the most dedicated to perfection. The ones we like best are easy to guess, and any lover of pure poetry will understand me when I say that in our anti-poetic race, Victor Hugo would be less admired if he were perfect, and that he has succeeded in getting himself forgiven for his abundant lyrical genius only by introducing, artificially and crudely, into his poetry what Edgar Poe thought was the crowning modern heresy – didacticism.

8. Some French Caricaturists[1]

Carle Vernet – Pigal – Charlet – Daumier – Monnier –
Grandville – Gavarni – Trimolet – Traviès – Jacque

AN astonishing man, this Carle Vernet.[2] His work is a world
in itself, a *Comédie humaine* in miniature; for trivial illus-
trations, thumb-nail sketches of the crowd and the street
scene, caricatures are often the most faithful mirror of life.
Often too, caricatures, like fashion plates, become more pro-
nouncedly caricaturish the more old-fashioned they become.
Thus the stiff ungainly impression given by the figures of
those days causes us odd surprise and affront; and yet all that
world is much less deliberately odd than we are apt to believe.
Such was fashion, such the human being; the men were like
the paintings of the day; society had taken its form from the
mould of art. Each individual was stiff, erect, and with his
skimpy frock-coat, his hunting boots and his locks cascading
down over his brow, every citizen looked like a nude study
that had been round to the second-hand clothes shop. It is not
only because he has so faithfully kept the sculptural imprint
and the claims to stylishness of the period, it is not only, I
repeat, from a historical point of view that Carle Vernet's
caricatures have great value; they also have an undoubted art-
istic value. The poses, the gestures, have the accent of truth;
the heads and physiognomies have a style that many of us can
verify as we recall the guests in our parents' drawing-rooms
in the days of our childhood. His fashion caricatures are
superb. Everyone will remember the big plate illustrating a
gaming house.[3] Around a vast oval table, gamblers of all sorts
and all ages are gathered, amongst them, inevitably, loose
women, eagerly watching the run of the play, the eternal

courtesans of the gamblers in luck. The violence of joy or despair can be seen on every face; young impetuous gamblers, squandering their winnings; cold, earnest and tenacious gamblers; old men, whose few grey hairs testify to the furious gales of past equinoxes. No doubt this composition, like everything that comes from the pen of Carle Vernet and his school, lacks freedom; but, on the other hand, it is a really serious piece, its harshness is pleasing, its astringency of manner suits the subject well, since gambling is a passion both violent and contained.

One of those who were later to make a big name for themselves was Pigal.[4] Pigal's earliest works go back quite a long way, and Carle Vernet lived to a very old age. But, often enough, it can be said that two contemporaries represent two distinct epochs, even though in age they may have been fairly close to each other. Does this amusing and mild caricaturist not still send to our annual exhibitions small pictures informed with an innocent spirit of comedy that M. Biard[5] must find very feeble? Character, and not age, decides these things. And so Pigal is something quite different from Carle Vernet. His style serves as a transition between caricature as conceived by the latter and the more modern style of a Charlet for example, whom I shall be speaking about presently. Charlet, who belongs to the same generation as Pigal, invites the same comment: the word 'modern' applies to his manner, not to the period in time. Pigal's popular scenes are good. It is not that their originality is particularly lively, nor even the drawing of them very comic. Pigal is a moderate comic, but the feeling of his composition is sound and accurate. His truths are commonplace, but truths they are. Most of his pictures are direct from life. He has followed a simple and modest technique: he looks, he listens, and then he tells his story. Usually all his compositions are full of harmless good nature: almost always working-class types, popular sayings, old drunkards, domestic scenes, and in particular an un-

conscious bias towards old folk, which explains why Pigal, in company with many caricaturists, is not good at interpreting youth; his young people often look as if they were made up. His drawing, generally free, is richer and more rounded than that of Carle Vernet. Almost the sum total of Pigal's merits therefore consists in the habit of reliable observation, a good memory, and an adequate sureness of execution; little or no imagination, but good common sense. There is neither Italian gaiety with its exalted carnival mood, nor the violent bitterness of the English. Pigal is an essentially reasonable caricaturist.

I am in some doubt about how to express my opinion of Charlet[6] in a suitable way. His is a big reputation, an essentially French reputation, one of the glories of France. He has filled a whole generation of men still living today with joy, laughter, and even tears of pity, so they say. I have known people who were quite sincerely indignant that Charlet was not a member of the Institut.[7] For them this was just as much a scandal as Molière's not having been a member of the Academy. I am well aware that no glamour attaches to telling people how wrong they have been to laugh or be moved in a given manner; it really hurts to have a bone to pick with universal suffrage. Yet I must have the courage of my convictions and say that Charlet does not belong to the order of men who live for ever, and are cosmopolitan geniuses. He is not a caricaturist citizen of the universe; and if I am told that a caricaturist can never be that, my answer is he can be, more or less. Charlet is an artist of circumstance and a patriot exclusively, two hindrances to genius. In common with another famous man,[8] whom I shall refrain from naming because the time is not yet ripe, he has built up his reputation entirely on France and especially on the nobility of the soldiery. I maintain that this is bad and betrays a small mind. Like the other great man, he has lavishly insulted the priesthood; that, I maintain, is bad too, a bad symptom; such characters are

unintelligible beyond the Rhine and the Pyrenees. Presently we shall deal with the artist, that is to say with the talent, the execution, the draughtsmanship, the style; we will go into it all thoroughly. For the moment I am talking about the spirit of his work.

Charlet has always courted favour with the populace. He is not a free man; he is a slave; do not hope to find in him a disinterested artist. A drawing by Charlet is rarely a truth; it is almost always a pat on the back for his favourite social group. Beautiful, kind, noble, agreeable, witty, only the soldier is all these things. The few milliard animalculae that feed on this planet have been created by God and endowed with organs and senses for no other purpose than to stand in admiration before the soldiery and the drawings of Charlet in all their glory. Charlet proclaims that the 'poor bloody infantry' and the grenadier are the be-all and end-all of creation. Quite certainly all this is a long way from caricature; it is a matter of dithyrambs and panegyrics, to such an extent did this man understand his profession the wrong way round. The oafish simplicity that Charlet attributes to his raw recruits is portrayed with a certain charm, which does them credit and makes them interesting. It recalls the vaudevilles where the peasant commits the most touching and the most diverting linguistic lapses. They have hearts of gold and the wit of an academy except for the liaisons. To show the peasant as he really is is a useless fantasy of Balzac's[9]; to paint with ruthless accuracy the evil in men's hearts, that is good for Hogarth, that teasing hypochondriac; to show in their true colours the vices of the soldiery, oh how cruel! It might discourage him. That is how the famous Charlet understands caricature.

Towards the priest, precisely the same attitude of mind guides our prejudiced artist; no question of portraying in an original way with brush or pencil the moral ugliness of the sacristy; the important thing is to please the soldier-peasant; the soldier-peasant was the sworn enemy of the Jesuit. In the

arts the whole aim is to please, as the bourgeois are wont to say.

Goya also made attacks on the race of monks. I presume he did not like monks, for his monks are very ugly; but how resplendent they are, in their ugliness, how triumphant they are in their monkish filth and debauchery! Here, art dominates, art as purifying as fire; there, the sort of servility that corrupts art.

Now compare the artist with the courtier: in one case, magnificent drawings, in the other, a Voltairian sermon.

Much has been said of Charlet's urchins, those dear little angels, who will make such pretty little soldiers, who are so fond of old campaigners, who are for ever playing war games with wooden swords. Always plump and fresh like a crab apple, heart on sleeve, clear-eyed and smiling at nature. But what of the little terrors, what of the 'pale urchin' of the great poet,[10] with raucous voice and a complexion as yellow as an old *sou*? Charlet has too pure a heart to so much as see such things.

Sometimes, we are bound to say, his intentions were praiseworthy. Scene: a forest; a group of brigands and their womenfolk are having a meal and resting at the foot of an oak tree from which a corpse already long and emaciated hangs, taking in the freshness of the upper air and breathing the dew; his nose points downwards, his toes are strictly aligned like those of a dancer. One of the brigands, pointing his finger at him, exclaims: That is what we will be like perhaps, come Sunday!

Alas, he gives us few sketches such as this. Moreover, even though the idea be good, the drawing is not good enough; the faces, poorly studied, have little character. It could all be much more impressive, and quite certainly does not compare with the verses of Villon[11] supping with his cronies at the foot of the gallows in the darkening plain.

Charlet's drawing is little else but *chic*, nothing but circles and ovals. As for the sentiments expressed, he took them

ready-made from the current vaudevilles. He is a very artificial man, who had the idea of imitating the popular ideas of the day. He took a carbon copy of public opinion. He modelled himself on fashion. The public, really, was his dressmaker's pattern.

Once, however, he did do quite a good thing, and that is a set of drawings showing the dress of the Young and the Old Guard, a set not to be confused with a similar work, published recently, and which I think is a posthumous work.

The figures really have individual character. They must have been taken from life. The bearing, the gestures, the carriage of the head are excellent. But Charlet was young then, he did not suppose himself to be a great man, and his popularity did not yet allow him to dispense with careful drawing of his figures or planting them firmly on the ground. Thereafter he became more and more careless, until in the end he came to doing and for ever repeating commonplace scribblings that the youngest art student with a bit of pride would not own to. It is proper to add that the work I am referring to is of a simple sincere workmanlike kind, demanding none of the qualities subsequently attributed, quite gratuitously, to an artist so poorly endowed with comic gift. If I had remained faithful to my strict line of thought, I would not, my task being to write of the caricaturists, have included Charlet in my list, any more than Pinelli: but I would have been accused of serious omissions.

To sum up: Charlet was a manufacturer of nationalistic nonsense, a dealer, under patent, in political proverbs, a type of idol that, by and large, has as easy a life as any other type of idol; he will soon experience the power of oblivion and along with the *great* painter[12] and the *great* poet,[13] his first cousins in ignorance and fatheadedness, he will lie undisturbed in the waste-paper basket of indifference, like so much waste paper, uselessly scrawled on, and useless for anything but making new paper.

Now I propose to turn to one of the most important men, not only in caricature but also in modern art, to a man who every morning gives the Parisian population a laugh, who, every day, supplies the need of public gaiety, and gives it something to feed on. Honest burgher, businessman, youngster, fine lady, one and all laugh, and often go their way – the ungrateful creatures! – without looking at the signature. Until now, only artists have appreciated the serious vein that lies hidden there, and the fact that it deserves serious study. The reader will have guessed that Daumier is the man I am referring to.

Honoré Daumier's[14] early career was not all that bright; he drew because he felt the need to draw, an inescapable vocation. He first published a few thumb-nail sketches in an insignificant daily, launched by William Duckett; then Achille Ricourt, who was at that time a dealer in engravings, bought a few from him. The revolution of 1830, like all revolutions, produced a rash of caricatures. It really was a heyday for caricaturists. In this merciless war against the government and especially against the King, passion and ardour were the order of the day. This vast series of historical buffoonery, which was called *La Caricature*,[15] is in truth a phenomenon worthy of our interest today; we have here rich archives, to which all artists of any value made their contribution. It is a hubbub, an untidy lumber room, a prodigious satanic comedy, now buffooning, now drawing blood, in which appear all the political notables, dressed up in the most motley and grotesque costumes imaginable. In this gallery of big names of the Monarchy in its early years, what a number are already forgotten! This fantastic epic is dominated, crowned by the pyramidal and olympian *Poire*[16] of litigious memory. Readers will remember that Philipon, who was constantly in trouble with the royal courts of law, wishing on one occasion to demonstrate to the court that nothing could be more innocent than this tiresome and unfortunate pear,

actually drew during the hearing itself a succession of sketches, of which the first was the exact image of the Monarch's face, and the others, moving further and further away from the first state, got closer and closer to the fatal last state: the pear. 'Look,' quoth he, 'what connection can you see between this last sketch and the first?' Similar experiments have been made with the head of Jesus and that of Apollo, and I believe that the artist actually succeeded in reducing one or other of them to the likeness of a toad. This proved nothing at all. The symbol had been found, thanks to an obliging analogy. From then on the symbol was enough. With this kind of plastic slang, artists could express and convey to the populace anything they liked, and it was therefore around this tyrannical and cursed pear that the large mob of yelling patriots collected. The truth is that remarkable relentlessness and cohesion were displayed in the operation, and, however dogged the reply of the authorities, it is a matter of great surprise today, when we look through these archives of buffoonery, that such a furious war could have been kept up for so long.

Just now I think I used the expression 'blood-drawing buffoonery', and indeed these drawings are often full of blood and fury. Massacres, jailings, arrests, searches, trials, police brutalities, all these episodes, dating from the first years of the 1830 government, reappear constantly; let the reader judge for himself:

Liberty, with her Phrygian bonnet on her head, young and beautiful, has fallen asleep, unguardedly and quite unaware of the danger that threatens her. A man stealthily advances towards her, with evil designs. He has the heavy shoulders of a market porter or a fat landlord. His pear-shaped head is crowned with a prominent tuft of hair and flanked with large mutton-chop whiskers. The monster is seen from behind, and the fun of guessing his name added not a little to the value of the print. He advances on the young lady and prepares to rape her.

Have you said your prayers this evening, madam? – Othello/ Philippe, none other, smothers innocent Liberty in spite of her cries and her struggles.

Or again, along the wall of a highly suspicious-looking house comes a girl, a little Phrygian bonnet on her head; she wears it with the innocent coquetry of a democratic *grisette*. Messrs So-and-so and So-and-so (well-known faces – ministers of the Crown and, you may be sure, highly respected) are here shown plying an unusual trade. They close in on the poor child, whisper sweet nothings or coarse jests in her ear and manoeuvre her slowly towards the narrow passage. Behind the door the *Man* is just visible in the shadow. His features cannot be seen but it is He all right. Look! there is the tuft of hair and the mutton-chop whiskers. He is waiting impatiently.

And here Liberty is being dragged before a Provost's Court or some other Gothic tribunal: a huge gallery of contemporary portraits in ancient garb.

In another print, Liberty is being brought into the torture chamber. Her slender ankles are going to be crushed, her stomach will be distended with torrents of water, or some other abomination is to be wreaked on her. These athletic types with bare arms and robust torsos, hungry for torture, are easy to recognize: surely Messrs So-and-so, So-and-so, and So-and-so – the most hated targets of public opinion.*

In all these drawings, most of which are executed with remarkable earnestness and conscientiousness, the Monarch always plays the role of an ogre, an assassin, an unsated Gargantua, or sometimes something worse. Since the February Revolution[17] I have seen only one caricature which for ferocity recalled to my mind the days of the great political hatreds; for all the political propaganda displayed in shop windows at the time of the big presidential election[18] offered

*I no longer have the documents in front of me; it could be that one of these latter was by Traviès.

only anaemic things in comparison with the production of the period I have just been talking about. That caricature appeared soon after the unfortunate massacres at Rouen[19]; in the fore-ground a corpse, riddled with bullets, lying on a stretcher; behind the body stand all the local bigwigs, in uniform, hair well curled, tight-laced, well-groomed, mustachios curled up, and inflated with pride; in that lot surely there must be some bourgeois dandies just going on guard duty or to help crush a riot, with a posy of violets in the buttonhole of their tunics: in fact, the ideal of the *garde bourgeoise*, to quote the most celebrated of our demagogues. Kneeling in front of the stretcher wrapped in his judge's gown, his mouth open and displaying like a shark his two rows of saw-teeth, F.C.[20] is slowly drawing his talons across the corpse's flesh, and scratching it with delight – 'Ah! The Norman twister!' he exclaims, 'he's shamming death so as to avoid answering to Justice!'

It was with just that sort of fury that *La Caricature* made war on the government. Daumier played a leading role in this permanent skirmishing. A means had been found to meet the fines that rained down on the *Le Charivari*[21]; it consisted of publishing supplementary drawings in *La Caricature*, the sale of which was used to pay the fines. On the deplorable massacre of the Rue Transnonain,[22] Daumier revealed himself as a really great artist; the drawing has become quite rare because it was seized and destroyed. It is not what you would call caricature exactly, it is history, it is reality, trivial and terrible. The scene is a poor miserable bedroom, the tradi-tional type of proletarian bedroom, with only the poorest and most essential sticks of furniture; stretched across the floor lies a dead workman, sprawling on his back, naked but for his nightshirt, and his head in its cotton nightcap, legs and arms outstretched. The room must have been the scene of a violent struggle and hubbub, for the chairs have been knocked over, as well as the bedside table and chamber-pot. Under the weight

of his corpse, the father is crushing between his back and the floor boards the body of his small son. In this cold attic nothing but silence and death.

It was also at this time that Daumier began working on a portrait gallery of prominent politicians. There were two sets, one full-length, the other bust-size. The latter is, I think, more recent, and contained only peers of the realm in it. The artist displayed a wonderful understanding of portraiture; whilst giving emphasis and exaggeration to the original features, he has nonetheless remained so faithful to nature's framework that these works can serve as models for all portrait painters. All the meannesses of soul, all the absurdities, all the idio-syncrasies of mind, all the heart's vices, can be read, and are clearly visible on these animalized faces; and at the same time the drawing is bold and clearly defined. Daumier had, at one and the same time, the suppleness of an artist and the accuracy of a Lavater.[23] For the rest, those of his works which date from that time are very different from what he is doing today. Lacking are the ease of improvisation, the supple delicacy of pencil he acquired later. Now and then, but rarely, there is a touch of heaviness. But the execution is always thorough, conscientious and rigorous.

I remember another very beautiful drawing that belongs to the same class: *La Liberté de la Presse*. Surrounded by his instruments of emancipation, his printing equipment, a journeyman-printer, with the traditional paper bonnet over his ear, shirt sleeves rolled up, facing us, squarely and firmly planted on his large feet, is clenching his fists and scowling. The bone structure and the muscle development of the man recall the figures of the great masters. In the background lurks the eternal Philippe and his policemen. They dare not try conclusions with him.

But our great artist has done many widely different things. First let me describe some of the most outstanding engravings chosen from different genres, and then I shall analyse the

philosophic and artistic value of this unusual man, and finally,
before taking leave of him, I shall give a list of the different
series and categories of his work, or at least I shall do my best,
for by now his work is a veritable labyrinth, an inextricable
jungle.

Le Dernier Bain, a serious and heartbreaking caricature: the
scene is a quay-side; standing on the parapet, and already
leaning outwards, thus describing an acute angle with the
base he is about to quit, like a toppling statue, a man is letting
himself fall, straight as a ramrod, into the river. His mind must
be firmly made up. His arms are quietly folded; a large
cobblestone is roped to his neck. He must have sworn a great
oath not to come through alive. This is no poet's suicide,
hoping to be fished out and get himself talked about. Take a
look at the threadbare frock-coat, gaping at the seams, and the
man's bones jutting out! And the sordid necktie, twisted like
a snake; and, bony and pointed, the Adam's apple. Who
could be cruel enough to condemn the poor devil for seeking
escape under water from the spectacle of civilization! In the
background, on the far side of the river, a contemplative
bourgeois, with rounded paunch, is enjoying the innocent
pleasures of fishing.

Now imagine a remote spot, hard by an unknown and
unfrequented toll gate, under the full weight of a burning sun.
A man of rather funereal appearance, an undertaker's mute or
a doctor, is clinking glasses and drinking with a hideous
skeleton opposite him in a leafless arbour under a dusty
trellis. Beside them the hour-glass and the scythe. I cannot
remember the title of this plate. Doubtless these two charac-
ters, bursting with vanity, are laying some murderous wager,
or carrying on a learned disputation on mortality.

Daumier has scattered his talents in a thousand different
places. He executed some wonderful drawings when com-
missioned to illustrate a rather second-rate medico-poetic
journal, the *Némésis médicale*. One of these, which deals with

the cholera outbreak, shows a public square inundated, oppressed, with sunlight and heat. The Parisian sky, faithful to its ironic habits at times of great scourges and great political upheavals, is perfect; it is colourless and burning with heat. The shadows are black and clear-cut. A corpse lies across a door. A woman hurries in, holding her hand tightly over her nose and mouth. The square is hot and deserted, more desolate than a square that a riot has swept clear of its teeming crowds, and transformed into a desert solitude. In the background the silhouettes of two or three little hearses can be descried, harnessed to comic old nags; and, lost in the centre of this abandoned forum, a pathetic dog with its tail between its legs is sniffing the scorched paving stones, aimless, thoughtless, nothing but skin and bone.

And here is a convict station. A very learned gentleman, black coat, white cravat, a philanthropist, a redresser of wrongs, is seated, with an ecstatic air, between two convicts with terrifying faces, stupid as cretins, fierce as bulldogs, worn-out like old rags. One of them is telling the learned gentleman that he has murdered his father, raped his sister or done some other outstanding deed. 'Ah! my friend!' exclaims the scholar in ecstasy, 'what a rich nature must have been yours.'

These specimens will suffice to show how serious Daumier's thought often is, and how vigorously he treats his theme. Look through his work, and you will see parading before you in its fantastic and gripping reality all the living monstrosities a great city can contain. All the fearful, grotesque, sinister and ludicrous treasures it gathers together, Daumier knows them all. The living and famished corpse, the fat well-fed corpse, the ridiculous trivialities of married life, every sort of silliness, of pride, of enthusiasm, of despair that bourgeois flesh is heir to, not a thing is missing. No one better than he has known and loved (in the manner of artists) the bourgeois, this last vestige of the Middle Ages, this ruin of Gothic times, tough

as they make them, this type at once so commonplace and so eccentric, Daumier has lived in close contact with him, has watched him day and night; he has learned his intimate secrets, has made the acquaintance of his wife and children, knows the shape of his nose, the structure of his head, he knows the sort of spirit that gives life to the household, from top to bottom.

To make a complete analysis of Daumier's work would be an impossible task; here are the titles of his main series, without too much being said in evaluation or commentary – in all of them there are some wonderful things: *Robert Macaire*, *Mœurs conjugales*, *Types parisiens*, *Profils et silhouettes*, *Les Baigneurs*, *Les Baigneuses*, *Les Canotiers parisiens*, *Les Bas-bleus*, *Pastorales*, *Histoire ancienne*, *Les Bons Bourgeois*, *Les Gens de Justice*, *La Journée de M. Coquelet*, *Les Philanthropes du jour*, *Actualités*, *Tout ce qu'on voudra*, *Les Représentants représentés*. Add to that the two sets of portraits that I have spoken of.*

I have two important observations to make about two of these series, *Robert Macaire* and *Histoire ancienne*. *Robert Macaire* was the clear starting point of the caricature of manners. The bitter political strife had abated somewhat. The persistence of court prosecutions, the attitude of the government, which had established itself more firmly, and a certain lassitude, natural to the human mind, had all largely quenched the fire. Something new had to be found. The political pamphlet gave way to comedy. The *Satire Ménippée*[24] made way for Molière, and the grand epic of *Robert Macaire*, related by Daumier in flamboyant vein, followed the revolutionary fury and contemporaneous allusions. And so caricature took on a new character, and was no longer particularly political. It became the general satire of the citizenry. It impinged on the domain of the novel.

*His unceasing and regular production has made this list most incomplete. Once, with Daumier's help, I tried to make a complete catalogue of his work. Between us we were not able to do it.

The *Histoire ancienne* seems important to me because it is the best paraphrase, so to speak, of the celebrated line:

Qui nous délivrera des Grecs et des Romains?[25]

Daumier has launched a brutal attack on antiquity, on false antiquity – for none better than he is aware of the great things of antiquity – and has spat upon it; that hot-head Achilles, and that cautious fellow Ulysses, and the sagacious Penelope, and that great booby Telemachus, and the beautiful Helen, bane of Troy, the whole lot of them in fact appear before us under a guise of grotesque ugliness, which recalls those old carcasses of tragic actors taking a pinch of snuff in the wings. In all, a most entertaining piece of irreverence, and one, moreover, that was not without its usefulness. I can see now a friend of mine, a lyric poet and one of the 'Pagan School',[26] being highly indignant about it. He called it impious, and spoke of the lovely Helen as others speak of the Virgin Mary. But those of us who have no great respect for Olympus and for tragedy were naturally inclined to enjoy the joke.

To conclude, Daumier extended greatly the limits of his art. He has made a serious art of it; he is a great caricaturist. To assess his true worth, he needs to be analysed both as an artist and as a moralist. As artist, Daumier's distinguished mark is sureness of hand. He draws like the great masters. His drawing is rich and flowing, it is an uninterrupted improvisation and yet it is not just *chic*. He has a wonderful and almost divine visual memory, which takes the place of the model. All his figures stand firmly and are faithfully portrayed in movement. His gift of observation is so sure that it would be quite impossible to find in his drawings a single head that does not seem to fit on to the body that carries it. A given nose, a given forehead, an eye, foot, hand; it is all the logic of the scholar transplanted into a light and fleeting art, which competes with the mobility of life itself.

As for the moral aspect, Daumier has some affinities with Molière. Like him, Daumier goes straight to his goal. The image emerges at once. You look and you understand at once. The texts that accompany his drawings do not serve much purpose, and could usually be dispensed with. His comic sense is involuntary, so to speak. The artist does not have to search for an idea; the idea seems rather just to spring out of him. His caricature has a formidable breadth, but no rancour or bitterness. In all his work there is a fund of courtesy and bonhomie. Often, and the point should be noted, he refused to treat certain satirical themes, both very beautiful and very violent, because, he said, they went beyond the limits of the comic and might wound the conscience of humanity. That is why when he is heartbreaking or terrible it is almost without intending to be. He has described what he has seen, and the result thus came about. As he has a very passionate and natural love of nature, he could rise only with difficulty to the absolute comic.[27] He even takes care to avoid anything that might fail to arouse, in a French public, a clear and immediate response.

One final word. The quality that completes Daumier's remarkable character, and makes of him an outstanding artist belonging to the illustrious family of the masters, is that his drawing, by its nature, has colour. His lithographs and his woodcuts arouse the idea of colour. His pencil contains something else besides the black necessary for drawing outlines. It enables you to guess the presence of colour as well as the thought; that is the hall-mark of the finest art, one that all intelligent artists have clearly seen in his works.

Henri Monnier[28] made a great stir a few years ago; he scored a great success both in the bourgeois world and in the world of the studios, two different worlds. The two reasons for this are first that he fulfilled three functions at the same time, like Julius Caesar: actor, writer, caricaturist; and secondly that his talent is peculiarly bourgeois. As an actor he was precise

and cold; as a writer pernickety; as an artist he had found a way of doing *chic* as though he were drawing from life.

He is the very opposite of the man we have just been talking about. Instead of grasping wholly and at once a complete statement of a figure or a subject, Henri Monnier would proceed by a slow and successive examination of details. He has never known great art. Thus, for example, Monsieur Prudhomme, that monstrously true type, M. Prudhomme was not conceived on the grand scale. Henri Monnier studied him, the living flesh-and-blood Prudhomme; he studied him, day in, day out, for a long space of time. I cannot begin to guess how many cups of coffee Henri Monnier had to swallow, how many games of dominoes he had to play, to achieve this prodigious result. Having studied him, he translated him; no, I am wrong, he took a tracing of him. At first sight the product appears extraordinary; but when the Monsieur Prudhomme vein was worked out, Henri Monnier had nothing else to say. Several of his *Scènes populaires*[29] are certainly pleasing; otherwise, we should be obliged to deny the cruel and surprising charm of daguerreotypes; but Monnier can create, idealize, compose nothing. To come back to his drawings, which are the important things here, they are generally cold and hard; and, strangely enough, in spite of the pointed exactitude of the pencil the impression left in the mind is vague. Monnier has one unusual faculty, but only one, the cold clarity of a mirror that does not think, and contents itself with reflecting the passers-by.

As for Grandville,[30] this is another thing altogether. Grandville is a pathologically literary type of mind, always on the look-out for bastard means of introducing his thought into the sphere of the plastic arts; that is why we have often seen him resort to the old-fashioned means of attaching balloons to the lips of the characters, with their spoken words. A philosopher or a doctor would have a splendid subject in Grandville for an interesting psychological or physiological

study. He spent his life looking for ideas, finding them some-
times. But as he was an artist by profession and a man of
letters by habit of mind, he was never able to give them
adequate expression. He naturally touched upon a number of
important questions, and he ended by falling between two
stools, being neither wholly a philosopher nor wholly an
artist. For a large part of his life, Grandville traded on the
general notion of analogy. That is indeed what he began with:
Métamorphoses du Jour. But he was incapable of drawing the
correct consequences; he jolted along like a derailed steam
engine. This man, with superhuman courage, spent his life in
rebuilding creation. He took it in his hands, kneaded it, re-
arranged it, explained it and commented on it; and Nature
became an Apocalypse. He turned the world upside-down –
which reminds me, did he not produce a collection of draw-
ings called *Le Monde à l'envers*? There are certain superficial
people whom Grandville amuses; for my part he alarms me.
For, unfortunately, it is the artist himself that interests me, not
his drawings. When I step into the work of Grandville, some
sort of disquiet takes hold of me, as though I were going into
an apartment where the disorder was systematically organized,
where absurd cornices were supported by the floor, where the
pictures were distorted by optical means, where objects were
damaged by being huddled against each other cornerwise,
where the furniture had its feet in the air and the drawers went
inwards instead of outwards.

Doubtless Grandville did some fine things, his obstinate
and scrupulous habits standing him in good stead; but he has
no suppleness, and, as a result, could never draw a woman.
Moreover, it is by the lunatic side of his talent that Grand-
ville is significant. At the time of his death, he was busy
applying himself, with characteristic obstinacy, to the
problem of noting in plastic form his succession of dreams and
nightmares, with the accuracy of a shorthand writer taking
down an orator's speech. Grandville the artist wanted, yes, he

wanted his pencil to elucidate the law of the association of ideas. Grandville is very comic; but he is often a comic without knowing it.

And here we have an artist with a certain bizarre grace, and much more important. Yet Gavarni[31] started his career by engineering draughtsmanship, and then drawing fashion plates, and it seems to me that scars of all this remained with him for a long time; but it is fair to say that Gavarni has always shown progress. He is not a caricaturist pure and simple, nor exclusively an artist; he is also a literary man. He touches on things, leaves you to guess. His particular contribution to the comic is a great delicacy of observation, which at times borders on the tenuous. Like Marivaux,[32] he knows the full value of reticence which is both an attraction and a piece of flattery to the public's intelligence. He writes the captions of his drawings himself, and sometimes they are very involved. Many people prefer Gavarni to Daumier, which is not at all surprising. As Gavarni is less of an artist, he is easier for them to understand. Daumier is a frank and straightforward genius. Take away the caption, the drawing remains a beautiful stark creation. Not so Gavarni; his work is on two levels: the drawing and the text. Secondly, Gavarni is not essentially satirical; he often flatters rather than bites; he does not censure, he encourages. Like all men of letters, himself being one, he is just a little tainted with corruption. Thanks to the charming hypocrisy of his thought, and to the powerful means of semi-expressed allusions, he is greatly daring. At other times, when his cynical thought comes out into the open, it clothes itself graciously, flatters prejudices, and makes the world into its accomplice. A sheaf of good reasons for popularity! Here is an example amongst many: do you recall that lovely tall girl who is looking, with a disdainful pout, at a young man with hands clasped in suppliant attitude? 'Just a little kiss, dear kind lady, for the love of God, oh, please, please!' – 'Come back this evening, your father had one this

morning.' The lady could well be a portrait drawing. These creatures are so pretty that the young will inevitably want to imitate them. Moreover, note that the best part of it is in the caption, the drawing itself being unable to convey so much.

Gavarni created the Lorette. To be sure, she did exist before him, but he perfected her image. I rather believe that it was he that coined the word. The Lorette, as has been said before, is not the kept woman, the social phenomenon of the Empire, condemned to live in a funereal tête-à-tête with the moneyed corpse, general or banker, she battened on. The Lorette is a free agent, comes and goes as she pleases, keeps open house, has no master, mixes with artists and journalists, does her best to be witty. I have just said that Gavarni added the final touches to her image; and indeed, carried away by his literary imagination, he invents at least as much as he sees, and, for that reason, he has greatly influenced manners. Paul de Kock created the '*grisette*', and Gavarni the Lorette; and some of these damsels have perfected their technique at his school, just as the youth of the Latin quarter had felt the influence of his 'students', and as there are many people who do their best to look like the fashion plates.

Such as he is, Gavarni is an artist, with a great deal to him, and much of him will go down to posterity. His will be the pages to thumb through to understand the last years of the Monarchy. The republic has rather blurred his memory; cruel but natural law. He was born at a moment of calm, and eclipsed by the tempest. The true glory and true mission of Gavarni and of Daumier were to complete Balzac, who, for that matter, was well aware of it, and appreciated them both as his auxiliaries and commentators.

Gavarni's most important series of drawings are: *La Boîte aux lettres*, *Les Étudiants*, *Les Lorettes*, *Les Actrices*, *Les Coulisses*, *Les Enfants terribles*, *Hommes et femmes de plume*, in addition to an innumerable quantity of individual subjects.

It remains for me to speak of Trimolet,[33] Traviès[34] and

Jacque.[35] Trimolet's was a melancholy destiny; who would guess, from the charming and childlike clowning that enlivens his compositions, that so much serious suffering and bitter sorrow fell to his lot, in the course of a wretched life. He himself etched some admirable drawings, or rather sketches, where the maddest and most innocent gaiety reigned, for the collection of *Chanson populaires de la France*, and for Aubert's comic almanacs. Trimolet drew freely, on to the plate, without preliminary drawings, the most complicated compositions, a method resulting, it must be admitted, in a certain amount of muddled drawing. Evidently the artist had been much impressed by the work of Cruikshank; but, in spite of all, he retains his originality; he is a humorist, who deserves a special place; his work has a savour all its own, a delicate taste which people possessing a sensitive palate can distinguish from all others.

One day Trimolet painted a picture; it was well conceived, and inspired by a noble idea: on a dark wet night, one of those old boys who look like a walking ruin and a living bundle of rags, has lain down by the foot of a dilapidated wall. Raising his eyes in gratitude to the starless sky he exclaims: 'I thank thee, O God, for giving me this wall as shelter and this matting to cover me!' Like all the disinherited racked with pain this worthy fellow is not too fussy, and willingly gives the Almighty credit for everything else. Whatever may be said by the breed of optimists, who, according to Desaugiers,[36] sometimes lose their equipoise when in their cups, and may easily crush, in falling, a poor man who has not dined, there are men of genius who have spent nights like that.

Trimolet is dead; he died just when dawn was beginning to bring some light to his horizon, and when a kindlier fortune seemed inclined to smile upon him. His talent was developing, his intellectual mechanism was good and was working vigorously; but his physical mechanism was seriously damaged and impaired by former storms.

Traviès too was dogged by misfortune. To my mind he is
an outstanding artist, who did not, in his day, receive the
delicate appreciation he deserved. He produced a lot, but he
lacked sureness. He tried to be amusing, and he certainly was
not. At other times, he stumbled on a good thing without
knowing it. He amended and corrected his work constantly;
he twisted and turned and pursued an ideal will-o'-the-wisp.
He was the prince of bad luck. His muse was a nymph, born
in the back streets, pale and melancholy. Through all these
tergiversations, we can discern a subterranean vein of startling
colours and distinctiveness. Traviès had a deep feeling for the
joys and the sufferings of the common people; he knew the
rabble thoroughly, and we can affirm that he loved it with
tenderness and charity. That explains why his *Scènes bachiques*
will remain a remarkable work; his rag-and-bone men,
moreover, are usually most lifelike, and all their rags and
tatters have the abundance and the almost imperceptible
distinction of a ready-made style, such as nature, in its
capricious moods, may produce. Nor must we forget that
Traviès is the creator of Mayeux, that eccentric and true type,
who gave Paris so much amusement. Mayeux belongs to him,
as Robert Macaire belongs to Daumier and M. Prudhomme
to Monnier. In those already distant days, there lived in Paris a
kind of physiognomanic clown, Léclaire by name, who often
performed in suburban bars, wine-dives and little theatres.
His turn consisted in making faces; and by the light of two
candles his face would depict all the human passions. It was
like the note-book for *Les Caractères des passions de M. Lebrun
peintre du roi*. This fellow, strange clown, more common on
the eccentric fringe of society than may be suspected, was of a
melancholy humour and possessed by a mania for friendship.
Apart from his grotesque exercises and performances, he spent
his time in search of someone to befriend him, and when
drunk he would weep salt tears of solitude. The hapless
creature had such a power of objectivity, such skill for make-

up, that he could imitate to the life the hunchback's hump and furrowed brow, his great ape-like paws, and the shrill slobbering speech. Traviès saw him; the great patriotic ardour of July was still in full swing; a luminous idea descended upon his brain; Mayeux was created, and for a long time the turbulent Mayeux was to talk, yell, perorate, gesticulate, in the memory of the Paris populace. Since those days, it has come to be said that Mayeux was a living person, and it is believed that Traviès had known and copied him. The same thing happened over a number of popular creations.

For quite a time now, Traviès has disappeared from the scene; one wonders why, since there are today, as always, a number of sound ventures in comic albums and papers. The loss is very real, for he is highly observant, and in spite of his hesitations and his lapses, his talent has a serious and tender side which makes him peculiarly engaging.

Collectors should take note that in the Mayeux caricatures the female figures – for women, as is well known, played a large part in the epic of this gallant and patriotic Ragotin[37] – are not by Traviès. They are by Philipon, who had a gift for comic invention, and could draw women delightfully, so that he reserved for himself the pleasure of doing the women in Traviès's Mayeux cartoons. Thus every drawing displayed an additional style that did not really reinforce the comic intention.

Jacque, that excellent artist of many-sided intelligence, has also on occasion been a caricaturist worthy of commendation. Besides his paintings and his etchings, in which he has always shown himself to be serious and poetic, he has done some excellent grotesque drawings, where the idea comes out well, and at once. Look, for example, at *Militairiana* and *Malades et médecins*. He draws richly and wittily, and his caricatures, like all he does, have the causticity and unexpectedness of the observer poet.

9. Some Foreign Caricaturists[1]

Hogarth – Cruikshank – Goya – Pinelli – Bruegel

I

A NAME that is wholly popular, not only with the artists but also with society people, a most eminent artist in the comic sphere, one that sticks in the memory like a proverb, is Hogarth. I have often heard it said about Hogarth: 'He is the death of the comic spirit.' I will not deny it; some may think the remark witty, but I want it to be understood as praise; I draw from this malevolent opinion, the symptom and the diagnosis of a very special merit. Yes, indeed, consider the matter carefully, and you will see that Hogarth's talent has something cold, something astringent and funereal about it. It wrings our hearts. Brutal and violent, but always concerned with the moral message of his compositions, above all a moralist, he loads his works, as our Grandville does, with allegorical and allusive detail, whose function, to his mind, is to complete and throw light on his thought. For the viewer – 'pon my word I nearly said 'the reader' – it sometimes happens, contrary to his wish, that they retard and confuse the understanding.

Moreover, Hogarth, like all artists with keenly searching minds, shows a considerable variety of styles and compositions. His method is not always as hard, as explanatory, as fussy. If, for example, the plates of *Marriage à la Mode* are compared with those that illustrate *The Dangers and the Consequences of Incontinence, Gin Lane, The Enraged Musician, The Distressed Poet,* then the latter will be seen to have much more ease and spontaneity about them. One of the oddest, certainly, is the one that shows us a corpse flattened, rigid and stretched out on

a dissecting table. On a pulley or some such mechanism, fastened to the ceiling, the intestines of the rake's corpse are being unwound. This dead man is horrible to see, and nothing could produce a more singular contrast with the corpse, cadaverous above all corpses, than the high foreheads, the long scraggy or rotund faces, grotesquely serious, of all these British doctors, in their enormous curled wigs. In a corner, a dog greedily sticks his snout into a bucket and filches a few human bits from it. Hogarth, the death of the comic! I would rather say he is the comic in death. This cannibalistic dog has always made me dwell in my mind on that historic pig that got shamelessly drunk on the blood of the hapless Fualdès,[2] whilst a barrel-organ ground out the funeral service, so to speak, of the dying man.

I was saying just now that the studio witticism was to be taken as praise; and it is a fact that I discover in Hogarth that mysterious essence, at once sinister, violent, and resolute, that informs almost all the works from the land of the spleen. In *Gin Lane*, besides the innumerable misadventures and ludicrous accidents that the lives and careers of drunkards are strewn with, there are a few terrible details, which are anything but comic from our French point of view: almost always cases of violent death. I do not intend to embark here on a detailed analysis of Hogarth's works; numerous studies have already been made of this unusual and scrupulous moralist, and I shall content myself with establishing the general character that prevails in the works of each important artist.

To speak of England without mentioning Seymour[3] would be unjust, since everyone has seen his series, so full of comic exaggeration, on fishing and hunting, the double epic of cranks. From him originally came that wonderful allegory of the spider that had spun its web between the rod and the arm of the fisherman, who never trembles with impatience.

In Seymour, as in all other Englishmen, we see violence and the love of the excessive; a simple way, cruelly brutal and

direct, of stating the subject. When it comes to caricature, the English are extremists – 'Oh! The deep, deep sea!' exclaims a fat Londoner, sitting quietly on the thwart of his rowing boat, a quarter of a league from the harbour, in smug contemplation. I even seem to remember that roof tops are visible in the background. The ecstasy of this ass is extreme; no wonder, then, that he should fail to notice the two fat legs of his dear spouse, sticking straight out of the water, toes upwards. It appears that this stout party has taken a header into the unstable element, the sight of which inspires such enthusiasm in our fathead. Of the hapless creature only the legs are visible. Presently, this powerful lover of nature will phlegmatically start looking around for his wife and will fail to find her.

George Cruikshank's[4] distinctive quality (I leave out of account all his other qualities: delicacy of expression, understanding of the fantastic, etc.) is his inexhaustible abundance of grotesque invention. His verve is unbelievable, and would be dismissed as an impossibility if the evidence were not there, in the form of an immense output, an innumerable collection of vignettes, a long series of comic albums, and, to end with, such a quantity of characters, scenes and physiognomies and grotesque pictures that the viewer's memory loses its bearings; the grotesque flows unceasingly and inevitably from the point of Cruikshank's burin, just as rhyming comes easily to born poets. The grotesque is a habit to him.

If it were possible to analyse with certainty such a fugitive and impalpable thing as feeling in art, that indefinable something that always distinguishes one artist from another, however intimate may appear the relationship between them, I would say that the main element in Cruikshank's form of grotesque is the extravagant violence of gesture and movement, and the intensity of expression. All his little figures mime with furious vigour and boisterousness, like actors in pantomime. The only fault than can be attributed to him is that he is often

more a man of wit, more a sketcher than an artist, with the result that he does not always draw conscientiously enough. It is almost as though the pleasure he derives from giving full rein to his prodigious verve is such that the author forgets to endow his characters with enough vitality. He is apt to draw rather in the manner of men of letters who amuse themselves in dashing off a few sketches. These amazing little creatures of his are not always born with life in them. All this minute world tumbling over itself, gesticulating, intermingling with indescribable liveliness, does not bother much whether its arms and legs are strictly where nature meant them to be. Too often the figures are no more than the suggestion of human beings, rushing around as best they can. But such as he is, Cruikshank is an artist, endowed with rich comic gifts, and one who will figure in every collection. But what are we to say about these modern French plagiarists, impertinent to the point of borrowing not only subjects and general ideas but even the manner and style? Fortunately naïveté cannot be filched. They have succeeded in being as cold as ice in their affected childishness, and their drawing is even more unsatisfying.

II

In Spain an unusual man has opened up new horizons in the comic.

In speaking of Goya, I must begin by referring my readers to Théophile Gautier's excellent article on him in *Le Cabinet de l'Amateur*, republished in a volume of collected articles. Théophile Gautier is ideally endowed to understand such natures. Besides, on the question of Goya's techniques – aquatints, etchings, mixed with retouchings with dry point – the article in question says all that is required. I shall content myself with adding a few words on the very rare element that Goya introduced into the comic; I mean the fantastic. Goya does not exactly fit into any special or peculiar grouping,

neither into the absolute comic nor the purely significant
comic in the French manner. Doubtless, he often plunges into
the ferocious comic, and rises to the absolute comic; but the
general point of view from which he looks at things is the
fantastic, or rather his natural way of seeing things conveys
them in fantastic terms. *Los Caprichos* are a wonderful work,
not only for the originality of the ideas, but also for the
execution. Imagine, standing in front of *Los Caprichos*, a man
full of curiosity, an art-lover, quite ignorant of the historical
events that several of these plates allude to, simply a sensitive,
artistic mind, knowing nothing of Godoy⁵ or King Charles or
the Queen; nonetheless he will experience, in the recesses of
his brain, a lively commotion, because of the artist's original
manner, the fullness of his composition and his sureness of
hand, and also because of the fantastic atmosphere that en-
velopes all his subjects. To all this may be added that, in all
works that come from profound natures, there is something
resembling those periodic or chronic dreams that lay regular
siege to our sleep. That is what distinguishes the true artist, a
lasting and vital something, even in those fugitive pieces
attached, so to speak, to daily happenings, called caricatures;
that, I repeat, is what distinguishes the historical caricaturists
from the artistic caricaturists, the fugitive comic from the
eternal comic.

Goya is always a great artist, often terrifying. To the gaiety
and joviality, to the Spanish satire of the good old days of
Cervantes, he adds a much more modern attitude of mind, or
at least one that has been much more sought-after in modern
days, the love of the intangible, the feeling for violent con-
trasts, the love of the terrifying phenomena of nature and of
human physiognomies strangely animalized by circumstances.
It is interesting to observe that this artist, who comes after the
great satirical and destructive movement of the eighteenth
century, and to whom Voltaire would have been grateful for
the idea at least (for the poor man, great though he was, knew

nothing beyond that) of all those monastic caricatures – yawning monks, gluttonous monks, square-headed, assassin types, getting ready for matins, cunning, hypocritical, refined and spiteful-looking, so many profiles of birds of prey – it is interesting, I repeat, that this hater of monks should have been so preoccupied with witches and sabbaths, satanic practices, children roasted on spits, and so on, all the wild extravagances of dreams, all the hyperboles of hallucination, and then all those fair-skinned and elegant Spanish girls, being washed and scented by ageless hags, either for midnight revels or for the evening's prostitution, the sabbath of civilization! Light and darkness play in and around these grotesque horrors. What strange joviality! I particularly remember two extraordinary plates; one shows a nightmarish landscape, a medley of clouds and rocks. Is it some remote corner of a sierra, unknown and desolate? A sample of chaos? There, against this fearful backcloth, a fierce battle is taking place between two airborne witches. One, astride the other, is raining blows on her mount and subduing her. These two monstrous creatures are rolling headlong through the gloom. All the hideousness, all the moral filth, all the vices conceivable to human minds, are writ large on these two faces, which, in accordance with a frequent habit and an inexplicable technique of the artist, are halfway between man and beast.

The other plate depicts an unhappy being, a solitary monad, struggling with all his strength to get out of his tomb. Malevolent demons, a swarm of hideous lilliputian gnomes, are pressing down for all they are worth on the half-raised tomb lid. These vigilant guardians of death have united to oppose the rebellious soul, exhausting itself in a hopeless struggle. This nightmare unfolds in the horror of vague and infinite depths.

At the end of his career, Goya's eyesight had weakened to such an extent that his pencils, so it was said, had to be sharpened for him. Yet even at that time he executed some big

and most important lithographs, including a number of bull-
fights, full of swarming crowds, admirable plates, enormous
pictures in miniature – a further proof in support of that
strange law governing the destiny of great artists, according
to which, since life and intelligence move in opposite direc-
tions, they make up on the swings what they lose on the
roundabouts, and, following a progressive rejuvenation, they
grow for ever stronger, more jovial, bolder, to the very edge
of the grave.

In the foreground of one of these plates, where reigns an
impressive tumult and hubbub, a raging bull, the vindictive
type that enjoys mangling the dead, has just ripped the
breeches of one of the combatants. The latter, only wounded,
is dragging himself clumsily along on his knees, whilst the
formidable brute, having caught the lacerated shirt on its
horns, and exposed its victim's buttocks, is again lowering its
muzzle menacingly; but this indecent exposure in the midst of
carnage seems to worry the crowd not at all.

The great virtue of Goya consists in creating a monstrous
kind of verisimilitude. His monsters are born viable, harmoni-
ous. No one has dared go further than he in making the absurd
appear possible. The contortions, the bestial faces, the
diabolical grimaces, all remain imbued with humanity. Even
taking the particular standpoint of natural history, the critic
would find difficulty in condemning them, such are the logic
and the harmonious proportions of their beings; in short, the
seam, the juncture between the real and the fantastic is im-
possible to detect; it is a vague frontier, which even the most
subtle analyst could not trace, so transcendent and natural at
one and the same time is the art displayed.★

★Some years ago we possessed a number of precious paintings by Goya,
now unfortunately banished to dark corners of the gallery; they have dis-
appeared at the same time as the museum of Spanish painting.[6]

III

The climate of Italy, southern though it is, is not that of Spain, and the fermentation of the comic does not produce the same results. Italian pedantry (I use this term for want of a better) has found expression in the caricatures of Leonardo da Vinci and in scenes of contemporary manners by Pinelli.[7] All artists know the caricatures by Leonardo da Vinci, which are veritable portraits. These caricatures, startling examples of ugliness, and cold into the bargain, do not lack cruelty, but they lack comic; there is no expansiveness, no abandon in them; the great artist was not amusing himself as he drew them; it was the scholar, the geometrician, the teacher of natural history in him that was at work. He was careful not to omit the minutest mole, the tiniest hair. Perhaps after all he was not claiming to be drawing caricatures. He looked about him for types of unusual ugliness and he copied them.

However, the Italian character is not usually like this. The jest is often low, but it is open and straightforward. The paintings of Bassano[8] depicting the carnival of Venice give us a good idea of it. This gaiety is stuffed with sausages, hams and macaroni. Once a year the Italian comic erupts on the Corso and reaches its paroxysm of frenzy. Everyone bubbles with wit, every individual becomes a comic artist; Marseilles and Bordeaux could perhaps give us samples of this type of temperament. I refer you to *Princess Brambilla*, where Hoffman shows how well he has understood the Italian character, and how delicately the German artists speak of it over their drinks at the Café Greco. Italian artists tend toward clowning, rather than to the comic proper. They lack depth, but all of them are subject to the frank intoxication of the national gaiety. Their humour is materialist, as the South usually is, and reeks of the kitchen and the brothel. When all is said and done, it is a French artist, it is Callot,[9] who by sheer concentration of mind and by will-power, both characteristic of our country, has

provided the finest expression of this sort of comic. It is a Frenchman who remains the best Italian clown.

I mentioned just now the name of Pinelli, the classic Pinelli, a star now much diminished in magnitude. We can scarcely say that he is a caricaturist; he is rather a sketcher of picturesque scenes. I mention him merely because as a child I had it drummed into me that he was the type of the noble caricaturist. The truth is that the comic figures here only to an infinitesimal degree. In all the studies from this artist's pencil we can see a constant attention to line and to the composition of antiquity, a systematic search for style.

But Pinelli – and this fact has no doubt contributed not a little to his reputation – lived a life that was much more romantic than his talent. His originality showed itself much more in his character than in his works; for he was one of the most typical artists, as the worthy bourgeois imagines the artist to be, namely classic disorder, bouts of inspiration taking the form of evil living and violent habits. Pinelli possessed all the charlatanism that some artists have; his two big dogs, which followed him everywhere, like confidants and companions, his big gnarled stick, his hair falling in long tresses over his cheeks, the tavern, evil company, the affectation of destroying, with extravagant abandon, works he was not offered enough for, all that was part of his reputation. Pinelli's household was scarcely better ordered than the conduct of its head. Sometimes, on coming home, he would find his wife and daughter tearing each other's hair, eyes starting from their sockets, with hot-blooded Italian fury. To Pinelli, this scene was superb: 'Hold it!' he would cry, 'don't move a muscle, stay like that!' And the deplorable scene would be transformed into a drawing. The reader will see that Pinelli belonged to the race of artists who hope material nature will come to the help of their lazy-mindedness, as they wander along, always ready to seize the brush. Thus in one way he comes close to the unfortunate Léopold Robert,[10] who also claimed to find in

nature, and exclusively in nature, that type of ready-made subjects which, for artists endowed with more imagination, have value only as notes. And even then, these subjects, even those that reflect the most characteristically national comic or picturesque elements, are always carefully passed through the implacable sieve of good taste, both by Pinelli and by Léopold Robert.

Has Pinelli been calumnied? I have no idea, but such is his legend, and to me it is all a sign of weakness. I wish someone would coin a neologism, or create a word destined to condemn this sort of *poncif*, the *poncif* in manner and conduct, which sometimes creeps into the lives of artists as it does into their works. Moreover, I have noticed that the reverse frequently happens in reality, and that the artists who reveal themselves, in their ideas, to be the most creative, the most astonishing, the most eccentric, are often the men whose lives are peaceful and minutely ordered. Several of these have displayed the domestic virtues to a high degree. Have you not noticed how often nothing is so like the perfect bourgeois as an artist of concentrated genius?

IV

The Flemings and the Dutch have, from the outset, done some very beautiful things, of a very special and indigenous character. Everyone knows the old and very odd productions of Bruegel the Droll,[11] who must not be confused with Hell Bruegel, as several writers have done. That these works display a certain element of system, a deliberate eccentricity, a technique of the bizarre, is beyond doubt. But equally it is certain that this strange talent has a higher origin than a mere artistic wager. The fantastic paintings of Bruegel the Droll reveal the full power of hallucination. What artist could compose such monstrously paradoxical works if he were not driven to it, from the very start, by some unknown force? In art, a fact

that is not noticed enough is that the part left to man's will is much less great than is thought. In the baroque ideal, which Bruegel seems to have pursued, there are distinct affinities with the ideal of Grandville, especially if we are attentive to the tendencies the French artist displayed in the last years of his life: visions of a diseased brain, hallucinations of fever, changes we see in our dreams, odd associations of ideas, fortuitous and heteroclite combinations of shapes.

The works of Bruegel the Droll fall into two categories. One comprises political allegories, almost indecipherable to us today; it is in this series that are to be found houses with eyes for windows, windmills with arms for sails, and a thousand horrifying compositions, in which nature is constantly transformed into word-puzzles. And often enough it is impossible to determine whether this type of composition belongs to the class of political and allegorical drawings or to the second category, which is evidently the more strange. This group, which our age (for which, thanks to its double character of incredulity and ignorance, nothing is difficult to explain) would describe simply as capricious fantasy, contains, it seems to me, a sort of mystery play. The most recent works of certain medical men, who have at last begun to see the need to explain a crowd of historical and miraculous facts by means other than the convenient ones of the Voltairian school, which saw everywhere nothing but the skills of imposture, have not yet explored all the arcana of the psyche. And I defy anyone to explain the diabolical and droll curiosities of Bruegel the Droll other than by a kind of special satanic grace. For the words 'special grace' substitute, if you like, 'lunacy' or 'hallucination'; but the mystery remains almost as obscure. All these works together spread a contagion; the clowning jests of Bruegel the Droll make one feel giddy. How can a human intelligence have contained such a mass of devilment and wonders, how could it spawn and depict so many appalling absurdities? I can neither understand it nor positively

account for it; but often we find in history the proof of the immense power of contagion, of poisoning by the moral climate, and I cannot forbear from observing (but without affectation, without pedantry, without a positive aim, as for example that of proving that Bruegel may have seen the devil in person) that this prodigious flowering of monstrosities coincides in the most peculiar way with the notorious and historical epidemic of sorcerers.[12]

10. *Madame Bovary* by Gustave Flaubert[1]

I

IN matters of criticism, the writer who comes after everyone else, the late-comer, has advantages not enjoyed by the writer-prophet, the one who foretells success, who conjures it up, so to speak, by the authority of boldness and devotion.

Monsieur Gustave Flaubert no longer needs devotion, if it be true he ever did. Numerous artists, amongst them men with the acutest minds and of the highest standing, have sung the praises of his excellent book and brought it garlands of flowers. Nothing therefore remains for criticism to do, but to emphasize a few forgotten points, and to stress a little more vigorously certain traits and high-lights that have not, in my view, received their due meed of praise and comment. Furthermore, this position of late-comer writer, left behind by public opinion, has, as I was trying to suggest, a paradoxical charm. Alone, like a straggler, he is that much freer; he resembles a man who is summing up a debate, and, in virtue of that fact, has to avoid the vehemence alike of opponents and proponents; his duty is to clear a new road for himself with no other stimulus but the love of beauty and justice.

II

Since I have used that splendid and awe-ful word 'justice', I trust I may be allowed to perform what is an agreeable task for me, namely to thank the French judges for the shining example of impartiality and good taste they have given in the

present instance.[2] Despite all the pressure from people blinded by excessive zeal for morality, and a wrong choice of target, they have, when confronted with a novel from the pen of an author unknown the day before, with a novel, and what a novel! – the most impartial, the most honest – a field as ordinary as all fields, lashed and soaked, like nature itself, by wind and storm – they have, I say, when so confronted, shown themselves to be honest and impartial, like the book dragged before them for sacrifice. Nay more! If it be permitted to hazard a guess from the reasoned case which accompanied the verdict, we believe that if the learned judges had found something really reprehensible in the book, they yet would not have condemned it, because of the beauty that clothes it, and in gratitude for that. This noteworthy solicitude for beauty in men whose abilities are called into play only in the names of Justice and Truth is a most moving symptom in comparison with the ardent lusts of modern society, which has abjured for ever all spiritual love and which, forgetting its former bowels of compassion, cares only about satisfying its stomach. To sum up, we may say that this verdict, by its high poetic spirit, is final, that the Muse has won the day, and that all writers, all those worthy the name at least, have been acquitted in the person of M. Gustave Flaubert.

Do not let us therefore follow those who, with a suspicion of unthinking ill-humour, say that the book owes its great success to the trial and acquittal. Even unpersecuted, the book would have awakened the same interest, caused the same astonishment, the same stir. Moreover it had won the approval of cultivated opinion long before. Already in its original form in the *Revue de Paris*,[3] where some injudicious cuts had destroyed its balance, the work had aroused intense interest. The position of Gustave Flaubert, who had become famous overnight, was both good and bad; and I propose, as best I can, to account for that equivocal situation, which his honest and outstanding talent has triumphed over.

III

Good; – because since the death of Balzac, that prodigious meteor which will cover our country with a cloud of glory, like a strange and unusual dawn, like an aurora borealis casting its fairy lights over the deserts of ice, all public interest in the novel had fallen into a peaceful slumber. Some surprising attempts had admittedly been made. A long time ago M. de Custine,[4] well-known in a more and more rarefied atmosphere for his *Aloys, le Monde comme il est* and *Ethel*[5] – M. de Custine, creator of the ugly girl, a character so envied by Balzac (see the true Mercadet[6]), had given the public *Romuald ou la Vocation*,[7] a work sublimely clumsy, where some inimitable pages induce the reader both to condemn and to forgive languorous or uninspired passages. But M. de Custine is a subordinate type of genius, a genius whose dandyism rises to the ideal of careless detachment. This aristocratic good faith, this romantic ardour, this straightforward irony, this transparently honest and nonchalant personality lie beyond the feelings of the vulgar herd, and this valuable writer had, arrayed against him, all the bad luck his talent deserved.

M. d'Aurevilly had violently attracted all eyes by *Une Vieille Maîtresse*[8] and by *L'Ensorcelé*.[9] This dedication to truth, expressed with fearful ardour, could not fail to displease the crowd. D'Aurevilly, true catholic, conjuring up passion in order to overcome it, singing, weeping, crying aloud in the height of the storm, like Ajax astride a rock of desolation, and with an expression that always seems to say to his opponent – be it man, thunderbolt, God or matter – 'Away with me or away with you!', could not hope to make an impression on dormant readers whose eyes are closed to the miracle of uniqueness.

Champfleury,[10] with a childlike and charming spirit, had disported himself very skilfully in the field of the picturesque, had fixed his poetic spy-glass (more poetic than he himself

suspects) on the comic or touching accidents and mischances of family or street life; but by originality or weakness of vision, deliberately or inevitably, he neglected the commonplace, that meeting-place for the crowd, that forum for windy eloquence.

More recently still, M. Charles Barbara,[11] that rigorous and logical soul, keenly hunting its intellectual prey, has made some unquestionably distinguished efforts; he has sought – always an irresistible temptation – to describe, to analyse exceptional moral quandaries, and to work out the direct consequences of false situations. If I do not here express all the sympathy I feel for the author of *Héloïse* and of the *Assassinat du Pont-Rouge*, the reason is that he impinges on my theme only indirectly, as a kind of historical note.

Paul Féval,[12] who stands at the opposite pole, is a spirit enamoured of adventure, admirably gifted to exploit absurdity and horror; he has fallen into line, rather late in the day, behind Frédéric Soulié[13] and Eugène Sue.[14] But the abundant abilities of the author of *Les Mystères de Londres*[15] and *Le Bossu*, any more than those of so many outstanding minds, have not been able to produce the delicate and sudden miracle of that poor little provincial adulteress whose whole story, devoid of all complications, is an unrelenting series of sadnesses, distastes, sighs, here and there feverish swoonings, and all from a life cut short by suicide.

If these writers, some of them fashioned in the manner of Dickens, the others cast in the mould of Byron or Bulwer, too clever perhaps, too disdainful, have not been able, like a mere Paul de Kock,[16] to force their way over the creaking threshold of Popularity, alone of all loose women to invite ravishment, I for one shall not reproach them with that – nor praise them for it either; by the same token, I feel no personal sense of indebtedness to M. Gustave Flaubert for having achieved at the first attempt what others seek all their lives. At most I shall look upon that fact as a supererogatory symptom of power,

and I shall seek to isolate the reasons why the author's mind moved in a given direction rather than in another.

But I also said that this position of newcomer was bad: alas! for a lugubriously simple reason. For a number of years, the interest the public is at any time prepared to devote to the things of the spirit had been diminishing; its budget of enthusiasm had been shrinking all the time. The last years of Louis Philippe[17] had witnessed the final eruptions of minds still open to the stimulating effects of works of imagination; but our new novelist was faced with a society wholly worn-out – worse than worn-out – brutalized and greedy, wholly repelled by fiction, adoring only material possession.

Under such conditions, a man with a well-stocked mind, dedicated to beauty, but schooled to expect harsh struggles, assessing both the good and the bad aspects of the situation, must have said to himself: 'What is the surest means of moving these desiccated souls? The fact is they do not really know what they would like; their one positive dislike is for all great things: unaffected, ardent passion, release of poetic emotion, these things make them blush and affront them. Let us therefore be commonplace in our choice of subject, since the choice of too noble a subject is an impertinence in the eyes of the nineteenth-century reader. And let us further studiously avoid letting ourselves go, speaking in our own name. We shall be as cold as ice, as we relate passions and adventures that provide the ordinary run of men with ardent excitement; as they say in the school,[18] we shall be objective and impersonal.

'And furthermore, as our ears have recently been assailed by the puerile chatter of literary cliques, as we have been hearing about a certain literary theory called realism – disgusting insult, tossed in the face of all those given to clear concepts, vague and elastic word, which for the common herd signifies, not a new method of creation, but a minute description of what is superfluous – we will take advantage of the confusion in people's minds and of universal ignorance. We will cover

a commonplace canvas with a high-tension style, rich in imagery, subtle, accurate. We will imprison the warmest, the most burning feelings within the most trivial adventure. The most solemn, the most fateful words will fall from the lips of the most vacuous.

'Where is the home of vacuity, where the environment that is at once the most inane, the most fertile in absurdities, the most productive of intolerant fools?

'In the provinces.

'Who are the most insufferable characters there?

'The small fry that busily perform their petty jobs, in the exercise of which they acquire a host of distorted notions.

'What is the most threadbare and most hackneyed theme, the song droned out by every barrel organ?

'Adultery!

'No need', the poet said to himself, 'for my heroine to be a heroine. Provided she be adequately pretty, suffer from her nerves, have ambition and an ungovernable aspiration towards higher things, she will arouse interest. Besides, the very skill involved will have greater dignity, and our little sinner will at least have the merit, comparatively very rare, of contrast with the voluptuous chatterboxes of the age that has preceded us.

'I need not worry about style, descriptive detail, social background, I have got all that taped; I shall proceed, leaning on the twin supports of analysis and logic, and, like that, I shall be able to show convincingly that all subjects are equally good or bad according to the way they are treated, and that the most commonplace can become the best.'

From that moment *Madame Bovary* – a wager, a real wager, a bet, like all works of art – was born.

To accomplish this feat in full, nothing remained for the author to do but to divest himself (as far as possible) of his sex and to become a woman. The result is a miracle; for in spite of all his actor's zeal, he could not avoid injecting virile blood

into the veins of his character, or prevent Madame Bovary herself from being a man, in the most vigorous, ambitious and also the most imaginative side of her nature. Like the armed Pallas, sprung from the head of Jupiter, this strange androgyne has retained all the seductions of a virile soul in a charming feminine body.

IV

A number of critics had opined: this work, truly beautiful for the minuteness and the vividness of the descriptions, contains no single character who speaks for morality, who is the mouthpiece for the author's conscience. Where, oh! where is the proverbial and legendary character whose duty it is to point the moral of the tale and to guide the reader's understanding? In other words, where is the accusing finger?

Rubbish! Eternal and incorrigible confusion of functions and art forms. A true work of art has no need of an indictment. The logic of the work itself is equal to all the postulates of morality, and it is up to the reader to draw the conclusions from the conclusion.

As for the question which character stands at the very heart of the tale, unquestionably it is the adulteress; she alone, the dishonoured victim, possesses all the attractiveness of a fictional hero – I was saying just now that she seemed almost a man in her attitudes, and that the author had adorned her (unconsciously, perhaps) with all the virile qualities.

Consider these points attentively.

1. The imagination, supreme and tyrannical faculty, substituted for the heart, or what we call the heart, whence reasoning is ordinarily excluded and which is usually dominant in women as in animals;

2. Sudden desire for action, speed in decision, that mystical fusion of reasoning and passion that marks out men of action;

3. An immoderate love of seducing, of dominating and

even of all the commonplace means of seducing, down to the meretricious value of dress, scent and cosmetics – the whole thing briefly summed up in the words 'dandyism, and the exclusive love of domination'.

And yet Madame Bovary gives herself; carried away by the sophistries of her imagination, she falls magnificently and generously, just as a man would, for cads who are not her equals, just as a poet falls for trollops.

The virile nature of the blood that courses in her veins is also shown, broadly speaking, by this unfortunate creature's preoccupation, less with external and visible deficiencies, with the blinding provincialisms of her husband, than with the total lack of genius, with that spiritual inferiority well established by the bungled club-foot operation.

And whilst we are on the subject, pray reread the pages that deal with that episode, so unjustly treated as extraneous, whereas it serves to bring out in vivid colours the whole character of the woman – a fit of black rage, harboured inwardly for a long time, bursts out in Emma Bovary, doors bang; the stupefied husband, who has been incapable of giving his romantic wife any spiritual satisfaction, is consigned to his bedroom; he is in disgrace, the guilty ignoramus! and Madame Bovary, in despair, exclaims, like a little Lady Macbeth paired off with an inadequate army captain: 'Ah! If only I were at least the wife of one of those old scientists, bald and bowed, whose eyes, shielded behind green spectacles, are for ever glued to the archives of science! I could lean proudly on his arm; I should at least be the wife of an intellectual giant; but to be chained like a convict to this bonehead who cannot even straighten out the foot of a cripple, oh!'

In reality this woman is a sublime example of her kind, in her narrow world, hemmed in by restricted horizons!

4. Even in her convent education, I see a proof of Madame Bovary's equivocal temperament. The kindly nuns discern in the girl an astonishing appetite for life, for profiting from

what life has to offer, for guessing what are its joys; there is the man of action for you!

Yet the girl yielded with delight to a feeling of intoxication at the beauty of the stained glass, of the oriental colours it threw on her schoolgirl's prayer book from the delicate tracery of the lancet windows, she drank in eagerly the solemn music of vespers, and, by a paradox for which the nervous system may take all the credit, she exchanged in her soul the image of the true God for that of a God of her own imagining, a God of promise and chance, a keepsake image of God, with spurs and moustaches – behold the hysterical poet.

Hysteria! Why should this physiological mystery not constitute the basis and substance of a work of literature, this mystery, unsolved as yet by the Faculty, which takes the form, in women, of a feeling of rising and choking oppression (to mention only the main symptom), and which produces, in men of nervous temperament, every form of impotence and also a capacity for all kinds of excess?

V

In fine, this woman is truly great, but, above all, worthy of pity, and, despite the systematic inflexibility of the author, who has made every effort to withdraw from his work, and to play the part of a puppet showman, all women with intellectual pretensions will be grateful to him for having developed the feminine potential to such a degree of power, so far removed from the pure animal, so close to the ideal man, and for having made it reflect that dual character, compounded of calculation and reverie, that constitutes the perfect being.

People say that Madame Bovary is ridiculous. Indeed, look at her, now taking for a hero from Walter Scott a gentleman of a sort – shall I call him a country squire? – with his shooting waistcoats and clothes of contrasted hues, now in love with a notary's clerk (who has not even got the spirit to risk a

dangerous action for his mistress), until in the end, poor exhausted creature, strange Pasiphae[19] that she is, imprisoned within the narrow confines of a village, she pursues her will-o'-the-wisp through the dance halls and taverns of the county town; what of it? Let us recognize freely; here is a Caesar at Carpentras[20]; a woman in pursuit of the ideal.

I shall certainly not echo the remark of the Lycanthropus[21] of insurrectional memory, of the rebel who resigned the part[22]: 'Faced with all the platitudes and the follies of this day and age have we not still got cigarette paper and adultery?' But I will say that, after all, when all is said and done, even with the help of precision balances, our society, born of Christ, is harsh indeed, that it is scarcely entitled to cast a stone at the adulteress; and that a few cuckolds more or less will not make the spheres rotate faster, and will not hasten on by a second the final destruction of the universe. The time has come to put an end to the growing contagion of hypocrisy, and to regard as ridiculous the claim of men and women, themselves corrupted in the smallest things, to cry shame on a luckless author who has deigned, with the discretion of a public speaker, to cast a mantle of glory on bedroom goings-on, always squalid and grotesque when poetry does not cast its gleam over them, like a nightlight under an opaline shade.

Were I to let myself go on this analytical slope, I could discourse indefinitely about *Madame Bovary*; this book, by all that it suggests, could inspire a volume of observations. I must content myself for the moment with pointing out that several of the most important episodes were either taken no notice of or condemned by the critics. Examples: the botched club-foot operation, and the episode, so outstanding, so full of heartbreak, so truly 'modern', where the adulteress-to-be – for, poor soul, she is as yet only on the edge of the slippery slope – seeks help from the church, from the holy mother, from her who has no excuse for not always being on the alert, from the Pharmacy, where none has the right to slumber! The kindly

priest, Bournisien, his attention wholly taken up with his catechism rascals climbing about over the church pews and chairs, answers guilelessly: 'Since you are ill, Madam, and since M. Bovary is a doctor, why not go and consult your husband?'

Find me the woman who would not, faced with the priest's inadequacy, plunge head first, poor fond forgiven creature, into the turbulent waters of adultery – what man amongst us has not, in his more innocent years, and in moments of stress, inevitably learnt to know the incompetent priest?

VI

With two works by the same author in front of me (*Madame Bovary* and *La Tentation de Saint Antoine*, the instalments of which have not yet been published in book form), my first intention was to establish a kind of parallel between them. I wanted to show how they equate and correspond. I would have found it easy to recognize, under the closely woven texture of *Madame Bovary*, the high capacity for irony and lyricism that extravagantly lights up *La Tentation de Saint Antoine*. Here the poet appears without disguise, and his Bovary, tempted by all the devils of illusion, of heresy, by all the lusts of the physical surroundings – in short, his St Anthony, harassed by all the lunatic urges that get the better of us, would have provided a better apologia than his humble tale of bourgeois life. In this work, of which the author has unfortunately given us only fragments, there are passages of blinding brilliance; I am not referring only to the prodigious feast of Nebuchadnezzar, of the wonderful apparition of that little feather-brained Queen of Sheba, minute dancing image reflected on the retina of an ascetic's eye, of the fraudulent and pompous scene featuring Apollonius of Tyana, followed by his elephant keeper or rather his financier-lover, the millionaire nincompoop he drags after him from place to place – I

would particularly like to draw the reader's attention to the underlying capacity for suffering and revolt that runs through the whole work, this hidden seam that glistens in the shadows – this undercurrent, as the English say – that guides us through the pandemoniacal assortment of visions, conjured up in solitude.

I repeat that I should have found it easy to show that Gustave Flaubert has deliberately veiled in *Madame Bovary* the brilliant lyrical and ironic gifts so freely displayed in the *Tentation*, and that this latter work, secret recess of his mind, evidently remains the more interesting one for poets and philosophers.

Perhaps one day I shall have the pleasure of undertaking that task.[23]

11. Théophile Gautier[1]

Although we have given drink to no old crone, we are in the position of the maiden in Perrault's story; we cannot open our mouth without gold pieces, diamonds, rubies and pearls falling from our lips; if only for a change we should like to see a toad, an adder and a red mouse issue forth from them, but that is not within our power.

THÉOPHILE GAUTIER, *Caprices et Zig-zags*

I

I KNOW no more awkward feeling than admiration. Like love, it finds difficulty in expressing itself adequately. Where are we to find expressions with colours strong enough, or delicately varied enough, to meet the requirements of an exquisite feeling? 'Fear of what people may say is a curse in every order of things,' says a moral treatise which I happen to have by me; but let it not be thought that this unworthy fear of public opinion is the cause of my quandary, which has no other source but the fear of not treating my subject with becoming dignity.

Some biographies are easy to write: those, for example, of men whose lives are crowded with incident and adventure; in those cases, we merely have to chronicle and classify facts and their dates. But here there is none of this variety of matter that reduces the task of the writer to that of a compiler. Nothing is here but greatness of spirit. The biography of a man whose most dramatic adventures are played out silently under his brain cupola is a literary labour of quite another order. A given star is born with given functions; so is a man. Each carries out his predestined part, magnificently and humbly. Who could conceive a biography of the sun? It is a story which, since that star first gave signs of life, is full of monotony, light and grandeur.

Since, in fact, I have but to write the story of a fixed idea, which, moreover, I shall presently be defining and analysing, it would matter little, strictly speaking, whether or not I were to acquaint my readers with the fact that Théophile Gautier was born at Tarbes in 1811. I have had the joy of being his friend for many years, and yet I have no idea whether, from an early age, he revealed his future talents by successes at school, by those puerile prizes which, often enough, children marked out for greater things fail to win, and in any case are obliged to share with a crowd of cruel asses fatally stamped as such. Of these trivia I know nothing at all. Théophile Gautier himself has forgotten all about them perhaps, and if, by chance, he remembers them, I feel quite sure he would find it disagreeable to see this schoolboy rubbish picked over. No one carries further than he the dignified modesty of the true man of letters; no one more than he has a horror of exposing to view what has not been created, prepared and ripened for the public, for the edification of souls enamoured of beauty. Do not ever expect from him memoirs or confidences, or even recollections of anything that is not the product of the sublime function.

There is a point that increases the pleasure I feel at giving an account of a fixed idea, and that is, finally, to be speaking, quite freely, of an unknown man. Anyone who has pondered the misapprehensions of history or its tardy acts of justice will understand the significance of the word 'unknown', applied to Théophile Gautier. He has for many years been filling Paris and the provinces with the sound of his articles; no one will deny that many a reader, interested in matters literary, eagerly awaits his verdict on the plays of the preceding week; still more incontrovertible is the fact that his reports on the Salons, reports so calm in tone, so full of frankness and dignity, are oracles for all poor exiles, incapable of judging and feeling with their own eyes. For these various groups amongst the public, Théophile Gautier is an

incomparable and indispensable critic; and yet he remains an *unknown* man. Let me explain my meaning.

I will suppose you to be imprisoned in a bourgeois drawing-room, sipping your coffee after dinner with the master of the house, his lady, and her daughters. Odious and laughable jargon that the pen should avoid using, just as any writer should abstain from such debilitating company! Soon the talk will turn to music, painting perhaps, but inevitably to literature. Sooner or later Théophile Gautier will crop up; but after the usual commonplace bouquets ('What wit he has!' 'How diverting he is!' 'How well he writes and how flowing his style!' – the prize of a 'flowing style' is given indiscriminately to all well-known writers, limpid water probably being the most obvious symbol of beauty for people to whom thinking is not a habit), if it occurs to you to point out that his chief merit, his irrefutable and most brilliant merit, is going by the board, that in fact the company is forgetting to mention that he is a great poet, you will see acute surprise painted on every face. 'No doubt he has a highly poetic style,' the brightest of the bunch will observe, without knowing that poetry demands rhythms and rhymes. The whole company will have read Monday's article, but no one, in all the years, has spared either money or leisure for *Albertus*, *La Comédie de la mort* and *España*.[2] This is a harsh truth for a Frenchman to own to, and were I not speaking of a writer exalted enough to shrug off injustice, I think I should have preferred to hide our public's infirmity in this matter. But such is the fact. And yet editions have multiplied and have easily been sold out. Where have they gone? In what cupboard have these admirable samples of the purest French beauty been hidden away? I do not know; doubtless in some mysterious region located well away from the Faubourg St Germain and the Chaussée d'Antin,[3] to quote the geographical jargon of our worthy chroniclers. I know there is no single man of letters, no artist at all given to reverie, whose memory is not furnished

and adorned with these beautiful things; but society folk, the very people who drank deep, or pretended to, of the *Méditations* and *Les Harmonies*,[4] are unaware that this new, precious source of enjoyment and beauty exists.

As I have already said, that is a bitter admission for French hearts, but to recognize a fact is not enough; we must try to account for it. It is true that Lamartine and Victor Hugo enjoyed, for a greater length of time, the favour of a public more interested in the creative fancies of the Muse than the present lot of readers, who were already sinking into sloth of mind just when Théophile Gautier was achieving permanent fame. Since then, this public has gradually been reducing that part of its time that legitimately belongs to the pleasures of the mind. But such an explanation would be inadequate by itself; for, leaving aside the poet we are dealing with, I notice that the public has gleaned with care, in the works of the poets, only those parts that were adorned (or marred) by a kind of political reference, a condiment in keeping with its present-day passions. At one time the public knew by heart the *Ode à la Colonne*,[5] the *Ode à l'Arc de Triomphe*,[6] but it knows nothing of the most charming parts of Victor Hugo's works, their mystery, their shaded groves. Auguste Barbier's *Iambes*[7] on the July Days used often to be on everyone's lips, but no one has echoed the poet's 'lament'[8] on Italy devastated, nor did anyone follow him in his pilgrimage to the Lazarus[9] of the North.

But the condiment that Théophile Gautier throws into his works, a condiment which, for the devotees of art, is most exquisite in choice and sharp in flavour, has little or no effect on the palate of the crowd. To become thoroughly popular means, surely, condescending to the idea of earning popularity – in other words, of stooping to vulgarity in some small secret way, but a way that catches on. In literature, as in morality, there is danger as well as glory in being fastidious. To be aristocratic is to be isolated.

I frankly confess that I am not of those for whom that is a misfortune; and that I may have carried to excess my ill-humour against unfortunate philistines. Recriminating and indulging in opposition, and even demanding justice, is there not in all that a certain degree of 'philistinization'? How easily we forget that to hurl insults at a crowd puts us ourselves amongst the rabble. From an exalted position, any stroke of fate takes on the appearance of an act of justice. Let us then salute, with all the respect and enthusiasm it deserves, this aristocracy that hedges itself about with solitude. We observe, moreover, that a given quality is more or less highly prized according to the spirit of the age, and that, as the centuries run on, they afford splendid opportunities for revenge. Anything can be expected of human oddity, even fairness, although, truth to tell, injustice comes more naturally to it. Did not a political writer express the opinion, only the other day, that Théophile Gautier enjoyed an 'inflated reputation'!

II

My first meeting with this writer – whom the world will envy us, as it envies us Chateaubriand, Hugo and Balzac – is very much in my mind as I write. I had called at his house in order to present him with a small volume of verse, on behalf of two friends who were away at the time. Before me was a man with less presence than is his today, but already full of dignity, at ease and gracious, in loosely fitting clothes. What struck me about him first, as he received me, was the total absence of that coldness, so excusable, be it said, in men accustomed, by virtue of their position, to fear visitors. To describe his welcome, I would willingly use the word bonhomie, were it not so hackneyed; it could apply in this case only if seasoned, to bring out its flavour, according to the Racinian recipe, with a decorative adjective such as 'Asiatic', or 'oriental', to convey a kind of humour at once simple, dignified and mellow. As

for our conversation – and what a solemn thing it is, a first conversation with a well-known man, who towers above you even more in talent than in years! – it, too, is deeply rooted in my mind; when he saw me with a volume of poems in my hand, his fine countenance was lit up by a charming smile; he stretched out his hand with a kind of childlike eagerness; for it is strange how this man, who can express anything, and who, more than anyone, has the right to feel surfeited, is easily excited by curiosity, and casts an eager eye on the world outside himself. After quickly turning the pages of the book, he pointed out to me that the poets in question were too fond of writing what he called 'libertine', in other words, un-orthodox, sonnets, which escape too easily from the rule of the quadruple rhyme. He then asked me, with a curiously suspicious eye, and as though to put me to the test, if I liked reading dictionaries. The question was put with the calm manner he brings to all he says, and in a tone of voice someone else might have adopted to inquire whether I preferred reading travel books or fiction. Fortunately, I had been seized very young with lexicomania, and I saw that my stock had risen as a result of my reply. It was precisely with reference to diction-aries that he added that 'The writer incapable of expressing everything, caught on the wrong foot by an idea, be it never so strange or subtle, never so unexpected, falling like a stone from the moon, was no writer at all'. Next, we talked of hygiene, of the care a man of letters owes to his body, of his being obliged to live soberly. Although to illustrate the subject he drew comparisons, if I remember right, from the life of ballerinas and racehorses, his manner of treating his theme of sober living, as a proof of the respect due to art and the poetic gift, reminded me of what books of piety say on the need for us to respect our bodies as sanctuaries of God. We also talked of the immeasurable complacency of the age, and of the lunacy of progress. I have found, in subsequent works of his, some of the expressions he used to sum up his views; this one

for instance: 'there are three things that civilized man can never create: a vase, a weapon, a harness.' Need I add that beauty, not usefulness, is the point here. I spoke with enthusiasm of the astonishing power he had displayed, in portraying clowning and the grotesque; but, to this compliment, he replied with simplicity that, at heart, he had a horror of wit and laughter, the laughter that distorts man, made in God's image! 'A man may occasionally be witty, just as the sage may be allowed an occasional drinking bout, to show fools that he could be their equal, but it is not essential.' – Those to whom this opinion of his might come as a surprise have not noticed that, as his mind is a cosmopolitan mirror of beauty, in which, as a result, the Middle Ages and the Renaissance have been quite rightly and most splendidly reflected, he very soon sought acquaintance with the Greeks and the beauty of antiquity, to the point of baffling those of his admirers who did not possess the true key of his spiritual home. In this context, *Mademoiselle de Maupin*[10] may usefully be consulted, where Greek beauty was vigorously defended at a time when romantic exuberance was in full spate.

All this was said with clear-cut decisiveness, but without laying down the law, without pedantry, with great finesse but without undue subtlety. As I listened to this eloquent talk, so far removed from our age and its turgid claptrap, I was irresistibly reminded of the clarity of the ancients, of an indefinable Socratic echo, borne softly in to me on the wing of an oriental breeze. I withdrew, conquered by so much nobility and sweetness, captivated by this spiritual power, of which physical strength acts, so to speak, as a symbol, as though to give further emphasis to the true doctrine, and to confirm it by a fresh argument.

Since that distant red-letter day of my youth, how many years, with plumage of varying colours, have taken wing, and vanished into the thirsting sky! Yet even now I cannot think of it without some emotion. That is the solid excuse I can put

forward to those that may have thought me unduly bold and rather *parvenu* to speak familiarly, at the outset of this story, of my close contacts with a famous man. But I must stress that, if some of us allowed ourselves to be on familiar terms with him, the reason is that, in tolerating this attitude, he seemed to invite it. In the simplest way, he enjoys affectionate and familiar paternalism. In that way too, he resembles those celebrated worthies of antiquity who enjoyed the society of the young, and who, in verdant groves, at the river's edge or beneath porticos as noble and simple as their souls, perambulated with them, gravely discoursing the while.

This pen portrait, sketched in broad strokes, really needs the help of the engraver. Fortunately, Théophile Gautier has, in various collections of essays, carried out functions, usually connected with the arts and the drama, which have made of him a public figure, to be met with everywhere on the Parisian scene. Nearly everyone knows his fine long hair, his noble carriage and that expression full of feline reverie.

III

Any French writer ardent in the cause of his country's glory cannot, without pride and without regret, look back to that period of prolific crisis in which romantic literature was unfolding, so vigorously. Chateaubriand, still full of creative strength, but as though prostrate on the horizon, was like an Athos, contemplating with nonchalance the stirrings on the plain; Victor Hugo, Sainte-Beuve,[11] Alfred de Vigny[12] had rejuvenated, nay more, resuscitated French poetry, dead since Corneille.[13] For André Chénier,[14] with his languid atticism in the mode of Louis XVI,[15] was not a vigorous enough symptom of renewal, and Alfred de Musset,[16] feminine and without a doctrine, could have fitted into any period, and would never have been anything but a sluggard given to graceful effusions. Alexandre Dumas[17] was producing one after the other his

spirited dramas where the volcanic eruption was controlled
with the dexterity of a skilful engineer. What ardour in the
man of letters of that day and what curiosity, what zeal in the
public! 'O splendeurs éclipsées, O soleil descendu derrière
l'horizon!'[18]

A second phase developed in our modern literature move-
ment, and this gave us Balzac[19] (the real Balzac, that is),
Auguste Barbier and Théophile Gautier. For we must observe
that, although the latter became a writer well in the public eye
only after the publication of *Mademoiselle de Maupin*, his first
collection of poems, bravely launched whilst the Revolution
was in full swing, dates from 1830. Only in 1832, I think, was
Albertus incorporated with his other poems. However vital and
rich the new literary sap had been hitherto, we are bound to
admit that it wholly lacked one element, or at least displayed
it only rarely, as for example in *Notre-Dame de Paris*, Victor
Hugo being a marked exception by the number and the
abundance of his gifts: I refer to laughter and the sense of the
grotesque. Les '*Jeunes-France*'[20] were not slow in showing that
the School was making up the deficiency. Slight though this
work may seem to some, it possesses great merits. Apart from
'la beauté du diable',[21] or in other words the enchanting grace
and audacity of youth, the work ripples with laughter of the
best quality. Obviously, in a period full of dupery, here was
an author exploiting the ironic vein in full, and showing that
he was no dupe. A robust good sense saved him from imita-
tions and modish creeds. With a slight addition to its scale of
mood, *Une Larme du Diable*[22] continued to work this vein of
generous joviality. *Mademoiselle de Maupin* served to establish
even more clearly his position. For a long time people said that
this work was a response to childish passions, that its magic lay
in the subject rather than in its outstanding formal artistry.
Certain persons must really be bursting with erotic passion,
since they see it everywhere. It is as though they used nutmeg
to flavour their every dish. Because of its prodigious style, its

impeccable and refined beauty, pure and gaily-coloured, this book was a veritable event. That is how Balzac saw it, and he at once wanted to meet the author. To have, not only a style, but a style all one's own, was one of the greatest ambitions, if not the greatest, of the author of *La Peau de chagrin* and *La Recherche de l'Absolu*.[23] In spite of the clumsiness and the convolutions of his own prose, he has always been amongst the most discerning and severe of judges. With *Mademoiselle de Maupin* there appeared in literature a mode of dilettantism, which, thanks to its characteristics of exquisite and extreme refinement, is always the best proof of the gifts indispensable in art. This novel, this tale, this picture, this reverie prolonged with a painter's persistence, this kind of hymn to beauty, had, as its outstanding result, the final establishment of the condition that brings forth works of art, namely the exclusive love of beauty!

The things I have to say on this subject (and I shall be brief) were well-known in other days; then they were lost sight of, forgotten for good. Strange heresies slipped into literary criticism. Some impenetrable cloud or other, blown hither from Geneva or Boston[24] or hell, blotted out the beautiful rays of the sun of aesthetics. The loudly-trumpeted doctrine of the indissoluble union between beauty, truth and goodness is an invention of modern philosophical nonsense[25] (by what strange contagion do we use the jargon of lunacy when trying to define it!).

The different objects of the mind's activities demand faculties that are for ever appropriated to them; sometimes a given object demands only one faculty, sometimes all of them at once: but that is surely a very rare circumstance, and they are never required in equal quantities or to an equal degree. Further, let it be observed that the more faculties an object of study demands, the less noble and pure it is, the more complex it is, the greater the number of its bastard elements. The true serves as basis and aim of the sciences; it concerns, in particular

the intellect pure and simple. Purity of style in this domain
will be welcome, but beauty of style may there be regarded
as a luxury. Goodness is the basis and aim of ethical inquiry.
Beauty is the single ambition, the exclusive aim, of taste.
Although truth be the aim of history, there is a muse of
history, to show that some of the qualities necessary to the
historian appertain to the muse. The novel is one of those com-
plex art forms in which a greater or lesser share derives, now
from the true, now from the beautiful. The share of the beauti-
ful in *Mademoiselle de Maupin* was excessive. The author was
entitled to make it so. The novel's aim was to reflect, not the
social customs any more than the passions of an age, but one
passion only, of a very special nature, universal and eternal,
under the impulse of which the whole book flows, so to speak,
in the same bed as poetry, without however mingling its
waters wholly with the latter, deprived as the book is of the
double element of rhythm and rhyme. That goal, that aim,
that ambition, was to express, in an appropriate style, not the
frenzy of love, but the beauty of love and the beauty of those
objects that are worthy of love, in a word the enthusiasm (so
different from passion) engendered by beauty. For a mind not
in thrall to the fashion of error, the complete confusion of art
forms and faculties is a matter of enormous astonishment. Just
as different crafts demand different tools, so the different ob-
jects of intellectual investigation demand their corresponding
faculties. A man may occasionally, I presume, be allowed to
quote from his own writings, especially to avoid paraphrasing
himself, and I propose to do so here[26]: 'There is another
heresy, an error far harder to kill; I refer to the heresy of
didacticism, which includes, as inevitable corollaries, the
heresies of passion, truth and morality. A whole crowd of
people imagine that the aim of poetry is some sort of lesson,
that its duty is to fortify conscience, or to perfect social be-
haviour, or even, finally, to demonstrate something or other
that is useful. If we will even briefly look into ourselves, ques-

tion our souls, bring to mind our moments of enthusiasm, poetry will be seen to have no other aim but itself; it can have no other, and no poem will be as great, as noble, so truly worthy of the name "poem" as the one written for no purpose other than the pleasure of writing a poem.

'Let there be no misunderstanding: I do not mean to say that poetry does not ennoble manners – that its final result is not to raise man above the level of squalid interests; that would clearly be absurd. What I am saying is that, if the poet has pursued a moral aim, he will have diminished his poetic power; nor will it be incautious to bet that his work will be bad. Poetry cannot, except at the price of death or decay, assume the mantle of science or morality; the pursuit of truth is not its aim, it has nothing outside itself. The modes of demonstration of truth are other, and elsewhere. Truth has nothing to do with song. The things that go to make the charm, the grace, the compelling nature of a song would rob the truth of its authority and power. Cold, calm, unmoved, the proving humour rejects the diamonds and the flowers of the muse; it is therefore at the opposite pole from the poetic humour.

'Pure intellect pursues truth, taste reveals beauty to us, and our moral sense shows us the path of duty. It is true that the middle term has intimate connections with the two extremes, and is separated from the moral sense only by such a narrow shade of difference that Aristotle did not hesitate to number some of its delicate operations amongst the virtues. This is why the thing that particularly exasperates the man of taste, as he looks on vice, is its deformity, its lack of proportion. Vice offends against accuracy and truth, disgusts intellect and conscience; but as an outrage to harmony, as dissonance, it will in particular hurt certain poetic spirits; nor do I think it shocking to regard any infringement of morality, of moral beauty, as a kind of offence against universal rhythm and prosody.

'It is this admirable, this immortal, instinctive sense of beauty

that leads us to look upon the spectacle of this world as a glimpse, *a correspondence* with heaven. Our unquenchable thirst for all that lies beyond, and that life reveals, is the liveliest proof of our immortality. It is both by poetry and through poetry, by music and through music, that the soul dimly descries the splendours beyond the tomb; and when an exquisite poem brings tears to our eyes, those tears are not the proof of overabundant joy: they bear witness rather to an impatient melancholy, a clamant demand by our nerves, our nature, exiled in imperfection, which would fain enter into immediate possession, while still on this earth, of a revealed paradise.

'Thus the poetic principle is strictly and simply the human longing for a superior form of beauty, and the manifestation of this principle lies in an enthusiasm, an uplifting of the soul; an enthusiasm that is quite independent of passion, which is an intoxication of the heart, and of truth, which is a nourishment of reason. For passion is natural, too natural not to introduce a hurtful, jarring note into the realm of pure beauty; too familiar and too violent not to shock the pure desires, the sweet melancholies, the noble despairs, that dwell in the supernatural spheres of poetry.'

Elsewhere I have said[27]: 'In a country where the utilitarian idea, the most hostile in the world to the idea of beauty, takes first place and dominates all other considerations, the perfect critic will be the most "respectable", that is to say, the critic whose instinctive attitudes and desires will come closest to the attitudes and desires of his readers; the one who, confusing faculties and types of production, will ascribe to them all one single purpose; the one who will seek in a book of poetry a means of perfecting the conscience.'

For some years, indeed, a great frenzy of respectability has seized hold of stage, poetry, novel and criticism alike. Setting aside the question what advantages hypocrisy can find in this confusion of functions, what comfort literary impotence may

derive from it, I am content to note and analyse the error, in the belief that it is committed in good faith. During the confused period of romanticism, the period of burning effusions, a phrase often used was: 'the poetry of the heart!' In this way sovereign rights were conferred on passion: a kind of infallibility was attributed to it. What a number of wrong meanings and sophistries a mistake in aesthetic theory may impose on the French language! The heart is the source of love, the heart is the source of self-sacrifice, of crime; the imagination alone contains poetry. But today error has taken another line and assumed greater proportions. For example a woman, in a moment of enthusiastic gratitude, says to her husband, a barrister by profession:

'O, poet! I love you!'

Encroachment of feeling on reason's ground! The typical reasoning of a woman who does not know how to fit words to their strict usage! What it really means is 'You are a respectable man and a good husband; *ergo*, you are a poet and much more of a poet than all those users of metres and rhymes to express ideas of beauty. I will even go so far as to say', babbles on this blue-stocking in reverse 'that every respectable man that knows how to please his wife is a sublime poet. – Better still! I declare in my bourgeois infallibility that whoever knows to perfection the art of stringing verses together is much less of a poet than any worthy man devoted to his home and family; for the talent of composing impeccable verse is evidently damaging to the uxorious capacities which are the basis of all poetry.'

But let the academician guilty of this error so flattering to barristers be comforted. He is in good and numerous company; for the wind of the century is reaching lunatic force; the barometer of modern reason has dropped to storm level. Have we not recently witnessed a celebrated writer,[28] with the highest credentials, placing, to the sound of unanimous

plaudits, all poetry not in beauty but in love! – in love of the common or garden, domestic and sick-nurse type – and exclaiming in his hatred of all beauty: 'a good tailor is worth more than three classical sculptors!', and affirming that, if Raymond Lully[29] became a theologian, it was because God punished him for drawing back at the sight of the cancer that was eating away the breast of a lady, object of his gallant attentions! Had he really loved her, he adds, how greatly the infirmity would have embellished her in his eyes! And so he became a theologian! Well! Serve him right. The same author advises the providential husband to beat his wife, when she comes as a suppliant, demanding the sense of relief expiation gives. And what punishment will he allow us to inflict on an old man lacking all dignity, febrile, feminine, playing at dolls, rhyming compliments in honour of sickness, and rolling with delight in the dirty linen of humanity. For my part, I know of only one; it is a form of torture that leaves deep and lasting scars; for, to quote the song our fathers used to sing, those vigorous men who could laugh in all circumstances, even the most ultimate:

> Le ridicule est plus tranchant
> Que le fer de la guillotine.[30]

But to return to my main theme from this byway into which indignation has led me, the feelings that flow from the heart are not necessarily propitious to poetic creation. Excessive sensibility of heart may even be harmful in this context. Imaginative sensibility is different in nature; it knows how to select, judge, compare, eschew some things, seek out others, all with speed and spontaneity. That form of sensibility usually called taste confers on us the power to avoid evil and pursue what is good in poetic matters. As for ordinary human decency, the commonest courtesy enjoins that we assume all men, even poets, to possess it. That the poet should think it necessary, or not think it necessary, to give his labours the

foundation of clean conventional living, that is a matter that concerns none but his confessor or the law courts; and in this context, his position is wholly similar to that of his fellow citizens.

Readers will see that, within the framework I have given to the question, if we limit the meaning of the word 'writer' to imaginative writing, Théophile Gautier is a writer in the highest sense of the word; because he is the slave of his duty, because he does not cease to obey the obligations of his calling, because the love of beauty is for him a matter of destiny, because he sees his duty as an irresistible compulsion. With his luminous good sense (I mean the good sense of genius, not the good sense of common folk) he was quickly back again on the broad highway. Every writer is more or less branded by his principal faculty. Chateaubriand made the painful glory of melancholy and ennui the burden of his song. Victor Hugo, imposing, awe-inspiring, as vast as a mythical creation, cyclopean so to speak, represents the forces of nature and their harmonious struggle. Balzac, imposing, awe-inspiring, complex too, represents civilization's Caliban, and all his struggles, his ambitions, his outbursts of rage. Gautier stands for the exclusive love of beauty with all its categories, a love expressed in the most appropriate style. And observe that almost all important writers, those we can call leaders of industry or captains, have under them others of the same kind, if not like them, capable of taking their places. Thus, when a civilization dies, if one poem of a particular kind be found, that is enough in itself to give an idea of all the others of the same order lost for ever, and to enable a critical mind to reconstitute, without a missing link, the chain of generations. But, by his love of beauty, an immense productive love, constantly rejuvenated (compare, for instance, the last articles on Petersburg and the Neva with *Italia*,[31] or *Tra los montes*[32]), Théophile Gautier is a writer whose merit is both new and unique. Of him we may truly say that, so far, he has no understudy.

To speak worthily of the tool that serves this passion for beauty, of his style I mean, I would need to possess the same resources: a knowledge of the language that is never at fault, a magnificent dictionary whose pages, stirred by a divine breath, open only to release the right word, the one and only word, finally, a sense of order that knows the right place for every detail, every touch, that never omits any shade of meaning. If we bear in mind that, to this marvellous faculty, Gautier joins a profound and innate understanding of universal correspondence and symbolism, that repository of metaphor, we shall understand how he can unceasingly, tirelessly, faultlessly, define the mysterious attitude that all created objects present as men look at them. There is, in words, in the Word itself, something sacred that forbids our turning them into a game of chance. Handling a language with skill is to practise a kind of evocative witchcraft. Then does colour speak, like a deep and vibrant voice, then do monuments stand out, erect, against the unplumbed depths of space, then do animals and plants, the representatives of ugliness and evil, make their meaningful grimaces, then does scent provoke its corresponding thoughts and memories, and passion murmur or roar its unchanging language. There is, in Théophile Gautier's style, a precision that delights, astonishes and calls to mind the miraculous effects produced in gaming by a profound knowledge of mathematics. I remember, when I was still very young, and was tasting for the first time of the works of our poet, my shivering sense of pleasure, at a brushstroke accurately placed, or a thrust well-aimed, and how my admiration produced in me a kind of nervous tension. Little by little, I got used to perfection, and was carried along by the rhythms of this beautiful style, sinuous, scintillating, like a man astride a well-mannered horse that allows him to give way to dreaming as he rides, or aboard a vessel stout enough to ride out foul weather unforetold by the barometer, so that he can freely contemplate the magnificent and flawless scenery that

nature builds in her inspired moments. It is thanks to these innate gifts, so preciously cultivated, that Gautier could often (we, his friends, have seen him do it) sit down at a common or garden table, in the office of a newspaper, and improvise a piece of criticism or fiction which had the stamp of finished artistry, and which could, the following morning, provoke in the readers a pleasure, equal in degree to the astonishment of the typesetters in the printing house, at the speed of the work's execution and the beauty of the writing. The nimbleness with which he could resolve any problem of style or composition surely recalls the stern maxim he once casually let drop in conversation, and to which he has doubtless always remained faithful: 'Any man who is baffled by an idea, be it never so subtle and unexpected, is no writer. The inexpressible does not exist.'

IV

This constant care, so much a part of his nature as to be involuntary, for beauty and plastic imagery was naturally to lead the author towards a type of novel appropriate to his temperament. Both novel and short story have the advantage of a wonderful flexibility. They can conform to the needs of every nature, accommodate every subject, and pursue divers aims, as they like. Now it will be a study of passion, now a search for truth; one novel appeals to the crowd, another to the chosen few, this one evokes the life of past ages, and that one, the silent drama played out in the mind of a single individual. The novel, which holds such an important place beside poetry and history, is a bastard art form, whose domain is really limitless. Like many other bastards, it is a child of fortune, spoilt, who succeeds in everything. It suffers under no difficulties, knows no dangers, other than its own unlimited freedom. The short story, more restricted, more condensed, enjoys the permanent benefits of constraint; its impact is more

vigorous, and, as the time given to reading a short story is much shorter than that needed for digesting a novel, nothing is lost of its total effect.

Théophile Gautier's mind, poetic, plastic, meditative, was inevitably drawn to this art form, to dressing it up lovingly in the variety of dress that suits it best. No wonder, then, that he should have fully succeeded in the different types of short story he has applied himself to. In grotesque and slapstick, he is very powerful. That is, surely, the solitary gaiety to be expected of the dreamer, who, from time to time, opens the floodgates to an outpouring of repressed joviality, and maintains, without respite, a grace *sui generis* that aims above all to please itself. But where he has risen to his highest point is in what I would call the poetical short story. We can safely say that, amongst the innumerable forms of novel and short story that have filled or entertained the human mind, the most popular has been the novel of manners; that is the form the crowd likes best. Just as Paris likes above all to hear about Paris, so the crowd enjoys looking in the mirrors that reflect its own image. But, when the novel of manners is not redeemed by the natural good taste of the author, it runs the grave risk of being pedestrian, and even (since, in artistic matters, usefulness can be measured by the degree of distinction) wholly useless. If Balzac has made an admirable thing out of this common or garden form, always interesting and often sublime, the reason is that he has thrown his whole being into it. Many a time have I been astonished that Balzac's chief title to fame should have been to rank as an observer; to me, his principal merit had always appeared to be that of a visionary – a passionate visionary. All his characters are imbued with the vital incandescence that was his own. All his stories have the rich colour of dreams. From the top levels of the aristocracy down to the dregs of the populace, all the actors of his *Comédie* are more aggressive, more active and cunning in the struggle, more patient in adversity, greedier for possession,

more angelic in devotion, than the comedy of the real world shows them to be. In short, everyone in Balzac, even the portresses, has genius; every soul is like a firearm loaded to the muzzle with will-power. That is truly Balzac himself. And as all beings in the external world appeared in his inner eye in bold relief and hideous facial expressions, his characters adopt exaggerated attitudes; he has darkened their shadows, and added candle-power to the light they shed. His prodigious liking for detail, which derives from his enormous ambition to see, to make the reader see, to divine and make the reader divine everything, forced him, moreover, to give greater strength to the main parts of his canvas, so as to preserve the perspective of the whole. He sometimes puts me in mind of those etchers who are never content with the acid's bite, and transform the main scratchings on the copper into veritable ravines. To this astonishing natural disposition some miraculous works are due. But this disposition is usually described as Balzac's defects. More accurately speaking, we should call them his merits. But who may pride himself on being so fortunately endowed, and on being able to apply a method enabling him, with a complete mastery of touch, to clothe pure triviality in light and purple? Who can do that? And, to tell the truth, he who does not do that does not achieve much.

Théophile Gautier's muse dwells in a more ethereal world. She cares little – too little, some people think – how Mr Smith, or Mr Jones, or Mr Everyman spends his day, and whether Mrs Everyman prefers the compliments of the bailiff, her neighbour, to the box of sweets of the druggist, who, in his day, was one of the most graceful dancers at the Assembly Rooms. Such problems do not worry his muse at all. She likes to hover on less frequented heights than Lombard Street; she likes awe-ful, uninviting landscapes, or those that breathe a montonous charm, the blue coasts of Ionia, the blinding sands of the desert. She willingly occupies sumptuously decorated apartments, where floats the aroma of an exquisite scent. The

characters she creates are the gods, the angels, the priest, the monarch, the lover, the rich man, the beggarman, etc. She enjoys conjuring up vanished cities, and persuading the re-juvenated dead to recall their passions cut short in death. She borrows from poetry neither metre nor rhyme, but the grandeur or the concentrated vigour of its language. Like that, she shakes off the ordinary worries of day-to-day realities, and is more free to pursue her dream of beauty; but at the same time, she would run the grave risk, were she less supple, less obedient, were she not the daughter of a master who knows the secret of giving life to everything he cares to look at, of not being *visible or palpable* enough. In fine, to abandon meta-phor, the short story gains greatly in dignity if it is in poetic vein; it has a more noble, a more universal air; but it is ex-posed to a big danger, namely that of losing contact with reality, or the magic of verisimilitude. And yet, who does not remember the feast of Pharaoh, and the dance of the slaves, and the home-coming of the triumphant army in *Le Roman de la momie*?[33] The reader feels his imagination carried into the heart of truth, it lives the truth, it is intoxicated with a second-ary reality, created by the witchcraft of the Muse. I did not select the example; I took the first that came into my mind; I could have cited twenty.

When we turn over the pages of a powerful master always sure of his intentions and his touch, choice is difficult, such is the number of pieces that crowd into the memory or the mind's eye, all with the same character of clear definition and good workmanship. Yet I would willingly recommend, as a sample not only of putting things well, but also of mysterious delicacy (for our poet's range of feeling is much wider than is commonly supposed), the well-known story of the *Roi Candaule*.[34] It would surely have been difficult to choose a more threadbare theme, a drama with a more universally foreseen ending; but genuine writers enjoy these challenges. The whole merit (if we set aside the language) lies therefore in the inter-

pretation. If there be a commonplace sentiment, well-worn, within the reach indeed of all women, it is modesty. But here modesty has an extreme character that makes it resemble a religion; it becomes the cult of woman for herself, an archaic, Asiatic modesty, nourished by the excess that characterized the ancient world, a true flower of the hothouse, harem or gynaeceum. A stranger's eye is no less sullying to her than a kiss or a caress. Contemplation is possession! Candaule has revealed to Gyges the hidden beauties of his wife; therefore Candaule is guilty, he shall die – Gyges thereafter is the only husband possible for a queen so jealous of herself. But has not Candaule a powerful excuse? Is he not victim of a feeling as commanding as it is strange, victim of the compulsion that makes a highly-strung and artistic man unable to carry the burden of an immense joy without someone to confide in? Certainly, this interpretation of the story, this analysis of the feelings that produced the facts, is greatly superior to Plato's fable, where Gyges is simply a shepherd possessing a talisman, thanks to which he finds it easy to seduce the wife of his king.

Thus does this strange muse pursue her way, with her varied gait, all manner of dresses at her disposal, a cosmopolitan muse, endowed with the suppleness of Alcibiades[35]; at times, her forehead girt in sacred splendour with the oriental mitre, wrappings fluttering in the wind; at others, strutting about like some merry-making Queen of Sheba, holding her copper-handled sunshade, and mounted on the type of porcelain elephant that adorned the chimney-pieces in the rococo age. But what she loves above all is to stand on the shores of the Inner Sea, and discourse in golden words on 'the glory that was Greece or the grandeur that was Rome'[36]; for then indeed she is 'the true Psyche who returns from the true Holy Land'.[37]

This innate love of form and liking for formal perfection inevitably made of Théophile Gautier a critic with a place apart. None better than he has expressed the happiness vouch-

safed to the imagination by the sight of a thing of beauty, however desolate or awe-inspiring. One of the prodigious privileges of Art is that what is horrible, if artistically rendered, becomes beautiful, and that grief, if expressed in rhythmic cadences, fills the mind with tranquil joy. As a critic Théophile Gautier has experienced, loved, explained in his 'Salons' and in his admirable travel articles, the Asiatic, the Greek, the Roman, the Spanish, the Flemish, Dutch and English types of beauty. When the works of all the artists in Europe were gathered solemnly in the Avenue Montaigne,[38] as though in some sort of grand aesthetic council, who, pray, was the first to speak, and who spoke best, of the English school, which even the most informed members of the public were scarcely in a position to form an opinion on, save from a few memories of Reynolds and Lawrence? Who was it that saw at once the varied and essentially original merits of Leslie, of the two Hunts, one the nature painter, the other the leader of the Pre-Raphaelites, of Maclise, that audacious master of composition, wild yet in control of himself, of Millais, the poet of the minute detail, of J. Chalon, the recorder of afternoon fêtes in spacious parks, with all the gaiety of Watteau and the dreaminess of Claude,[39] of Grant, that heir of Reynolds, of Hook, painter of Venetian reveries, of Landseer, whose animals have thoughtful eyes, of that strange Paton, who recalls Fuseli, and who, with the patience of a bygone age, embroiders pantheistic visions, of Cattermole, the historical painter in watercolour – and of that other artist, whose name escapes me (Cockerell or Kendall?[40]), architect and dreamer, who builds, on paper, cities with bridges supported by elephants, under whose legs pass great three-masted schooners in full sail? Who was able to anglicize his genius in a flash? Who found the right words to describe the enchanting freshness, and those depths, melting into distance, of English water-colours? Wherever an artistic product demands description or explanation, Gautier is there and always ready.

I am convinced that we have his innumerable articles and his excellent travel sketches to thank, if all young men (those who already had an innate love of beauty) have acquired the complementary education they lacked. Théophile Gautier has given them the love of painting, just as Victor Hugo had suggested to them a taste for archaeology. This constant work, pursued with such patience, was harder and more praiseworthy than appears at first; for let us remember that France, the French public, I mean (if we except a few artists and writers), is not artistic, naturally artistic; that public is interested in philosophy, ethics, engineering, enjoys stories and anecdotes, is anything you like, but never spontaneously artistic. It feels or rather judges things successively, analytically. Other peoples, more favoured, are more sensitive to an immediate and total impact on their feelings. Where we ought to see only beauty, our public seeks only truth. Where one should be looking with a painter's eye, Frenchmen adopt the attitude of the man of letters. One day I saw, at the annual Salon, two soldiers standing in perplexed contemplation of a kitchen interior. 'But where on earth is Napoleon?' one of them was saying. (A mistake in the programme had resulted in the kitchen interior having the number properly belonging to a famous battle.) 'Ass,' said the other; 'don't you see that the stew is being prepared against his return?' And they went their way, pleased with the painter, and pleased with themselves. That is France all over. I was relating this incident to a general, who saw in it a reason for admiring the prodigious intelligence of the French soldier. He ought to have said: the prodigious intelligence of all Frenchmen in painting matters! Even these soldiers, men of letters!

V

Alas! France has little of the poet in her either. Every man jack of us, even the least chauvinistic, has defended France at some

inn table in distant lands; but here, at home, in the family circle, let us have the courage to tell the truth. France is no poet; to make a clean breast of it, France even has a congenital horror of poetry. Amongst the writers who express themselves in verse, her favourites will always be the most prosaic. I really believe – forgive me, ye true lovers of the muse! – that I lacked courage at the beginning of this study, when I said that, for France, beauty was easily digestible only if flavoured with political condiments. I should have said the opposite: however political the condiment, beauty brings indigestion, or rather the French stomach rejects it at once. This stems not only, I believe, from France's having been providentially created for the quest of truth rather than of beauty, but also from the fact that the utopian, communistic, alchemical composition of all French brains allows France only one exclusive passion, that of social formulas. Here, each of us wants to be like everyone else, but on condition that everyone else is like each of us. From this contradictory tyranny arises a conflict that applies only to social forms, or, if you like, a level, a general similarity. Hence the ruin and the oppression of any original character. And so it is not only in matters literary that true poets appear like fabulous and foreign beings; we may safely say that, in all fields of invention, the great man here in France is looked upon as a monstrosity, whereas in other countries originality springs up in thick abundant growth, like uncultivated grass, for there social manners allow this to happen.

Let us therefore love our poets secretly and in hiding. Abroad, we shall have the right to boast about them. Our neighbours say: 'Shakespeare and Goethe!' We can reply: 'Victor Hugo and Théophile Gautier!' Some people may be surprised that on the art form that is the latter's main honour, his main title to fame, I should have less to say than on others! I certainly cannot give a complete course on poetics and prosody here. If, in our tongue, terms exist, both numerous and subtle enough, to explain a certain type of poetry, am I capable of

finding them? Of verse, the same is true as of some beautiful women, in whom originality and regularity of features are fused; we do not define, we love them. Théophile Gautier continued, in one respect, the great school of melancholy created by Chateaubriand; indeed his melancholy has a more positive character, is more carnal, and comes sometimes very close to the sadness of the ancients. There are poems in *La Comédie de la mort*, and amongst those inspired by Gautier's sojourn in Spain, that betray the feeling of vertigo and horror produced by the idea of nothingness. Reread, for example, the pieces inspired by Zurbarán and Valdés Leal; the admirable paraphrase of the maxim inscribed on the face of the Urrugne clock: *Vulnerant omnes, ultima necat*[41]; finally, the miraculous symphony entitled *Ténèbres*.[42] I say 'symphony' because this poem sometimes makes me think of Beethoven. It even happens to this poet, at whom the accusation of sensuality is levelled, to fall into a positively catholic terror, so intense does his melancholy become. To look at the question from another angle, he has brought into poetry a new element, which I shall call consolation through the arts, through all picturesque phenomena that rejoice the eye and stimulate the mind. In this sense he has truly been an innovator; he has extracted from French metre a greater range of expression than it had hitherto; he has successfully adorned it with countless details that bring light and sharp definition without damaging the structure as a whole or its general outline. His poetry, which is at once majestic and precious, moves with dignified steps, like courtiers in full ceremonial dress. It is moreover the character of true poetry to have a regular flow, like the great rivers as they approach the sea, at once their death and their extension into the infinite, to avoid hurry and jolting. Lyrical poetry takes wing, but always with a supple and rhythmical movement. Everything that is brusque and broken displeases it, and it consigns such things to the drama or to the novel of manners. The poet, whose talent we love so passionately,

knows all about these great questions, and he has convincingly demonstrated the fact by systematically introducing the majesty of alexandrine into the octosyllable verse (*Émaux et camées*). There, in particular, may be found the full effects arising from the fusion of the double element, painting and music, from the shape of the melody, and from the gorgeous colour effects that are the reward of the regularity and symmetry in rhyme impeccably precise.

Shall I recall that succession of little pieces, each comprising only a few verses, which are interludes, amorous or dreamy, reminiscent now of pieces of sculpture, now of flowers, now of jewellery, but all of them clothed in colours finer or more brilliant than those of China or India, and all of them purer and more decisive in cut than objects carved in marble or crystal? Whoever loves poetry knows them by heart.

VI

I have tried (have I really succeeded?) to express the admiration I feel for the works of Théophile Gautier, and to deduce the reasons that justify that admiration. Some people, even amongst writers, may not share my opinion. The time will soon come when everyone will. The public of today looks upon him merely as an enchanting mind; for posterity, he will be one of the master writers, not only of France but also of Europe. His raillery, his mockery, his firm determination never to be had for a mug: all that is the French side of him, but were he entirely French, he would not be a poet.

Shall I dwell, if only shortly, on his manners, so unaffected, so affable, on his readiness to help, on his forthrightness, when he feels free to speak his mind, when he is not faced with the philistine enemy, of his clock-like punctuality in the performance of all his duties? What would be the use? All our writers have had occasion to appreciate these noble qualities.

I have heard people complain of the blind spot in his mind

on religion and politics. I could, if the mood took me, write another article which would victoriously refute this unjust mistake. I know, and that is enough for me, that discerning minds will understand me when I say that the need of order which possessed his fine intelligence was his sure protection against error in politics and religious matters, and that he possesses, more than others, the feeling of the universal hierarchy, writ large in nature, from the heights to the depths, to every degree of the infinite. Others have sometimes spoken of his apparent coldness, of his lack of humanity. That criticism, too, betrays superficiality and lack of reflection. Every man who professes to love his fellow-men never fails, when certain questions arise which lend themselves to philanthropic ranting, to quote the famous tag:

Homo sum; nihil humani a me alienum puto . . .[43]

A poet might have the right to reply: 'I have imposed upon myself such a high code of duty that *Quidquid humani a me alienum puto*. My function lies outside the human.' But without taking advantage of his prerogative, Gautier could simply answer (I, who know his tender and compassionate heart, I know he has the right to): 'You think me cold, and you do not see that my outward calm is wholly put on, and that your ugliness and crudeness are for ever ready to shatter it. Oh! Ye men of prose and crime! What you call indifference is nothing but the resignation of despair; he who believes the wicked and the fools to be incurably sick can rarely give way to pity. And it is precisely to avoid the distressing sight of your lunacies and your cruelty that my gaze remains obstinately turned towards the immaculate Muse.'

Doubtless this very despair of ever persuading or correcting anyone accounts for our having in recent years witnessed an occasional weakening, outwardly at least, in Gautier, to the extent of his letting fall here and there a few words of praise to 'Mylud' Progress and to all-puissant dame Industry. In such

cases, avoid taking him too quickly at his word, for what could there be truer than to say that 'contempt sometimes fills the heart with an excess of kindness.' For, at such moments, he keeps his true opinion to himself, showing simply, by a slight concession (visible to those who can discern the truth in the twilight), that he wants to live at peace with all men, even with Industry and Progress, those despotic enemies of all poetry.

I have heard a number of people express regret that Gautier has never filled official functions. Certainly in many fields, particularly in the Fine Arts, he could have rendered great services to France. But all things considered, it is better so. However extensive a man's genius may be, however great his goodwill, official functions always have the effect of diminishing his dignity, be it never so slightly; either his independence suffers, or his powers of discernment. For my part, I prefer to see the author of *La Comédie de la mort*, *Une Nuit de Cléopâtre*,[44] *La Morte amoureuse*,[45] *Tra los montes*, *Italia*, *Caprices et Zig-zags*,[46] and so many other masterpieces remain what he has been hitherto: the equal of the greatest writers of the past, a model for the men of the future, a diamond ever rarer in an age drunk with ignorance and materialism, in fine a perfect man of letters.

12. The Salon of 1859[1]

Letters to the Editor of the *Revue Française*

I. THE MODERN ARTIST

My dear M★★★★,[2]

When you did me the honour of asking for a critical review of the Salon you said: 'Be brief; do not produce a catalogue but a general survey, something like the account of a brisk philosophic walk round the exhibition.' Well, your wishes will be fully satisfied; not because your programme fits in, which in fact it does, with my own conception of this boring type of article called a 'Salon'; not because this way of tackling it is easier than the other, brevity always demanding greater efforts than prolixity; but simply because, especially in the present case, no other way is possible. Certainly, my quandary would have been more serious if I had found myself lost in a forest of original works, if the modern French temperament had suddenly undergone a change, and, in its purified, rejuvenated state, had put forth such vigorous and variously scented flowers that the result would have been a series of irrepressible Ohs and Ahs of astonishment, abundant praise, a flow of wordy admiration, and the need for new categories in the language of criticism. But fortunately (for me), nothing of that sort happened. No explosions; no unknown geniuses. The thoughts generated by the sight of this Salon are so simple, so ancient, so classic, that relatively few pages will, no doubt, be all I need to develop them. Do not be surprised, therefore, if banality in the painter has engendered commonplaces in the writer. In any case, you will lose nothing by that; for is there anything (and I am delighted to note that you agree with me in this), anything more charming, more productive, more positively exciting, than the commonplace?

Before I begin, allow me to express a regret that will, I believe, only rarely find expression. We had been told that we were to have some guests to welcome, guests not exactly unknown to us; for the Exhibition in the Avenue Montaigne[3] had already introduced to Parisian exhibition-goers a number of those charming artists who had been unknown to them far too long. I had therefore looked forward eagerly to renewing my acquaintance with Leslie,[4] that rich, naïve and noble humorist, one of the most vigorous embodiments of the British mind; with the two Hunts, one[5] of them a stubborn naturalist, the other[6] the ardent and determined creator of Pre-Raphaelitism; with Maclise,[7] that bold master of composition, as impetuous as he is sure of himself; with Millais,[8] that poet of minute detail; with J. Chalon,[9] that mixture of Claude and Watteau, chronicler of lovely afternoon fêtes in the great Italian parks; with Grant,[10] that natural heir of Reynolds; with Hook,[11] who has the secret of filling his dreams of Venice with a magic light; with that strange Paton,[12] who carries the mind back to Fuseli,[13] and who, with a patience characteristic of another age, embroiders graceful visions of pantheistic chaos; with Cattermole,[14] the painter of historical scenes in water-colour, and with that other astonishing artist, whose name escapes me,[15] architect and dreamer, who builds, on paper, cities with bridges supported by elephants – colossi, under whose legs pass great three-masted schooners in full sail! Wall space had even been reserved for these friends of the imagination and of unusual colour effects, for these, the beloved of the bizarre muse; but alas! for reasons which are unknown to me, and which would, I think, be out of place in your paper, my hopes were disappointed. And so, tragic fires, gestures in the manner of Kean and Macready, intimate studies of the home, oriental splendours, reflected in the poetic mirror of the English mind, Scottish verdures, enchanting arbours, receding depths in water-colours, as spacious as a stage set and yet so small, we shall not gaze on you, not this time at least.

Oh! enthusiastic representatives of the imagination and of the most precious faculties of the soul, were you so badly received at your first coming, and do you think us unworthy of understanding you?

And so, my dear M****, we shall have to content ourselves with France; and, believe me, nothing would give me more intense pleasure than to rise to lyrical heights in speaking of my own country's artists; unhappily, in a critical mind with some experience, patriotism does not play an absolutely tyrannical role, and we have certain humiliating admissions to make. The first time I set foot in this Salon, on the very stair-case, I met one of our most subtle and most esteemed critics, and to my first question, the question I could naturally be expected to ask, he replied: 'Flat, mediocre; I have seldom seen so depressing a Salon.' He was both right and wrong. An exhibition that can boast a large number of works by Delacroix, by Penguilly[16] and Fromentin[17] cannot be depressing; but looking at the thing as a whole I came to see that there was truth in what he said. True, mediocrity has always dominated the scene in every age, that is beyond dispute; but what is also as true as it is distressing is that the reign of mediocrity is stronger than ever, to the point of triumphant obtrusiveness. After allowing my gaze to wander round for some time on a crowd of platitudes brought to successful conclusions, so many bits of rubbish carefully licked over with the brush, so many stupid or specious things skilfully constructed, I was led, by the natural trend of my reflections, to consider the artist in the past, setting him alongside the artist of today; and then, as usual, at the end of my discouraging meditations, the terrible, the eternal 'Why?' arose inevitably before me. It would seem that meanness, puerility, incuriosity, the flat calm of fatuity have taken the place of ardour, nobility, and turbulent ambition, both in the fine arts and in literature; and that nothing, for the moment, gives us grounds for hope of seeing any spiritual flowering comparable with that of the Restoration.

Nor am I alone in feeling oppressed by these sour reflections, believe me; and I shall prove it to you presently. I was accordingly saying to myself: in former days, what manner of man was the artist (Lebrun or David, for example)? Lebrun stands for erudition, imagination, knowledge of the past, love of grandeur. David, that colossus, maligned by a crowd of myrmidons, was he not also love of the past, love of grandeur, allied to erudition? And today, what is the artist, that ancient brother-in-arms of the poet? To answer that question well, my dear M****, we must not be afraid of being too harsh. Scandalous favouritism sometimes calls for a reaction of equal force. Despite his lack of merit, the artist is today, and for many years has been, simply a spoilt child. Just think of the honours, the money squandered on soulless and uncultivated men! For my part, I certainly do not support introducing into a given art means that are foreign to it; and yet, to give an example, I cannot help feeling some sympathy for an artist like Chenavard,[18] always agreeable, agreeable, that is, like good books, and graceful even when most ponderous. At least with him (and what do I care if he be the target of art students' jokes?) I know I can discuss Virgil or Plato. Préault[19] has a delightful talent; it is his instinctive good taste that flings him on the beautiful like a beast of prey on its natural victim. Daumier is endowed with luminous good sense, and this colours his whole conversation. Ricard,[20] in spite of the dazzling and disjointed nature of his talk, reveals at every turn that he knows a lot, and has done a lot of comparative study. There is no need, I think, for me to mention Eugène Delacroix's conversation, which is an admirable mixture of philosophic solidity, light wit and burning enthusiasm. Beyond them I can remember no one worthy of conversing with a philosopher or a poet. Apart from them, you will scarcely find anyone but spoiled children. Tell me, I beg, I entreat you, in what drawing-room, in what tavern, in what social or intimate gathering you have ever heard any witty remark come from

the lips of a spoilt child, any profound, brilliant, pregnant remark, a thought- or reverie-provoking one, in short a significant remark! If such a remark has been flung out in conversation, it may not have come from a politician or a philosopher, but certainly from a man of some unusual profession, a hunter, a sailor, a chair-mender; but from an artist, a spoilt child – never!

The spoilt child has inherited from his predecessors a privilege which was legitimate in their day. The enthusiasm that greeted David, Guérin, Girodet, Gros, Delacroix, Bonington,[21] still sheds a kindly afterglow on his mean little person; and while good poets and vigorous historians painfully earn a living, the dunder-headed financier pays sumptuous prices for the spoilt child's indecent bits of impertinence. And please note, that if such favours came the way of worthy recipients, I should not complain. I am not one of those people who begrudge a singer or a dancer who has reached the peak of her art a fortune earned by the hard work and the risks that are her daily portion. If I were, I should be afraid of falling into the pernicious ways of the late Girardin,[22] of fraudulent memory, who one day reproached Théophile Gautier for setting a higher price on his imagination than a Sous-Préfet for his services. That, if you remember rightly, happened on one of those ill-starred days when a terrified public heard him talking in Latin: *pecudesque locutae*![23] No, I am not as unjust as all that; but it is a good thing to raise one's voice and denounce present-day folly when a lovely picture by Delacroix could scarcely find a buyer at a thousand francs, and, at the very same time, the insignificant little figures of Meissonier[24] were fetching ten or even twenty times more. But those happy days are over; now we have sunk even lower, and M. Meissonier, who, in spite of his merits, had the misfortune of introducing and popularizing the taste for the diminutive, is a veritable giant in comparison with our creators of little baubles today.

Imagination discredited, grandeur disdained, love (no, that

word is too beautiful) -- exclusive concentration on technique, such, I believe, are the main reasons, so far as the artist is concerned, for his decline. The greater the degree of imagination, the surer must be the corresponding mastery of technique, if the latter is to keep pace with the former in its adventurous flights, and to conquer the difficulties imagination eagerly seeks. And the surer his technical mastery, the less the painter should boast and make a parade of it, so that his imagination may shine with its full brilliance. Thus speaks wisdom, and wisdom adds: the man who has mere skill is a fathead, and the man with imagination who tries to do without skill is a lunatic. But simple though such things may be, they are above or below our present-day artist. The daughter of a concierge says to herself: 'I shall go to the Conservatoire, I shall make my début at the Comédie-Française, and I shall speak the lines of Corneille, until such time as I win the same recognition as those who have been speaking them for a long time.' And she is as good as her word. Most classically monotonous, most classically boring and ignorant she is too; but she has succeeded in what was perfectly easy, namely obtaining, by her patience, the privileges of full membership of the Comédie-Française troupe. And the spoilt child, the modern painter, says to himself: 'What is this imagination they talk about? Something dangerous and tiring. What is the study and contemplation of the past? A waste of time. I shall be classical, not like Bertin[25] (for the classical changes its place and its name), but like . . . Troyon,[26] for example.' And he does what he said he would. He paints away, and he stops up his soul, and he goes on painting until at last his manner is like that of the artist in fashion, and by his stupidity and skill he deserves the public's favour and money. The imitator of the imitator finds imitators in his turn, and in this way each chases after his own dream of greatness, stopping up more and more tightly his own soul, and above all reading nothing, not even a cookery book, which could at least have provided him with a more glorious,

if less lucrative, career. Once he has mastered the art of sauces, patinas, glazes, rubbings, gravies, stews (I am speaking of painting), the spoilt child starts striking attitudes, and repeats, with more conviction than ever, that all the rest is unnecessary.

Once upon a time a German peasant went to see a painter, and this is what he said to him: 'Sir, I want you to paint my portrait. You will show me sitting at the main entrance of my farm in the big armchair I inherited from my father. You will paint my wife by my side, with her distaff; behind us, coming and going, my daughters preparing the family supper. To the left, you will depict the grand avenue, and emerging from it those of my sons who are returning from the fields, after having brought the cows back to the cowshed; others of them, with my grandsons, are busy putting the farm carts stacked with hay under cover. As I contemplate the scene, please do not forget the puffs of smoke from my pipe, tinted by the rays of the setting sun. I should also like the viewer to hear the sounds of the Angelus ringing from the church belfry close by. That is where we all got married, father and sons. It is important that you should paint the satisfied air I enjoy at that time of the day, as I look upon my family and my wealth, increased by the labour of another day.'

Loud cheers for that peasant! Without knowing it, he had understood painting. The love of his profession had heightened his imagination. Which of our fashionable painters would be worthy of executing that portrait, and which of them has an imagination on a level with that one?

II. THE MODERN PUBLIC AND PHOTOGRAPHY

My dear M****,

If I had time to amuse you, I could easily do so by thumbing through the pages of the catalogue, and extracting a list of all the ridiculous titles and laughable subjects that aim to attract

the eye. That is so typical of French attitudes. The attempt to
provoke astonishment by means that are foreign to the art in
question is the great resource of people who are not painters
born. Sometimes even, but always in France, this form of vice
takes hold of men who are by no means devoid of talent, and
who dishonour it, in this way, by an adulterous mixture. I
could parade before your eyes the comic title in the manner
of the vaudevillist, the sentimental title, lacking only an ex-
clamation mark, the pun-title, the deep and philosophical
title, the misleading or trap title such as *Brutus, lâche César*.[27]
'Oh ye depraved and unbelieving race,' says Our Lord, 'how
long must I remain with you, how long shall I continue to
suffer?' This people, artists and public, has so little faith in
painting that it is for ever trying to disguise it, and wrap it up
in sugar-coated pills, like some unpalatable physick – and what
sugar! Ye Gods! Let me pick out the titles of two pictures,
which, by the way, I have not seen: *Amour et gibelotte*![28] How
your curiosity is at once whetted, is it not? I am groping about
in an effort to relate intimately these two ideas, the idea of love
and the idea of a skinned rabbit dished up as a stew. You can
scarcely expect me to suppose that the painter's imagination
has gone to the length of fixing a quiver, wings and an eye
bandage on the corpse of a domestic animal; the allegory
would really be too obscure. I am more inclined to think the
title must have been composed, following the formula of
Misanthropie et repentir.[29] The true title should therefore be
'Lovers eating rabbit stew'. Then comes the question: are they
young or old, a workman and his girl friend, or an old soldier
and his moll sitting under a dusty arbour? Only the picture
could tell me. Then we have *Monarchique, Catholique et
Soldat*![30] This title belongs to the high-falutin, paladin type,
the *Itinéraire de Paris à Jerusalem*[31] type (oh Chateaubriand, my
apologies to you! the most noble things can become means
for caricature, and the words of a leader of Empire[32] for
daubers' squibs). The picture boasting this title must surely

represent a personage doing three things at once: fighting, attending communion, and being present at the 'petit lever' of Louis XIV. Or could it be a warrior, tattooed with a fleur de lys and devotional pictures? But what is the good of losing oneself in speculation? The simple truth is that titles such as these are a perfidious and sterile means of creating an impact of surprise. And what is particularly deplorable is that the picture may be good, however strange that may sound. This applies to *Amour et gibelotte* too. And I noticed an excellent little group of sculpture, but unfortunately did not take down its number; and when I wanted to look up what the subject of the piece was, I read through the catalogue four times in vain. In the end you told me, of your kindness, that the piece was called *Toujours et jamais*.[33] It really distressed me to see that a man with genuine talent could go in for the rebus sort of title.

You must forgive my having allowed myself a few moments' amusement in the manner of cheap newspapers. But, however frivolous the matter may seem to you, you will nonetheless discover there, if you examine it carefully, a deplorable symptom. To sum up my thought in a paradoxical way, let me ask you, and those of my friends who are more learned than I in the history of art, whether the taste for the silly, the taste for the witty (which comes to the same thing) have always existed, whether *Appartement à louer*[34] and other such alembicated notions have appeared in every age, to provoke the same degree of enthusiasm as today, if the Venice of Veronese and Bassano was affected by these sorts of logogriph, if the eyes of Giulio Romano,[35] Michelangelo and Bandinelli[36] were astounded by similar monstrosities; in short I would like to know whether M. Biard[37] is eternal and omnipresent, like God. I do not believe it, and I regard these horrors as a special form of grace granted to the French. It is true that their artists inoculate them with this taste; and it is no less true that they in their turn call upon the artists to satisfy this need; for if the artist makes dullards of the public, the latter pays him back in

his own coin. They form two co-relative terms, which act upon one another with equal force. Accordingly let us watch with wonder the rate at which we are moving downwards along the road of progress (and by progress I mean the progressive domination of matter), the wonderful diffusion, occurring daily, of commonplace skill, of the skill that may be acquired simply by patience.

In this country, the natural painter, like the natural poet, is almost a monster. Our exclusive taste for the true (so noble a taste when limited to its proper purposes) oppresses and smothers the taste for the beautiful. Where only the beautiful should be looked for – shall we say in a beautiful painting, and anyone can easily guess the sort I have in mind – our people look only for the true. They are not artistic, naturally artistic; philosophers, perhaps, or moralists, engineers, lovers of instructive anecdotes, anything you like, but never spontaneously artistic. They feel, or rather judge, successively, analytically. Other more favoured peoples feel things quickly, at once, synthetically.

I was referring just now to the artists who seek to astonish the public. The desire to astonish or be astonished is perfectly legitimate. 'It is a happiness to wonder': but also 'It is a happiness to dream'. If you insist on my giving you the title of artist or art-lover, the whole question is by what means you intend to create or to feel this impact of wonder? Because beauty always contains an element of wonder, it would be absurd to assume that what is wonderful is always beautiful. Now the French public, which, in the manner of mean little souls, is singularly incapable of feeling the joy of dreaming or of admiration, wants to have the thrill of surprise by means that are alien to art, and its obedient artists bow to the public's taste; they aim to draw its attention, its surprise, stupefy it, by unworthy stratagems, because they know the public is incapable of deriving ecstasy from the natural means of true art.

In these deplorable times, a new industry has developed, which has helped in no small way to confirm fools in their faith, and to ruin what vestige of the divine might still have remained in the French mind. Naturally, this idolatrous multitude was calling for an ideal worthy of itself and in keeping with its own nature. In the domain of painting and statuary, the present-day credo of the worldly wise, especially in France (and I do not believe that anyone whosoever would dare to maintain the contrary), is this: 'I believe in nature, and I believe only in nature.' (There are good reasons for that.) 'I believe that art is, and can only be, the exact reproduction of nature.' (One timid and dissenting sect wants naturally unpleasing objects, a chamber pot, for example, or a skeleton, to be excluded.) 'Thus if an industrial process could give us a result identical to nature, that would be absolute art.' An avenging God has heard the prayers of this multitude; Daguerre[38] was his messiah. And then they said to themselves: 'Since photography provides us with every desirable guarantee of exactitude' (they believe that, poor madmen!) 'art is photography.' From that moment onwards, our loathsome society rushed, like Narcissus, to contemplate its trivial image on the metallic plate. A form of lunacy, an extraordinary fanaticism, took hold of these new sun-worshippers. Strange abominations manifested themselves. By bringing together and posing a pack of rascals, male and female, dressed up like carnival-time butchers and washerwomen, and in persuading these 'heroes' to 'hold' their improvised grimaces for as long as the photographic process required, people really believed they could represent the tragic and the charming scenes of ancient history. Some democratic writer must have seen in that a cheap means of spreading the dislike of history and painting amongst the masses, thus committing a double sacrilege, and insulting, at one and the same time, the divine art of painting and the sublime art of the actor. It was not long before thousands of pairs of greedy eyes were glued to the peepholes of the stereo-

scope, as though they were the skylights of the infinite. The love of obscenity, which is as vigorous a growth in the heart of natural man as self-love, could not let slip such a glorious opportunity for its own satisfaction. And pray do not let it be said that children, coming home from school, were the only people to take pleasure in such tomfooleries; it was the rage of society. I once heard a smart woman, a society woman, not of my society, say to her friends, who were discreetly trying to hide such pictures from her, thus taking it upon themselves to have some modesty on her behalf: 'Let me see; nothing shocks me.' That is what she said, I swear it, I heard it with my own ears; but who will believe me? 'You can see that they are great ladies,'[39] says Alexandre Dumas. 'There are greater ones still!' echoes Cazotte.

As the photographic industry became the refuge of all failed painters with too little talent, or too lazy to complete their studies, this universal craze not only assumed the air of blind and imbecile infatuation, but took on the aspect of revenge. I do not believe, or at least I cannot bring myself to believe, that any such stupid conspiracy, in which, as in every other, wicked men and dupes are to be found, could ever achieve a total victory; but I am convinced that the badly applied advances of photography, like all purely material progress for that matter, have greatly contributed to the impoverishment of French artistic genius, rare enough in all conscience. Modern fatuity may roar to its heart's content, eruct all the borborygmi of its pot-bellied person, vomit all the indigestible sophistries stuffed down its greedy gullet by recent philosophy; it is simple common-sense that, when industry erupts into the sphere of art, it becomes the latter's mortal enemy, and in the resulting confusion of functions none is well carried out. Poetry and progress are two ambitious men that hate each other, with an instinctive hatred, and when they meet along a pathway one or other must give way. If photography is allowed to deputize for art in some of art's activities, it will not

be long before it has supplanted or corrupted art altogether, thanks to the stupidity of the masses, its natural ally. Photography must, therefore, return to its true duty, which is that of handmaid of the arts and sciences, but their very humble handmaid, like printing and shorthand, which have neither created nor supplemented literature. Let photography quickly enrich the traveller's album, and restore to his eyes the precision his memory may lack; let it adorn the library of the naturalist, magnify microscopic insects, even strengthen, with a few facts, the hypotheses of the astronomer; let it, in short, be the secretary and record-keeper of whomsoever needs absolute material accuracy for professional reasons. So far so good. Let it save crumbling ruins from oblivion, books, engravings, and manuscripts, the prey of time, all those precious things, vowed to dissolution, which crave a place in the archives of our memories; in all these things, photography will deserve our thanks and applause. But if once it be allowed to impinge on the sphere of the intangible and the imaginary, on anything that has value solely because man adds something to it from his soul, then woe betide us!

I know perfectly well I shall be told: 'The disease you have just described is a disease of boneheads. What man worthy of the name of artist, and what true art-lover has ever confused art and industry?' I know that, but let me, in my turn, ask them if they believe in the contagion of good and evil, in the pressure of society on the individual, and the involuntary, inevitable obedience of the individual to society. It is an indisputable and irresistible law that the artist acts upon the public, that the public reacts on the artist; besides, the facts, those damning witnesses, are easy to study; we can measure the full extent of the disaster. More and more, as each day goes by, art is losing in self-respect, is prostrating itself before external reality, and the painter is becoming more and more inclined to paint, not what he dreams, but what he sees. And yet *it is a happiness to dream*, and it used to be an honour to express

what one dreamed; but can one believe that the painter still knows that happiness?

Will the honest observer declare that the invasion of photography and the great industrial madness of today are wholly innocent of this deplorable result? Can it legitimately be supposed that a people whose eyes get used to accepting the results of a material science as products of the beautiful will not, within a given time, have singularly diminished its capacity for judging and feeling those things that are most ethereal and immaterial?

III. THE QUEEN OF THE FACULTIES

In recent times we have heard it said in a thousand different ways: 'Copy nature; and nature only. No greater enjoyment, no more splendid triumph can exist than an outstanding copy of nature.' And this doctrine, which is hostile to art, claimed the right to be applied not only to painting but to all the arts, even to the novel, even to poetry. To these doctrinaires so satisfied with nature, an imaginative man would certainly have had the right to reply: 'I regard it as useless and tedious to copy what is there in front of me, because nothing of that satisfies me. Nature is ugly, and I like the figments of my own fantasy better than the triviality of material reality.' But it would have been more philosophical to ask the doctrinaires in question first whether they were quite certain of the existence of external nature; or, if that question seemed too likely to arouse their sarcasm, whether they were quite certain they knew nature in its entirety, nature and all it embodies? A 'yes' would have been the most boastful and the most extravagant of answers. As far as I have been able to understand its strange and degrading utterances, the doctrine really meant, or at least I do it the honour of supposing it really meant: the artist, the true artist, the true poet, should paint only in accordance with what he sees and feels. He must be really faithful to his own

nature. He must avoid, like death itself, the temptation of borrowing the eyes or the feelings of another man, however great, for in that case the production he gave us would be a pack of lies, relatively to himself, not realities. Now if the pedants I am speaking about (pedantry can be found even in meanness), who have their representatives everywhere, since this theory flatters both the uncreative and the lazy, did not intend the proposition to be understood in that way, we are entitled to assume that all they meant to say is: 'We have no imagination, and we hereby decree that no one else shall have any.'

What a mysterious faculty is this queen of the faculties! It touches all the others; it stimulates them, sends them forth to do battle. It sometimes resembles them so closely as to identify itself with them, and yet it never loses its own identity, and men in whom imagination is not active are easily recognizable by some nameless curse that dries up their work, like the fig tree of the Gospel.

Imagination is analysis, imagination is synthesis; and yet men who are skilful in analysis and competent enough to sum up problems can well be devoid of imagination. Imagination is all that, and yet not entirely that. Imagination is sensitiveness, and yet there are some very sensitive people, too sensitive perhaps, who have none. It is imagination that has taught man the moral significance of colour, contour, sound and scent. In the beginning of things, imagination created analogy and metaphor. It decomposes all creation, and, with the wealth of materials amassed and ordered according to rules whose origins can be found only in the deepest recesses of the soul, it creates a new world, it produces the sensation of something new. Since imagination created the world (I think we are entitled to say that much even in the religious sense), it is right that imagination should govern the world. What does opinion say about a soldier without imagination? That he may make a tough fighter, but that, if he is put in command of an army,

he will make no conquests. An analogous case would be that of a poet or a novelist who removed imagination from command of the faculties, and gave it, for example, to his knowledge of the language or to his observation of facts. What does opinion say of a diplomat without imagination? That he may well have a thorough knowledge of the history of treaties and alliances in the past, but he will never guess the treaties and alliances that lie hidden in the future. What does opinion say of a scholar without imagination? That he has learned all that can be learned, because it has been taught, but he will never discover laws as yet unsuspected of existing. Imagination is the queen of truth, and the possible is one of the provinces of truth. Imagination is positively related to the infinite. Without it, all the faculties, however firm and sharpened they may be, are as though they did not exist, whereas the weakness of some secondary faculties, provided these are stimulated by a vigorouse imagination, is a secondary misfortune. No faculties can do without imagination, but imagination can take the place of some. Often, proudly and simply, it goes straight to the heart of what these faculties have been seeking and finding only after successive efforts to apply a number of methods unsuited to the natural order of things. Finally, imagination plays a powerful part in ethics; for if you will allow me to go that far, what is virtue without imagination? You might as well speak of virtue without pity, virtue without heaven; it is something hard, cruel, sterilizing, which in some countries has turned into bigotry, and in others into protestantism.

Despite all the magnificent privileges I ascribe to imagination, I shall not insult your readers by presuming to explain that the better imagination is supported, the more powerful it will be, and that a fine imagination with an immense store of observed data at its disposal is the strongest combination of all in an artist's battles with the ideal. However, to come back to what I said just now about the right of deputizing that imagination has, in virtue of its divine origin, I will give you

an example, a very minor example which I hope you will not brush aside with scorn. Do you believe that the author of *Antony*, of *Le Comte Hermann*, of *Monte-Cristo*[40] is a scholar? You don't, do you? Do you believe him to be versed in the practice of the arts, to be a patient student of them? Of course not. For my part, I think that would go against the grain with him. Well, here is a good example which proves that imagination, although unsupported by the practice and knowledge of technical terms, is incapable of committing silly, heretical blunders in a domain that lies for the most part within its ambit. Recently, I happened to be in a railway compartment, and I was meditating on the article I am now writing; my mind was particularly occupied with this strange topsy-turvy world, which allows, admittedly in a century where for his punishment man may do anything, the most honourable and useful moral faculty to be treated with disdain, when my eye caught sight of a copy of *L'Indépendence Belge* left lying on a neighbouring seat. Alexandre Dumas had taken on the job of reporting in it on the Salon. This circumstance excited my curiosity. You can easily guess how delighted I was to find my musings fully verified by an example that chance was providing me with. That this man, who looks like the embodiment of universal vitality, should bestow generous praise on an epoch that was itself full of life, that the creator of the romantic drama should sing, in terms not devoid of grandeur, I can assure you, the glories of the fortunate times when, side by side with the new literary school, there flourished the new school of painting: Delacroix, the Deveria brothers,[41] Boulanger,[42] Poterlet,[43] Bonington, etc., what, you will say, is there to be surprised at in that? That is precisely his business. *Laudator temporis acti*![44] But that he should praise Delacroix perceptively, that he should clearly explain the sort of folly shown by his enemies, and that he should go even further, to the point of demonstrating the weaknesses of the very best painters to have been enjoying celebrity recently; that he,

Alexandre Dumas, so unorganized, so abundant a writer, should show so pertinently, for example, that Troyon has no genius, and what he lacks to make even some show of genius, tell me, my good friend, do you find that so simple? All this, of course, was written in that slipshod, dramatic style that he has adopted in talking to his innumerable audience; yet, on the other hand, what elegance and spontaneity in the expression of the truth! You will already have concluded for me. If Alexandre Dumas, who is no scholar, were not lucky enough to be endowed with a rich imagination, he would have spoken a lot of nonsense; he has spoken a lot of sense, and spoken it well because . . . (I must make an end) because imagination, thanks to its power of supplementing, contains the critical spirit within itself.

One way out remains to my opponents, namely to declare that Alexandre Dumas is not the author of his 'Salon'. But this insult is so outmoded, that way out is so commonplace, that it must be left for those with a taste for old clothes, for newspaper scribblers and columnists. If they have not already snatched it up, they surely will.

For our part we propose now to examine more closely the functions of this cardinal faculty (does not its wealth suggest crimson?). I shall simply tell you what I learned from the lips of a master; and just as I at that time confirmed, with all the joy of a man educating himself, his simple precepts by reference to all the pictures I could set eyes on, so we shall be able to apply them successively, like a touchstone, to some of our painters.

IV. THE GOVERNANCE OF THE IMAGINATION

Yesterday evening, after sending you the last pages of my letter, where I had written (but not without a certain diffidence): 'Since imagination created the world, imagination

should govern the world', I was turning over the pages of *The Night Side of Nature*[45] and happened upon the following passage, which I quote only because it is a paraphrase and a justification of the sentence of my own that was worrying me:

By imagination, I do not simply mean to convey the common notion implied by that much abused word, which is only fancy, but the constructive imagination, which is a much higher function, and which, inasmuch as man is made in the likeness of God, bears a distant relation to that sublime power by which the creator projects, and upholds his universe.

I am not in the least ashamed, on the contrary I am profoundly glad, to find myself on common ground with the worthy Mrs Crowe, whose capacity of believing, as much developed in her as doubt is in others, I have always admired.

I was saying that, a long time ago now, I heard a man[46] really learned and profound in his art expressing ideas on this subject that were as vast as could be and yet of the simplest. When I met him for the first time, I had no experience other than that which intense love gives, and no form of argument other than instinct. Admittedly both that love and that instinct were fairly alert; for, even when I was very young, my eyes, although steeped in images painted and engraved, were always eager for more, and I verily believe that the end of all worlds could come, *impavidum ferient*,[47] before ever I became an iconoclast. Evidently he wished to be full of kindness and affability; for we began by talking of commonplace things, that is, of the vastest and profoundest things: of nature, for example. 'Nature is but a dictionary', he was fond of saying. To understand clearly the full meaning implied in this remark, we must bear in mind the numerous and ordinary uses a dictionary is put to. We look up the meaning of words, the derivation of words, the etymology of words; and, finally, we get from a dictionary all the component parts of sentences and

ordered narrative. But no one has ever thought of a dictionary as a composition in the poetic sense of the word. Painters who obey imagination consult their dictionaries in search of elements that fit in with their conceptions; and even then, in arranging them with artistry, they give them a wholly new appearance. Those who have no imagination copy the dictionary, from which arises a very great vice, the vice of banality, to which are particularly exposed those painters whose speciality lies nearest to external nature: the landscape artists, for example, who regard it generally as a triumph if they can conceal their personalities. They contemplate so much that in the end they forget to feel and to think.

For this great painter, all the areas of art, of which one man selects this one, and another that one, as the most important, were – are, I mean – no more than the most humble handmaids of a unique and superior faculty. If a very neat execution is necessary, that is so that the language of dreams may be very clearly translated; if it should be very quick, that is to ensure that nothing is lost of the extraordinary impression that accompanied the birth of the idea; if the artist should pay attention to the cleanness of his tools, that too is easily understood, since every precaution should be taken to ensure that the execution is nimble and decisive.

In such a method, which is essentially logical, all the figures, their grouping in relation to each other, the landscape or interior that provides their background or horizon, their clothes, everything, in short, must serve to shed light on the generating idea, and wear its original colour – its livery, so to speak. Just as a dream is bathed in its own appropriate atmosphere, so a conception, become composition, needs to have its being in a setting of colour peculiar to itself. Obviously a given tone will be attributed to some portion or other of the picture, and this then becomes the key, controlling all the others. Everyone knows that yellow, orange and red inspire and represent ideas of joy, wealth, glory and love; but there

are thousands of yellow or red atmospheres, and all the other colours will be modified logically and in given proportions by the dominant atmosphere. The art of the colourist is evidently connected, in some respects, with mathematics and music. Yet its most delicate operations are the result of a sentiment which long practice has brought to a degree of sureness that defeats description. It will be seen that this great law of overall harmony condemns many garish efforts and raw daubings, even though by the hand of the most illustrious painters. There are some paintings by Rubens that remind us, not only of a coloured firework, but of several fireworks set off on the same ground. The bigger the picture, the broader must be the touches of colour, that goes without saying; but the touches are better not worked into each other[48]; they melt naturally together, at a given distance, by the law of sympathy that brought them together. In this way colour gains in energy and freshness.

A good picture, faithful and worthy of the dreams that gave it birth, must be created like a world. Just as the creation we see is the result of several creations, the earlier ones always being completed by the later, so a harmonically fashioned picture consists of a series of superimposed pictures, each fresh surface giving added reality to the dream, and raising it by one degree towards perfection. In complete contrast, I remember seeing, in the studios of Paul Delaroche and Horace Vernet,[49] enormous canvases, not broadly sketched in, but begun piece-meal, in other words, completely finished in certain areas whilst others existed only in a black or white outline. This sort of product could be compared to a purely manual type of work, to which is assigned the job of covering a given area in a given time, or to a long road divided into a large number of stages. As soon as one stage has been completed, that is the end of that, and when the road has been followed throughout its whole length, the artist is delivered of his picture.

All these precepts are, of course, modified, more or less, by

the different temperaments of the artists. But I am convinced that the foregoing is the surest method for men with rich imaginations. It follows that too great deviations from the method in question are proof that an abnormal and unjustified importance is being attributed to some secondary aspect of art.

I am not afraid of its being said that it is absurd to imagine a single system of teaching being applied to a crowd of different individuals. For it is evident that systems of rhetoric and prosody are not arbitrarily invented forms of tyranny, but collections of rules demanded by the very structure of a man's spiritual being. Nor have systems of rhetoric and prosody ever prevented originality from showing itself clearly. The contrary, namely that they have helped the flowering of originality, would be infinitely truer.

For the sake of brevity, I must omit a number of corollaries deriving from the main principle, which, so to speak, contains within itself the whole code of true aesthetics, and may be expressed as follows: the whole visible universe is nothing but a storehouse of images and signs, to which man's imagination will assign a place and relative value; it is a kind of pasture for the imagination to digest and transform. All the faculties of the human soul must be subordinated to the imagination, which puts them all under contribution at once. Just as a good knowledge of the dictionary does not necessarily imply a knowledge of the art of composition, and the art of composition itself does not imply the gift of universal imagination, so a good painter may well not be a great painter. But a great painter is of necessity a good painter, because a universal imagination comprises the understanding of all technical means and the desire to acquire them.

From the ideas I have just explained to the best of my ability (and how many more things there would be to say, particularly on the areas of common ground between the arts and the similarities between their methods), it is evident that the immense group of artists, or, in other words, of men

dedicated to artistic expression, may be divided into two very distinct camps. In one, we have those who call themselves 'realists', a word with a double meaning, and the sense of which is not precisely determined; to bring out more clearly their error, we will call them 'positivists'. The 'positivist' says: 'I want to represent things as they are, or as they would be on the assumption that I did not exist.' The universe without man. In the other camp, there are the imaginative ones who say: 'I want to illuminate things with my mind and cast its reflection on other minds.' Although both these methods, which are diametrically opposed, may enhance or diminish any subject, from a religious scene to the most modest landscape, yet the imaginative man must usually have come to the fore in religious painting and in fantasy, whereas genre paintings, so-called, and landscapes must, on the face of it, have offered vast resources to lazy minds not easily stimulated.

Besides the imaginative painters and the self-styled realists, there is yet another class of men, timid and obedient, who attach all their pride to obeying a falsely dignified code. Whilst the realists fondly think they are representing nature, and the imaginatives try and paint their own souls, others conform to rules of pure convention, wholly arbitrary, not drawn from the human soul, and simply imposed by some well-known studio, as a pure matter of routine. This very numerous but most uninteresting category comprises false admirers of antiquity, the false admirers of style, and in short all men who, by dint of their impotence, have elevated the *poncif* to the honours of true style.

V. RELIGION, HISTORY, FANTASY

Every time there is a new exhibition, the critics observe that religious paintings are getting scarcer and scarcer. I do not know whether they are right, so far as numbers go; but they are certainly not mistaken in the matter of quality. More than

one religious writer, naturally inclined, like the democratic writers, to attach the idea of beauty to belief, has not failed to attribute this difficulty in expressing matters of faith to the absence of faith. That is an error that could be philosophically demonstrated were it not that the facts amply prove the contrary, and if the history of painting did not offer us unbelieving and atheistic artists producing excellent religious works. Let us accordingly say simply that because religion is the most exalted fiction of the human mind (I am deliberately expressing myself as an atheistic professor of the fine arts might do, and no conclusion is to be drawn from this against my own faith), it demands the most vigorous imagination and the most strenuous efforts of concentration from those who dedicate themselves to the representation of its observances and feeling. Thus, for example, the character of Polyeucte[50] demands, from poet and actor, a loftier striving of the spirit, and a much more vital enthusiasm, than would any humdrum character in love with some humdrum creature of this world, or even than an exclusively political hero. The only concession that may reasonably be made to those who believe faith to be the only source of religious inspiration is that the poet, the actor and the artist, at the moment when they are creating the work in question, believe in the reality of what they are representing, spurred on as they must be by a kind of inevitability. Thus art is the only spiritual sphere where man can say: 'I shall believe if I want to, and if I don't, I won't.' The cruel humiliating maxim *Spiritus flat ubi vult*[51] loses its right in matters of art.

. . .

Delacroix's imagination! Here was an imagination that never feared to scale the difficult heights of religion; heaven belongs to it, just as hell does, and war, and Olympus and pleasure. He surely is the archetype of the painter-poet! He surely is one of the rare elect, and the breadth of his mind brings religion into its domain. His imagination, as fiercely bright as a mortuary chapel, is alight with every shade of flame

and crimson. All the grief in the Passion enthrals him; all the splendours in the Church fill him with light. Onto his inspired canvases he pours blood, light and darkness, by turns. I believe he would gladly add his own natural magnificence to the majesty of the Gospel, as an extra offering. I remember seeing a little *Annonciation* by Delacroix, where the angel, messenger to Mary, was not alone but ceremoniously escorted by two other angels, and the impact of this heavenly company was powerful and full of charm. One of his early paintings, *Le Christ aux Oliviers* ('Lord, take thou this cup from me', at the Church of Saint-Paul, Rue Saint Antoine), is suffused with feminine tenderness and poetic suavity. The suffering and the majesty which resound so loudly in religion always awaken an echo in his mind.

Well, believe it or not, my friend, this extraordinary man, who has wrestled with Scott, Byron, Goethe, Shakespeare, Ariosto, Tasso, Dante, and the Gospels, who has illuminated history with the rays of his palette, and poured his fantasy in streams of light into our dazzled eyes, this man, well advanced in years, but with the mark of stubborn youthfulness upon him, who from his earliest youth has devoted all his time to exercising his hand, his memory and his eyes, in order to forge ever-surer weapons for his imagination, this genius has recently found a teacher, ready to show him the skills of his own art, in the person of a young scribbling columnist, whose ministry to date has been limited to reporting on the dress of Madame So-and-so at the last ball of the season at the Town Hall. Oh! those *pink* horses, oh! the *lilac-coloured* peasants, oh! the *red* smoke (what audacity, red smoke!) have been dealt with in a *green*[52] fashion! Delacroix's work has been ground to powder and scattered to the four winds of heaven. This kind of article, which incidentally is stock conversation in bourgeois drawing-rooms, invariably begins with these words 'I must say that I make no claim to be an expert, the mysteries of painting are a sealed book to me, and yet . . . etc. . . .' (if so,

why speak of it at all?), and usually ends with a remark full
of gall, which amounts to an envious glance at the happy few
who understand the incomprehensible.

What does stupidity matter, you will say, if genius tri-
umphs? But, my good friend, it is not superfluous to assess the
strength of resistance that genius runs up against, and the whole
importance (quite enough, in all conscience!) of this young
chronicler[53] boils down to representing the average state of
mind of the bourgeoisie. Bear in mind that this sort of non-
sense has been levelled at Delacroix since 1822, and that since
that time, with punctual regularity, our artist has given us a
series of paintings, one of which at least was a masterpiece, at
each exhibition, thereby tirelessly displaying, to quote the
polite and indulgent words of M. Thiers, 'that impulse of
superiority that revives our hopes, drooping a little at the sight
of the over-moderate merits of all the others.' And he added,
a little further on: 'What reminiscence is it of the great masters
that overwhelms me at the sight of this picture [*Dante et
Virgile*]? Here once more I can see the wild, glowing, but
natural power that yields without effort to its own mo-
mentum . . . I do not think I am mistaken: to M. Delacroix
genius has been given; let him stride forward with assurance,
let him undertake those vast works that are the indispensable
condition of talent . . .'[54] I do not know how many times in
his life M. Thiers has been a prophet, but he surely was one
that day. Delacroix has devoted himself to immense tasks, and
he has not disarmed opinion. At the sight of this majestic, in-
exhaustible outpouring of painting, what easier than to discern
the personality of the man[55] I overheard one evening saying:
'Like all men of my age, I have experienced a number of
passions; but only in work have I felt completely happy.'
Pascal says that togas, purple, and plumes have been most
happy inventions to impress the vulgar herd, to attach a label
to what is really worthy of respect; and yet the official
honours that Delacroix has received have not silenced ignor-

ance. But to look at the thing closely, for the people who, like me, want artistic matters to be treated only between aristocrats, and who believe that the small number of elect is what makes Paradise, everything is for the best as things stand. Oh! privileged man! Providence keeps some enemies in reserve for him. Oh! blessed amongst the blessed! Not only does his talent triumph over all obstacles, but he creates others, to triumph over those too! He is of the stature of the old masters, in a century and in a country where the old masters could not have survived. For when I hear men such as Raphael and Veronese being praised to the sky, with the manifest intention of diminishing the merit of those who came after them, whilst giving my enthusiasm to these great shades, who have no need of it, I ask myself whether a merit that is the equal of theirs (let us admit for a moment, purely to oblige, that it is inferior to theirs) is not infinitely more meritorious, since it has developed triumphantly in a hostile climate and soil? The noble artists of the Renaissance would have been very blameworthy had they not been great, creative and sublime, encouraged and stimulated as they were by an illustrious company of lords and prelates, nay more, by the multitude, itself so full of artistic feeling in that golden age! But the modern artist who has risen to a great height in spite of his times, what shall we say of him, if not certain things that the age will not accept, and which we must leave to future ages to say?

To come back to religious paintings, tell me if you have ever seen a better expression of the inevitable solemnity of the *Mise au tombeau*? Do you honestly believe that Titian would have invented that? He would have conceived, he has conceived, the thing differently; but I prefer this conception. The scene is the burial vault itself, symbol of the underground existence that the new religion was itself destined to lead for a long time! Outside, the air and light form a slowly upward moving spiral. The Holy Mother is on the point of swooning, she can scarcely stand! Let us note, in passing, that instead of

depicting the Holy Mother as a scrap-book figure, Eugène Delacroix always endows her with a measure of tragedy, in gesture and presence, which is wholly appropriate to this queen of mothers. It is impossible for an art-lover with a dash of the poet in him not to feel his imagination struck, not by a historical, but by a poetic, religious and universal impression, as he looks upon this little band of men in the act of lowering with tender care the body of their God into the depths of the vault, into this sepulchre which the world will worship there-after, 'The only one', as René[56] proclaims superbly, 'that will have nothing to yield up at the end of time.'

The *Saint Sébastien* is miraculous, not only as a painting, but for its exquisite sadness. *La Montée au Calvaire* is a complex, ardent and learned composition. The artist, who knows the sort of people he has to deal with, explains: 'The canvas was to have been executed on a large scale at Saint-Sulpice, in the baptistery now converted to other uses.' Although he has chosen his words with care, and has clearly said to the public: 'I want to show you a small-scale project of a big work I had been entrusted with', the critics have not been lacking, as usual, who have taunted him with being incapable of painting anything but sketches.

And behold here, lying on a bed of wild verdure, as soft and drooping as a woman, the illustrious poet[57] who taught the *Art of Love*. Will his devoted friends in Rome be able to overcome the imperial rancour? Will he, one day, enjoy anew the voluptuous splendours of the prodigious city? No, from the depths of these unfavoured lands the steady melancholy flow of the *Tristia* will be poured forth, here will he live, here die.

One day, having crossed the Ister near its mouth, and being at a little distance from the band of hunters, I found myself within sight of the Black Sea. I discovered a stone tomb over which grew a laurel. I tore away the grasses covering some Latin lettering and soon I succeeded in making out the first line of the elegies of an unfortunate

poet: 'My book, you will go to Rome, but you will go to Rome without me.'[58]

I cannot describe to you my feelings at stumbling upon the tomb of Ovid in the midst of this desolate region, nor the sadness of my reflections on the sufferings of exile, which were mine as well, and on how useless talents are for happiness! Rome today enjoys the descriptions of the most ingenious of her poets, yet for twenty years Rome witnessed, dry-eyed, the flowing tears of Ovid. Ah! Less ungrateful than the peoples of Ausonia, the savage inhabitants of the banks of the Ister still remember the Orpheus that appeared in their forests. They come and dance around his ashes; they have even retained something of his language. So dear to them is the memory of this Roman, who accused himself of being a barbarian, because he was not understood by the Sarmatians.

Not without cause have I quoted, in reference to Ovid, these reflections of Eudorus.[59] The melancholy tones of the poet of *Les Martyrs* are suited to this picture, and the languishing sadness of the Christian prisoner is solicitously reflected there. It displays alike that breadth of touch and feeling which is characteristic of the pen that wrote *Les Natchez*[60]; and I can discern in Delacroix's barbaric idyll a 'story of perfect beauty' because he has put there 'the flower of the desert, the charm of the lonely hut, and a simplicity in the telling of a great sorrow, which I do not flatter myself to have preserved'. Certainly, I shall not attempt to express with my pen the voluptuous sadness that emanates from the lush greens of this *exil*. The catalogue, modelling itself in this case on the precise and terse notes of Delacroix, wisely contents itself with stating: 'Some of them are looking at him with curiosity, others are welcoming him in their simple way, and are offering him wild fruit and mare's milk.' Sad though he is, the poet of Roman sophistication is not insensitive to the graciousness of these barbarians, to the charm of this rustic hospitality. All Ovid's delicacies and inventiveness of talent have passed into Delacroix's painting; and just as exile gave to the brilliant poet the note of sadness he lacked, so melancholy has cast its

magic glaze over the painter's fertile countryside. I find it impossible to say this or that picture of Delacroix's is his best; for the wine is always from the same cask, heady, exquisite, with a flavour all its own; but one may claim that *Ovide chez les Scythes* is one of those astonishing works that Delacroix alone could conceive and execute. The artist who produced that may consider himself a happy man, and happy too will he be who can feast his eyes on it every day. The mind sinks into it, with slow and greedy pleasure, as it does into the sky, into the sea horizon, into eyes full of thought, or a saying pregnant with reverie. I am convinced that this picture has a quite outstanding charm for discerning minds; I could almost swear that, more than others perhaps, it must have pleased highly-strung, poetic temperaments, M. Fromentin[61] for example, about whom I shall have the pleasure of talking to you presently.

I am cudgelling my brains to extract some formula or other to describe the peculiar quality of Eugène Delacroix. Excellent draughtsman, prodigious colourist, ardent and inventive master of composition, all that is obvious, and has all been said before. But how does he always manage to convey a sensation of novelty? What does he give us more than the past has done? As great as all the great, as skilled as all the skilled, why does he give us greater pleasure? We could perhaps say that, being endowed with a richer imagination, he expresses in particular the most intimate recesses of the brain and the unexpected aspect of things, such is the fidelity of his work to the character and mood of his conception. The infinite is there in the finite. A dream quality is there, and I mean by 'dream', not the store of figments conjured up at night, but the vision produced by intense meditation or, in less fertile intellects, by an artificial stimulant. In a word, the soul at its golden hours, that is Delacroix's theme, as a painter. Believe it or not, my dear sir, this man sometimes makes me want to live as long as a patriarch, or, in spite of all the courage the dead would need

to consent to come back to life again ('Send me back to Hell' was the cry of the poor soul recalled from the dead by the Thessalian sorceress), to be resuscitated in time to see and hear the joys and praises he will excite in the future. But what is the good? And even if my puerile wish to see a prophecy realized were granted, what profit would I derive from that, other than the shame of recognizing that I was a feeble soul, possessed by the need to have the approval of other men, for my convictions?

VI. RELIGION, HISTORY, FANTASY (continued)

French wit, with its epigrammatic bent, combined with an element of pedantry destined to inject a flavour of seriousness into its natural levity, was to engender a school, which the naturally benign Théophile Gautier calls the neo-Greek School and which, with your permission, I shall call the school of the *pointus*.[62] Here erudition serves to disguise the absence of imagination, and for most of the time, therefore, the game consists in transplanting the life of every day into Greek or Roman surroundings. Dézobry[63] and Barthélemy[64] will be of great help here, and imitations of frescoes from Herculaneum, their pale tints reproduced by means of imperceptible rubbings, enable the painter to avoid all the difficulties of rich and solid painting. Thus, on the one hand bric-à-brac (the serious element) and, on the other, the transposition of the commonplaces of life into the surroundings of antiquity (the surprise element and the success formula) will henceforth between them play substitute for all the conditions required for good painting. Thus we shall see urchins of antiquity playing antique ball, or trundling antique hoops, or playing with antique dolls and toys; idyllic tiny tots playing at grown-ups (*Ma Sœur n'y est pas*); cupids astride marine monsters (*Décoration pour une salle de bain*); and crowds of *Marchandes d'Amours*, offering their wares hung up by their wings, like rabbits by their ears,

and who should be sent back to the Place de la Morgue, which is a spot where a brisk trade is done in birds of a more natural kind. Love, inevitable lóve, the immortal cupid of the confectioners, plays a dominating and universal role in this school. He is the president of this flirtatious and simpering republic. He is a fish to be served up in any kind of sauce. And yet, are we not heartily sick of seeing colour and marble liberally used for this dirty old man, winged like an insect or a duck, whom Thomas Hood shows us[65] squatting on a cloud cushion, and, like a cripple, squashing it beneath his flabby obesity? In his left hand, he holds his bow leaning against his hams like a sword; with his right, holding his arrow, he obeys the command 'Slope arms'. His hair is a crop of short curls, like a coachman's wig; his bulbous cheeks compress his nostrils and his eyes; his flesh, or rather his meat, well-lined, tubular, and inflated, recalling the lumps of lard hung on a butcher's meat-hook, is doubtless distended by the sighs of the universal idyll; to his capacious back are appended a pair of butterfly's wings.

'In sober verity, does such an incubus oppress the female bosom? . . . Is this the personage, the disproportionate partner, for whom Pastorella sigheth in the narrowest of virginal cots? Is the platonic Amanda (who is all soul) alluding, in her discourses on love, to this palpable being, who is all body? Or does Belinda indeed believe that such a substantial sagitarrius lies ambushed in her perilous eye?

'It is the legend that a girl of Provence was once smitten with love by the marble Apollo, and died of it: but did impassioned damsel ever dote and wither beside the pedestal of this preposterous effigy? or, rather, is not the unseemly emblem accountable for the coyness and proverbial reluctance of maidens to the approaches of Love?

'I can believe in his dwelling alone in the heart, seeing that he must occupy it to repletion; in his constancy, because he looks sedentary and not apt to roam. That he is given to melt, from his great pinguitude. That he burneth with a flame, for

so all fat burneth; and hath languishings, like other bodies of his tonnage. That he sighs, from his size.

'I dispute not his kneeling at ladies' feet, since it is the posture of elephants; nor his promise that the homage shall remain eternal. I doubt not of his dying, being of a corpulent habit, and a short neck. Of his blindness, with that inflated pig's cheek. But for his lodging in Belinda's blue eye, my whole faith is heretic, for she hath never a stye in it.'

That makes agreeable reading, does it not? And it gives us a feeling of revenge on that big, fat, dimple-punctured baby, who stands for love in the popular imagination. For my part, if I were asked to represent love, I think I should paint him in the form of a mad horse, devouring its master, or a devil with dark rings round his eyes from debauchery and sleepless nights, dragging, like a spectre or a galley-slave, clanking chains at his ankles, shaking with one hand a poison phial, with the other brandishing a dagger dripping with the blood of his crime.

The school in question, whose main characteristic (in my eyes) is to be a perpetual source of irritation, borders, at one and the same time, on the proverb, the riddle and the old-in-new-guise type of thing. In the riddle type, the new school is as yet inferior to *L'Amour fait passer le temps* and *Le temps fait passer l'amour*,[66] which have the merit of being a shameless rebus, accurate and irreproachable. With its mania for dressing up trivial modern life in the fashion of antiquity, the school constantly commits what I would willingly call a caricature in reverse. I believe I may be rendering it a service by drawing its attention, if it wants to be still more irritating, to the little book by M. Édouard Fournier[67] as an inexhaustible source of subjects. Dressing up modern history, modern professions and modern industry in the clothes of past ages, that, I imagine, would be an infallible and infinite means, for painting, of provoking astonishment. The scholarly author will surely derive some pleasure from the game himself.

There is no mistaking some noble qualities in M. Gérome,[68] the main ones being the pursuit of novelty and the liking for great subjects; but his originality (if in fact there be any) is often of a laborious kind and scarcely discernible. Coldly he warms up his subjects with trivial ingredients and childish expedients. The idea of a cock fight naturally evokes memories of Manila or England, M. Gérome will attempt to whet our curiosity by transporting this game into a sort of antique pastoral. In spite of great and noble efforts (his *Siècle d'Auguste*, for example – which is another proof of that French tendency, to be found in M. Gérome, to seek success elsewhere than in painting proper), he has been hitherto, and will remain, or at least I fear so, no more than the first among the *pointus*. That these Roman games are faithfully represented, that the local colour is scrupulously observed, I do not doubt for a moment; I shall not raise the slightest suspicion on that score (although, since there stands the Retiarius, where is the Mirmillo?[69]) but is there not something, if not fraudulent at least dangerous, in building success on factors such as these, and may not a sales resistance be aroused in the minds of many people, who will go away shaking their heads and wondering whether that really was the way things happened? And even supposing such a criticism to be unfair (for, generally speaking, one can recognize in M. Gérome a mind full of curiosity for the past and eagerness to learn) it is a well deserved punishment for an artist who substitutes the entertainment provided by a page of erudition for the pleasure of pure painting. M. Gérome's technique, it has to be said, has never been either vigorous or original. On the contrary, lacking decisiveness and character, it has always oscillated between Ingres and Delaroche. I have, besides, a sharper criticism to make of the picture in question. Even to show up the hardened habit of crime and debauchery, even to implant in our minds some idea of the secret meanness of gluttony, it is not necessary to seek the help of caricature, and I believe that the habit of

command, especially of dominion over the whole world, confers, in the absence of other merits, at least a certain dignity of attitude, which this self-styled Caesar, this butcher, this fat wine-merchant, who, to judge from his self-satisfied and insulting posture, could at best aspire to the role of editor of the *Fat Boys' and Other Most Replete Persons' Journal*, is far from achieving.

Le Roi Candaule[70] is another 'catch' and a distraction. Many people wax lyrical about the furnishings and about the decorations of the royal couch; so that is what an Asiatic bedroom looks like! What a triumph! But could it be true that the terrible queen, so jealous of her person, who felt soiled as much by a look as by a touch, looked like that anaemic puppet? There is moreover a great danger in a subject such as this, poised at equal distance from tragedy and comedy. If an Asiatic anecdote is not treated in an Asiatic manner, baleful and bloody, it will always produce a comic effect; it will invariably call to mind the licentious scenes of your Baudouins[71] and Biards of the eighteenth century, where a door, ajar, allows two wide-open eyes to watch the handling of a syringe between the exaggerated charms of a marquise.

Julius Caesar! What sunset splendours does this man's name cast upon the imagination! If ever mortal man resembled the divinity it was he! Powerful and seductive! Brave, scholarly, and generous! Every kind of power, of glory, of elegance, was his! He, whose greatness always outstripped his victory, and who grew greater even in death; he whose breast, pierced by the knife, gave vent only to the cry of a father's love, and who found the dagger's wound less cruel than that of ingratitude! This time certainly M. Gérome's imagination has been carried away! It was undergoing a moment of fortunate tension when it conceived the idea of his Caesar, alone, stretched out in front of his overturned throne, and of the corpse of this Roman, sometime pontiff, warrior, orator, historian, and master of the world, filling an immense and deserted hall. Criticism has

been levelled at this way of presenting the subject; but it deserves the greatest praise. The effect is truly powerful. This dreadful summing-up is enough. We all know enough Roman history to picture to ourselves what is left unsaid, the disorder that preceded, and the tumult that followed. Beyond that wall, we can evoke Rome and hear the cries of the populace, stupefied and relieved, ungrateful towards both the victim and the assassin: 'Brutus for Caesar'! One inexplicable detail remains to be explained in the picture itself. Caesar cannot be a Moroccan; he had a very white skin; nor is it childish to recall that the dictator took as much care of his person as a fastidious dandy. Why then the muddy colour of the face and arm? I have heard it alleged that the explanation is the cadaverous hue that death puts on faces. In that case how long ago are we to suppose that the living man became a corpse? The partisans of an excuse of that sort must regret the absence of putrefaction. Others content themselves with observing that the head and arm are enveloped in shadow. But that excuse would imply that M. Gérome is incapable of representing white flesh in a penumbra, and that is not credible. Accordingly, I give up trying to unravel that mystery. Such as it is, and with all its defects, this canvas is the best, and certainly the most striking, he has shown us for a long time.

French victories continue to inspire a large number of military paintings. I do not know what you, my dear M****, think of military painting, considered as a craft and a speciality. For my part, I do not believe that patriotism calls upon us to cultivate a taste for the false and the insignificant. But this kind of painting, when one begins to think about it, demands falseness or insignificance. A battle, a real one, is not a picture; because, to be intelligible and therefore interesting as a battle, it can be represented only by a series of white, blue or black lines, representing the units in line of battle. In a composition of this kind, as in reality, the terrain becomes more important than the men. But, in these circumstances, good-bye to the

picture, or at least to any picture other than a tactical or topographical one. M. Horace Vernet once, several times even, thought he had solved the difficulty by means of a series of accumulated and juxtaposed episodes. At once the picture, deprived of any unity, resembles those bad plays where an excess of extraneous incidents prevents our seeing the main theme, the conception that was at its origin. Thus, apart from pictures made for tacticians and topographers, which must be excluded from pure art, a military picture is intelligible and interesting only if understood as a mere episode in military life. M. Pils,[72] for example, whose amusing and solid compositions we have often had occasion to admire, has grasped that very well; so, earlier, did Charlet[73] and Raffet.[74] But even in the mere episode, in the mere evocation of a struggling mass of men on a given small space of ground, what an accumulation of false, exaggerated and monotonous things the spectator's eye has to put up with! I have to confess that what pains me most in this sort of spectacle is not the abundance of wounds, the hideous prodigality of torn limbs, but the stand-still frozen violence, and the horrible, cold grimaces of static fury. What a number of other just criticisms could be added! To start with, these long columns of troops, in monochrome uniforms such as modern governments provide, do not lend themselves easily to the picturesque, and when artists are feeling bellicose they are more apt to look to the past (as M. Penguilly has done in the *Combat des Trente*) for plausible pretexts to depict a fine variety of weapons and costumes. Then again, there is, in the heart of man, a love of victory, exaggerated to the point of falsehood, which often gives these canvases the false air of a defending counsel's speech. To a reasonable mind, this is not a little apt to dampen an enthusiasm that is, be it added, always ready to blossom. Alexandre Dumas latterly received a swingeing reply from one of his colleagues, for having on this point recently recalled the fable: 'Oh! if only lions could paint!'[75] It must in

justice be said that the moment was not very well chosen, and
that he ought to have added that every nation displays naïvely
the same fault on the boards of its theatres and in its picture
galleries. Here, my friend, is a good example of the degree of
madness to which an exclusive passion, foreign to the arts, can
drive a patriotic writer: one day I was turning over the pages
of a well-known collection of engravings representing French
victories with textual commentaries. One of these prints had
as its subject the conclusion of a peace treaty. The French
representatives, booted, spurred, haughty in mien, displayed
an almost insulting air towards a group of humble and dis-
mayed diplomats; and the text applauded the artist for his
skill in expressing moral vigour in the French party, by the
energetic drawing of the muscles, and in the other party,
cowardice and weakness, by a wholly feminine roundness of
form. But enough of these puerilities; too lengthy an analysis
of them would be out of place. Let us content ourselves with
drawing this moral, namely that men can be without modesty
even in the expression of the noblest and the most exalted
sentiments.

There is a military picture that we must praise, and praise
whole-heartedly; but it is not a battle scene; on the contrary,
it is almost a pastoral. You will already have guessed that I am
referring to M. Tabar's picture. The catalogue simply states:
Guerre de Crimée, Fourrageurs. What verdure, and what beauti-
ful verdure, gently undulating with the rhythm of the hills!
Here the soul breathes a complex scent; the freshness of plant
life, the peaceful beauty of nature, which induces reverie
rather than thought, and at the same time contemplation of
the ardent adventurous life, where each day brings different
tasks. It is an idyll traversed by war. The sheathes are stacked,
the needed harvest is gathered in, and doubtless the work is
over, for the bugle sounds its echoing recall. The soldiers are
seen returning in scattered groups across the undulating
ground with a free and easy nonchalance. Better advantage

could scarcely be derived from such a simple subject; every-
thing about it is poetic, nature and man; everything in it is
true and pictorially good, to the bit of string or the single
brace that, here and there, holds up a pair of red trousers. For
once the uniform with its flaming poppy red gives a touch of
gaiety to the vast ocean of green. The subject moreover is
stimulating to the imagination; and although the scene is laid
in the Crimea, before I opened the catalogue my thoughts, at
the sight of this army of harvesters, had sped first to our troops
in Africa, whom we always picture ready to turn their hands
to anything, so busy, so truly Roman.

. . .

X. PARTING WORDS

At last I may utter that irresistible *ouf!* which any ordinary
mortal who is not deprived of his spleen and condemned
willy-nilly to run a race allows to escape him, with such joy,
when at last he may throw himself down in the longed-for
oasis of rest. I willingly confess that from the very beginning
those beatific characters that make up the word 'End' appeared
to my brain, clad in their black skins, like little Ethiopian
mountebanks performing the most agreeable character-dance.
The artists – I refer to the genuine ones: those who believe, as
I do, that everything that is not perfect ought to keep out of
sight, and that everything that is not sublime is useless and
sinful; those who can measure the awe-ful depth of the first
idea that comes to mind, and who know that, of the thousand
and one ways of expressing it, no more than two or three at
most are excellent (I am being less strict than La Bruyère[76]) –
those artists, I say, always dissatisfied and never surfeited, like
imprisoned souls, will not take amiss certain playful jests, and
certain capricious outbursts of ill-humour, which they, every
bit as often as the critic, are liable to. They, too, are well aware
that nothing is more wearisome than having to explain what
everyone ought to know. If ennui and contempt may be

regarded as passions, they too will have found contempt and ennui the most difficult of all passions to throw off, the most inevitable, the most ready to hand. I impose on myself the hard conditions I should like to see everyone accepting; I am for ever saying to myself 'What is the good?', and I ask myself the question, always supposing I have made a good case, 'To whom can it be useful, what useful purpose can it serve?' Amongst the numerous omissions I have been guilty of, some are deliberate; I have deliberately left aside a crowd of evident talents, too obvious to be praised, but without enough character, either good or bad, to serve as a peg for criticism. I had set myself the aim of looking for signs of Imagination in this Salon, and, having found them rarely, I have had to speak of only a small number of artists. As for my involuntary omissions or mistakes, Painting will forgive them as being those of a man who makes up for his lack of extensive knowledge by a love of Painting implanted in the very fibre of his being. Moreover, those who may have some cause for complaint will find avengers or comforters by the dozen, not to mention that one of our friends to whom you will entrust the task of analysing the next exhibition, and to whom you will give as free a hand as you have kindly given me. I hope whole-heartedly that he may find more cause for surprise or dazzlement than I can conscientiously say I have. The noble and excellent artists I was appealing to just now will echo my words: to sum up, a lot of know-how and skill, but very little genius. That is what everyone is saying. Alas! I agree with everyone.

You see, my dear M****, how useless it was to explain what everyone and I think. My only consolation is that, in this parade of commonplaces, I have been able to please two or three people who are with me in spirit, when I think of them, and amongst whom I beg you to include yourself.

Your devoted collaborator and friend,

C.B.

13. Richard Wagner and *Tannhäuser* in Paris[1]

I

PRAY let us go back thirteen months, to the time when the whole affair began; and may I, in the course of the following appreciation, be allowed to speak often in my own name. That 'I', justly taxed with impertinence in many cases, implies, however, a high degree of modesty; it imprisons the writer within the strictest limits of sincerity. By reducing the extent of his task, it makes it easier for him. And finally, there is no need to be a great expert in probabilism to acquire the conviction that this sincerity will win friends amongst impartial readers; the chances evidently are that even the ingenuous critic, in recording his own impressions, will also be recording those of some unknown supporters.

Well then, thirteen months ago Paris was full of an exciting rumour. A German composer who, unknown to us, had dwelt for a long time amongst us, in obscure penury, scratching a miserable living, but who, for the last fifteen years at least, had been hailed by German opinion as a man of genius, was about to pay another visit to the city that had witnessed his youthful poverty, and was to submit his works to our judgement. Up till then, Paris had heard little of Wagner,[2] although it was vaguely known that, beyond the Rhine, the question of a reform in lyrical drama was being debated, and that Liszt[3] had enthusiastically espoused the opinions of the reformer. M. Fétis had launched a kind of indictment against him, and anyone interested enough to consult the relevant back numbers of the *Revue et Gazette musicale de Paris* will find renewed confirmation of the fact that the writers who boast of

professing the wisest, the most classical opinions scarcely pride themselves on wisdom or moderation or even common or garden courtesy in their critical assessment of opinions opposed to theirs. The articles by M. Fétis are hardly more than a distressing diatribe; but the old dilettante's exasperation served no purpose other than that of proving the importance of the works he was subjecting to anathema and ridicule. Besides, for the last thirteen months, during which public curiosity has not abated, Richard Wagner has suffered many other insults. A few years ago Théophile Gautier, back from a trip to Germany, where he had been much moved by a performance of *Tannhäuser*,[4] had recorded his impressions in *Le Moniteur*, with that wonderful precision of his, which confers an irresistible charm on everything he writes. But these various documents, coming at distant intervals of time, had not caught the attention of the public.

As soon as posters appeared announcing that Richard Wagner was to present extracts from his compositions at the Salle des Italiens, an amusing incident occurred, the sort of thing we have seen happen before and which shows the instinctive need, the precipitancy, of Frenchmen to make up their minds on anything and everything before they have had time to consider or examine the question at issue. Some people began prophesying wonders; others started vigorously disparaging works they had not yet heard. To this very day, this laughable situation persists, and it may safely be said that at no time has a subject about which less was known been more debated. In short, Wagner's concerts promised to be a veritable battle of doctrines, like one of those solemn crises in art, one of those confused scrimmages into which critics, artists and public have a habit of flinging all their passions, beneficial crises which show a state of health and abundance in the intellectual life of a nation, and which we had unlearnt, so to speak, since the great days of Victor Hugo. I quote the following passage from an article by M. Berlioz[5] (9 February 1860):

'The foyer of the Théâtre-Italien was a curious sight to see on the night of the first concert. It was nothing but angry shouts and arguments which always seemed on the point of ending in blows.' But for the presence of the sovereign, the same scandalous scene might have been re-enacted a few days ago at the Opera House, especially with a more normal type of public. I remember having seen, at the end of one of the dress rehearsals, one of the accredited Paris critics, planting himself at the door with a pretentious air, almost obstructing the out-going crowd, as he stood aggressively facing it, and laughing like a maniac, like one of those poor creatures who in mental hospitals are called excitables. This poor man, under the impression that his face was well-known to everyone, seemed to be implying by his behaviour: 'Just take a look at me in fits of laughter, me, the celebrated S—.[6] So see to it that your opinion is in line with mine.' In the article I was referring to just now, M. Berlioz, who showed much less enthusiasm than might have been expected from him, nonetheless added: 'The amount of nonsense, rubbish and even lies that could then be heard is really prodigious, and it shows conclusively that in our country at least, when it is a matter of appreciating a type of music different from the normal run, passion and prejudice alone are vocal, preventing good sense and good taste from getting a word in.'

Wagner had been very bold: the programme at his concert comprised neither instrumental solos nor songs, nor any of those exhibitions so dear to a public fond above all of virtuosos and their vocal feats – only choral or orchestral extracts. True, the struggle was violent; but the public, being left to itself, took fire at some of those irresistible pieces where they felt the thought was more clearly expressed, and so Wagner's music triumphed by virtue of its own power. The *Tannhäuser* over-ture, the solemn march from Act 2, the *Lohengrin*[7] overture in particular, the *Wedding Music* and the *Epithalamium* were magnificently received. Many aspects doubtless remained

obscure, but the impartial-minded people were saying to themselves: 'Since these compositions were written for the stage we must wait; whatever still needs explanation will become clear when produced on the stage.' In the meantime, what had been established was that, as a symphonist, as an artist expressing, by means of the innumerable combinations of sound, the tumults of the human soul, Richard Wagner was the equal of the most exalted and certainly as great as the greatest.

I have often heard the opinion expressed that music could not claim to convey anything with precision, as words or painting do. That is true to a certain extent, but it is not wholly true. Music conveys things in its own way and by means peculiar to itself. In music, as in painting, and even in the written word, which, when all is said and done, is the most positive of the arts, there is always a gap, bridged by the imagination of the hearer.

These are no doubt the reasons that led Wagner to look upon dramatic art – that is to say the meeting-point, the coincidence of several arts – as art in the fullest sense of the term, the most all-embracing and the most perfect. Now, if we disregard for a moment the help provided by plastic art, scenery, the embodiment in live actors of characters created by the imagination of the dramatist, and even song, it still remains beyond argument that the more eloquent the music is, the quicker and the more clear-cut will be the suggestions conveyed, the greater the chances that sensitive natures will conceive ideas akin to those that inspired the artist. Let me take the first example that comes: the well-known *Lohengrin* overture, of which M. Berlioz has written in technical language a splendid encomium; but for the moment I am proposing to content myself with testing its value by the ideas it gives birth to.

In the programme handed out at the time, at the Théâtre-Italien, occurs the following passage:

From the very first bar the pious solitary is waiting for the sacred vessel; his soul *soars to the infinite spaces*. Little by little, before his eyes unfolds an unearthly vision, which takes the shape of a body and a face. The outlines of the vision become sharper, and the *miraculous choirs of angels*, bearing the sacred cup in their midst, pass before him. The saintly procession comes nearer; his heart full to overflowing, God's elect is slowly uplifted in joy; his heart swells and expands; ineffable yearnings awaken in him; *he yields to a growing beatitude* as the *luminous apparition* comes ever closer, and when at last the Holy Grail itself appears amidst the sacred procession, he *sinks in ecstatic adoration as though the whole world had suddenly vanished*.

Meanwhile the Holy Grail pours out its blessings on the saint as he kneels in prayer, and consecrates him its knight. Then the *brightness of the burning flames slowly softens*; in holy joy, the angel choir, smiling in farewell to the earth, ascends once more the heavenly heights, leaving the Holy Grail in the keeping of the pure in heart, *in whom the divine elixir is active*; what time the august choirs fade once more into the *depths of space*, whence they came.

The reader will presently understand my purpose in italicizing some passages. But first let me take the book by Liszt, and open it at the page where the imagination of the celebrated pianist (who is both an artist and a philosopher) interprets in its own way the same piece:

This prelude contains and reveals the *mystical element* always present and always hidden in the work itself . . . So that we may learn the inexpressible power of this secret, Wagner first shows us the *ineffable beauty of the sanctuary* where dwells a God that avenges the oppressed and asks of those that believe in Him only *love and faith*. He reveals the Holy Grail to us; He displays to our gaze the dazzling temple built of incorruptible wood, whose walls are sweet-smelling, and doors of *gold*, whose lintels are of *greenish chrysolite*, whose columns are of *opal* and partitions of *cymophane*, whose resplendent portals are approached only by those of noble heart and unstained hands. Not in its imposing structural reality, but as if sparing the weakness of our senses, he shows it to us first reflected in *blue waters* or shimmering as though in an *iridescent haze*.

The effect at the outset is of a *broad slumbering surface* of sound, *an ethereal haze spread out* before us, so that our uninitiate eyes may see there the sacred vision; that effect is entrusted exclusively to the violins, divided into eight sections, which, after several bars of harmonic tones, climb to the highest notes of their register. The theme is next taken up by the softest wind instruments; the horns and bassoons, joining in, prepare the entry of the trumpets and the trombones, which take up the melody for the fourth time, *with a blinding climax of colour*, as though at this unique moment the holy edifice *had shone* before *our blinded eyes*, in *all its brightness and radiating magnificence*. But the *sparkling brilliance*, brought gradually to this *intense degree of solar radiance*, dies down quickly, like a *faint celestial light*. The clouds, from the *transparent haze* they were, become opaque once more, the vision fades slowly in the same cloud of *iridescent* incense it had appeared in, and the music ends with a repetition of the first six bars, *more ethereal than ever*. The ideally *mystical character* of the prelude is particularly brought out by the orchestra's *pianissimo*, maintained throughout by the orchestra and scarcely disturbed by the brief moment when the marvellous outlines of the only theme the piece contains *shine forth* in the *clash of the brass*. Such is the image suggested to our senses, overflowing with emotion, as we listen to this sublime *adagio*.

May I, in my turn, relate, express in words, what my imagination inevitably conjured up from the same piece of music, when I heard it for the first time, with my eyes closed, feeling as though transported from the earth. I would certainly not venture to speak complacently of my reveries, were it not useful to bracket them with the preceding ones. The reader knows the aim we are pursuing, namely to show that true music suggests similar ideas in different minds. Moreover, *a priori* reasoning, without further analysis and without comparisons, would not be ridiculous in this context; for the only really surprising thing would be that sound could not suggest colour, that colours could not give the idea of melody, and that both sound and colour together were unsuitable as media for ideas; since all things always have been expressed by

reciprocal analogies, ever since the day when God created the
world as a complex indivisible totality.

> La nature est un temple où de vivants piliers
> Laissent parfois sortir de confuses paroles;
> L'homme y passe a travers des forêts de symboles
> Qui l'observent avec des regards familiers.
>
> Comme de longs échos qui de loin se confondent
> Dans une ténébreuse et profonde unité,
> Vaste comme la nuit et comme la clarté,
> Les parfums, les couleurs et les sons se répondent.[8]

But to return to my theme, I remember the impression
made upon me from the opening bars, a happy impression
akin to the one that all imaginative men have known, in
dreams, while asleep. I felt freed from the *constraint of weight*,
and recaptured the memory of the *rare joy* that dwells in *high
places* (be it noted that I had not at the time come across the
programme notes I have just quoted from). Then, involun-
tarily, I evoked the delectable state of a man possessed by a
profound reverie in total solitude, but a solitude with *vast
horizons* and *bathed in a diffused light*; immensity without other
decor than itself. Soon I became aware of a heightened
brightness, of a *light growing in intensity* so quickly that the
shades of meaning provided by a dictionary would not suffice
to express this *constant increase of burning whiteness*. Then I
achieved a full apprehension of a soul floating in light, of an
ecstasy *compounded of joy and insight*, hovering above and far
removed from the natural world.

You could easily establish the differences between these
three interpretations. Wagner speaks of *a choir of angels bearing
a holy vessel*; Liszt sees a *miraculously beautiful edifice*, mirrored
in haze. My own dream is less adorned with material objects,
it is vaguer and more abstract. But the important point in this
context is to concentrate on the similarities. Even if they were
few in number, they would still be proof enough, but by good

fortune they are superabundant and striking even to excess. In the three versions we find the sensation of *spiritual and physical beatitude*; of *isolation*; of the contemplation of *something infinitely big and infinitely beautiful*; of an *intense light*, which is a joy to *eyes and soul to the point of swooning*, and finally the sensation of *space, extending to the furthest conceivable limits*.

No musician excels as Wagner does in *depicting* space and depth, material and spiritual. That is an observation that several of the most acute minds have often felt themselves compelled to make. He has the art of rendering by subtle gradations all that is excessive, immense, ambitious in both spiritual and natural man. Sometimes the sound of that ardent despotic music seems to recapture for the listener, against the background of shadow torn asunder by reverie, the vertiginous imaginings of the opium smoker.

From that moment, that is from the first concert, I was possessed by the desire to penetrate more deeply into an understanding of these singular works. I had undergone, or so at least it seemed to me, a spiritual operation, a revelation. My rapture had been so strong, so awe-inspiring, that I could not resist the desire to return to it again and again. My feeling was no doubt largely compounded of what Weber[9] and Beethoven[10] had already revealed to me, but also of something new that I was powerless to define; and that powerlessness produced in me a sense of vexation and curiosity mixed with a strange delight.

For several days, even longer, I was for ever saying to myself: 'Where could I hear some of Wagner's music tonight?' Those of my friends who possessed pianos were more than once my victims. Soon, like all novelties, symphonic passages from Wagner were to be heard in the casinos open nightly to crowds in eager search of trivial pleasures. The effulgent majesty of this music crashed down upon them like thunder on a brothel. The news spread quickly, and we were often treated to the comic spectacle of men of gravity and taste

accepting to rub shoulders with the malodorous crowds to enjoy, in the absence of a better opportunity, the solemn march of the *Guests to the Wartburg* or the majestic *Wedding Music* of *Lohengrin*.

But the frequent repetition of the same melodic theme in pieces drawn from the same opera implied mysterious intentions, and a technique as yet unknown to me. I determined to discover the why and the wherefore, and thus to exchange my sensuous pleasure for knowledge, before a performance on the stage brought complete enlightenment. I consulted both my friends and enemies. I waded through M. Fétis's indigestible and odious pamphlet. I read Liszt's book, and at last, for want of *Art and Revolution* and *The Art-work of the Future*, both works untranslated, I laid hands on *Opera and Drama*[11] in an English translation.

II

Gallic witticisms went on as before, and the commonest type of journalism played its professional schoolboy pranks without ceasing. As Wagner had never stopped repeating that the rôle of music (dramatic music, that is) was to *speak* the sentiment, adapt itself to the sentiment with the same precision as speech, but obviously in a different way, in other words to express the undefined part of feeling which speech, too positive by nature, cannot render (and, in this, he was saying nothing that was not accepted by all people of good sense), a number of people, persuaded by the wags of the press, got it into their heads that the master attributed to music the power of expressing the positive shape of things, in other words that he was inverting roles and functions. It would be as useless as it would be tiresome to enumerate the gibes arising from this false belief, which, produced now by malevolence, now by ignorance, resulted in leading public opinion astray in advance. But, especially in Paris, what chance is there of curbing a pen with

fancied claims to being amusing? Public curiosity, being drawn to Wagner, gave rise to articles and pamphlets that introduced us to his life, to his prolonged efforts and to his sufferings. Amongst these documents, which are well-known today, I propose to select only those that seem to me the most appropriate for illuminating and defining the nature and character of the master. He who wrote that 'the man who has not from the cradle up been endowed by a fairy with the spirit of discontent about all existing things will never win through to the discovery of something new' was without a doubt destined more than any other man to reap sufferings from the conflicts of life. To this capacity for suffering, common to all artists, and all the greater in proportion as their sense of justice and beauty is more developed, I ascribe the revolutionary opinions of Wagner. Soured by so many miscalculations, disappointed by so many dreams, he must at some time or other, as a result of an error that is excusable in such a sensitive and highly-strung nature, have discerned an ideological link between bad music and bad governments. Possessed as he was by the highest desire to see the ideal in art achieve final victory over the spirit of routine, he may well have hoped (the illusion is so very human) that revolutions in the political sphere would favour revolutions in art. Wagner's own success has given the lie to his forecasts and hopes; for in France a despot's order was needed for the work of a revolutionary to be performed. By the same token, we in Paris have seen the development of romanticism favoured by the monarchy, whilst liberals and republicans remained obstinately entrenched in the routine ideas of so-called classical literature.[12]

I see from the notes he himself has furnished on his youth that already as a small boy he lived in the bosom of the theatrical world, haunted the wings and wrote comedies. The music of Weber and later that of Beethoven exerted an irresistible power on his mind, and soon, with accumulating years and study, he could not help thinking on two planes, one

of the two arts taking up its role at the point where the limits of the other stopped. The dramatic instinct, which had such a large place in his faculties, inevitably drove him to rebel against the frivolous platitudes and the absurdities of the libretti written for music. Thus the particular Providence that presides over art revolutions was bringing to fruition, in a young German brain, the problem that had been a great subject of debate in the eighteenth century. Whoever has read attentively the *Lettre sur la musique* which serves as a preface to *Quatre poèmes d'opéras en prose française*[13] can be left in no doubt on this matter. The names of Gluck[14] and Méhul[15] are often quoted in it with passionate sympathy. M. Fétis is determined to establish for all eternity the predominant role of music in lyrical drama, but M. Fétis notwithstanding, the opinions of minds like Gluck, Diderot,[16] Voltaire and Goethe are not to be disdained. If the latter two were later to disavow their own pet theories, this was no more in their case than an act of discouragement and despair. As I turned over the pages of the *Lettre sur la musique* I became aware that re-emerging in my mind, by a phenomenon of mnemonic echo, were a number of passages from Diderot, where he declares that true dramatic music can be nothing else than the cry or sigh of passion, translated into note and rhythmical form. The same scientific, poetic and artistic problems appear again and again down the ages, and Wagner does not pose as an innovator but simply as the consolidator of an old idea that will doubtless more than once again be alternately vanquished and victorious. All these questions are in truth extremely simple, and what is not a little surprising is to find amongst those in revolt against the theories of 'the music of the future' (to quote an expression as inexact as it is currently heard on all sides) the very same people we have so often heard inveighing against the tortures inflicted on all sensible minds by the hidebound spirit of ordinary opera libretti.

In this same *Lettre sur la musique*, in which the author gives

a very brief and very lucid analysis of his three previous works, *Art and Revolution*, *The Art-work of the Future* and *Opera and Drama*, we find a very keen interest in the Greek theatre, which is quite natural, inevitable even, in a musician-dramatist, driven to seek in the past the justification of his distaste for things as they are, and helpful advice for the establishment of the new conditions of lyrical drama. In his letter to Berlioz, he was already saying, more than a year ago:

I asked myself on what terms art was likely to be able to inspire an invulnerable respect in the public, and in order not to roam too far afield in examining this question, I took my point of departure in Ancient Greece. There, at once, I came across the perfect art-work, the *drama*, in which, however deep an idea may be, it can show itself with perfect clarity, and in the most universally intelligible manner. We are rightly astonished, nowadays, that thirty thousand Greeks could follow with sustained interest the performance of Aeschylus's tragedies; but if we ask by what means such results were achieved, we find that they were due to the alliance of all the arts concentrated on the same goal, that is to say the production of the most perfect and the only true art-work. From there I went on to study the inter-relationship between the different branches of art, and having understood the relationship between plastic and mimic forms of art, I came to examine the links that exist between music and poetry: from this analysis, a light dawned suddenly that completely dissipated the darkness that had hitherto worried me.

I recognized in fact that at the precise point where one of these arts reached limits beyond which it could not go, there began at once with rigorous precision, the sphere of action of the other; that, consequently, by the intimate union of these two arts, it would be possible to express with wholly satisfying clarity what each of them could not express separately; that, conversely, any attempt to express with the means of one of them what could be expressed only by the two together, must inevitably lead to obscurity and confusion first of all, and then to the decay and corruption of each art individually.

And in the preface of his most recent book, he comes back to the same subject in the following terms:

I had found in a few rare works by different artists a solid basis on which to establish my dramatic and musical ideal; now history in its turn offered me the model and the type of the ideal relationship between the theatre and public life, as I conceived of them. I found this model in the theatre of ancient Athens: there, the theatre opened its precincts only for certain solemnities, when a religious festival was being held which was accompanied by the manifold enjoyments of art. The most distinguished men in the State took a direct part in these festivals as poets or producers; in the eyes of the assembled population from town and country, they seemed like priests, and this population were filled with such an intense expectation of the sublimity of the works about to be performed that the profoundest poems, those of an Aeschylus and of a Sophocles, could be put before the people and assured of perfect understanding.

This overriding despotic taste for a dramatic ideal where everything, from a passage of declamation, singled out and emphasized by the music with so much care that the singer cannot possibly stray from it in any syllable, veritable arabesque of sounds drawn by passion, to the minutest care expended on stage decoration and production, this overriding taste, where, I repeat, every single detail must concur to a total effect, this is what has marked out the destiny of Wagner. It was like a permanent demanding urge in him. From the day he broke away from the old habits of the libretto, when he courageously rejected his own youthful opera *Rienzi*,[17] which had been so successful, he has moved, without once deviating from his path, towards this imperious ideal. It was, in consequence, no cause of astonishment to me to find, in those works of his that have been translated, particularly *Tannhäuser*, *Lohengrin* and *The Flying Dutchman*,[18] excellent construction technique, a spirit of order and distribution, recalling the structure of the ancient tragedies. But phenomena and ideas that come back periodically down the ages always borrow, at every reappearance, something distinctive from variants and from circumstances. The radiant Venus of antiquity, Aphrodite, born of the white sea-foam, has not crossed the horrific

shades of the Middle Ages with impunity. No longer does she inhabit Olympus or the shores of some sweet-smelling archipelago. She has withdrawn into a cavern, admittedly magnificent, but illuminated by fires other than those of the kindly Phoebus. In going underground Venus has come nearer to hell, and, no doubt, on the occasion of certain abominable solemnities she goes and pays regular homage to the Archdemon, prince of the flesh and lord of sin. Similarly Wagner's poems, although they show a genuine liking for classical beauty and a perfect understanding of it, also have a strong admixture of the romantic spirit. They may suggest to us the majesty of Sophocles and Aeschylus, but they also forcibly recall to our minds the mystery plays of the period when Catholicism was dominant in the plastic arts. They are like those great visions that the Middle Ages spread out on the walls of its churches or wove into its magnificent tapestries. They have a decidedly legendary aspect; *Tannhäuser* is a legend; *Lohengrin* is a legend; so too is the *Flying Dutchman*. Nor is it only a propensity natural in any poetic soul that led Wagner towards this apparent speciality; it is a specific decision arising from the study of the most favourable conditions for lyric drama.

He himself has taken care to explain the question in his books. Not all subjects indeed are equally suitable for a vast drama endowed with the character of universality. It would obviously be very dangerous to try to express as a fresco the most charming and perfect genre picture. It is particularly in the universal heart of man and in the history of that heart that the dramatic poet will find scenes universally intelligible. To build the ideal drama in complete freedom, prudence demands the elimination of all difficulties that could arise from technical, political or even too positively historical details. I quote the master himself:

The only picture of human life that may be called poetic is the one where all motivations that have meaning only for the abstract in-

telligence give way to purely human motives rooted in the heart. This tendency (the one relating to the invention of the poetic subject) is the sovereign law that governs the poetic form and representation . . . The rhythmical arrangement and the (almost musical) adornment of the rhyme are, for the poet, means of assuring to his line or to his sentence a power that captivates, as though by means of a spell, and governs feeling as it wills. This tendency, which is essential to the poet, leads him to the extreme limit of his art, a limit to which music is immediately contiguous, and it follows therefore that the most complete work of any poet ought to be the one that in its ultimate form was perfect music.

From this stage I saw that I was inevitably being led to point to the *myth* as the ideal material for the poet. The myth is the primitive and anonymous poetry of the people, and we find it taken up again in every age, remodelled constantly by the great poets of cultivated ages. In the myth, indeed, human relations discard almost completely their conventional form, intelligible only to abstract reason; they show what is really human in life, what can be understood in any age, and show it in that concrete form, exclusive of all imitation, that confers upon all true myths their individual character, which is recognizable at the first glance.

In another passage, taking up the same theme, he says:

I abandoned once and for all the domain of history, and established myself in that of legend . . . I could afford to neglect all the detail necessary to describe and represent historical fact and its accidents, all the detail that a given remote period of history demands if it is to be thoroughly understood, and that contemporary authors of historical plays and novels gather together, for that very reason, in so circumstantial a manner . . . Whatever the epoch or nation it belongs to, legend has the advantage of incorporating exclusively what is purely human in the given epoch or nation, and of presenting it in an original and very striking form, thus intelligible at the first glance. A ballad, a popular refrain, are enough to evoke this character for you in the twinkling of an eye, in the most clear-cut and arresting form . . . The nature of the scene and the whole tone of the legend combine to transport the mind to a dream-state that quickly carries it on to perfect clairvoyance, and the mind then discovers a different

concatenation of phenomena, which the eyes could not perceive in the normal state of waking . . .

How could Wagner, who is poet and critic rolled into one, fail to understand perfectly the sacred, the divine character of myth? I have heard a number of people allege that the very breadth of his faculties and his high critical intelligence are a reason for feeling some mistrust of his musical genius, and I think this is a propitious occasion for me to refute an all too common error, rooted mainly in what is perhaps the ugliest of human feelings, envy. 'A man who reasons so much about his art cannot produce beautiful works naturally,' so some people opine, thereby depriving genius of its rationality and reducing it to a purely instinctive and, so to speak, vegetable function. Others choose to think of Wagner as a theorist who, they say, has produced operas only to verify *a posteriori* the value of his own theories. Not only is this view entirely wrong – since, as is well known, the master began producing a wide variety of poetic and musical essays at an early age, and since he succeeded in building up for himself an ideal conception of lyric drama only slowly – but it is an utterly impossible view. Critic into poet – that would indeed be a wholly new event in the history of the arts, a reversal of all psychical laws, a monstrosity; on the contrary, all great poets naturally, inevitably become critics. I feel sorry for poets guided by their instincts alone; I regard them as incomplete. In the spiritual life of great poets, a crisis is bound to occur that leads them to examine their art critically, to seek the mysterious laws that guided them, the idea being to draw from this study a series of precepts whose divine aim is infallibility in the poetic process. For a critic to become a poet would be miraculous, whereas for a poet not to have a critic within him is impossible. The reader will therefore not be surprised when I say that I regard the poet as the best of all critics. People who criticize Wagner the musician for having written books on the philosophy of his art, and harbour the suspicion that his music is not a natural,

spontaneous product, should also deny that Leonardo, Hogarth, Reynolds could paint good pictures, simply because they deduced and analysed the principles of their art. Who speaks better about painting than our great Delacroix? Diderot, Goethe, Shakespeare are creators all, and admirable critics. In the beginning was poetry, poetry was first in the field, poetry produced the study of the rules of the art. Such is the unchallenged history of how human things develop. And since every individual is a microcosm of humanity, since the development of one individual brain represents on a small scale the development of the universal brain, what more just and natural than to assume, in default of existing proofs, that the piecing together of Wagner's ideas was analogous to the developing process of humanity?

III

Tannhäuser represents the struggle between the two principles that have chosen the human heart as their main battle-ground, the flesh and the spirit, hell and heaven, Satan and God. And this duality is immediately indicated by the overture with incomparable skill. What has not already been written on this composition? Yet it may presumably give rise to many another thesis and eloquent commentary; for it is the peculiar mark of really artistic works to be an inexhaustible source of ideas. The overture, I repeat, sums up the guiding idea of the drama by two thematic melodies, the religious and the sensual, which, to borrow Liszt's formula, 'are established here like the terms of an equation, which are resolved in the finale'. The *Pilgrims' Chorus* appears first with all the authority of the supreme law, as though emphasizing at once the true meaning of life, the goal of the universal pilgrimage, God, in other words. But as the inner sense of the divine is soon smothered in every conscience, by the lusts of the flesh, so is the melody symbolizing holiness gradually submerged by the sounds of

pleasure. The true, the terrible, the universal Venus already emerges in every imagination. And whoever has not yet heard the wonderful *Tannhäuser* overture should on no account suppose that it is a question of a ditty of commonplace lovers trying to kill time in cool arbours, or the drunken notes of a band of topers, shouting defiance at God in the language of Horace. Something quite different is involved, both truer and more sinister. Languorous delights, lust at fever heat, moments of anguish, and a constant returning towards pleasure, which holds out hope of quenching thirst but never does; raging palpitations of heart and senses, imperious demands of the flesh, the whole onomatopoeic dictionary of love is to be heard here. Then little by little the religious theme re-establishes its supremacy, slowly, by gradations, and swallows up the other one in a peaceful, glorious victory, like the victory of the all-conquering being over the sickly and disordered being, of St Michael over Lucifer.

At the beginning of this study I drew attention to the power with which in the overture to *Lohengrin* Wagner expresses the ardour of mysticism, the yearnings of the spirit towards God the incommunicable. In the *Tannhäuser* overture, in the struggle between the two opposing principles, he has shown himself no less subtle or powerful. Whence, one may ask, has the master drawn this frenzied song of the flesh, this total knowledge of the diabolical element in man? From the very first bars our nerves vibrate in unison with the melody; lustful memories are awakened sharply. Every well-ordered brain has within it two infinities, heaven and hell; and in any image of one of these it suddenly recognizes the half of itself. First come the satanic titillations of a vague love, soon followed by enticements, swoonings, cries of victory, groans of gratitude, then again ferocious howls, victims' curses, impious hosannas from those officiating at the sacrifice, as though barbarism must always have its place in the drama of love, and the enjoyment of the flesh must lead, by an inescapable satanic logic, to

the delights of crime. When the religious theme, launching a renewed attack on sin let loose, gradually brings back order and gains the ascendancy, when it rises, in all its compact beauty, above this chaos of dying sensual joys, the whole soul feels refreshed and uplifted in redemptive beatitude; an ineffable experience which occurs again at the opening of the second scene, when Tannhäuser, after his escape from the grotto of Venus, finds himself back in life as it is, amidst the pious sound of his native bells, the humble song of the shepherd, the hymn of the pilgrims, and before him the cross planted on his road, emblem of all the crosses that have to be carried on every road. There is a power of contrast here that makes an irresistible impact on our minds and recalls the broad easy manner of Shakespeare. Shortly before, we were in the depths of the earth (Venus, as we mentioned, has her abode in the vicinity of hell), breathing a scented but stifling atmosphere, bathed in a pink glow that did not come from the sun; we were sharing the experience of the knight Tannhäuser himself who, satiated with enervating delights, *longs for suffering* – a sublime cry, which all professional critics would admire in Corneille, but which not one of them would care perhaps to recognize in Wagner. At last we are back above ground, breathing the earth's pure air, accepting its joys with gratitude, its sufferings with humility – poor humanity has been reunited to its homeland.

Just now, as I was trying to describe the sensual part of the overture, I asked the reader to close his mind to commonplace love songs such as a swain in high spirits might conceive them; and certainly there is nothing trivial here; rather is it the overflowing of a powerful nature, pouring into evil all the strength it should devote to the cultivation of good; it is love, unbridled, vast, chaotic, raised to the height of an anti-religion, a satanic religion. Thus in his musical interpretation the composer has avoided the vulgarity that too often accompanies the expression of the feeling, of all feelings, the most popular – I

nearly said 'of the populace' – and to achieve that all he had to do was to express the overabundance of desire and energy, the indomitable, unrestrained ambition of a delicate soul that has taken the wrong road. Similarly in the plastic representation of the idea, he wisely discarded the irksome crowd of victims, the Elviras by the dozen. The pure idea, personified by the one and only Venus, conveys a clearer, more eloquent message. Here is no ordinary libertine, flitting from beauty to beauty, but man in general, universal man, living morganatically with the absolute ideal of love, with the queen of all the she-devils, the female-fauns and female-satyrs, banished below ground since the death of the great Pan; in other words the indestructible and irresistible Venus.

A hand more skilled than mine in the analysis of operatic works will, in this very number,* be offering the reader a complete technical description of this strange and unjustly neglected *Tannhäuser*. I must therefore content myself with general considerations, which, brief as they are, are nonetheless useful. Moreover, is it not more convenient, for certain types of mind, to judge of the beauty of a landscape by standing on a height, rather than by following in turn all the paths that run through it.

I merely wish to observe, to the greater glory of Wagner, that, in spite of the importance he very rightly ascribes to the dramatic poem, the overture to *Tannhäuser*, like that to *Lohengrin*, is perfectly intelligible even to the hearer unfamiliar with the poem; and further, that this overture contains not only the main idea, the duality of the soul, which constitutes the drama, but also the principal themes clearly emphasized, and designed to describe the general sentiments expressed in the body of the work, a fact that is clearly shown by the deliberate reintroduction of the diabolically sensual theme and

*The first part of this study appeared in the *Revue Européenne*; M. Perrin, the former director of the Opéra-Comique and well-known as a supporter of Wagner, is the review's music critic.

of the religious theme or the *Pilgrims' Chorus* each time the action requires it. As for the grand march in the second act, it long ago won the approval of the most rebellious minds, and the same praise may be applied to it as to the two overtures I have spoken about, namely that it expresses what it wants to in the most visible, the most colourful, the most representative manner. Who, one wonders, on hearing those rich proud accents, those graceful cadences and majestic rhythms, those royal fanfares, could imagine anything other than a feudal ceremony, a march-past of heroes, in gorgeous apparel, all of lofty stature, all men of will and simple faith, as magnificent in their pleasures as they are terrible in their wars?

What shall we say of Tannhäuser's narration of his journey to Rome, in which the literary merit of the piece is so admirably completed and sustained by the musical structure that the two elements combine to create an inseparable whole? Any fears one might have had about the length of the passage are dissipated by its invincible dramatic power, already noted. The sadness, the despondency of the sinner during his rough journey, his joy at the sight of the supreme pontiff who has the power to absolve sins, his despair when the latter shows him the irreparable nature of his crime, and at the end, the feeling, almost ineffable by its very terror, of joy in damnation; everything is told, expressed, translated by the words and the music in a manner so positive that to find another way of saying it all is well-nigh impossible. And so we can fully understand that a disaster of this magnitude can be reversed only by a miracle, and we can forgive the unfortunate knight for taking once again the mysterious path leading to the grotto, to recover at least the favours of hell at the side of his diabolical consort.

Lohengrin, like *Tannhäuser*, bears the sacred, mysterious and yet universally intelligible character of legend. A young princess is accused of an abominable crime, the murder of her brother, and has no way of proving her innocence. Her case

is to be submitted to the judgement of God. No knight in the assembled company comes down into the lists to defend her; but she has faith in a strange vision; an unknown warrior has come to visit her in a dream. He it is that will take up her cause. And sure enough, at the last moment, when all have pronounced her guilty, a frail bark, drawn by a swan harnessed with a golden chain, approaches the river bank. Lohengrin, the knight of the Holy Grail, protector of the innocent, defender of the weak, has heard the prayer in the depths of the miraculous sanctuary where the holy cup is preciously guarded, twice consecrated, once by the Last Supper, and once by the blood of Our Lord, which Joseph of Arimathea caught as it poured from his wound. Lohengrin, son of Parsifal, gets out of the bark, resplendent in silver armour, helmeted, shield on his shoulder, a small golden horn hanging at his side, and leans on his sword. 'If I am victorious in the cause,' says Lohengrin to Elsa, 'wilt thou have me as thy husband? ... Elsa, if thou wishest me to call myself thy husband ... thou must give me a promise: never shalt thou ask me, never seek to find out, whence I come, or what my name and nature are.' And Elsa replies: 'Never, my lord, shalt thou hear that question from my lips.' And as Lohengrin solemnly repeats the promise in its due form, Elsa replies: 'My buckler, my angel, my saviour! Thou that believest firmly in my innocence, could there be a more criminal doubt than not to have faith in thee? Just as thou defendest me in my distress, so shall I faithfully keep the law thou imposest on me.' And Lohengrin, taking her in his arms, exclaims: 'Elsa, I love thee!' There is here great beauty in the dialogue, as so often in the operas of Wagner, soaked as they are in primitive magic lore, magnified by idealism, and with a solemnity that in no way reduces their natural grace.

Elsa's innocence is proclaimed by the victory of Lohengrin; Ortruda the sorceress and Frederick, two villains bent on Elsa's destruction, succeed in arousing her feminine curiosity, and poisoning her joy by doubt; under their obsessive in-

fluence she finally breaks her vow and demands from her husband the truth about his birth. Doubt has killed faith, and with the disappearance of faith goes happiness. Lohengrin kills Frederick in punishment for an ambush the latter had laid for him, and in the presence of the king, his assembled warriors and people, finally reveals his identity: ' . . . whoever is chosen to serve the Grail is forthwith granted supernatural power; even he that is sent by the Grail into distant lands, entrusted with the task of defending the rights of virtue, is not shorn of his sacred strength so long as his quality as knight of the Grail remains unknown; but such is the nature of the Holy Grail's virtue that, once revealed, it flees at once from the sight of the profane; that is why you must never harbour a doubt about the knight of the Grail; if he is recognized by you, he must leave you forthwith. Listen now and hear how he requites the forbidden question! I was sent to you by the Grail; my father, Parsifal, carries its crown; I, its knight, am called Lohengrin.' The swan reappears at the water's edge to carry the knight back to his miraculous country. The sorceress, driven by her hatred, reveals that the swan is none other than Elsa's brother, on whom the sorceress has cast a spell. Lohengrin steps into his bark after addressing a fervent prayer to the Holy Grail. A dove takes the place of the swan; Godfrey, Duke of Brabant, reappears. The knight has returned to Mount Salvat. Elsa, the doubter, Elsa, in her ardour to know, examine, confirm, Elsa has lost her happiness, the ideal has flown.

The reader will doubtless have noticed the striking analogy between this legend and the ancient myth of Psyche, who was also a victim of demonic curiosity, and who, unwilling to respect the incognito of her divine husband, lost all her happiness in penetrating the mystery. Elsa lends an ear to Ortruda, as Eve does to the serpent. The eternal Eve falls into the eternal trap. Do nations, then, and races hand on fables to each other, just as men hand on inheritances, patrimonies or scientific secrets? We might be tempted to believe it, so striking is the

moral analogy of the myths and legends that flower in different lands. But this explanation is too simple to satisfy a philosophic mind for long. An allegory created by a people cannot be compared with the seeds that a farmer gives in friendship to another who wants to acclimatize them in his own country. Nothing eternal and universal needs to be acclimatized. This moral analogy I have just mentioned is like the divine stamp on all popular fables. If you like, we can call it the sign of a common origin, the proof of an irrefragable relationship, provided we look for that original exclusively in the ultimate source and common origin of all beings. A given myth may be regarded as the brother of another, in the same way as the black man is called the brother of the white man. I deny neither fraternal relationship nor derivation in certain cases; I merely think that in many others, our judgement could be misled by surface similarities or even by moral analogies, and that, to return to our vegetable metaphor, myth is a tree that grows everywhere, in every climate under the sun, spontaneously and without propagation. The religions and the poetry of the four corners of the globe provide us with abundant evidence on this subject. Just as sin is everywhere, so is redemption everywhere, so is myth everywhere. What more cosmopolitan than the Eternal? May I be forgiven this digression which opened an irresistibly attractive path before me. I come back now to the author of *Lohengrin*.

It would appear that Wagner has a special predilection for feudal pomps, for Homeric gatherings, full of hidden reserves of vitality, for enthusiastic crowds, storehouse of human electricity, whence flows with natural impetuosity the heroic style. The *Wedding Music* and *Epithalamium* of *Lohengrin* are a worthy counterpart to the entry of the guests at the Wartburg in *Tannhäuser*, even more majestic, perhaps, and emphatic. But the master, with never-failing taste, and attentive to the slightest differences, has not evoked the turbulence that a common crowd would have displayed in these circumstances.

Even at the height of its most violent tumult, the music expresses no more than the joyful transports of people accustomed to the rules of good behaviour; this is a court in joyful mood, and its liveliest ecstasies still retain the rhythm of decorum. The boisterous joy of the crowd alternates with the soft, tender and solemn epithalamium; the storm of public joy is several times contrasted with the subdued and compassionate hymn celebrating the union of Elsa and Lohengrin.

I have already referred to certain melodic themes, whose persistent re-emergence in different passages from the same work had made a lively impression on my ear during the first concert presented by Wagner at the Salle des Italiens. We have observed that in *Tannhäuser* the recurrence of the two main themes, the religious motive and the hymn to pleasure, had as its purpose to awaken the attention of the public, and to produce in them a state of mind analogous to the actual situation. In *Lohengrin*, this mnemonic system is worked out much more thoroughly. Each character is, so to speak, emblazoned by the melody that represents his moral character and the part he is called on to play in the fable. Here I humbly turn to Liszt, whose book (*Lohengrin et Tannhäuser*) I take the opportunity of recommending to all lovers of deep and refined art, and who succeeds in interpreting with infinite charm all the master's musical rhetoric, in spite of the somewhat bizarre style he affects, a sort of composite idiom made up of extracts of several languages:

The spectator who is prepared for, and accepts, the fact that he will find *none of those detached pieces which, threaded one after the other on the string of some plot, formed the substance of our usual operas*, will derive a great deal of interest in detecting during three acts the deeply thought-out mechanism, astonishingly skilful and poetically intelligent, with which Wagner, *by means of several main musical themes, has woven a melodic web* that constitutes the whole of his drama. The sinuous lines described by these themes, as they weave their intricate patterns round the words of the poem, have a highly moving effect. But if,

after having been struck by this, after having felt its full impact at the performance, we should want to acquire a still better understanding of what has produced our lively emotion, and to study the score of this work so wholly new in kind, we shall be astonished at all the calculations and the shades of meaning it enfolds, all of which cannot be grasped at once. What plays and epics by great poets do not demand much study if we are to master their fullest import?

By means of a technique which he applies in a wholly unexpected way, Wagner succeeds in extending the sway and the claims of music. Not content merely with the power it exercises on the heart of man by awakening the whole scale of human sentiments, he enables it to stimulate our ideas, to speak to our minds, to appeal to our power of reflexion, he endows it with a moral and intellectual significance. He outlines melodically the character of his heroes and heroines and their main passions, and these melodic themes emerge, *in the vocal part or in the accompaniment*, every time the passions and feelings they express come into play. This systematic persistence is combined with an art of distribution that would, by the delicacy of the psychological, poetic and philosophical insights displayed, offer matter of the greatest interest even to those for whom the quavers and semi-quavers are meaningless hieroglyphics. Forcing as he does our thinking mechanisms and our memories to be constantly at work, Wagner by that fact alone removes the impact of the music from the plane of vague bouts of emotion, and adds to its charms some of the pleasures of the mind. By this method, which complicates the facile enjoyments derived from *a series of arias rarely related to each other*, he makes peculiar demands of attention on the public; but at the same time he prepares a number of more perfect emotions for those who can appreciate them. His themes are in a sense *personifications of ideas*; their re-emergence is the signal for the renewed interplay of the feelings that the words spoken do not *explicitly indicate*; to them Wagner entrusts the task of discovering to us all the secrets of the heart. Some phrases, for example the one from the first scene of the second act, run through the opera, like a poisonous snake, coiling itself about its victims and fleeing before their saintly defenders; others there are, like the one from the overture, that come back only rarely, with the ultimate and divine revelations. Situations or characters of some importance are all musically ex-

pressed by a melody that becomes their constant symbol. And as these melodies are of rare beauty, we venture to say to those who content themselves, when studying a score, with judging the inter-relations of quavers and semi-quavers that, even if the music of this opera were deprived of its fine text, it would still be a work of the first order.

Yes indeed, without the poetry Wagner's music would still be a poetic work, endowed as it is with all the qualities that go to make a well organized poem; self-explanatory, so well are its component parts united, integrated, mutually adapted, and, if I may invent a word to express the superlative of a quality, prudently *concatenated*.

The Phantom Ship or *The Flying Dutchman* is the highly popular story of that wandering Jew of the ocean, for whom one chance of redemption has been won by a succouring angel: *if the skipper, when he goes ashore once every seven years, finds a faithful wife, he shall be saved.* The hapless man, hurled back by the storm every time he tried to round a dangerous cape, had once exclaimed: 'I will break through this impassable barrier even if I have to struggle for all eternity!' And eternity had taken up the bold navigator's challenge. Since that day the doomed ship had appeared here and there off different shores, running head-on into the storm with the despair of a warrior seeking death; but always the storm spared her, and pirates themselves fled before him, making the sign of the cross. The Dutchman's first words, after his vessel has reached its anchorage, are sinister and solemn: 'The term is passed; another seven years have gone by! The sea has thrown me on shore in disgust . . . Ah! Proud ocean! In a few days' time you will have to carry me again! . . . Nowhere a grave! Nowhere death! Such is my terrible sentence of damnation! Day of Judgement, last day, when will you dawn in my night?' . . . A Norwegian vessel has dropped anchor alongside the accursed ship; the two skippers strike up an acquaintance and the Dutchman asks the Norwegian 'to grant him a few days' shelter in his house . . . to give him a new country.' He

offers him enormous sums, which dazzle the Norwegian, and at last comes the sudden question: 'Have you a daughter? . . . Let her be my wife! I shall never see my own country again. To what end do I amass riches? Let yourself be persuaded; consent to this match and take all my wealth.'

'I have a daughter, beautiful, true, tender and devoted to me.'

'May she always preserve that filial tenderness for her father, always remain true to him; then she will also be true to her husband.'

'You offer me precious stones and pearls of surpassing value; but the most precious jewel of all is a faithful wife.'

'Are you conferring that gift on me? . . . Shall I see your daughter today?'

In the Norwegian skipper's parlour a group of girls are talking about the Flying Dutchman, and Senta, obsessed by an idea, with her eyes fixed on a mysterious portrait, sings the ballad that tells how the seaman came to be cursed: 'Have you chanced at sea upon the vessel with blood-red sails and a black mast? On board, a man pale as a ghost, the ship's master, keeps a ceaseless watch. On he flees, without end, nor stay nor rest. One day, however, the man may find deliverance if he find on earth a woman who will be faithful to him unto death . . . Pray heaven that soon a woman will plight her troth to him! . . . Against headwinds, in a wild storm, he tried to round a cape; in his mad audacity he blasphemed: "Never in all eternity shall I give up!" Satan heard him and took him at his word. And now his sentence is to wander across the seas without pause, without rest! . . . But, for the ill-fated man to win deliverance on earth, an angel of God has revealed to him whence may come salvation. Ah! may you find it, pale wanderer of the seas! Pray heaven that soon a woman will pledge him this faith. – Every seven years he drops anchor, and to seek a wife he comes ashore. Every seven years he has wooed, but never yet has he found a faithful woman. Sails to

the wind! Haul up the anchor! False love, false pledges! Stand by! To sea! Without pause, without rest!' And then, all of a sudden, breaking out of an abyss of reverie, and in a moment of inspiration Senta exclaims: 'May I be the one to deliver you by my fidelity! Let the angel of God reveal me to you! By me shall you win your salvation!' The girl's mind is magnetically attracted by misfortune; her true betrothed is the doomed captain whom love alone can redeem.

Then at last the Dutchman appears, brought in by Senta's father; the identical man of the portrait, the legendary face hanging on the wall. When, like the terrible Melmoth,[19] full of pity for the fate of his victim Immalea, the Dutchman tries to deflect her from a too dangerous devotion, when the doomed captain, full of pity, rejects the means of salvation, and, hurrying aboard his ship, tries to leave her to the happiness of family life and ordinary love, she refuses and insists on going with him: 'I know who you are! I know your fate! I knew you when I first saw you.' And he, hoping to frighten her: 'Ask the Seven Seas, ask the sailor who has ploughed the ocean in every direction; he knows this ship, feared of all pious men: I am called the Flying Dutchman.' Pursuing the departing vessel with her devotion and her cries, she replies: 'Glory to your liberating angel! Glory to his law! Look and see if I am faithful to you unto death!' And she then throws herself into the sea. The ship goes down. Two ethereal forms arise above the waves: the Dutchman and Senta transfigured.

To love a victim because of his misfortune is too noble an idea to find a place elsewhere than in a simple heart, and it is certainly a very beautiful idea to link the redemption of a lost soul with the passionate imagination of a girl. The whole action of the drama, simple and direct, is treated with a skilful hand; every situation is handled openly; and Senta is a type that has in it a supernatural and romantic grandeur which both delights and frightens. The utter simplicity of the poem increases the intensity of the effect. Everything is in its place,

well ordered and well proportioned. The overture, which we heard at the Théâtre-Italien concert, is as deep and gloomy as the ocean, the wind, and the darkness.

I am constrained to restrict the limits of this study, and I believe I have said enough (today at least) to make an uninformed reader understand Wagner's general tendencies and the dramatic form. Besides *Rienzi, The Flying Dutchman, Tannhäuser* and *Lohengrin*, he has composed *Tristan and Isolde*,[20] and four other operas forming a tetralogy, the subject of which is drawn from the *Nibelungenlied*, without counting his numerous critical writings. Such are the works of this man, whose person and idealist ambitions have for so long been the subject of idle Parisian gossip, and who for a year and more has been the daily butt of facile witticisms.

IV

Setting aside for a moment, as can always be done, the systematic element which every great and deliberate artist inevitably introduces into his works, we then need to seek and assess the peculiar personal qualities that distinguish him from others. An artist, a man really worthy of that great name, must surely have in him something essentially *sui generis*, by the grace of which he is himself and not someone else. From this point of view, artists may be compared to a miscellany of flavours, and the store of human metaphors is not perhaps rich enough to provide approximate definitions of all known and all possible artists. We have already, I think, identified two men in Richard Wagner, the man of order and the man of passion. It is the man of passion, the man of feeling, I want to discuss here. In the least of his compositions his ardent personality is so evident that this quest for his main quality will not be difficult to pursue. From the outset, one point had struck me forcibly: it is that in the sensual and orgiastic part of the *Tannhäuser* overture, the artist had put as much power, had

developed as much energy, as in the description of the mysticism that characterizes the overture to *Lohengrin*; the same ambition in the one and the other, the same titanic climbing of the heights, and also the same refinements, the same subtleties. What therefore appears to me to characterize above all, and in an unforgettable way, the music of the master is nervous intensity, violence in passion and in will-power. That music expresses, now in the suavest, now in the most strident tones, all that lies most deeply hidden in the heart of man. An ideal ambition, certainly, hovers over every one of his compositions; but if, by the choice of his subjects and his dramatic method, Wagner comes close to antiquity, by the passionate energy of his expression he is in our day the most genuine representative of modern man. And all the technical knowledge, all the efforts, all the strategy of this fertile mind are, in truth, no more than the very humble, the very zealous servants of this irresistible passion.

Whatever subject he handles, the result is a superlative solemnity of accent. By this passion, he adds to everything he touches an indefinable superhuman element; by this passion he understands and makes others understand everything. Everything that is implied by the words will, desire, concentration, nervous intensity, explosion, is perceptible, may be apprehended through his works. I do not think I am deceiving myself or anybody else when I say that I see there the main characteristics of the phenomenon we call *genius*; or, at least, that in the analysis of all we have legitimately called *genius* until now, the very same characteristics are to be found. In matters of art, I confess I am not opposed to excess; moderation has never appeared to me the hall-mark of a vigorous artistic nature. I like those excesses of robust health, those over-flowings of will-power, which stamp themselves on a work like burning lava in the crater of a volcano, and which, in ordinary life, often accompany the phase, so full of exquisite delight, that comes after a great moral or physical crisis.

As for the reform the master wants to introduce in the application of music to drama, what will its result be? On that subject, it is impossible to make any clear prophecy. In a vague and general manner, we may say, with the Psalmist, that sooner or later those who have been humbled shall be exalted, and the exalted humbled, but nothing more than what is equally applicable to the known run of all human affairs. We have seen so many things, formerly regarded as absurd, that have later become models adopted by the crowd. The general public of today will remember the stubborn resistance met with, at the outset, by the plays of Victor Hugo and the paintings of Eugène Delacroix. Besides, as we have already observed, the quarrel which is now dividing the public was a forgotten quarrel, now suddenly revived, and Wagner himself had found in the past the first elements of the foundation on which to establish his ideal. What is certain is that his doctrine is just what is needed to rally all intelligent people long since tired of our Opera's errors, and it is not surprising that men of letters, in particular, should have shown sympathy with a musician proud to call himself both poet and dramatist. Similarly, the writers of the eighteenth century had acclaimed the works of Gluck, and I cannot help noticing that those who show the greatest dislike of Wagner's works also shows a clear dislike of his precursor.

And when all is said and done the success or failure of *Tannhäuser* can prove absolutely nothing, nor even influence the chances for or against, in the future. Even supposing *Tannhäuser* to be a thoroughly inferior work, it could well have had a colossal success; and if we assume it to be perfect, it could just as well have been disliked. In point of fact the question of the reform of opera is not settled, and the battle will go on; there may be a lull, but it will flair up again. Recently I heard someone say that if Wagner scored a brilliant success with his opera, that would be a purely individual accident, and that his method would have no subsequent influence

on the destiny and development of lyric drama. I feel entitled by my study of the past, in other words of the eternal, to say just the opposite, namely that a total failure in no way destroys the possibility of new experiments in the same direction; and in the very near future we might well come to see not only new authors but even men with established reputations profiting in some degree from the ideas expounded by Wagner and passing successfully through the breach opened by him. Where in history have we ever read of a noble cause being lost in one throw?

14. The Life and Work of Eugène Delacroix[1]

To the Editor of *L'Opinion nationale*

Sir,

Once more, and for the last time, I want to pay tribute to the genius of Eugène Delacroix, and I beg you to be good enough to find space in your paper for these few pages, where I shall endeavour to set down as briefly as possible the record of his talent, the reasons for his superiority (which, in my opinion, is not yet properly recognized), and finally some anecdotes and some observations on his life and character.

I had the good fortune when still very young (as early as 1845, if I remember rightly) to have friendly contact with this great man, now dead; and in this relationship, where respect on my side and kindness on his did not exclude mutual confidence and familiarity, I was able to form at leisure extremely accurate notions not only on his method but also on the most intimate qualities of his great soul.

You will not expect me, sir, to embark here on a detailed analysis of the works of Delacroix. Apart from the fact that each of us has done that according to his power, as and when the great painter showed the public the successive productions of his thought, the list of these is so long that, even allowing only a few lines to each of his major works, an analysis of this sort would well nigh fill a volume. Let it suffice for us to give a rapid summary.

His monumental paintings cover the walls of the Salon du Roi at the Chambre des Députés, of the Library of the Chambre des Députés, of the Library of the Luxemburg Palace, of the Galerie d'Apollon at the Louvre, and of the Salon de la Paix at the Hôtel de Ville. These decorative pieces

include an enormous mass of allegorical, religious and historical subjects, all of which belong to the highest spheres of human intelligence. As for his so-called easel pictures, his sketches, grisailles, water-colours, etc. – the total reaches an approximate figure of 236.

The great compositions exhibited at different Salons number seventy-seven. I am taking these facts from the catalogue that M. Théophile Silvestre published at the end of his excellent study of Eugène Delacroix in his book entitled *Histoire des Peintres Vivants*.

I have myself tried more than once to draw up this enormous catalogue; but my patience was invariably exhausted by this unbelievable fecundity, and in the end I gave up the unequal struggle. If M. Théophile Silvestre has made any mistakes, it can be only by omission.

To my mind, sir, the important thing here is simply to look for the characteristic quality of Delacroix's genius and to try and define it; to ask ourselves in what way he differs from his illustrious predecessors, whilst equalling them; and finally to show, in so far as the written word allows, the magical art thanks to which he succeeded in translating the spoken word into plastic images, more full of life and more appropriate than those of any other creator of the same profession: in short, to show what speciality Providence had entrusted to Eugène Delacroix in the historical development of painting.

I

What is Delacroix? What was his role and what his duty in this world? That is the first question we must examine. I shall be brief, and I aim to arrive at immediate conclusions. Flanders has Rubens, Italy has Raphael and Veronese; France has Lebrun, David and Delacroix.

A superficial mind may be shocked, at first sight, by my bracketing together these names, which stand for such different

qualities and methods. But a more penetrating spiritual eye will see at once that there is, between them all, a common relationship, a kind of brotherhood or cousinage, stemming from their love of the great, the national, the immense and the universal, a love that has always found expression in so-called decorative painting and in what are known as great *machines*.

Many others, no doubt, have executed great *machines*; but those I have named did them in the manner most likely to leave an eternal mark in human memory. Which is the greatest of these men, so diverse in their greatness? Each of us is free to decide that as he pleases, according to whether by nature he is inclined to prefer the prolific, shining, almost jovial abundance of Rubens, or the soft majesty and eurhythmic order of Raphael, the paradisal and land-of-afternoon colours of Veronese, the austere and intense severity of David, or the dramatic and quasi-literary fluency of Lebrun.

None of these men can be replaced; they had a similar aim but used different methods, drawn from their personal natures. Delacroix, the last-comer, expressed with admirable vehemence and fervour what the others had conveyed only incompletely. In doing so, did he perhaps sacrifice other qualities, as his predecessors, for that matter, did before him? It may be so, but that is not the question that claims our attention.

Many others besides me have taken care to emphasize the inevitable consequences of an essentially personal genius; and it could also well be, after all, that the finest expressions of genius elsewhere than in purest heaven – here below, in other words, where even perfection is imperfect – can be achieved only at the price of inevitable sacrifice.

But 'Come, sir!' you will doubtless be saying, 'what then is this mysterious, indefinable something that Delacroix, to the great glory of our age, has communicated better than anyone else?' The answer is: the invisible, the impalpable, reverie, the nerves, the soul; and this he did – pray, sir, take good note of

this – without any means other than contour and colour; he did it better than anyone you care to mention; he did it with the perfection of a consummate painter, with the rigour of a subtle writer, the eloquence of a passionate musician. It is one element in the diagnosis of the spiritual climate of our age, be it added, that the arts strive, if not to substitute for one another, at least to lend each other new power and strength, by the help of their own.

Delacroix is the most suggestive of all painters, the one whose works, even those chosen from amongst the minor or inferior ones, give the most food for thought, and recall to mind the greatest sum of poetic feelings and thought already experienced, but believed to have been engulfed for ever in the night of time.

The work of Delacroix sometimes seems to me to be like a mnemonic device of the greatness and the inborn passions of universal man. This peculiar and wholly new merit of M. Delacroix, which enabled him to express simply by contour man's gesture, however violent, and to evoke with colour alone what might be called the atmosphere of the human drama, or the spiritual mood of the creator – this quality, peculiar to him, has always drawn to him the sympathy of all poets; and, if it were legitimate to draw a philosophic proof from a purely material phenomenon, I would ask you to notice, sir, that in the crowd that gathered to pay him the last honours, many more writers could be counted than painters. To put it crudely, the truth is that the latter have never fully understood him.

II

And what, after all, is so surprising about that? Do we not know that the age of the Michelangelos, the Raphaels, the Leonardo da Vincis, yes, and even of the Reynoldses, is long since passed, and that the general intellectual level of artists has

gone down markedly? Doubtless it would be unfair to look for philosophers, poets and scientists amongst contemporary artists; but it would be legitimate to expect from them a greater degree of interest than they evince in religion, poetry and the sciences.

Beyond the walls of their studios what do they know? What do they like? What do they want to express? Eugène Delacroix, on the other hand, was, as well as a painter devoted to his art, a man of general culture, in contrast to other modern artists, who are for the most part scarcely more than well-known or obscure daubers, gloomy specialists, be they old or young; craftsmen pure and simple, some of them with the knack of producing academic figures, others fruit, others again cattle. Eugène Delacroix loved everything, could paint everything and was capable of appreciating every kind of talent. His was a mind open to all ideas and to all impressions; he was the most eclectic and impartial lover of all experience.

A great reader, that goes without saying. His readings from the poets left him with awe-inspiring visions, quickly achieving sharpness of outline: ready-made pictures, so to speak. However different he may have been from his master, Guérin, in his method and his colour, he inherited, from the great republican and imperial school, the love of the poets and an indefinably vigorous spirit of rivalry with the written word. David, Guérin and Girodet[2] set their minds aflame by contact with Homer, Virgil, Racine and Ossian.[3] Delacroix was the moving translator of Shakespeare, Dante, Byron and Ariosto. There is an important similarity, and a slight difference.

But let us now, by your leave, Mr Editor, go more deeply into what might be called the teaching of the master, teaching that, for me, arises not only from the successive contemplation of all his works and of several side by side, as one was able to enjoy them at the Universal Exhibition of 1855, but also from many a conversation I had with the artist himself.

III

Delacroix was passionately in love with passion, and coldly determined to seek the means of expressing passion in the most visible manner. In this dual character, be it said in passing, we find the two distinguishing marks of the most substantial geniuses, extreme geniuses, scarcely created to please timorous souls who are easy to satisfy, and find adequate nourishment in flabby, soft, imperfect works. An immense thrust of passion coupled with formidable will-power, such was the man.

And he was fond of repeating: 'Since I consider the impression communicated by nature to the artist as the most important thing to translate, is it not necessary that he should be forearmed with all the quickest means of translation?'

It is clear that, in his eyes, imagination was the most precious gift, the most important faculty, but that this faculty remained powerless and sterile if it did not have at its command a swift technical skill, capable of following the great despotic faculty in its impatient flights of fancy. There was certainly no need for him to stoke up the fires of his imagination, constantly at white heat; but he always found the day too short for the study of the technical means of expression.

To that ceaseless preoccupation must be attributed his unremitting researches into colour and the quality of colours, his interest in problems of chemistry and his discussion with colour manufacturers. In this matter he comes close to Leonardo da Vinci, who was also a prey to these obsessions.

In spite of his admiration for the ardent phenomena of life, never can Eugène Delacroix be confused with that mob of vulgar artists and writers whose myopic intelligence shelters behind that vague and obscure word *realism*. The first time I saw M. Delacroix, in 1845, I believe it was (how the swift and voracious years flow away!), we talked about many commonplace subjects, in other words, questions vast in scope and yet of the simplest: nature, for example. At this point, sir, I shall,

with your permission, quote a passage of my own, for a paraphrase would not be as good as the words I once wrote,[4] almost under the master's dictation: ' "Nature is but a dictionary", he was fond of saying. To understand clearly the full meaning implied in this remark, we must bear in mind the numerous and ordinary uses a dictionary is put to. We look up the meaning of words, the derivation of words, the etymology of words; and, finally, we get from a dictionary all the component parts of sentences and ordered narrative; but no one has ever thought of a dictionary as a composition in the poetic sense of the word. Painters who obey imagination consult their dictionaries in search of elements that fit in with their conceptions; and even then, in arranging them with artistry, they give them a wholly new appearance. Those who have no imagination copy the dictionary, from which arises a very great vice, the vice of banality, to which are particularly exposed those painters whose speciality lies nearest to so-called inanimate nature: the landscape artists, for example, who regard it generally as a triumph if they can conceal their personalities. They contemplate so much that in the end they forget to feel and to think.

'For this great painter, all the areas of art, of which one man selects this one, and another that one, as the most important, were – are, I mean – no more than the most humble handmaids of a unique and superior faculty. If a very neat execution is necessary, that is so that the dream may be very clearly translated; if it should be very quick, that is to ensure that nothing is lost of the extraordinary impression that accompanied the birth of the idea; if the artist should pay attention to the cleanness of his tools, that too is easily understood, since every precaution should be taken to ensure that the execution is nimble and decisive.'

In passing be it added that, never in my life, did I see a palette so minutely and delicately prepared as Delacroix's. It looked like a bouquet of skilfully assorted flowers.

'In such a method, which is essentially logical, all the figures, their grouping in relation to each other, the landscape or interior that provides their background or horizon, their clothes, everything, in short, must serve to shed light on the general idea, and wear its original colour – its livery, so to speak. Just as a dream is bathed in its own appropriate atmosphere, so a conception, become composition, needs to have its being in a setting of colour peculiar to itself. Obviously a given tone will be attributed to some portion or other of the picture, and this then becomes the key, controlling all the others. Everyone knows that yellow, orange and red inspire and represent ideas of joy, wealth, glory and love; but there are thousands of yellow or red atmospheres, and all the other colours will be modified logically and in given proportions by the dominant atmosphere. The art of the colourist is evidently connected, in some respects, with mathematics and music.

'Yet its most delicate operations are the result of a sentiment which long practice has brought to a degree of sureness that defeats description. It will be seen that this great law of overall harmony condemns many garish efforts and raw daubings, even though by the hand of the most illustrious painters. There are some paintings by Rubens that remind us, not only of a coloured firework, but of several fireworks set off on the same ground. The bigger the picture, the broader must be the touches of colour, that goes without saying; but the touches are better not worked into each other; they melt naturally together, at a given distance, by the law of sympathy that brought them together. In this way colour gains in energy and freshness.

'A good picture, faithful and worthy of the dreams that gave it birth, must be created like a world. Just as the creation, as we see it, is the result of several creations, the earlier ones always being completed by the later, so a harmonically fashioned picture consists of a series of superimposed pictures, each fresh surface giving added reality to the dream, and

raising it by one degree towards perfection. In complete contrast, I remember seeing, in the studios of Paul Delaroche and Horace Vernet, enormous canvases, not broadly sketched in, but begun piecemeal, in other words, completely finished in certain areas whilst others existed only in a black or white outline. This sort of product could be compared to a purely manual type of work, to which is assigned the job of covering a given area in a given time, or to a long road divided into a large number of stages. As soon as one stage has been completed, that is the end of that, and when the road has been followed throughout its whole length, the artist is delivered of his picture.

'All these precepts are, of course, modified, more or less, by the different temperaments of the artists. But I am convinced that the foregoing is the surest method for men with rich imaginations. It follows that too great deviations from the method in question are proof that an abnormal and unjustified importance is being attributed to some secondary aspect of art.

'I am not afraid of its being said that it is absurd to imagine a single system of teaching being applied to a crowd of different individuals. For it is evident that systems of rhetoric and prosody are not arbitrarily invented forms of tyranny, but collections of rules demanded by the very structure of a man's spiritual being. Nor have systems of rhetoric and prosody ever prevented originality from showing itself clearly. The contrary, namely that they have helped the flowering of originality, would be infinitely truer.

'For the sake of brevity, I must omit a number of corollaries deriving from the main principle, which, so to speak, contains within itself the whole code of true aesthetics, and may be expressed as follows: the whole visible universe is nothing but a storehouse of images and signs, to which man's imagination will assign a place and relative value; it is a kind of pasture for the imagination to digest and transform. All the faculties of the human soul must be subordinated to the imagination, which

puts them all under contribution at once. Just as a good knowledge of the dictionary does not necessarily imply a knowledge of the art of composition, and the art of composition itself does not imply the gift of universal imagination, so a *good* painter may well not be a *great* painter, but a great painter is of necessity a skilful painter, because a universal imagination comprises the understanding of all technical means and the desire to acquire them.

'From the ideas I have just explained to the best of my ability (and how many more things there would be to say, particularly on the areas of common ground between the arts and the similarities between their methods), it is evident that the immense group of artists, or, in other words, of men dedicated to artistic expression, may be divided into two very distinct camps. In one, we have those who call themselves "realists", a word with a double meaning, and the sense of which is not precisely determined; to bring out more clearly their error, we will call them "positivists". The "positivist" says: "I want to represent things as they are, or as they would be on the assumption that I did not exist." The universe without man. In the other camp, there are the imaginative ones who say: "I want to illuminate things with my mind and cast its reflection on other minds." Although both these methods, which are diametrically opposed, may enhance or diminish any subject, from a religious scene to the most modest landscape, yet the imaginative man must usually have come to the fore in religious painting and in fantasy, whereas genre paintings, so-called, and landscape must, on the face of it, have offered vast resources to lazy minds not easily stimulated . . .[5]

'Delacroix's imagination! Here was an imagination that never feared to scale the difficult heights of religion; heaven belongs to it, just as hell does, and war, and Olympus and pleasure. He surely is the archetype of the painter-poet! He surely is one of the rare elect, and the breadth of his mind brings religion into its domain. His imagination, as fiercely

bright as a mortuary chapel, is alight with every shade of flame and crimson. All the grief in the Passion enthrals him; all the splendours in the Church fill him with light. Onto his inspired canvases he pours blood, light and darkness, by turns. I believe he would gladly add his own natural magnificence to the majesty of the Gospel, as an extra offering.

'I remember seeing a little *Annonciation* by Delacroix, where the angel, messenger to Mary, was not alone but ceremoniously escorted by two other angels, and the impact of this heavenly company was powerful and full of charm. One of his early paintings, *Le Christ aux Oliviers* ("Lord, take thou this cup from me"), is suffused with feminine tenderness and poetic suavity. The suffering and the majesty which resound so loudly in religion always awaken an echo in his mind.'

And still more recently, with reference to the Chapel of the Holy Angels at St Sulpice (*Héliodore, chassé du Temple* and *La Lutte de Jacob avec l'Ange*), his last great work, so inanely criticized, I said[6]: 'Never, not even in the *Clémence de Trajan*, not even in *L'Entrée des Croisés à Constantinople*, has Delacroix displayed a sense of colour more splendidly and more learnedly supernatural; never has he executed a drawing more deliberately epic. I am well aware that some people, stonemasons, no doubt, architects perhaps, have pronounced the word *decadence* with reference to this last work. This is the place for me to recall that the great masters, poets or painters, Hugo or Delacroix, are always several years ahead of their timid admirers.

'In relation to genius the public are like a clock that is losing. Amongst perceptive people, who does not understand that the first picture by the Master contained all the others in embryo? But that he should constantly perfect his natural gifts, that he should sharpen them with care, draw new effects from them, that he should himself drive his nature to the utmost, that is inevitable, inescapable, and praiseworthy. The principal feature of Delacroix's genius is precisely that it knows not decadence;

it displays only progress. But his original qualities were so powerful and so rich, and they made such a vigorous impact on even the most commonplace minds, that the latter are insensitive to his daily progress; only informed minds can perceive it clearly.

'I referred just now to the remarks of certain *masons*. For me, the word describes that class of gross materialistic minds (their number is legion) that take an appreciative interest in objects only by their contour or worse still on a three-dimensional basis: breadth, length and depth, just as savages or peasants do. I have often heard people of that sort draw up a hierarchy of qualities, which was totally unintelligible to me; they would maintain, for example, that the faculty that enables this man to create an exact contour or that man a contour of supernatural beauty is superior to the faculty that can assemble colours in an enchanting manner. According to these people colour has no power to dream, to think or speak. It would appear that when I contemplate the works of those men especially known as colourists, I am giving myself up to a pleasure that is not of a noble kind; for twopence they would stamp me as a materialist, reserving for themselves the aristocratic epithet of spiritualists.

'These shallow minds do not reflect that the two faculties can never be entirely separated and that both are the result of an original seed carefully cultivated. External nature does no more than provide the artist with an ever-recurring chance of cultivating the seed; nature is no more than an unco-ordinated mass of material that the artist is invited to assemble and put in order, an *incitamentum*, an alarm-clock for the slumbering faculties. To speak with precision, there is in nature neither line nor colour. It is man that creates line and colour. Both are abstractions drawing their equal dignity from the same origin.

'As a child, a draughtsman-born will see in nature, whether still or moving, a number of sinuous shapes from which he gets some pleasure and which he enjoys recording by lines on

paper, accentuating or reducing as the spirit moves him their inflections. In this way he learns how to produce curves, elegance and character in drawing. Now let us imagine the case of a child destined to perfect that part of art called colour: it is from the collision or happy union of two tones and the pleasure he gets from it that he will derive the inexhaustible knowledge of tone combinations. In both cases nature has acted exclusively as a stimulus.

'Both line and colour arouse thought and induce reverie; the pleasures that flow from these are different in kind, but perfectly equal and absolutely independent of the subject of the picture.

'A picture by Delacroix, placed too far away for you to be able to assess the merits of the contours or the greater or lesser dramatic quality of the subject, offers even at that distance a supernatural pleasure. It is as though a magical atmosphere has moved towards you and is enveloping you. This impression, gloomy and yet delightful, luminous but calm, and planted for ever in your memory, is the proof of the genuine, the perfect colourist. Nor will the act of analysing the subject when you come closer take anything away from this initial pleasure, or add anything to it, its source being elsewhere and far removed from any defined thought.

'I can reverse the example. A well drawn figure inspires in you a pleasure that is quite foreign to the subject. Be it voluptuous or frightening, this figure owes its charm exclusively to the pattern it describes in space. The limbs of a martyr being flayed alive, or the body of a nymph in a swoon, provided they are skilfully drawn, offer a species of pleasure in which the nature of the subject counts for nothing; if it were otherwise for you, you would oblige me to write you down as a torturer or an amorist.

'But alas! what is the good, what is the good of for ever repeating these useless truths?'

Yet perhaps, sir, your readers will value all this rhetoric less

than the details I am myself impatient to give them on the personality and the way of life of our lamented great painter.

IV

It is particularly in the writings of Eugène Delacroix that the duality of nature I was referring to emerges. Many people, as you yourself know, sir, were surprised at the wisdom of his written opinions and the moderation of his style, a matter of regret for some people, for others a reason for approval. *Les Variations du beau*, the studies on *Poussin*, *Prud'hon*, and *Charlet*, and the other pieces published either in *L'Artiste*, which then belonged to M. Ricourt, or even in the *Revue des Deux Mondes*, only serve to confirm this dual character of great artists, which leads them, as critics, to praise and analyse with special relish the qualities which they stand in most need of as creative artists and which are the antithesis of those they possess in abundance. If Eugène Delacroix had praised and commended the things we particularly admire in him, his violence, the decisive gesture, the tumultuousness of his composition, the magic of his colour, that in truth would have been good reason for astonishment. Why look for the things we possess superabundantly, and how may we avoid the urge to extol the things that seem rarer to us and more difficult to acquire? We shall always see the same phenomenon emerge, Mr Editor, in creative geniuses, whether painters or writers, every time they apply their faculties to criticism. At the time of the great struggle between the two schools, the classic and the romantic, the simpletons gaped in surprise when they heard Eugène Delacroix constantly vaunting Racine, La Fontaine,[7] and Boileau.[8] I know a poet,[9] naturally given to storm and stress, who goes into prolonged ecstasy over a line of Malherbe,[10] symmetrical and musically four-square.

Moreover, however wise, sensible, and clearly defined in expression and intention the great painter's literary fragments

may seem to us, it would be absurd for us to think they were written easily and with the same sureness of attack as his brush displays. He was as confident of *writing* what he thought on canvas as he was worried at his inability to *paint* his thought on paper. 'The pen', he was fond of saying, 'is not my tool; I feel that I am thinking right, but the need for ordered argument, which I am forced to observe, puts me off. Would you believe it, but the fact of having to write a page of text gives me a migraine?' This awkwardness, which comes from lack of practice, accounts for certain rather threadbare, rather *poncif*, and even First Empire expressions that fell too often from a pen otherwise distinguished.

The most obviously characteristic features of Delacroix's style are conciseness, and a kind of intensity without ostentation, the usual type of thing arising from concentrating the whole of one's spiritual powers on a given point. 'The hero is he who is immovably centred', says Emerson,[11] the transatlantic moralist, who may have the reputation of being the leader of the boring Bostonian school, but who nonetheless has a certain touch of Seneca about him, which can well be a spur to meditation. 'The hero is he who is immovably centred' – the maxim that the leader of American 'transcendentalism' applies to the conduct of life and to the sphere of business – may equally well be applied to the domain of poetry and art. One could just as well say: 'The hero of literature, the true writer, in other words, is he who is immovably centred.' You will not therefore be surprised to learn, sir, that Delacroix had a very pronounced sympathy for concise and concentrated writers, those whose prose, little encumbered with ornaments of style, appears to imitate the quick movement of thought, and whose sentences have the decisiveness of a gesture, Montesquieu,[12] for example. I can give you a curious example of this fruitful and poetic brevity. No doubt you have read, as I have, a very interesting and very fine study by M. Paul de Saint-Victor,[13] which appeared recently in *La*

Presse, on the ceiling of the Galerie d'Apollon. The various conceptions of the flood, the way the legends about the deluge should be interpreted, the inner meaning of the scenes and actions that go to make up the whole of this marvellous piece of painting, nothing has been forgotten; and the painting itself is minutely described in that charming style, as witty as it is colourful, of which the author has given us so many examples. Yet the whole thing will leave only a formless shadow of itself in our memories, something like the very pale light of a photographic enlargement. Compare this lengthy passage with the following few lines, to my mind much more vigorous and more conducive to creating a mental picture, even if one were to suppose that the picture they sum up did not exist. I am simply giving what is said in the programme distributed by M. Delacroix to his friends when he invited them to come and see the work in question:

Apollo, conqueror of the serpent Python

Mounted on his chariot, the god has already shot a number of his arrows; his sister Diana behind him, in full cry, offers him her quiver. The hideous reptile, bleeding from wounds already inflicted by the arrows of the god of heat and life, is seen in its death throes, writhing with impotent rage, and enveloped in a fiery haze. The waters of the deluge are beginning to recede, leaving the corpses of men and animals behind them on the mountain tops, or carrying them away. The gods are indignant at the sight of the earth delivered over to ill-shapen monsters, foul spawn of primeval slime. They have armed themselves, as Apollo has done; Minerva and Mercury are seen springing forward to exterminate them, that eternal wisdom may in time repeople the solitude of the universe. Hercules is crushing them with his club; Vulcan, the god of fire, is driving night and its fetid vapours before him, while Boreas and the Zephyrs dry up the waters with their breath and scatter the remnants of the clouds. The nymphs of the rivers and the streams have returned to their withy beds and their urn, still soiled with mire and debris. A number of shyer divinities are watching from a distance this struggle between the gods and the elements. Meanwhile, from highest heaven, Victory

is shown coming down to crown Apollo victor, and Iris, messenger of the gods, unfurls in the soft air her veil, symbol of light's triumph over darkness and the rebellion of the waters.

I know the reader will have to imagine a great deal and collaborate, so to speak, with the author of the explanatory note; but do you honestly think, sir, that my admiration for the painter has transformed me into a visionary in this case, and that I am wholly wrong in claiming to see here the traces of aristocratic habits, acquired by reading good books, and of that precision of thought which has enabled society folk, soldiers, adventurers and even courtiers to write, with careless unconcern, mighty fine books, which we professional writers cannot help admiring?

V

Eugène Delacroix was a strange mixture of scepticism, courtesy, dandyism, fiery will, guile, despotism, and, withal, of a species of particular kindness and restrained tenderness that always accompanies genius. His father belonged to that race of strong men, the last of whom we knew in our childhood: some of them were fervent apostles of Jean-Jacques,[14] others were convinced disciples of Voltaire, but all of them took part with equal determination in the French Revolution; and their survivors, Jacobins or left-wing progressives, rallied in perfect good faith (it is important to remember) to the policies of Bonaparte.

Eugène Delacroix always retained traces of this revolutionary background. It may be said of him, as of Stendhal, that he was frightened to death of being taken in. Sceptical and aristocratic as he was, his experience of passion and the supernatural came to him only through his enforced acquaintance with reverie. A hater of the masses, he thought of them only as iconoclasts, and the violence suffered at their hands by some

of his own works in 1848 was scarcely calculated to convert
him to the political sentimentality of our times. In his bearing,
manners and opinions, there was even something in him
reminiscent of Victor Jacquemont.[15] I know that the com-
parison is slightly unflattering, and I therefore intend it to be
taken only with reserve. There was, in Jacquemont, a sugges-
tion of a middle-class wit, with a chip on his shoulder, and
a waggishness that was as ready to fool the priests of Brahma
as those of Jesus Christ. Delacroix, guided by the good taste
always inherent in genius, could never have stooped to such
low tricks. My comparison, therefore, refers only to the spirit
of cautiousness and moderation that marks them both. In the
same way, the hereditary traits which the eighteenth century
had left in his nature seemed to be borrowed particularly from
that class as far removed from utopians as from madmen, the
class of polite sceptics, the victors and survivors, who,
generally, derived from Voltaire, rather than Jean-Jacques.
Thus at first sight, Eugène Delacroix appeared simply as a
man of the 'Enlightenment' in the best sense of the word, a
perfect gentleman without prejudices and without passions.
Only by cultivating his society more assiduously could one
penetrate the veneer, and become aware of the deeper recesses
of his soul. A man to whom he could more legitimately be com-
pared, in his outward bearing and manners, is M. Mérimée.[16]
He had the same apparent coldness, slightly affected, the same
icy mantle covering modest sensitiveness and an ardent passion
for what is good and beautiful; under the same simulated
egoism was to be found the same devotion to personal friends
and dearly-held ideas.

There was something of the recluse in Eugène Delacroix;
that was the most precious side of his nature, the side entirely
dedicated to giving pictorial form to his dreams, and to the
worship of his art. There was something in him of the society
man; that part of him was destined to hide the other, and to
allay any resentment it could cause. I believe it to have been

one of the great preoccupations of his life to conceal the waves of anger welling up in his heart, and to appear not to be a man of genius. His spirit of domination, which was perfectly legitimate, inevitable moreover, had almost disappeared under the cloak of countless kindnesses. One could have compared him to the crater of a volcano artistically hidden under a bouquet of flowers.

Another point of resemblance with Stendhal was his liking for simple formulas, brief maxims, for the good conduct of life. Like all people whose liking for method is all the greater because their ardent and sensitive temperament seems to turn them away from it, Delacroix liked fashioning those little catechisms of practical morality, which nit-wits and layabouts without an aim in life are likely to attribute disdainfully to M. de la Palisse,[17] but which genius does not despise because genius is related to simplicity; sound, strong, simple, hard maxims that are a breast-plate and shield for the man driven by genius into an everlasting battle.

Need I tell you that the same spirit of unshakeable and disdainful wisdom inspired the opinions of M. Delacroix in political matters? He believed that nothing changes, although everything appears to change, and that certain climacteric periods in the history of nations invariably bring back analogous phenomena. In fact, his thought in this sort of question came very close, especially in its aspects of cold and distressing resignation, to the thought of a historian I, for my part, have a great respect for, and whom you, sir, who are so familiar with these arguments and can appreciate talent even when it contradicts you, have surely been constrained to admire more than once. I refer to M. Ferrari,[18] the subtle and learned author of the *Histoire de la Raison d'État*. Inevitably, any talker who, in the presence of M. Delacroix, let himself go in childish utopian enthusiasms very soon felt the effect of his bitter laugh, informed with sarcastic pity; and if, incautiously, one were, in his hearing, to launch the grand chimera of modern

times, the monster-balloon of perfectibility and indefinite pro-
gress, he was fond of asking: 'Where then are your Phidiases?[19]
Where are your Raphaels?'

You may be sure, on the other hand, that M. Delacroix's
robust good sense in no way detracted from his charm of
manner. This vigorous incredulity, this refusal to be taken in,
gave a kind of Byronic flavour to his conversation, so full of
poetry and colour. He had also, drawn from within himself
much more than derived from his long experience of society –
from himself, that is his genius, and from the knowledge of
his genius – a self-confidence, a wonderful ease of manner, and
with them a politeness that emitted, like a prism, every shade
from the most cordial bonhomie to the most irreproachable
brush-off. He had a good twenty ways of saying 'Mon cher
monsieur', in which a practised ear could detect a remarkable
scale of feelings. For after all, I must add, since the fact strikes
me as another reason for praise, Eugène Delacroix, although
a man of genius, or because he was a complete man of genius,
had much of the dandy about him. He himself admitted that,
in his youth, he had indulged with joy in all the material
vanities of dandyism, and, laughing at himself but not without
a suspicion of self-glorification, told how, with the help of his
friend Bonington, he had worked hard to implant in the
fashionable younger set the taste for English cut in footwear
and clothes. This detail, I presume, will not seem out of place
to you; for no memories are superfluous when we are portray-
ing the nature of certain men.

I have told you that what particularly struck the attentive
observer was the natural part of Delacroix's soul, in spite of
the obscuring veil cast over it by our refined way of life. He
was full of energy, but an energy that came from the nerves
and the will; for physically he was frail and delicate. The tiger,
shadowing his prey, has less glint in his eyes and impatient
twitching of his muscles than our great painter showed, when
his whole soul was pin-pointed on an idea, or wanted to take

possession of a dream. The physical character of his features, his Peruvian or Malaysian complexion, his big dark eyes, which seemed to get smaller as they blinked in concentration, appeared to be sipping at the light, his mass of glossy hair, his obstinate brow, his tight lips, to which the constant tension of his will imparted a cruel expression, his whole person, in fact, conveyed the idea of an exotic origin. More than once, as I stood looking at him, there came into my mind a vision of the ancient rulers of Mexico, of Montezuma, whose hand, practised in sacrificial rites, could dispatch, in the space of a single day, three thousand human creatures on the pyramidal altar of the sun, or one of the Hindu princes who, in the splendours of the most glorious festivals, have, in the depths of their eyes, a look of unsatisfied greed and an inexplicable nostalgia, something that might be the memory of things unknown and yearning for them. Pray note that the general tonality of Delacroix's paintings also conforms to the colour appropriate to eastern landscapes and interiors, and that it produces an impression analogous to that felt in tropical lands, where a vast diffusion of light creates, for the sensitive eye, a general effect that is quasi-crepuscular in spite of the intensity of local tones. The morality of his works, if in fact one may legitimately speak of morality in painting, also has a visible connection with Moloch; nothing in his work that does not tell of desolation, massacres, fire; everything bears witness against the everlasting and incorrigible barbarity of man; cities set alight and smoking, murder and rape, children thrown under the horses' hooves, or stabbed by mothers unhinged with horror; the whole work, I repeat, is like a terrible hymn composed in honour of fate and inescapable grief. Sometimes he found it possible to apply his brush to the expression of tender and voluptuous feelings, for he certainly did not lack tenderness; but there too the incurable sense of bitterness was present in strong degree, whilst carefree joy, the usual companion of simple pleasure, was absent. Only once, I think, did he make

a tentative incursion into drollery and buffoonery, and, as though he had guessed that to be beyond and beneath his nature, he never came back to it.

VI

I know a number of people who have the right to say *Odi profanum vulgus*; but which of them can add triumphantly *et arceo*?[20] Handshakes, too freely given, debase the character. If ever a man had an 'ivory tower',[21] well defended by bars and bolts, it was Eugène Delacroix. Who more than he has loved his 'ivory tower', his privacy, in other words? I believe he would willingly have armed it with cannon, and removed it to the depth of a forest or to the top of an inaccessible rock. Who more than he has loved his home, both sanctuary and den? Others may seek privacy for the sake of debauchery; he sought it for the sake of inspiration, and he indulged in veritable orgies of work. 'The one prudence in life is concentration; the one evil is dissipation', says the American philosopher we have already quoted.

M. Delacroix could have been the author of that maxim; in any case he certainly practised it with austerity. He was too much a man of society not to despise society; and the efforts he made to avoid being too visibly himself drove him naturally to enjoy our society most. 'Our' does not imply merely the humble author of these lines; but also some others, young or old, journalists, poets, musicians, amongst whom he could freely relax and let himself go.

In his delightful monograph study on Chopin, Liszt numbers Delacroix amongst the musician-poet's most frequent visitors, and says that he loved to fall into deep reverie at the sound of that delicate and passionate music, which evokes a brightly coloured bird, hovering over the horrors of a bottomless pit.

And so it came about that, owing to our very genuine

admiration, we were admitted, though still very young at the time, into that well guarded studio, where the temperature, despite our inclement climate, was equatorial, and where the first thing that struck the visitor's eye was the air of restrained solemnity, and that austerity peculiar to the old school. Exactly similar were the studios, seen in our childhood, of the former rivals of David, men of touching heroism, long since gone. To penetrate this retreat was to feel at once that it could not be the abode of a frivolous mind excited by a thousand incoherent whims.

No rusty armour, no Malayan kukris, no old Gothic iron-work, no trinkets, no old clothes, no bric-à-brac, nothing that reveals in its owner a liking for the latest trifle, or for wandering away in childish dreaming. A wonderful portrait by Jordaens,[22] which he had unearthed heaven knows where, a few studies, and a number of copies, done by the master himself, were all the decoration to be seen in this vast studio, where reigned a spirit of reflection, bathed in a soft peaceful light.

These copies will probably be seen at the sale of Delacroix's drawings and pictures due to take place, so I am told, next January. He had two very distinct manners in copying. One, the free and broad, was compounded of fidelity and infidelity, and into it he put a great deal of himself. From this manner a bastard and delightful product emerged, throwing the mind into an agreeable state of uncertainty. It is in this paradoxical guise that I first saw a copy of the *Miracles de Saint Benoît* by Rubens. In his other manner, Delacroix becomes his model's most obedient and humble slave, and he achieved an exactness of imitation that those people may well doubt who have not seen these miracles. Such, for example, are the copies made of two heads by Raphael in the Louvre, where the expression, the style and manner are imitated with such perfect naturalness that nothing could be easier than to take the originals for the translations and vice versa.

After a luncheon lighter than an Arab's, and having arranged

the colours on his palette with as much care as a flower girl or a cloth vendor, Delacroix would strive once more to re-capture the interrupted flow of ideas; but before launching into his stormy work, he would often experience a feeling of languor or of terror, or of exasperation that recalls the python-ess fleeing the presence of the God, or Jean-Jacques Rousseau frittering his time away or tidying up papers and books for a whole hour before putting pen to paper. But once the fascina-tion had gripped the artist, he would stop only when overcome by physical fatigue.

One day as we were discussing a matter of abiding interest to artists and writers, namely the tonic effect of work and the conduct of life, he said to me: 'Years ago, when I was young, I could settle down to work only when I had some pleasure in prospect for the evening. Some music, or dancing, or any other sort of entertainment. But nowadays I am no longer like a schoolboy; I can work without ceasing and without any hope of reward. Moreover,' he added, 'if only you knew how broad-minded and easy to please hard work makes one when it comes to pleasures! The man who has filled his working day to his own satisfaction will be quite happy in the company of the local street porter, playing cards with him!'

This remark made me think of Machiavelli[23] playing at dice with the peasants. One day, a Sunday, I caught sight of Delacroix in the Louvre; with him was his old maid, the one who looked after him so devotedly, and served him for thirty years. He, the man of fashion, the dandy, the scholar, was not at all above showing and explaining the mysteries of Assyrian sculpture to this worthy woman, who, moreover, was listen-ing to him with unaffected attention. The image of Machiavelli and the memory of my conversation years before at once came into my mind.

The truth is that in his last years, all the things we commonly call pleasure had disappeared from his life. One pleasure only, harsh, demanding, terrible, had replaced them all: work,

which by then was no longer merely a passion but could well have been called a craving.

After devoting all the hours of daylight to painting, either in his studio or on the scaffoldings to which his big decorative work called him, Delacroix still found strength in his love of art, and he would have felt his day had been badly filled if the evening hours at his fireside had not been used, by the light of the lamp, to draw, to cover his paper with dreams, with projects, with figures he had chanced to catch a glimpse of in the daily round, sometimes to copy the drawings of other artists with temperaments wholly opposed to his; for he had a passion for notes and sketches, and used to busy himself with them wherever he might be. For quite a long time, he had a habit of drawing at the houses of friends with whom he was spending the evening. That is how M. Villot comes to own quite a number of excellent drawings from this prolific pen.

He once said to a young man I know: 'If you have not got the knack of making a sketch of a man who has thrown himself out of the window whilst he is falling from the fourth story to the ground, you will never be able to go in for the big stuff.' I perceive in that colossal hyperbole the central preoccupation of his whole life, which, as is well known, was to execute a drawing with enough speed and enough exactness to let no particle evaporate of the action's intensity or of the idea.

As many other people have been able to observe, Delacroix was fond of conversation. But the funny thing is that he was suspicious of conversation, as if it were a kind of debauchery, a sort of dissipation in which he ran the risk of wasting his strength. His first words when you went to see him at his studio were: 'We won't have a talk this morning, if you agree? Or else only a very short one.'

And then he would talk for three hours on end. His conversation was startling, subtle but full of facts, memories and anecdotes: in short, full of nourishment.

When he was roused by contradiction, he would withdraw momentarily, and then, instead of delivering a frontal attack on his adversary, a manoeuvre that carries the danger of introducing the brutality of platform oratory into the skirmishes of the drawing-room, he would sport for a while with his opponent, and then return to the attack with a whole lot of unexpected arguments and facts. It was the characteristic talk of a man delighting in conflict, but a slave to courtesy of a wily kind, yielding by design, full of unexpected ruses in flight and attack.

In the intimacy of his studio, he would willingly let himself go to the point of confiding his opinion about living painters, and it was particularly on those occasions that we often had a chance to admire the generosity of genius, which stems perhaps from a particular form of simplicity, or from a capacity to enjoy things easily.

He had an astonishing weakness for Decamps, much out of favour today, but who doubtless still reigned over Delacroix's mind by the power of memory. The same applies to Charlet. He once summoned me to his house for the express purpose of hauling me over the coals about a disrespectful article[24] I had been guilty of on that spoilt child of chauvinism. In vain did I try to explain that it was not the Charlet of the earlier manner that I had been attacking, but the Charlet of the later decadent period: not the noble historian of Napoleon's veterans but the tavern wit. I never succeeded in getting myself forgiven.

He admired Ingres for certain parts of his work, and, to be sure, he needed a powerful critical faculty to admire by force of reason what he must have rejected by temperament. He even went so far as to copy with care the photographs of some of those pencil portraits done with such minute delicacy, where the hard and penetrating talent of M. Ingres, which gains in skill the more circumscribed it is, is to be seen at its best.

The horrible colour tones of Horace Vernet did not prevent

Delacroix from feeling the artist's natural strength, which gives life to most of his pictures; and he used to find surprising expressions of praise for this bubbling and indefatigable energy. His admiration for Meissonier went a little too far. He had acquired almost by violence the preparatory drawings for the composition called *La Barricade*, the best picture by Meissonier, whose talent, moreover, expresses itself much more vigorously in pencil than with the brush. Of Meissonier he often used to say, as though thinking anxiously of the future: 'After all, of all of us, he is the most certain to survive!' Is it not strange to see the author of such great works casting an envious eye on someone who excels only in little ones?

The only man whose name had the power to draw a few coarse epithets from those aristocratic lips was Paul Delaroche. For the works of that painter he could certainly find no excuse whatever, and he had an ineradicable recollection of what he had suffered at the sight of all that grimy, sour painting, done 'with ink and boot polish', as Théophile Gautier once said.

But the man he liked to choose particularly for launching into lengthy discussions with was the man who was the least like him in talent as in ideas, his diametrical opposite, whose brain, though clouded by the smoky skies of his native town, contains a host of admirable things. I refer to M. Paul Chenavard.[25]

The abstruse theories of this painter-philosopher from Lyons made Delacroix smile, and the abstract principle-chasing pedagogue, on his side, looked upon the sensuous joys of pure painting as frivolous, not to say guilty things. But however distant from each other – and even because of that distance – they liked to come together, and, like two ships locked together by grappling irons, they could no longer part company. Both, moreover, being highly cultivated and endowed with great sociability, they met on the common ground of scholarship. That, as is well known, is not the quality for which artists usually shine.

Chenavard was therefore for Delacroix a great stand-by. It was a real pleasure to see them fighting it out in harmless warfare, the words of the one tramping heavily along like an elephant in full panoply of war, the words of the other as vibrant, as pointed and flexible as a fencing foil. In the last hours of his life, our great painter expressed the wish to shake his friendly gainsayer by the hand. But the latter was far away at the time.

VII

Sentimental and affected women may perhaps be shocked to learn that, like Michelangelo (pray recall the ending of one of his sonnets: 'Sculpture! Divine sculpture, thou art my only love!'), Delacroix had made of painting his unique muse, his mistress, his sole and sufficient pleasure.

No doubt women had been a major preoccupation in the stormy hours of his youth. Who has not sacrificed too much at the altar of this dangerous idol? And who does not know that it is just those men who have served the idol best who complain of her most? But already long before his end he had cut women out of his life. Had he been a Moslem, he would perhaps not have driven her out of his mosque, but in his inability to understand what sort of dialogue she could have with Allah, he would have felt surprised to see her enter it.

In this matter, as in many others, oriental ideas were coming to take a lively and despotic hold of him. He looked upon woman as an object of art, delightful and made to excite the mind, but an unruly and disturbing object if we allow her to cross the threshold of our hearts, devouring greedily our time and strength.

I remember once in some public place, as I was pointing out to him a woman's face of uncommon beauty and melancholy expression, he condescended to admire its beauty, but said to me, with that characteristic laugh of his: 'How can you think

that a woman could be melancholy?' thereby insinuating, no doubt, that women lack an essential something to be capable of experiencing the sentiment of melancholy.

That, unfortunately, is a most unflattering theory, and, for my part, I would not wish to commend opinions of a kind defamatory to a sex that has so often shown ardent virtues. But who will not agree that it is a theory full of caution; that talent cannot be too cautious in a world where booby-traps abound; and that a man of genius has the privilege of holding certain opinions (provided they do not threaten public order) which would scandalize us in the citizen pure and simple, or the ordinary father of a family.

I must add, at the risk of casting a shadow over his memory, at least in the opinion of wistful souls, that he showed no greater tenderness for children either. In his mind, children always had jam on their fingers (which dirties canvases and paper) or were for ever beating drums (which disturbs meditation), or were as incendiary, and full of dangerous animal spirits, as monkeys.

'I remember well', he used sometimes to say, 'that when I was a child I was a little monster. The understanding of duty is acquired only very slowly; and only through suffering, punishment and the developing exercise of reason does man diminish, little by little, his natural wickedness.'

Thus, by simple good sense, he was coming back towards the Catholic idea. For it may be said that children in general, and relatively to the grown man in general, are much closer to original sin.

VIII

It was as though Delacroix had treasured up all his sensibility, which was manly and deep, for the austere feeling of friendship. There are some people who take easily to the first-comer; others allow the divine faculty to operate only on

great occasions. The famous man I am speaking to you about with so much pleasure may not have liked being bothered with little things, but he could be helpful, courageous, ardent when important matters were at stake. Those who have known him well have had numerous opportunities of appreciating his wholly English sense of loyalty, punctiliousness and dependability, in social relationships. If he was demanding towards others, he was no less strict with himself.

It is only with sadness and ill-humour that I come to say a few words of certain accusations levelled against Eugène Delacroix. I have heard people tax him with selfishness and even avarice. Pray note, sir, that this reproach is always made, by innumerable hordes of mediocrities, against those who take the trouble to administer their generosity with no less care than their friendship.

Delacroix was very careful with his money; that was the only way for him to be very generous on occasion. I could give several examples of that, but I would hesitate to do it without his authority and that of the people who have had good cause to be glad of him.

Observe too that for many years his paintings fetched poor prices, and that his decorative works swallowed nearly the whole of his salary, when he was not actually out of pocket. He gave many proofs of his own disdain for money when impecunious artists showed their desire to possess one or other of his works. Then, like physicians of a liberal and generous temper, who sometimes insist on being paid for their services and at other times give them for nothing, he would make a present of his pictures or let them go at a knock-down figure.

And finally, sir, let us emphasize that the superior man, more than any other, has to take particular care to defend himself. It is no exaggeration to say that the whole of society is at war with him. More than once we have been able to see how true that is. His politeness is called coldness; his irony, however subdued, becomes spite; his economy, meanness.

But if, on the other hand, the unfortunate man shows himself to be improvident, then, far from showing pity for him, society will say: 'Serve him right; his penury is a punishment for his prodigality.'

I can confidently say that in matters of money and economy Delacroix entirely shared Stendhal's opinion, which reconciled greatness with prudence.

'The intelligent man', the latter used to say, 'should apply himself to acquiring what is strictly necessary to avoid his having to depend on anybody' (in Stendhal's day, this meant an annual income of 6,000 francs); 'but if, having achieved that degree of security, he wastes time in increasing his fortune, the man's a scoundrel.'

The pursuit of what is necessary, disdain for what is superfluous, that is the conduct of a wise man and a stoic.

One of the great preoccupations of our painter in his latter days, was the thought of what posterity's verdict on him would be, and of the uncertain durability of his works. At one moment his lively imagination would catch fire at the thought of immortal glory; at another, he would speak bitterly of the fragility of canvases and colours. At other times again, he would refer with envy to the old masters, nearly all of whom had had the luck to be translated by skilful engravers who had understood how to adapt their own needles and burins to the nature of the master's talent, and he ardently deplored the fact that he had not found his translator. This friability of the painted work of art, compared with the solidity of the printed work, was one of his habitual themes of conversation.

When this man, who was so frail and so stubborn, so highly-strung and so stout-hearted, this man unique in the annals of European art, the sickly, the chilly artist, for ever dreaming of covering great walls with his powerful conceptions, was carried off by one of those attacks of inflammation of the lungs of which he had an instinctive foreboding, we were all over-come with a feeling similar to the depression of soul, to the

growing sense of solitude, that the deaths of Chateaubriand and of Balzac had already made us feel, an experience quite recently renewed by the death of Vigny. There is, in a time of great national mourning, a lowering of the general vitality, a shadow comes over the intellect similar to a solar eclipse, that momentary imitation of the end of the world.

I think, however, that this impression particularly comes to those men who, in their exalted solitariness of soul, succeed in gathering a family about them only by their intellectual relationships. As for other citizens, they learn to know only slowly the great loss their country has suffered by the death of the great man, and the gap he has created by his going. Even then they need telling.

I thank you heartily, sir, for having allowed me to say freely all the things that were suggested to me by the memory of one of the rare geniuses of our unhappy age, both so poor and so rich, now too demanding, now over-generous, and unjust too often.

15. The Painter of Modern Life[1]

I. BEAUTY, FASHION AND HAPPINESS

IN all social circles, and even in art circles, there are people who go to the Louvre, walk quickly past a large number of most interesting though secondary pictures, without throwing them so much as a look, and plant themselves, as though in a trance, in front of a Titian or a Raphael, one of those which the engraver's art has particularly popularized; then they go out satisfied, as often as not saying to themselves: 'I know my gallery thoroughly.' There are also people who, having once read Bossuet and Racine, think they have got the history of literature at their finger-tips.

Happily from time to time knights errant step into the lists – critics, art collectors, lovers of the arts, curious-minded idlers – who assert that neither Raphael nor Racine has every secret, that minor poets have something to be said for them, substantial and delightful things to their credit, and finally that, however much we may like general beauty, which is expressed by the classical poets and artists, we nonetheless make a mistake to neglect particular beauty, the beauty of circumstance, the description of manners.

I am bound to admit that, for several years now, society has shown some improvement. The value that today's collectors attach to the delightful engraved and coloured trifles of the last century shows that a reaction has begun in the direction needed by the public; Debucourt, the Saint-Aubins[2] and many others have achieved mention in the dictionary of artists worthy of study. But these represent the past, whereas my purpose at this moment is to discuss the painting of our con-

temporary social scene. The past is interesting, not only because of the beauty that the artists for whom it was the present were able to extract from it, but also as past, for its historical value. The same applies to the present. The pleasure we derive from the representation of the present is due, not only to the beauty it can be clothed in, but also to its essential quality of being the present.

I have here in front of me a series of fashion plates, the earliest dating from the Revolution, the most recent from the Consulate or thereabouts. These costumes, which many thoughtless people, the sort of people who are grave without true gravity, find highly amusing, have a double kind of charm, artistic and historical. They are very often beautiful and wittily drawn, but what to me is at least as important, and what I am glad to find in all or nearly all of them, is the moral attitude and the aesthetic value of the time. The idea of beauty that man creates for himself affects his whole attire, ruffles or stiffens his coat, gives curves or straight lines to his gestures and even, in process of time, subtly penetrates the very features of his face. Man comes in the end to look like his ideal image of himself. These engravings can be translated into beauty or ugliness: in ugliness they become caricatures; in beauty, antique statues.

The women who wore these dresses looked more or less like one or the other, according to the degree of poetry or vulgarity evident in their faces. The living substance gave suppleness to what appears too stiff to us. The viewer's imagination can even today see a marching man in this tunic or the shrug of a woman's shoulder beneath that shawl. One of these days perhaps some theatre or other will put on a play where we shall see a revival of the fashions in which our fathers thought themselves just as captivating as we ourselves think we are, in our modest garments (which also have their attractiveness, to be sure, but rather of a moral and spiritual kind); and, if they are worn and given life to by intelligent actors and actresses,

we shall be surprised at our having laughed at them so thought-lessly. The past, whilst retaining its ghostly piquancy, will recapture the light and movement of life, and become present.

If an impartially-minded man were to look through the whole range of French fashions, one after the other, from the origins of France to the present day, he would find nothing to shock or even to surprise him. He would find the transition as fully prepared as in the scale of the animal kingdom. No gaps, hence no surprises. And if to the illustration representing each age he were to add the philosophic thought which that age was mainly preoccupied with or worried by, a thought which the illustration inevitably reflects, he would see what a deep harmony informs all the branches of history, and that, even in the centuries which appear to us the most outrageous and the most confused, the immortal appetite for beauty has always found satisfaction.

Here we have indeed a golden opportunity to establish a rational and historical theory of beauty, in contrast to the theory of a unique and absolute beauty, and to show that beauty is always and inevitably compounded of two elements, although the impression it conveys is one; for the difficulty we may experience in distinguishing the variable elements that go to make beauty's unity of impression does not in any way invalidate the need of variety in its composition. Beauty is made up, on the one hand, of an element that is eternal and invariable, though to determine how much of it there is is extremely difficult, and, on the other, of a relative circum-stantial element, which we may like to call, successively or at one and the same time, contemporaneity, fashion, morality, passion. Without this second element, which is like the amusing, teasing, appetite-whetting coating of the divine cake, the first element would be indigestible, tasteless, un-adapted and inappropriate to human nature. I challenge any-one to find any sample whatsoever of beauty that does not contain these two elements.

Let me take as an example the two extreme stages of history. In hieratic art duality is evident at the first glance; the eternal element of beauty reveals itself only by permission and under the control of the religion the artist belongs to. In the most frivolous work of a sophisticated artist, belonging to one of those ages we vaingloriously call civilized, the duality is equally apparent; the eternal part of beauty will be both veiled and expressed, if not through fashion, then at least through the individual temperament of the artist. The duality of art is an inevitable consequence of the duality of man. If you like it that way, you may identify the eternally subsisting portion as the soul of art, and the variable element as its body. That is why Stendhal, that impertinent, teasing, even repugnant mind (whose impertinences are, nevertheless, usefully thought-provoking), came close to the truth, much closer than many other people, when he said: 'The beautiful is neither more nor less than the promise of happiness.'[3] No doubt this definition oversteps the mark; it subordinates beauty much too much to the infinitely variable ideal of happiness; it divests beauty too lightly of its aristocratic character; but it has the great merit of getting away from the mistake of the academicians.[4]

More than once before I have explained these things[5]; these few lines are explanation enough for those who enjoy these pastimes of abstract thought; but I am well aware that French readers for the most part take little pleasure in them, and I am myself keen to enter into the positive and solid part of my subject.

II. MANNERS AND MODES

For sketches of manners, for the portrayal of bourgeois life and the fashion scene, the quickest and the cheapest technical means will evidently be the best. The more beauty the artist puts into it, the more valuable will the work be; but there is in the trivial things of life, in the daily changing of external

things, a speed of movement that imposes upon the artist an equal speed of execution. The multi-coloured engravings of the eighteenth century are again enjoying the favour of current fashion, as I was saying just now; pastel, etching, aquatint have provided their successive quotas to this vast dictionary of modern life in libraries, in art collector's portfolios and in the humblest shop windows. As soon as lithography was invented, it was quickly seen to be very suitable for this enormous task, so frivolous in appearance. We possess veritable national records in this class. The works of Gavarni and Daumier have been accurately described as complements to the *Comédie humaine*.[6] Balzac himself, I feel sure, would not have been unwilling to adopt that idea, which is all the more accurate in proportion as the artist-portrayer of manners is a genius of mixed composition, in other words, a genius with a pronounced literary element. Observer, idler, philosopher, call him what you will, but, in order to define such an artist, you will surely in the end be brought to giving him an attributive adjective that you could not apply to a painter of things eternal, or at least things of a more permanent nature, of heroic or religious subjects. Sometimes he may be a poet; more often he comes close to the novelist or the moralist; he is the painter of the fleeting moment and of all that it suggests of the eternal. Every country, for its pleasure or its fame, has possessed a few men of that sort. In our own time, to Daumier, to Gavarni, the first names that come to mind, we may add Deveria, Maurin, Numa (all chroniclers of the Restoration's shady charms), Wattier, Tassaert, Eugène Lami,[7] this last one almost English in his affection for aristocratic society, and even Trimolet and Traviès,[8] the chroniclers of poverty and humble life.

III. AN ARTIST, MAN OF THE WORLD, MAN OF CROWDS, AND CHILD

Today I want to talk to my readers about a singular man, whose originality is so powerful and clear-cut that it is self-sufficing, and does not bother to look for approval. None of his drawings is signed, if by signature we mean the few letters, which can be so easily forged, that compose a name, and that so many other artists grandly inscribe at the bottom of their most carefree sketches. But all his works are signed with his dazzling soul, and art-lovers who have seen and liked them will recognize them easily from the description I propose to give of them. M. C. G.⁹ loves mixing with the crowds, loves being incognito, and carries his originality to the point of modesty. M. Thackeray, who, as is well known, is very interested in all things to do with art, and who draws the illustrations for his own novels, one day spoke of M. G. in a London review, much to the irritation of the latter who regarded the matter as an outrage to his modesty. And again quite recently, when he heard that I was proposing to make an assessment of his mind and talent, he begged me, in a most peremptory manner, to suppress his name, and to discuss his works only as though they were the works of some anonymous person. I will humbly obey this odd request. The reader and I will proceed as though M. G. did not exist, and we will discuss his drawings and his water-colours, for which he professes a patrician's disdain, in the same way as would a group of scholars faced with the task of assessing the importance of a number of precious historical documents which chance has brought to light, and the author of which must for ever remain unknown. And even to reassure my conscience completely, let my readers assume that all the things I have to say about the artist's nature, so strangely and mysteriously dazzling, have been more or less accurately suggested by the works in question; pure poetic hypothesis, conjecture, or imaginative reconstructions.

M. G. is an old man. Jean-Jacques[10] began writing, so they say, at the age of forty-two. Perhaps it was at about that age that M. G., obsessed by the world of images that filled his mind, plucked up courage to cast ink and colours on to a sheet of white paper. To be honest, he drew like a barbarian, like a child, angrily chiding his clumsy fingers and his disobedient tool. I have seen a large number of these early scribblings, and I admit that most of the people who know what they are talking about, or who claim to, could, without shame, have failed to discern the latent genius that dwelt in these obscure beginnings. Today, M. G., who has discovered unaided all the little tricks of the trade, and who has taught himself, without help or advice, has become a powerful master in his own way; of his early artlessness he has retained only what was needed to add an unexpected spice to his abundant gift. When he happens upon one of these efforts of his early manner, he tears it up or burns it, with a most amusing show of shame and indignation.

For ten whole years I wanted to make the acquaintance of M. G., who is by nature a great traveller and very cosmopolitan. I knew that he had for a long time been working for an English illustrated paper and that in it had appeared engravings from his travel sketches (Spain, Turkey, the Crimea). Since then I have seen a considerable mass of these on-the-spot drawings from life, and I have thus been able to 'read' a detailed and daily account, infinitely preferable to any other, of the Crimean campaign. The same paper had also published (without signature, as before) a large quantity of compositions by this artist from the new ballets and operas. When at last I ran him to ground[11] I saw at once that I was not dealing exactly with an artist but rather with a man of the world. In this context, pray interpret the word 'artist' in a very narrow sense, and the expression 'man of the world' in a very broad one. By 'man of the world', I mean a man of the whole world, a man who understands the world and the mysterious

and legitimate reasons behind all its customs; by 'artist', I mean a specialist, a man tied to his palette like a serf to the soil. M. G. does not like being called an artist. Is he not justified to a small extent? He takes an interest in everything the world over, he wants to know, understand, assess everything that happens on the surface of our spheroid. The artist moves little, or even not at all, in intellectual and political circles. If he lives in the Bréda quarter he knows nothing of what goes on in the Faubourg Saint-Germain.[12] With two or three exceptions, which it is unnecessary to name, the majority of artists are, let us face it, very skilled brutes, mere manual labourers, village pub-talkers with the minds of country bumpkins.[13] Their talk, inevitably enclosed within very narrow limits, quickly becomes a bore to the man of the world, to the spiritual citizen of the universe.

Thus to begin to understand M. G., the first thing to note is this: that curiosity may be considered the starting point of his genius.

Do you remember a picture (for indeed it is a picture!) written by the most powerful pen of this age[14] and entitled *The Man of the Crowd*? Sitting in a café, and looking through the shop window, a convalescent is enjoying the sight of the passing crowd, and identifying himself in thought with all the thoughts that are moving around him. He has only recently come back from the shades of death and breathes in with delight all the spores and odours of life; as he has been on the point of forgetting everything, he remembers and passionately wants to remember everything. In the end he rushes out into the crowd in search of a man unknown to him whose face, which he had caught sight of, had in a flash fascinated him. Curiosity had become a compelling, irresistible passion.

Now imagine an artist perpetually in the spiritual condition of the convalsecent, and you will have the key to the character of M. G.

But convalescence is like a return to childhood. The

convalescent, like the child, enjoys to the highest degree the faculty of taking a lively interest in things, even the most trivial in appearance. Let us hark back, if we can, by a retrospective effort of our imaginations, to our youngest, our morning impressions, and we shall recognize that they were remarkably akin to the vividly coloured impressions that we received later on after a physical illness, provided that illness left our spiritual faculties pure and unimpaired. The child sees everything as a novelty; the child is always 'drunk'. Nothing is more like what we call inspiration than the joy the child feels in drinking in shape and colour. I will venture to go even further and declare that inspiration has some connection with congestion, that every sublime thought is accompanied by a more or less vigorous nervous impulse that reverberates in the cerebral cortex. The man of genius has strong nerves; those of the child are weak. In the one, reason has assumed an important role; in the other, sensibility occupies almost the whole being. But genius is no more than childhood recaptured at will, childhood equipped now with man's physical means to express itself, and with the analytical mind that enables it to bring order into the sum of experience, involuntarily amassed. To this deep and joyful curiosity must be attributed that stare, animal-like in its ecstasy, which all children have when confronted with something new, whatever it may be, face or landscape, light, gilding, colours, watered silk, enchantment of beauty, enhanced by the arts of dress. A friend of mine was telling me one day how, as a small boy, he used to be present when his father was dressing, and how he had always been filled with astonishment, mixed with delight, as he looked at the arm muscle, the colour tones of the skin tinged with rose and yellow, and the bluish network of the veins. The picture of the external world was already beginning to fill him with respect, and to take possession of his brain. Already the shape of things obsessed and possessed him. A precocious fate was showing the tip of its nose. His damna-

tion was settled. Need I say that, today, the child is a famous painter.

I was asking you just now to think of M. G. as an eternal convalescent; to complete your idea of him, think of him also as a man-child, as a man possessing at every moment the genius of childhood, in other words a genius for whom no edge of life is blunted.

I told you that I was unwilling to call him a pure artist, and that he himself rejected this title, with a modesty tinged with aristocratic restraint. I would willingly call him a dandy, and for that I would have a sheaf of good reasons; for the word 'dandy' implies a quintessence of character and a subtle understanding of all the moral mechanisms of this world; but, from another aspect, the dandy aspires to cold detachment, and it is in this way that M. G., who is dominated, if ever anyone was, by an insatiable passion, that of seeing and feeling, parts company trenchantly with dandyism. *Amabam amare*, said St Augustine. 'I love passion, passionately,' M. G. might willingly echo. The dandy is blasé, or affects to be, as a matter of policy and class attitude. M. G. hates blasé people. Sophisticated minds will understand me when I say that he possesses that difficult art of being sincere without being ridiculous. I would willingly confer on him the title of philosopher, to which he has a right for more than one reason; but his excessive love of visible, tangible things, in their most plastic form, inspires him with a certain dislike of those things that go to make up the intangible kingdom of the metaphysician. Let us therefore reduce him to the status of the pure pictorial moralist, like La Bruyère.

The crowd is his domain, just as the air is the bird's, and water that of the fish. His passion and his profession is to merge with the crowd. For the perfect idler, for the passionate observer it becomes an immense source of enjoyment to establish his dwelling in the throng, in the ebb and flow, the bustle, the fleeting and the infinite. To be away from home and yet to feel

at home anywhere; to see the world, to be at the very centre of
the world, and yet to be unseen of the world, such are some of
the minor pleasures of those independent, intense and impartial
spirits, who do not lend themselves easily to linguistic defini-
tions. The observer is a prince enjoying his incognito wherever
he goes. The lover of life makes the whole world into his family,
just as the lover of the fair sex creates his from all the lovely
women he has found, from those that could be found, and
those who are impossible to find, just as the picture-lover lives
in an enchanted world of dreams painted on canvas. Thus the
lover of universal life moves into the crowd as though into an
enormous reservoir of electricity. He, the lover of life, may
also be compared to a mirror as vast as this crowd; to a
kaleidoscope endowed with consciousness, which with every
one of its movements presents a pattern of life, in all its
multiplicity, and the flowing grace of all the elements that go
to compose life. It is an ego athirst for the non-ego, and re-
flecting it at every moment in energies more vivid than life
itself, always inconstant and fleeting. 'Any man', M. G. once
said, in one of those talks he rendered memorable by the
intensity of his gaze, and by his eloquence of gesture, 'any man
who is not weighed down with a sorrow so searching as to
touch all his faculties, and who is bored in the midst of the
crowd, is a fool! A fool! and I despise him!'

When, as he wakes up, M. G. opens his eyes and sees the
sun beating vibrantly at his window-panes, he says to himself
with remorse and regret: 'What an imperative command!
What a fanfare of light! Light everywhere for several hours
past! Light I have lost in sleep! and endless numbers of things
bathed in light that I could have seen and have failed to!' And
off he goes! And he watches the flow of life move by, majestic
and dazzling. He admires the eternal beauty and the astonish-
ing harmony of life in the capital cities, a harmony so provi-
dentially maintained in the tumult of human liberty. He gazes
at the landscape of the great city, landscapes of stone, now

swathed in the mist, now struck in full face by the sun. He enjoys handsome equipages, proud horses, the spit and polish of the grooms, the skilful handling by the page boys, the smooth rhythmical gait of the women, the beauty of the children, full of the joy of life and proud as peacocks of their pretty clothes; in short, life universal. If in a shift of fashion, the cut of a dress has been slightly modified, if clusters of ribbons and curls have been dethroned by rosettes, if bonnets have widened and chignons have come down a little on the nape of the neck, if waist-lines have been raised and skirts become fuller, you may be sure that from a long way off his eagle's eye will have detected it. A regiment marches by, maybe on its way to the ends of the earth, filling the air of the boulevard with its martial airs, as light and lively as hope; and sure enough M. G. has already seen, inspected and analysed the weapons and the bearing of this whole body of troops. Harness, highlights, bands, determined mien, heavy and grim mustachios, all these details flood chaotically into him; and within a few minutes the poem that comes with it all is virtually composed. And then his soul will vibrate with the soul of the regiment, marching as though it were one living creature, proud image of joy and discipline!

But evening comes. The witching hour, the uncertain light, when the sky draws its curtains and the city lights go on.[15] The gaslight stands out on the purple background of the setting sun. Honest men or crooked customers, wise or irresponsible, all are saying to themselves: 'The day is done at last!' Good men and bad turn their thoughts to pleasure, and each hurries to his favourite haunt to drink the cup of oblivion. M. G. will be the last to leave any place where the departing glories of daylight linger, where poetry echoes, life pulsates, music sounds; any place where a human passion offers a subject to his eye where natural man and conventional man reveal themselves in strange beauty, where the rays of the dying sun play on the fleeting pleasure of the 'depraved animal!'[16] 'Well,

there, to be sure, is a day well filled,' murmurs to himself a type of reader well-known to all of us; 'each one of us has surely enough genius to fill it in the same way.' No! few men have the gift of seeing; fewer still have the power to express themselves. And now, whilst others are sleeping, this man is leaning over his table, his steady gaze on a sheet of paper, exactly the same gaze as he directed just now at the things about him, brandishing his pencil, his pen, his brush, splashing water from the glass up to the ceiling, wiping his pen on his shirt, hurried, vigorous, active, as though he was afraid the images might escape him, quarrelsome though alone, and driving himself relentlessly on. And things seen are born again on the paper, natural and more than natural, beautiful and better than beautiful, strange and endowed with an enthusiastic life, like the soul of their creator. The weird pageant has been distilled from nature. All the materials, stored higgledy-piggledy by memory, are classified, ordered, harmonized, and undergo that deliberate idealization, which is the product of a childlike perceptiveness, in other words a perceptiveness that is acute and magical by its very ingenuousness.

IV. MODERNITY

And so, walking or quickening his pace, he goes his way, for ever in search. In search of what? We may rest assured that this man, such as I have described him, this solitary mortal endowed with an active imagination, always roaming the great desert of men, has a nobler aim than that of the pure idler, a more general aim, other than the fleeting pleasure of circumstance. He is looking for that indefinable something we may be allowed to call 'modernity', for want of a better term to express the idea in question. The aim for him is to extract from fashion the poetry that resides in its historical envelope, to distil the eternal from the transitory. If we cast our eye over our exhibitions of modern pictures, we shall be struck by the

general tendency of our artists to clothe all manner of subjects in the dress of the past. Almost all of them use the fashions and the furnishings of the Renaissance, as David used Roman fashions and furnishings, but there is this difference, that David, having chosen subjects peculiarly Greek or Roman, could not do otherwise than present them in the style of antiquity, whereas the painters of today, choosing, as they do, subjects of a general nature, applicable to all ages, will insist on dressing them up in the fashion of the Middle Ages, of the Renaissance, or of the East. This is evidently sheer laziness; for it is much more convenient to state roundly that everything is hopelessly ugly in the dress of a period than to apply oneself to the task of extracting the mysterious beauty that may be hidden there, however small or light it may be. Modernity is the transient, the fleeting, the contingent; it is one half of art, the other being the eternal and the immovable. There was a form of modernity for every painter of the past; the majority of the fine portraits that remain to us from former times are clothed in the dress of their own day. They are perfectly harmonious works because the dress, the hairstyle, and even the gesture, the expression and the smile (each age has its carriage, its expression and its smile) form a whole, full of vitality. You have no right to despise this transitory fleeting element, the metamorphoses of which are so frequent, nor to dispense with it. If you do, you inevitably fall into the emptiness of an abstract and indefinable beauty, like that of the one and only woman of the time before the Fall. If for the dress of the day, which is necessarily right, you substitute another, you are guilty of a piece of nonsense that only a fancy-dress ball imposed by fashion can excuse. Thus the goddesses, the nymphs, and sultanas of the eighteenth century are portraits in the spirit of their day.

No doubt it is an excellent discipline to study the old masters, in order to learn how to paint, but it can be no more than a superfluous exercise if your aim is to understand the

beauty of the present day. The draperies of Rubens or Veronese will not teach you how to paint watered silk *à l'antique*, or satin *à la reine*, or any other fabric produced by our mills, supported by a swaying crinoline, or petticoats of starched muslin. The texture and grain are not the same as in the fabrics of old Venice, or those worn at the court of Catherine.[17] We may add that the cut of the skirt and bodice is absolutely different, that the pleats are arranged into a new pattern, and finally that the gesture and carriage of the woman of today give her dress a vitality and a character that are not those of the woman of former ages. In short, in order that any form of modernity may be worthy of becoming antiquity, the mysterious beauty that human life unintentionally puts into it must have been extracted from it. It is this task that M. G. particularly addresses himself to.

I have said that every age has its own carriage, its expression, its gestures. This proposition may be easily verified in a large portrait gallery (the one at Versailles, for example). But it can be yet further extended. In a unity we call a nation, the professions, the social classes, the successive centuries, introduce variety not only in gestures and manners, but also in the general outlines of faces. Such and such a nose, mouth, forehead, will be standard for a given interval of time, the length of which I shall not claim to determine here, but which may certainly be a matter of calculation. Such ideas are not familiar enough to portrait painters; and the great weakness of M. Ingres, in particular, is the desire to impose on every type that sits for him a more or less complete process of improvement, in other words a despotic perfecting process, borrowed from the store of classical ideas.

In a matter such as this, *a priori* reasoning would be easy and even legitimate. The perpetual correlation between what is called the soul and what is called the body is a quite satisfactory explanation of how what is material or emanates from the spiritual reflects and will always reflect the spiritual force it

derives from. If a painter, patient and scrupulous but with only inferior imaginative power, were commissioned to paint a courtesan of today, and, for this purpose, were to get his inspiration (to use the hallowed term) from a courtesan by Titian or Raphael, the odds are that his work would be fraudulent, ambiguous, and difficult to understand. The study of a masterpiece of that date and of that kind will not teach him the carriage, the gaze, the come-hitherishness, or the living representation of one of these creatures that the dictionary of fashion has, in rapid succession, pigeonholed under the coarse or light-hearted rubric of unchaste, kept women, Lorettes.[18]

The same remark applies precisely to the study of the soldier, the dandy, and even animals, dogs or horses, and of all things that go to make up the external life of an age. Woe betide the man who goes to antiquity for the study of anything other than ideal art, logic and general method! By immersing himself too deeply in it, he will no longer have the present in his mind's eye; he throws away the value and the privileges afforded by circumstance; for nearly all our originality comes from the stamp that time impresses upon our sensibility. The reader will readily understand that I could easily verify my assertions from innumerable objects other than women. What would you say, for example, of a marine painter (I take an extreme case) who, having to represent the sober and elegant beauty of a modern vessel, were to tire out his eyes in the study of the overloaded, twisted shapes, the monumental stern, of ships of bygone ages, and the complex sails and rigging of the sixteenth century? And what would you think of an artist you had commissioned to do the portrait of a thorough-bred, celebrated in the solemn annals of the turf, if he were to restrict his studies to museums, if he were to content himself with looking at equine studies of the past in the picture galleries, in Van Dyck, Bourguignon,[19] or Van der Meulen[20]?

M. G., guided by nature, tyrannized over by circumstance, has followed a quite different path. He began by looking at life, and only later did he contrive to learn how to express life. The result has been a striking originality, in which whatever traces of untutored simplicity may still remain take on the appearance of an additional proof of obedience to the impression, of a flattery of truth. For most of us, especially for businessmen, in whose eyes nature does not exist, unless it be in its strict utility relationship with their business interests, the fantastic reality of life becomes strangely blunted. M. G. registers it constantly; his memory and his eyes are full of it.

V. MNEMONIC ART

The word 'barbarousness', which may have come too often from my pen, might lead some people to believe that I am alluding to a number of shapeless drawings that only the imagination of the viewer is capable of transforming into perfect things. This would be a serious misunderstanding of what I mean. I refer to a sort of inevitable, synthetic, childlike barbarousness, which can often still be seen in a perfect type of art (Mexican, Egyptian, or Ninevehite barbarousness) and derives from the need to see things big, to look at them particularly from the point of view of their effect as a whole. It is not superfluous to remark here that the accusation of barbarousness has often been made against all painters who have an eye for synthesis and abbreviation, M. Corot, for example, who begins by tracing the main lines of a landscape, its structure and features. Similarly, M. G., faithful interpreter of his own impressions, notes with instinctive vigour the culminating features or highlights of an object (they can be culminating or luminous from a dramatic point of view) or its main characteristics, sometimes even with a degree of exaggeration useful to human memory; and the imagination of the viewer, undergoing in its turn the influence of this imperious

code, conjures up in clear outline the impression produced by objects on the mind of M. G. In this case, the viewer becomes the translator of a translation, which is always clear and always intoxicating.

There is a factor that adds greatly to the vitality of this pictorial record of everyday life. I refer to M. G.'s habit of work. He draws from memory, and not from the model, except in those cases (the Crimean War, for example) where there is an urgent need to take immediate, hurried notes and to establish the broad outlines of a subject. In fact all true draughtsmen draw from the image imprinted in their brain and not from nature. If the admirable sketches of Raphael, of Watteau and many others are quoted as examples to invalidate our contention, our reply is that these are indeed highly detailed notes, but mere notes they remain. When a true artist has reached the stage of the final execution of his work, the model would be more of an embarrassment to him than a help. It even happens that men like Daumier and M. G. who have been accustomed for years to using their memory, and filling it with images, find that, when confronted with a model and the multiplicity of detail this means, their main faculty is as though confused and paralysed.

Then begins a struggle between the determination to see everything, to forget nothing, and the faculty of memory, which has acquired the habit of registering in a flash the general tones and shape, the outline pattern. An artist with a perfect sense of form but particularly accustomed to the exercise of his memory and his imagination, then finds himself assailed, as it were, by a riot of details, all of them demanding justice, with the fury of a mob in love with absolute equality. Any form of justice is inevitably infringed; any harmony is destroyed, sacrificed; a multitude of trivialities are magnified; a multitude of little things become usurpers of attention. The more the artist pays impartial attention to detail, the greater does anarchy become. Whether he be short-

or long-sighted, all sense of hierarchy or subordination disappears. This is an accident that often occurs in the works of one of our most fashionable painters,[21] whose defects moreover are so well attuned to the defects of the crowd that they have greatly contributed to his popularity. The same sort of analogy may be sensed in the practice of the actor's art, that mysterious, profound art which in these days has fallen into the confusion of many forms of decadence. M. Frédérick-Lemaître[22] builds up a role with the breadth and boldness of genius. Adorned as his acting is with brilliant detail, it nonetheless remains a unified sculptural composition. M. Bouffé[23] builds his with the painstaking efforts of a myope or a bureaucrat. In him everything sparkles and crackles, but nothing strikes the eye, nothing claims a place in our memories.

Thus in M. G.'s execution two things stand out: the first is the absorbed intenseness of a resurrecting and evocative memory, a memory that says to every object: 'Lazarus, arise'; the second is a fire, an intoxication of pencil or brush, almost amounting to frenzy. This is the fear of not going fast enough, of letting the spectre escape before the synthesis has been extracted and taken possession of, the terrible fear that takes hold of all great artists and fills them with such an ardent desire to appropriate all means of expression, so that the commands of the mind may never be weakened by the hand's hesitation; so that, in the end, the ideal execution may become as unconscious, as flowing, as the process of digesting is for the brain of a healthy man after dinner. M. G. begins with a few light pencil touches, which scarcely do more than indicate the positions of the objects in space. The main planes are indicated next by a series of colour-washes, masses vaguely and lightly tinted at first, but worked over again later with applications of stronger colour. In the last stage, the outlines of objects are clearly traced with pencil and ink. Without having seen them, no one would guess the remarkable effects he can achieve by this so simple and almost elementary method. It has the in-

comparable advantage that, at almost any stage, each drawing
seems to have reached a stage of completion satisfying enough
to the viewer; you may call this a thumbnail sketch, but it is
a perfect one. All the tone values are in harmony, and if he
wants to work the tones up, they will always retain their re-
lationship as they move towards the desired state of per-
fection. In this way he can work at up to twenty drawings at
a time with a liveliness and joy charming to the eye and
amusing even for him; the sketches pile up, one on top of the
other, by tens, hundreds, by thousands. From time to time he
runs through them, glancing at some, examining others, and
then he chooses a few, to which he gives more intensity by
giving greater depth to the shadow and touching up the high-
lights.

He attaches great importance to the backgrounds, which,
whether strongly or lightly worked, are always of a quality
and nature appropriate to the figures. The scale of tones and
the general harmony are strictly observed, with a genius that
derives more from instinct than from study. For M. G. pos-
sesses that mysterious talent of the colourist, by the light of
nature, a veritable gift, which study can strengthen but which
it cannot of itself, I believe, create. To sum it all up, our
strange artist expresses both the gestures and attitudes, be they
solemn or grotesque, of human beings and their luminous
explosion in space.

VI. THE ANNALS OF WAR

Bulgaria, Turkey, the Crimea, Spain have all been a gorgeous
feast for M. G.'s eyes, or rather for those of the imaginary
artist we are agreed to call M. G.; for now and then it comes
back to me that, to reassure his modesty, I promised to pretend
he did not exist. I have looked through these archives of the
Eastern War[24] (battlefields strewn with the debris of death,
heavy baggage trains, shipment of livestock and horses),

scenes throbbing with life and interest, as though moulded on life itself, elements of a valuable form of picturesque, which many well-known painters would have thoughtlessly neglected if they had found themselves in the same circumstances; amongst these, however, I would willingly make an exception of M. Horace Vernet, veritable journalist rather than true artist, with whom M. G., though a more delicate artist, has an evident relationship, assuming we want to think of him only as an archivist of life. No journal, I declare, no written record, no book could express so well this great epic of the Crimean War, in all its distressing detail and sinister breadth. The eye moves from the banks of the Danube to the shores of the Bosphorus, from Cape Kerson to the plain of Balaclava or the fields of Inkerman, and on to the English, French, Turkish and Piedmontese encampments, from the streets of Constantinople to the hospitals and to a variety of solemn religious and military ceremonies.

One of the drawings that sticks in my memory more than others is the *Consécration d'un terrain funèbre à Scutari par l'évêque de Gibraltar*.[25] The picturesque character of the scene, which arises from the contrast between the surrounding oriental countryside and the western attitudes and uniforms of the participants, is brought out strikingly, and in a manner that gives food for thought and reverie. The ordinary soldiers and officers alike, all have that ineradicable air of 'gentlemen', that determined and reserved air they carry with them to the end of the earth, whether it be in the garrison towns of Cape Colony or the settlements in India; the Anglican clergy put one vaguely in mind of ushers or stockbrokers in cap and bands for the occasion.

And here in another drawing is the residence of Omar Pasha[26] at Shumla. Turkish hospitality, pipes and coffee; all the visitors are seated on divans, sucking at pipes as long as blow-pipes, with the bowls at their feet. And here, *Kurdes à Scutari* depicts a weird-looking soldiery whose aspect suggests

an invasion of barbarian hordes; and, no less strange, in another sketch are bashi-bazouks,[27] with their European officers, Hungarian or Polish, veritable dandies in feature these latter, contrasting oddly with the curiously oriental character of their men.

One magnificent drawing that caught my eye is of a single standing figure; the man is stout and vigorous, his expression all at once thoughtful, carefree and bold; he is wearing high boots, which come up above his knees; his uniform is hidden under a heavy, ample topcoat, tightly buttoned up; his gaze, through his cigar smoke, is directed towards the threatening misty horizon; he has been wounded in the arm, and is wearing a sling. At the foot, a scribbled pencil note states: *Canrobert*[28] *on the battlefield of Inkerman. Taken on the spot.*

And who might this horseman be? With white moustaches so vigorously drawn, with head erect, he seems to be scenting the terrible poetry of the battlefield, whilst his horse, sniffing the ground, picks his way between the heaps of corpses, feet upturned, faces contorted, in strange attitudes. At the bottom of the drawing, in a corner, are these words: *Myself at Inkerman.*

And who is this but M. Baraguay-d'Hilliers,[29] with the Seraskier,[30] inspecting the artillery at Béchichtash. Rarely have I seen a better likeness in the portrait of a soldier, done by a bolder or livelier hand.

Hard by, I caught sight of a name of sinister reputation since our Syrian disasters: *Achmet-Pacha, général en chef à Kalafat, debout devant sa hutte avec son état-major, se fait présenter deux officiers européens.*[31] Despite the generous extent of his Turkish paunch, Achmet-Pacha has, both in his bearing and in his face, the noble aristocratic air that usually belongs to the master races.

The battle of Balaclava figures several times, from different angles, in this interesting collection. There, amongst the most striking, is the historic cavalry charge sung by the heroic clarion

of Alfred Tennyson, the Poet Laureate: a mass of cavalry are shown thundering at speed towards the horizon, between the rolling clouds of gunsmoke. The background is shut in by a line of green hills.

From time to time a religious subject provides a welcome change to the viewer's gaze, saddened by this chaos of gunpowder and restless carnage. In the midst of the British troops of all arms, amongst whom the picturesque uniform of the kilted Scots is conspicuous, an Anglican chaplain holds the Sunday service; three drums, the topmost resting on the other two, serve as a lectern.

It is difficult in all conscience for the mere pen to translate this vast and complex poem, composed of a thousand sketches, and to express the feelings of intoxication arising from all the picturesque details – often distressing but never maudlin – which are collected in these few hundred pages. The stained and torn condition of these is eloquent in its own way of the chaos and tumult in the midst of which the artist noted down his memories of each day. As evening came the mail would carry away towards London M. G.'s notes and drawings, and, often enough, he would thus entrust to the post ten or more quickly executed thumbnail sketches, done on thin paper, which the engravers and subscribers to the magazine were eagerly awaiting.

Sometimes ambulances are depicted, where the very atmosphere seems sick, gloomy and heavy, every bed a bed of pain; another time, it is the hospital at Pera, with two sisters of mercy, tall, pale and straight like the figures of Lesueur,[32] talking, I notice, to an informally dressed visitor quaintly designated as 'my humble self'. Or again, on rough, winding paths strewn with the debris of a past engagement, a long string of pack animals – mules, donkeys, or horses – moves slowly, carrying in rough paniers, balanced on either flank, pale and inert wounded. Across vast expanses of snow come camels, with majestic dewlaps and heads held high. Led by

Tartars, they are hauling provisions and munitions of all kinds; a whole warlike world appears, full of life and silent activity, encampments, bazaars, where samples of every type of supplies are displayed, like barbarian cities, conjured up for the circumstances. Amidst the huts, along the stony or snowy roads, in the defiles, can be seen the uniforms of several countries, more or less worn and torn by war, or altered in appearance by lumpy fur coats or heavy boots.

How sad it is to think that this album, which has now been scattered in a variety of places, and the precious pages of which have been kept by the engravers commissioned to reproduce them, or by the editors of the *Illustrated London News*, should not have been submitted to the Emperor. He, I am sure, would have been glad to see (not without emotion) this record of his soldiers, their day-in, day-out doings, expressed with minute care, from the most brilliant feats of arms to the most trivial occupations of life, by this soldier-artist's sure and intelligent hand.

VII. POMP AND CEREMONY

Turkey has also contributed some admirable subjects to our dear G.: the festivals of Bairam,[33] profound and rippling splendours, in the background of which appears, like a pallid sun, the ineradicable boredom of the late Sultan; ranged to the left of the sovereign stand all the officers of the civil order; to his right, all those of the military order, the chief of them being Said Pasha,[34] Sultan of Egypt, who was at Constantinople at the time; processions, moving with solemn pomp to the little mosque near the palace, and in these throngs are to be seen a number of Turkish functionaries, veritable caricatures of decadence, crushing their splendid horses under the weight of their fantastic obesity; the heavy massive carriages, not unlike coaches from the days of Louis XIV, gilded and otherwise adorned with oriental fantasy, from the inside of which

curious feminine glances dart from time to time, through the
narrow interval left to the eyes by muslin veils worn close to
the face; the frenzied dances of mountebanks of the 'third
sex' (never has Balzac's humorous phrase been more applicable
than in the present case, for beneath these throbbing unsteady
lights, under the generous waving folds of the garments, under
the heavy make-up of cheeks, eyes and eyebrows, in all these
hysterical and convulsive gestures, in the long hair down to
the hips, you would find it difficult, not to say impossible, to
guess that virility was there): and finally the women of easy
virtue (if one can speak in such terms, where the Levant is
concerned), generally provided by Hungarian, Walachian,
Jewish, Polish, Greek and Armenian women; for under a
despotic government, it is the oppressed races, and especially
those amongst them that suffer the greatest privations, that
provide the most recruits to prostitution. Amongst these
women some have kept their national costumes, embroidered
bodices, short sleeves, loosely hanging scarves, baggy trousers,
Turkish slippers with upturned points, striped or spangled
muslins, and all the tinsel of their homeland; others, by far the
more numerous, have adopted the principal mark of civiliza-
tion, which, for a woman, is invariably the crinoline, not,
however, without introducing in their attire a faint reminisc-
ence of the Levant, with the result that they have an air of
Parisian women attempting to disguise themselves.

M. G. excels at depicting all the display of official cere-
monies, the pomp and circumstance of national occasions, not
coldly and didactically, like painters who see only lucrative
drudgery in commissions of this kind, but with all the ardour
of a man in love with space, perspective, great expanses or
explosions of light, hanging like teardrops or sparkling dia-
monds on the asperities of the uniform or court dresses. *La
fête commémorative de l'indépendance dans la cathédrale d'Athènes*
affords an interesting example of this talent. All the little
figures, each of them so well placed, give more depth to the

space that contains them. The cathedral is vast and festooned with solemn draperies. King Otto[35] and the Queen, standing on a dais, are depicted in the traditional dress, which they are wearing with marvellous ease, as though to bear witness to the sincerity of their adoption, and to the most refined Hellenic patriotism. The King is as tightly belted as the smartest palikar,[36] and his kilt flairs out with all the exaggeration of national dandyism. Opposite the royal couple, the patriarch is stepping towards them, an old man with bowed shoulders, flowing white beard, little eyes behind green glasses, his whole bearing betraying the most consummate oriental impassivity. All the figures that people this composition are portraits; one of the most interesting, on account of the oddness of the features, which are anything but Hellenic, is that of a German woman standing next to the Queen and attached to her service.

In all M. G.'s series of drawings, a figure often to be found is the French Emperor, whose face the artist has succeeded in reducing to an infallible shorthand sketch without losing the likeness, which he executes with all the sureness of a signature flourish. Now the Emperor, at full gallop, is holding a review, accompanied by officers with easily recognizable features, or by foreign potentates, European, Asiatic, or African, to whom he is doing, as it were, the honours of Paris. Sometimes he is shown motionless on his horse, whose hooves are as firmly on the ground as the four legs of a table, with the Empress on his left in riding habit, and on his right, the little Prince Imperial, in a busby, and holding himself militarily erect on a little rough-haired horse, like the ponies English artists love to show dashing about in their landscapes; at other times, cascades of light and dust enfold him as he rides in the alleys of the Bois de Boulogne; at others again, we see him greeted by the acclamations of the crowds as he moves amongst them in the faubourg Saint-Antoine. One of these water-colours in particular quite dazzled me by its magical quality: the Empress,

composed and relaxed, is seen at the front of a richly and majestically decorated box at the theatre; the Emperor is leaning forward slightly, as though to get a better view of the theatre; below, two guardsmen stand erect in military, almost religious immobility, their brillant uniforms sparkling with the reflections of the light from the footlights. Behind this band of light in the ideal atmosphere of the stage, the actors are singing, declaiming and gesticulating harmoniously; on the near side, there is an abyss of suffused light and a circular space full of human faces at every tier: the chandelier and the audience.

The mob demonstrations, the clubs, the solemn occasions of 1848 also provided M. G. with subjects for a series of scenes, most of which have been engraved for the *Illustrated London News*. A few years ago, after a sojourn in Spain, which was very fruitful for his genius, he compiled an album of the same kind, of which I have seen only a few fragments. The carelessness with which he gives away or lends his drawings often exposes him to irreparable losses.

VIII. THE SOLDIER

To define once more the kind of subject this artist likes best, let us call it the pomp of life, as it is displayed in the capitals of the civilized world, the pageant of military life, of high life, of loose life. Our eye witness is always punctually at his observation post, wherever flow the deep and impetuous desires, the great rivers of the human heart, war, love, gaming; wherever the festivities and figments which are the external form of these great elements of happiness and sorrow are in full swing. But the artist shows a very marked predilection for military life, for the soldier, and I think that this love of his derives, not only from the virtues and qualities that inevitably flow from the warrior's soul into his bearing and his face, but also from the showy apparel his profession clothes him in.

M. Paul de Molènes[37] has written a few pages, as delightful
to read as they are full of good sense, on military coquetry and
on the moral significance to be drawn from those dazzling
costumes in which all governments like dressing their troops.
M. G. would willingly sign these pages.

We have already spoken of the idiom of beauty peculiar to
every age, and we have noted that every century had, so to
speak, its own characteristic grace. The same observation may
be applied to the professions; each one draws its external
beauty from the moral laws that govern it. In some, this type
of beauty will be marked by energy, and in others it will bear
the visible signs of idleness. It is, as it were, the emblem of
character, the stamp of fate. The soldier considered in general
has his type of beauty, just as the dandy and the woman of the
town have theirs, and each has its own distinctive quality. The
reader will accept it as natural that I should ignore those pro-
fessions where, as a result of a single form of violent exercise,
muscles become distorted and the face is marked by servitude.
Accustomed as he is to surprises, the soldier does not easily lose
his composure. Thus, in this case, beauty will consist of a care-
free, martial air, a strange mixture of calm and boldness; it is
a form of beauty that comes from the need to be ready to die
at any moment. But the face of the ideal military man must be
stamped with a great air of simplicity; for living as they do in
a community, like monks and schoolboys, accustomed as they
are to unload the daily concern of living on to a remote,
paternalist organization, soldiers are, in many matters, as
simple as children; and like children, once duty has been done,
they are easy to amuse, and given to boisterous forms of fun.
I do not think I am exaggerating when I maintain that all these
moral considerations spring naturally from the sketches and
water-colours of M. G. Not a single military type is missing,
and all of them have been caught by the artist with a kind of
enthusiastic joy: the old infantry officer, of the sad counten-
ance, distressing his horse by his obesity; the pampered staff

officer, wasp-waisted and bending forward over ladies' chairs without bashfulness, with affected movements of the shoulders, and, seen from the rear, reminiscent of some slender and elegant insect; the zouave and the rifleman, whose whole bearing suggests outstanding audacity, self-reliance and, as it were, a more than ordinary sense of personal responsibility; and the free and easy manner, the mercurial gaiety of the light cavalry; the vaguely professorial and academic features of the technical arms, like the gunners and the sappers, often confirmed by the unwarlike apparatus of spectacles: none of these models, none of these nuances is neglected, and all of them are summed up, defined, with the same love and wit.

I have in front of me, as I write, one of these drawings; its subject, which conveys a general impression of heroism, is the head of an infantry column; maybe these men are back from Italy[38] and have halted on the boulevards, basking in the enthusiasm of the crowds; maybe they have just accomplished long marches on the roads of Lombardy; I do not know, but what is clearly visible, what comes across fully, is the steadfast audacious character, even in repose, of all these sun-tanned, weather-beaten faces.

This is without a doubt the uniform expression produced by discipline, sufferings undergone together, the resigned air of courage, tempered by long periods of exhausting strain. Trousers turned up and tucked into gaiters, great-coats tarnished by dust and vaguely discoloured, the whole equipment in fact has itself taken on the indestructible appearance of beings that have returned from afar, and have experienced strange adventures. It really is as though these men were more solidly screwed on to their hips, more firmly planted on their feet, more self-assured than ordinary mortals. If Charlet, who was always on the look-out for just this kind of beauty, and who found it often enough, had seen this drawing, he would have been greatly impressed by it.

IX. THE DANDY[39]

The wealthy man, who, blasé though he may be, has no occupation in life but to chase along the highway of happiness, the man nurtured in luxury, and habituated from early youth to being obeyed by others, the man, finally, who has no profession other than elegance, is bound at all times to have a facial expression of a very special kind. Dandyism is an ill-defined social attitude as strange as duelling; it goes back a long way, since Caesar, Catilina,[40] Alcibiades[41] provide us with brilliant examples of it; it is very widespread, since Chateaubriand found examples of it in the forests and on the lake-sides of the New World. Dandyism, which is an institution outside the law, has a rigorous code of laws that all its subjects are strictly bound by, however ardent and independent their individual characters may be.

The English novelists, more than others, have cultivated the 'high life' type of novel, and their French counterparts who, like M. de Custine,[42] have tried to specialize in love novels have very wisely taken care to endow their characters with purses long enough for them to indulge without hesitation their slightest whims; and they freed them from any profession. These beings have no other status but that of cultivating the idea of beauty in their own persons, of satisfying their passions, of feeling and thinking. Thus they possess, to their hearts' content, and to a vast degree, both time and money, without which fantasy, reduced to the state of ephemeral reverie, can scarcely be translated into action. It is unfortunately very true that, without leisure and money, love can be no more than an orgy of the common man, or the accomplishment of a conjugal duty. Instead of being a sudden impulse full of ardour and reverie, it becomes a distastefully utilitarian affair.

If I speak of love in the context of dandyism, the reason is that love is the natural occupation of men of leisure. But the

dandy does not consider love as a special aim in life. If I have mentioned money, the reason is that money is indispensable to those who make an exclusive cult of their passions, but the dandy does not aspire to wealth as an object in itself; an open bank credit could suit him just as well; he leaves that squalid passion to vulgar mortals. Contrary to what a lot of thoughtless people seem to believe, dandyism is not even an excessive delight in clothes and material elegance. For the perfect dandy, these things are no more than the symbol of the aristocratic superiority of his mind. Thus, in his eyes, enamoured as he is above all of distinction, perfection in dress consists in absolute simplicity, which is, indeed, the best way of being distinguished. What then can this passion be, which has crystallized into a doctrine, and has formed a number of outstanding devotees, this unwritten code that has moulded so proud a brotherhood? It is, above all, the burning desire to create a personal form of originality, within the external limits of social conventions. It is a kind of cult of the ego which can still survive the pursuit of that form of happiness to be found in others, in woman for example; which can even survive what are called illusions. It is the pleasure of causing surprise in others, and the proud satisfaction of never showing any oneself. A dandy may be blasé, he may even suffer pain, but in the latter case he will keep smiling, like the Spartan under the bite of the fox.[43]

Clearly, then, dandyism in certain respects comes close to spirituality and to stoicism, but a dandy can never be a vulgar man. If he were to commit a crime, he might perhaps be socially damned, but if the crime came from some trivial cause, the disgrace would be irreparable. Let the reader not be shocked by this mixture of the grave and the gay; let him rather reflect that there is a sort of grandeur in all follies, a driving power in every sort of excess. A strange form of spirituality indeed! For those who are its high priests and its victims at one and the same time, all the complicated material

conditions they subject themselves to, from the most flawless dress at any time of day or night to the most risky sporting feats, are no more than a series of gymnastic exercises suitable to strengthen the will and school the soul. Indeed I was not far wrong when I compared dandism to a kind of religion. The most rigorous monastic rule, the inexorable commands of the Old Man of the Mountain,[44] who enjoined suicide on his intoxicated disciples, were not more despotic or more slavishly obeyed than this doctrine of elegance and originality, which, like the others, imposes upon its ambitious and humble sectaries, men as often as not full of spirit, passion, courage, controlled energy, the terrible precept: *Perinde ac cadaver*![45]

Fastidious, unbelievables, beaux, lions or dandies: whichever label these men claim for themselves, one and all stem from the same origin, all share the same characteristic of opposition and revolt; all are represesentatives of what is best in human pride, of that need, which is too rare in the modern generation, to combat and destroy triviality. That is the source, in your dandy, of that haughty, patrician attitude, aggressive even in its coldness. Dandyism appears especially in those periods of transition when democracy has not yet become all-powerful, and when aristocracy is only partially weakened and discredited. In the confusion of such times, a certain number of men, disenchanted and leisured 'outsiders', but all of them richly endowed with native energy, may conceive the idea of establishing a new kind of aristocracy, all the more difficult to break down because established on the most precious, the most indestructible faculties, on the divine gifts that neither work nor money can give. Dandyism is the last flicker of heroism in decadent ages; and the sort of dandy discovered by the traveller in Northern America in no sense invalidates this idea; for there is no valid reason why we should not believe that the tribes we call savage are not the remnants of great civilizations of the past. Dandyism is a setting sun; like the declining star, it is magnificent, without heat and full of

melancholy. But alas! the rising tide of democracy, which spreads everywhere and reduces everything to the same level, is daily carrying away these last champions of human pride, and submerging, in the waters of oblivion, the last traces of these remarkable myrmidons. Here in France, dandies are becoming rarer and rarer, whereas amongst our neighbours in England the state of society and the constitution (the true constitution, the one that is expressed in social habits) will, for a long time yet, leave room for the heirs of Sheridan, Brummell and Byron, always assuming that men worthy of them come forward.

What to the reader may have seemed a digression is not one in fact. The moral reflections and musings that arise from the drawings of an artist are in many cases the best interpretation that the critic can make of them; the notions they suggest are part of an underlying idea, and, by revealing them in turn, we may uncover the root idea itself. Need I say that when M. G. commits one of his dandies to paper, he always gives him his historical character, we might almost say his legendary character, were it not that we are dealing with our own day and with things that are generally held to be light-hearted? For here we surely have that ease of bearing, that sureness of manner, that simplicity in the habit of command, that way of wearing a frock-coat or controlling a horse, that calmness revealing strength in every circumstance, that convince us, when our eye does pick out one of those privileged beings, in whom the attractive and the formidable mingle so mysteriously: 'There goes a rich man perhaps, but quite certainly an unemployed Hercules.'

The specific beauty of the dandy consists particularly in that cold exterior resulting from the unshakeable determination to remain unmoved; one is reminded of a latent fire, whose existence is merely suspected, and which, if it wanted to, but it does not, could burst forth in all its brightness. All that is expressed to perfection in these illustrations.

X. WOMAN

The being who, for most men, is the source of the most lively,
and even, be it said to the shame of philosophical delights, the
most lasting joys; the being towards or for whom all their
efforts tend; that awe-inspiring being, incommunicable like
God (with this difference that the infinite does not reveal itself
because it would blind and crush the finite, whereas the being
we are speaking about is incommunicable only, perhaps, be-
cause having nothing to communicate); that being in whom
Joseph de Maistre saw a beautiful animal, whose charm
brightens and facilitates the serious game of politics; for whom
and by whom fortunes are made and lost; for whom, but
especially by whom, artists and poets compose their most
delicate jewels; from whom flow the most enervating pleasures
and the most enriching sufferings – woman, in a word, is not,
for the artist in general and for M. G. in particular, only the
female of the human species. She is rather a divinity, a star, that
presides over all the conceptions of the male brain; she is like
the shimmer of all graces of nature, condensed into one being;
she is the object of the most intense admiration and interest that
the spectacle of life can offer to man's contemplation. She is
a kind of idol, empty-headed perhaps, but dazzling, enchant-
ing, an idol that holds men's destinies and wills in thrall to her
glances. She is not, I repeat, an animal whose limbs, correctly
assembled, provide a perfect example of harmony; nor is she
even that type of pure beauty which might be imagined by
a sculptor, in his moments of most austere meditation; not
even that would suffice to explain her mysterious and complex
spellbinding power. Neither Winckelmann nor Raphael can
help us in this context; and I am sure that M. G., in spite of the
breadth of his intelligence (be it said without affront to him),
would turn away from a piece of ancient statuary if, by look-
ing at it, he were to lose the opportunity of enjoying a portrait
by Reynolds or Lawrence. All the things that adorn woman,

all the things that go to enhance her beauty, are part of herself; and the artists who have made a special study of this enigmatic being are just as enchanted by the whole *mundus muliebris*[46] as by woman herself. Woman is doubtless a light, a glance, an invitation to happiness, sometimes a spoken word; but above all, she is a harmonious whole, not only in her carriage and in the movement of her limbs, but also in the muslins and the gauzes, in the vast and iridescent clouds of draperies in which she envelops herself, and which are, so to speak, the attributes and the pedestal of her divinity; in the metal and precious stones that serpentine round her arms and neck, that add their sparkle to the fire of her eyes, or whisper softly at her ears. When he describes the pleasure caused by the sight of a beautiful woman, what poet would dare to distinguish between her and her apparel? Show me the man who, in the street, at the theatre, or in the Bois,[47] has not enjoyed, in a wholly detached way, the sight of a beautifully composed attire, and has not carried away with him an image inseparable from the beauty of the woman wearing it, thus making of the two, the woman and the dress, an indivisible whole. This seems to me the moment to come back to certain questions relating to fashion and adornment, which I only briefly touched on at the beginning of this study, and to vindicate the art of dress against the inept slanders heaped upon it by certain highly equivocal nature-lovers.

XI. IN PRAISE OF MAKE-UP

I know a song so valueless and futile that I scarcely dare quote from it in a work with some claims to being serious; but it expresses very aptly, in vaudeville style, the aesthetic notions of people not given to thinking. 'Nature embellishes beauty.' It may be presumed that the 'poet', had he been able to write his own language properly, would have said: 'Simplicity embellishes beauty', which is tantamount to this truth of a wholly unexpected kind: 'Nothing embellishes what is.'

Most wrong ideas about beauty derive from the false notion the eighteenth century had about ethics. In those days, Nature was taken as a basis, source and prototype of all possible forms of good and beauty. The rejection of original sin is in no small measure responsible for the general blindness of those days. If, however, we are prepared merely to consult the facts that stare us in the face, the experience of all ages, and the *Gazette des Tribunaux*,[48] we can see at once that natures teaches nothing or nearly nothing; in other words, it compels man to sleep, drink, eat and to protect himself as best he can against the inclemencies of the weather. It is nature too that drives man to kill his fellow-man, to eat him, to imprison and torture him; for as soon as we move from the order of necessities and needs to that of luxury and pleasures, we see that nature can do nothing but counsel crime. It is this so-called infallible nature that has produced parricide and cannibalism, and a thousand other abominations, which modesty and nice feeling alike prevent our mentioning. It is philosophy (I am referring to the right kind), it is religion that enjoins upon us to succour our poor and enfeebled parents. Nature (which is nothing but the inner voice of self-interest) tells us to knock them on the head. Review, analyse everything that is natural, all the actions and desires of absolutely natural man: you will find nothing that is not horrible. Everything that is beautiful and noble is the product of reason and calculation. Crime, which the human animal took a fancy to in his mother's womb, is by origin natural. Virtue, on the other hand, is *artificial*, super-natural, since in every age and nation gods and prophets have been necessary to teach it to bestialized humanity, and since man by himself would have been powerless to discover it. Evil is done without effort, *naturally*, it is the working of fate; good is always the product of an art. All I have said about nature, as a bad counsellor in matters of ethics, and about reason, as the true power of redemption and reform, can be transferred to the order of beauty. Thus I am led to regard adornment as

one of the signs of the primitive nobility of the human soul. The races that our confused and perverted civilization so glibly calls savage, with a quite laughable pride and fatuity, appreciate, just as children do, the high spiritual quality of dress. The savage and the infant show their distaste for the real by their naïve delight in bright feathers of different colours, in shimmering fabrics, in the superlative majesty of artificial shapes, thus unconsciously proving the immateriality of their souls. Woe to him who, like Louis XV (who far from being the product of a true civilization was that of a recurrence of barbarism), drives depravity to the point of appreciating nothing but nature unadorned.*

Fashion must therefore be thought of as a symptom of the taste for the ideal that floats on the surface in the human brain, above all the coarse, earthy and disgusting things that life according to nature accumulates, as a sublime distortion of nature, or rather as a permanent and constantly renewed effort to reform nature. For this reason, it has been judiciously observed (though without discovering the cause) that all fashions are charming, or rather relatively charming, each one being a new striving, more or less well conceived, after beauty, an approximate statement of an ideal, the desire for which constantly teases the unsatisfied human mind. But, if we want to enjoy fashions thoroughly, we must not look upon them as dead things; we might as well admire a lot of old clothes hung up, limp and inert, like the skin of St Bartholomew, in the cupboard of a second-hand-clothes dealer. They must be pictured as full of the life and vitality of the beautiful women that wore them. Only in that way can we give them meaning and value. If therefore the aphorism 'All fashions are charming' offends you as being too absolute, say – and then you can be

*It is recorded that when Madame Dubarry wanted to avoid receiving the King, she was careful to put on rouge. That was enough; it meant she was closing her door. In beautifying herself she used to put to flight the royal disciple of nature.

sure of making no mistake – all were legitimately charming in their day.

Woman is well within her rights, we may even say she carries out a kind of duty, in devoting herself to the task of fostering a magic and supernatural aura about her appearance; she must create a sense of surprise, she must fascinate; idol that she is, she must adorn herself, to be adored. It follows, she must borrow, from all the arts, the means of rising above nature, in order the better to conquer the hearts and impress the minds of men. It matters very little that the ruse and the artifice be known of all, if their success is certain, and the effect always irresistible. These are the kind of reflections that lead the philosopher-artist to justify readily all the means employed by women, over the centuries, to consolidate and, so to speak, divinize their fragile beauty. Any enumeration would have to include countless details; but, to limit ourselves to what in our day is commonly called make-up, who can fail to see that the use of rice powder, so fatuously anathematized by innocent philosophers, has as its purpose and result to hide all the blemishes that nature has so outrageously scattered over the complexion, and to create an abstract unity of texture and colour in the skin, which unity, like the one produced by tights, immediately approximates the human being to a statue, in other words to a divine or superior being? As for black pencil for eye effects, and rouge for heightening the colour of the upper part of the cheek, although their use comes from the same principle, the need to surpass nature, the result is destined to satisfy a quite opposite need. Red and black represent life, a supernatural, excessive life; black rings round the eyes give them a deeper and stranger look, a more decisive appearance of a window open on the infinite; the rouge which heightens the glow of cheek-bones confers still greater brightness on the pupils, and gives to a lovely woman's face the mysterious passion of a priestess.

Thus, if I have been properly understood, painting the face

is not to be used with the vulgar, unavowable intention of imitating the fair face of nature, or competing with youth. It has, moreover, been observed that artifice does not embellish ugliness, and can only serve beauty. Who would dare assign to art the sterile function of imitating nature? Make-up has no need of concealment, no need to avoid discovery; on the contrary, it can go in for display, if not with affectation, at least with a sort of ingenuousness.

I will readily allow people whose ponderous gravity prevents their looking for beauty in its very minutest manifestations to laugh at my reflections, and to condemn their childish solemnity; the austere judgements of such folk worry me not at all; I am content to appeal to the true artists, and to women who have received at birth a spark of that sacred fire they would feign use to light up their whole being.

XII. WOMEN: HONEST ONES, AND OTHERS

Thus M. G., having undertaken the task of seeking and explaining beauty in modernity, enjoys depicting women in all their finery, their beauty enhanced by every kind of artifice, regardless of what social class they belong to. Moreover, in the whole of his works, just as in the throng and bustle of human life itself, the differences of class and breeding, whatever may be the apparatus of luxury used by the individual, are immediately apparent to the eye of the spectator.

At one moment we see, bathed in the diffused light of the auditorium, a group of young women of the highest social circles, the brightness reflected in their eyes, in their jewellery and on their shoulders, framed in their boxes, resplendent as portraits. Some of them are grave and serious, others fair and feather-brained. Some display their precocious charms with aristocratic nonchalance, others, in all innocence, their boyish busts. All are biting their fans, and have a far-away look in their eyes, or a fixed stare; their postures are theatrical and

solemn, like the play or opera they are pretending to listen to.

Another time we see smartly dressed families strolling along the paths of the public gardens, the wives without a care in the world, leaning on the arms of their husbands, whose solid contented air betrays the self-made man, full of money and self-satisfaction. Here the general air of wealth takes the place of haughty distinction. Little girls with match-stick arms and ballooning skirts, looking like little women by their gestures and appearance, are skipping, playing with hoops or pretending to be grown-ups on a visit, performing in the open air the social comedy their parents perform at home.

Or again, we are shown a lower level of society, where chits of actresses from the suburban theatres, proud as peacocks to appear at last in the glare of the footlights, slim, frail, scarcely grown-up, are shaking down, over their virginal, sickly bodies, absurd garments which belong to no period, but are the joy of their owners.

Or, at a café door, we see, leaning against the broad windows lit from without and within, one of those lounging half-wits; his elegance is the work of his tailor, and the distinguished cut of his jib, that of his hairdresser. Beside him, her feet resting on the indispensable footstool, sits his mistress, a great cow of a woman, in whom almost nothing is lacking (but that 'almost nothing' meaning almost everything, in a word: distinction) to make her look like a high-born lady. Like her pretty boy-friend, she has, filling the whole orifice of her little mouth, an outsize cigar. Neither of these two beings has a thought in his head. Can one even be sure they are looking at anything – unless, like Narcissuses of fat-headedness, they are contemplating the crowd, as though it were a river, offering them their own image. In reality they exist much more for the joy of the observer than for their own.

And now we get a glimpse of the amusement halls, your Valentinos, your Casinos, your Prados (the Tivolis, the Idalias, the Follies, the Paphoses of former days), glory-holes

with their galleries full of light and hubbub, where the idle, gilded youth can give free rein to their animal spirits. Women, who have exaggerated the latest fashion to the point where its grace of line is spoilt, are ostentatiously sweeping the polished floors with their trains and the points of their shawls, as they come and go, pass and repass, wide-eyed like animals, apparently seeing nothing but in fact observing everything.

Against a background of light as from the infernal regions or of the aurora borealis, red, orange, sulphurous, pink (a pink suggesting a notion of ecstasy in frivolity), sometimes violet (that colour, like dying embers behind a blue curtain, so beloved of canonesses), against such magical backgrounds, with diversified firework effects, we are shown the varied image of the shadier type of beauty, now majestic, now frolicsome, now slim, thin even, now cyclopean, now doll-like and sparkling, now heavy and statuesque. This shady type of beauty either displays an alluring and barbaric form of elegance of her own invention, or she apes, more or less successfully, the simplicity current in higher circles. She moves towards us, glides, dances, sways as though by the weight of her embroidered petticoats, acting as both pendulum and pedestal to her; her eyes flash from under her hat like a portrait in its frame. She is a perfect image of savagery in the midst of civilization. She has a kind of beauty, which comes to her from sin; always lacking spirituality, but at times tinged with fatigue masquerading as melancholy. Her eyes are cast towards the horizon, like a beast of prey: the same wildness, the same indolent detachment, sometimes the same riveted attention. She is a gipsy type, dwelling on the fringes of regular society; the triviality which is the substance of her life of trickery and struggle inevitably betrays itself beneath the surface finery. To her may well be applied the words of the inimitable master La Bruyère: 'Some women have an artificial nobility, which is due to the way they move their eyes or hold their heads, or their manner of walking; and it goes no deeper . . .'[49]

These reflections about the courtesan may, to a certain extent, be applied to the actress; for she too is a creature of show, an object of public pleasure. But in this case the conquest and the prey are of a nobler, more spiritual kind. The aim is to win public favour, not only by pure physical beauty, but also by talents of the rarest order. If, on the one hand, the actress comes close to the courtesan, on the other she reaches up to the poet. Let us not forget that, apart from natural beauty and even artificial beauty, all beings have the stamp of their trade, a characteristic which may, on the physical level, express itself as ugliness, but also as a kind of professional beauty.

In this extensive gallery of London and Paris life, we meet with the different types of unattached woman, of the woman in revolt, at every level: first the woman of the town in the first flower of her beauty, cultivating, as best she can, patrician airs, proud both of her youth and of her luxury, which expresses such genius and soul as she possesses; we see her delicately holding with two fingers a broad flounce of the satin, the silk or the velvet that floats about her, and showing off her pointed foot, in a shoe whose excessive ornateness would be enough to reveal her for what she is, even without the rather showy emphasis of her dress. Down the ladder a few rungs, and we come upon the slaves confined in those hovels, often enough decorated like cafés; unfortunate creatures these, subjected to the most avaricious tutelage, with nothing they can call their own, not even the eccentric adornments that act as condiment to their beauty. Amongst these, some, in whom an innocent yet monstrous sort of fatuity is only too apparent, carry in their faces and in their eyes, which look you brazenly in the face, the evident joy of being alive (in truth, one wonders why). Sometimes they effortlessly adopt poses, both provocative and dignified, that would be the joy of the most fastidious sculptor, if only the sculptor of today had the courage and the wit to seize hold of nobility everywhere, even in the mire; at others, they show themselves in

prostrate attitudes of despairing boredom, or flaunt the indo-
lent postures of café life, with masculine effrontery, and
smoking cigarettes to pass away the hours with resigned,
oriental fatalism; there they lie, sprawling on sofas, skirts
ballooning to front and back double-fanwise, or they balance
themselves precariously on stools or chairs; fat, dejected,
empty-headed, absurd, their eyes glazed with brandy, and
their obstinacy written across their rounded foreheads. We
have reached the bottom step of the spiral to find the *foemina
simplex* of the Latin satirist.[50] Nor shall we fail, at some time, to
discern through the drink and smoke-laden atmosphere, here
the emaciated, feverish cheeks of the consumptive, there the
curves of adiposity, that hideous form of health born of sloth.
In this foggy chaos, bathed in golden light, undreamed of by
indigent chastity, gruesome nymphs and living dolls, whose
childlike eyes have sinister flashes, move and contort them-
selves; whilst behind a counter laden with liqueur bottles lolls
a fat shrew, her hair tied up in a dirty silk scarf, which throws
on the wall the shadow of its satanic points, thus convincing us
that everything dedicated to Evil must be condemned to have
horns.

In truth, my purpose in spreading out before the reader's
eyes scenes such as these is neither to please nor to scandalize
him; in either case, that would have been to show him scant
respect. What gives these scenes value and a kind of sanctity is
the innumerable thoughts they give rise to, usually austere and
gloomy. But if, by chance, some ill-advised person were to
seek an opportunity to satisfy an unhealthy curiosity in these
works of M. G.'s, scattered as they are here, there and every-
where, let me give him a charitable warning that he will find
nothing to excite a prurient imagination. He will find nothing
but inevitable vice, in other words the eye of the devil hidden
in the shadows, or Messalina's[51] shoulder gleaming under the
gaslight; nothing but pure art, in other words the type of
beauty peculiar to evil, the beautiful in the horrible. And even,

to recall in passing what has previously been said, the general impression conveyed by this great store-house is more full of sadness than fun. What constitutes the specifically beautiful quality of these pictures is their moral fecundity. They are big with suggestion, cruel, harsh suggestion, which my pen, accustomed though it is to struggle with the evocation of plastic images, may have rendered only inadequately.

XIII. CARRIAGES

And so they extend into the distance, these long galleries of 'high life' and 'low life', with innumerable side galleries leading from them. Let us for a moment escape towards a world which, if not pure, is at least more refined; let us breathe perfumes, not more wholesome perhaps, but more delicate. I have already said that M. G.'s brush, like that of Eugène Lami, was wonderfully fitted to depict the glories of dandyism and the elegance of society lionesses. The attitudes of the rich man are well-known to him; he can, with a light stroke of the pen and a sureness of hand which is never at fault, capture that indefinable sense of security evident in eye, gesture and carriage which comes from the monotony of good fortune in the lives of privileged beings. In this particular series of drawings we are presented with sporting, racing, hunting occasions in their innumerable aspects, with horse and carriage exercise in the woods, with proud dames or a delicate miss controlling, with practised hand, steeds of impeccable contour, stylish, glossy, and themselves as capricious as women. For M. G. not only knows all about the horse in general, but applies himself with equal success to expressing the individual beauty of horses. Some drawings depict a meeting, a veritable encampment, of numerous equipages, where, perched up on the cushions, the seats, the boxes, shapely youths and women, attired in the eccentric costumes authorized by the season, are seen watching some solemn turf event, the runners disappearing in the dis-

tance; another shows a horseman cantering gracefully alongside an open light four-wheeler, his curveting mount bowing, it might seem, in his own way, whilst the carriage follows an alley streaked with light and shade, at a brisk trot, carrying along a bevy of beauties, cradled as in the gondola of a balloon, lolling on the cushions, lending an inattentive ear to compliments, and lazily enjoying the caresses of the breeze.

Fur or muslin wraps them to the chin and flows in waves over the carriage door. The domestics are stiff and perpendicular, motionless and all alike; as always, they are the monotonous and uncharacterized effigy of servility, precise and disciplined; their whole character consists in having none. In the background, the woods are decked in green or brown, shimmering with light or darkening, according to the hour and the season. Its bowers are full of autumn mists, blue shadows, yellow beams, rose-pink effulgence or thin streaks of lightning flashing through the darkness, like sword thrusts.

If the countless water-colours from the war in the Levant had not shown us M. G.'s powers as a landscape artist, these would certainly suffice to do so. But here no question of the war-torn ground of the Crimea, nor the theatrical shores of the Bosphorus; we are back in the familiar intimate landscapes that encircle any of our big cities with verdure, and where the play of light produces effects that a truly romantic artist cannot disdain.

Another merit which is not unworthy of mention here is the remarkable knowledge of harness and coachwork. M. G. draws and paints a carriage, and every kind of carriage, with the same care and the same ease as a skilled marine artist displays over every kind of ship. All his coachwork is correct, every detail is in its right place, and does not need to be gone over again. In whatever position it is drawn, at whatever speed it may be going, a carriage, like a vessel, derives, from the fact of motion, a mysterious and complex gracefulness which is very difficult to note down in shorthand. The

pleasure that the artist's eye gets from it comes apparently from the series of geometrical figures that the object, already so complex in itself, vessel or carriage, describes successively in space.

We are betting on a certainty when we say that in a few years the drawings of M. G. will become precious archives of civilized life. His works will be sought after by discerning collectors, as much as those of Debucourt, of Moreau,[52] of Saint-Aubin, of Carle Vernet, of Lami, of Deveria, of Gavarni, and of all those exquisite artists who, although they have confined themselves to recording what is familiar and pretty, are nonetheless, in their own ways, important historians. Several of them have even sacrificed too much to the 'pretty-pretty', and have sometimes introduced into their compositions a classic style foreign to the subject; several have deliberately rounded the angles, smoothed over the harshness of life, toned down its flashing colours. Less skilful than they, M. G. retains a profound merit, which is all his own; he has deliberately filled a function which other artists disdain, and which a man of the world above all others could carry out. He has gone everywhere in quest of the ephemeral, the fleeting forms of beauty in the life of our day, the characteristic traits of what, with the reader's permission, we have called 'modernity'. Often bizarre, violent, excessive, but always full of poetry, he has succeeded, in his drawings, in distilling the bitter or heady flavour of the wine of life.

Notes

All footnotes in the text are Baudelaire's.

Abbreviations

A.r. = *L'Art romantique* (originally published in 1869, as Vol. III of the first edition (Michel Lévy), posthumous and incomplete, of Baudelaire's collected works)
C.e. = *Curiosités esthétiques* (originally published in 1868, as Vol. II of the above)
F. du m. = *Les Fleurs du mal* (1861 text, from the Pléiade edition)

Introduction

1. (p. 8) *Correspondance générale* II, 292.
2. (p. 9) *F. du m.* Nos. XC, XCI.
3. (p. 9) 'Des prochaines élections de l'Académie' (20 January 1862); see *Nouveaux lundis*, Vol. I.
4. (p. 9) Verlaine, 'Art poétique' (1874, but published in *Jadis et Naguère*, 1884).
5. (p. 9) See *Journaux intimes*; *Fusées* No. XI (Pléiade edition).
6. (p. 10) e.g. *Œuvres complètes*, Conard edition, 19 vols., edited by J. Crépet, 1922–53; *Œuvres complètes*, Pléiade edition, 1 vol., edited by Y. G. Le Dantec, revised by C. Pichois, 1966; *C. Baudelaire: Lettres inédites aux siens*, Grasset, 1966; *Petits Poèmes en prose*, critical edition by R. Kopp, Corti, 1969; *Les Fleurs du mal*, critical edition by J. Crépet and G. Blin; revised by G. Blin and C. Pichois, Corti, 1968.
7. (p. 12) See *Racine et Shakespeare* (1823), Chapter III, 'Ce que c'est que le romantisme'.
8. (p. 13) See *Lettres inédites aux siens* (Grasset), No. iv.
9. (p. 14) *F. du m.*, *Tableaux Parisiens*, No. XCI:

> In the sinuous folds of ancient capitals,
> Where everything, even horror, turns into enchantments ...

10. (p. 14) See 'The Universal Exhibition of 1855', section III.
11. (p. 14) See 'The Salon of 1859', section IV.
12. (p. 16) From 'Edgar Allan Poe, his Life and Works', section I.
13. (p. 16) On 26 March 1853.
14. (p. 16) In a letter (dated 30 June 1845) to Ancelle, his financial guardian, he writes: 'I am going to kill myself because I can no longer live, because the fatigue of going to sleep and the fatigue of waking up

are unbearable to me: I am going to kill myself because I am useless to others and dangerous to myself.'

15. (p. 17) *F. du m.* No. CIV, *L'Âme du vin*:

> Vegetable ambrosia, I shall fall into you,
> . . .
> So that poetry may be born of our love
> And spring up towards God like a rare flower.

16. (p. 20) Dated 10 October 1863.

17. (p. 21) Letter dated 21 October 1857.

18. (p. 22) 1821–70. The article appeared as a preface to Vol. I of Dupont's *Chants et Chansons* (4 vols., 1851–4).

19. (p. 22) See 'The Salon of 1846', section IV.

20. (p. 25) None of Wagner's major works had yet been created: *Das Rheingold, Die Walküre, Siegfried, Götterdämmerung*.

21. (p. 25) *F. du m.* No. IV.

22. (p. 26) Total art.

23. (p. 27) See 'The Universal Exhibition of 1855', section I.

24. (p. 27) ibid.

25. (p. 27) 'The Salon of 1859'.

26. (p. 27) See 'The Universal Exhibition of 1855', section I.

27. (p. 27) See 'Théophile Gautier', section III.

28. (p. 28) 'Richard Wagner and *Tannhäuser* in Paris', section IV.

29. (p. 30) See 'The Universal Exhibition of 1855', section I.

1. The Salon of 1845

1. (p. 33) First published May 1845; later included in *C.e.*

2. (p. 33) Gustave Planche (1805–57), professional critic. Spent six years (from 1840) in Italy: this would account for his silence.

3. (p. 33) Étienne-Jean Delécluze (1781–1863), painter, turned art critic.

4. (p. 34) Louis-Philippe, King of the French 1830–48.

5. (p. 34) A collection of pictures bequeathed by Lord Standish to Louis-Philippe and on loan to the Louvre. (Pléiade)

6. (p. 35) Eugène Delacroix (1798–1863).

7. (p. 36) Henry of Navarre, King of France 1589–1610.

8. (p. 36) At the Louvre. The series was commissioned by Marie de Médicis, widow of Henri IV, in 1622.

9. (p. 36) The Paris street mobs during the French Revolution.

10. (p. 37) Théophile Gautier (1811–72), poet and critic, friend of Baudelaire. See pp. 256–84 in this edition.

11. (p. 37) Thomas Couture (1815–79): historical subjects (e.g. *Romains de la décadence*, 1847) and portraits.

12. (p. 38) Honoré Daumier (1818–79), painter, lithographer and caricaturist. See 'Some French Caricaturists'.

13. (p. 38) Dominique Ingres (1780–1867), one of the greatest French draughtsmen, but not greatly admired as a painter by Baudelaire. See especially 'The Universal Exhibition of 1855', section II.

14. (p. 38) Also by Delacroix.

15. (p. 39) Horace Vernet (1789–1863), mainly a military painter, battle scenes being his speciality. He found little favour with Baudelaire, who mentions him often (see particularly 'The Salon of 1846', section XI).

16. (p. 39) *Prise de la Smalah d'Abd-el-Kader à Taguin*. (Pléiade)

17. (p. 40) Jean Jouvenet (1644–1717): portraits and religious subjects.

18. (p. 40) Alexandre Decamps (1803–60): Oriental and African scenes especially.

19. (p. 40) Frederick, Baron von Münchhausen (1720–97), served in the Russian army against the Turks 1740–41. His name is chiefly re-membered for the boasts attributed to him, which became the subject of a book: *The Adventures of Baron von Münchhausen*, originally published in English (1785) and then translated into German (1786).

20. (p. 42) Achille (1800–1865) and his brother Eugène (1805–65) Deveria. The former was mainly a draughtsman and lithographer, the latter a history painter; they were prominent in early Romantic circles.

21. (p. 42) Picture by Eugène Deveria, exhibited 1827.

22. (p. 43) 1798–1870. Wife of Charles X's second son, and mother of the Comte de Chambord, last of the elder Bourbon line and Legitimist Pretender who might have been restored to the throne in 1873 but for his refusal to accept the 'tricolor', symbol of the French Revolution.

23. (p. 44) Théodore Chassériau (1819–56). Pupil of Ingres, but greatly influenced by Delacroix.

24. (p. 44) Jean-Baptiste Corot (1796–1875), prolific landscape painter.

25. (p. 44) 1812–67. Member of the Barbizon school. Much influenced by the seventeenth-century Dutch school.

26. (p. 46) *Paysage avec figures*, subsequently called *Le Concert*. (Pléiade)

27. (p. 46) Byzantine general (*c.* 494–565).

2. The Salon of 1846

1. (p. 47) First published May 1846; later in *C.e.*

2. (p. 48) Louis-Philippe was no parvenu; yet he seems the perfect image of the upper bourgeoisie of his day, which, as Baudelaire rightly

says, held political power at the time (in fact from 1830 to 1848).

3. (p. 48) i.e. before the July Revolution.

4. (p. 50) 'Gavarni' was the pseudonym of Sulpice-Guillaume Chevalier (1804–66), caricaturist. See 'Some French Caricaturists'.

5. (p. 51) See section XVII of this article.

6. (p. 51) Novelist; real name Henri Beyle (1783–1842). The quotation comes from *Histoire de la peinture en Italie* (1817), Chapter CLVI, (p. 338, n. 2 Michel Lévy Edition, 1859).

7. (p. 52) i.e. the early 1840s, which saw the end of romantic drama and efforts at classical revival.

8. (p. 52) 1798–1854. Archaeologist.

9. (p. 52) Stendhal, *Histoire de la peinture en Italie*, end of Book V.

10. (p. 57) 1796–1872. Spent some ten years with the Red Indians and painted scenes of Red Indian life. A gallery in the National Museum, Washington, is named after him. (Crépet)

11. (p. 58) Ernst Theodor Amadeus Hoffmann (1776–1822), German musician and writer.

12. (p. 59) Adolphe Thiers (1797–1877), historian, journalist and politician.

13. (p. 61) Pierre-Narcisse Guérin (1774–1833), history painter. As a neo-classic, he could hardly approve of Delacroix's work.

14. (p. 61) Louis David (1748–1825). Conspicuous in the reaction against the spirit of eighteenth-century French painting; head of the Revolution and neo-classical school.

15. (p. 61) Théodore Géricault (1791–1824). Most famous canvas *Le Radeau de la Méduse* (1819). Much admired by Delacroix.

16. (p. 61) François Gérard (1770–1837), history and battle painter; also portraits. Pupil of David.

17. (p. 63) Victor Hugo (1802–85), poet, dramatist and novelist. Leader of the French Romantic school.

18. (p. 64) The constitution of the year III (1795) revived the academies (suppressed in 1793) of the Ancien Régime, and grouped them into five classes under the name of the Institut de France. The Académie Française is one of these. The seat of the Institut is on the *quais* of the Left Bank.

19. (p. 66) From the German poet Heine's 'Salon' of 1831. (Crépet)

20. (p. 68) Fashionable quarter of Paris in the seventeenth century.

21. (p. 70) The fresco is by Paul Delaroche (1797–1856). His work, mostly historical, was much disliked by Baudelaire.

22. (p. 70) By Ingres.

23. (p. 72) *Les Aventures de Télémaque* (1699), by Fénelon.

24. (p. 75) 1800–1876. French romantic actor.

25. (p. 75) William Macready (1793–1873), Shakespearian actor. He played twice in Paris (1822 and 1828).

26. (p. 79) Baudelaire's italics.

27. (p. 81) Count Louis-Mathieu Molé (1781–1855). Prime Minister 1837–9.

28. (p. 81) Salvador Cherubini (1760–1842), born in Florence, naturalized French. Composer and director of the Paris Conservatoire. Portrait by Ingres.

29. (p. 81) Character invented by the caricaturist Traviès (see 'Some French Caricaturists'), and representative of the post-1830 generation.

30. (p. 81) In Ingres's portrait of Cherubini, the latter's muse is shown standing behind him.

31. (p. 84) An exhibition held in January 1846. Baudelaire had written an article on it. See *C.e.*

32. (p. 85) From E. T. Hoffmann.

33. (p. 85) A model of every perfection in Don Quixote's eyes, Dulcinea was in reality a buxom peasant girl from Toboso.

34. (p. 87) The reference is to the song-writer Béranger (1780–1857), one of the architects of the Napoleonic legend.

35. (p. 88) Sometime collaborator of the journal *Le Corsaire-Satan*, and subsequently director of the Saint-Martin theatre. (Pléiade) The expression *être né coiffé* ('to be born with a caul') means 'to be born lucky, to be born with a silver spoon in one's mouth'. With all respect to Baudelaire, the expression is traditional and in consequence unlikely to have been coined by Fournier, as is suggested by Baudelaire's note.

36. (p. 88) Ernest Meisonnier (1815–91), genre and battle painter. Very popular in his own day because of his skill at representing large scenes on a small scale, with great accuracy down to small details. Now quite out of favour.

37. (p. 88) This passage comes from E. T. Hoffmann's *The Last Adventures of the Dog Berganza*. (Pléiade)

38. (p. 89) Lines by the Comte de Bonneval. (Crépet)

39. (p. 91) 1795–1858.

40. (p. 91) Friedrich Overbeck (1789–1869), chief of the German Catholic and Romantic school of painters.

41. (p. 92) Compare 1 Corinthians ii.9.

42. (p. 93) 1798–1862. Brother of Ary.

43. (p. 93) The Girondins were the moderate party in the Convention, during the French Revolution; moderate opinions may do in politics, but Baudelaire will have none of them in painting.

44. (p. 94) Jean Nicolas Bouilly (1763–1842), author of plays and sentimental, moralizing stories.

45. (p. 94) Bernardin de Saint-Pierre (1732–1814), author of *Paul et Virginie* (1787), disciple of Jean-Jacques Rousseau and one of the sources of French Romanticism.

46. (p. 94) 1831. Play by Victor Hugo; the heroine is modelled on a noted seventeenth-century courtesan.

47. (p. 95) Jean Watteau (1684–1721). Fused his admiration of Rubens and the Venetian masters into a personal style; greatest of the *fêtes galantes* painters.

48. (p. 97) Baudelaire is presumably tilting at the typical weekly outing of the Parisian bourgeois family of his day (and not only his): the Sunday matinée at the Comédie-Française to see a performance from the classical repertoire.

49. (p. 97) Nicolas Poussin (1594–1665). Spent most of his life in Rome. Master (*pace* Baudelaire) of the French classical school and of historical landscape.

50. (p. 98) 1809–79.

51. (p. 98) 1510–*c*. 1567. Sculptor and architect.

52. (p. 98) 1537–90. Sculptor.

53. (p. 99) 1788–1856. Sculptor; known as David d'Angers to distinguish him from Louis David, the painter.

54. (p. 99) The tombs of the French kings at the Abbey church of Saint-Denis to the north of Paris.

55. (p. 99) 1810–67. Sculptor.

56. (p. 100) 1792–1852.

57. (p. 101) i.e. in classical comedy.

58. (p. 102) Giulio Pippi (1482–1546), of the Roman school.

59. (p. 104) *Notre-Dame de Paris* (1831), historical novel by Victor Hugo, Book V, Chapter 2.

60. (p. 105) Jean-Jacques Rousseau (1712–78). He died of apoplexy.

61. (p. 105) Hero of Balzac's novel *La Peau de chagrin* (1831).

62. (p. 105) Hero of Alexandre Dumas's play of that name (1831).

63. (p. 106) Eugène Lami (1800–1890), painter of manners, much in vogue during the Second Empire. Admired by Baudelaire.

64. (p. 106) 1808–89. Novelist and critic.

65. (p. 107) The chaplain at the prison of La Roquette.

66. (p. 107) All characters in Balzac's novels.

67. (p. 107) Hero of Balzac's comedy *Les Ressources de Quinola* (1842).

3. Of Virtuous Plays and Novels

1. (p. 108) First published November 1851; later included in *A.r.*

2. (p. 108) The so-called *École du bon sens* ('School of Good Sense').

3. (p. 108) 1820–89. Later became leading exponent, with A. Dumas *fils*, of social drama in its heyday, *c.* 1850–75.

4. (p. 108) 'Hemlock' (1844).

5. (p. 108) Heroine of the play of the same name (1849).

6. (p. 109) Donatien, Comte, better known as Marquis de Sade, (1740–1814).

7. (p. 109) i.e. the *École du bon sens*. In their efforts to revive a form of classical comedy the playwrights in question wrote in verse.

8. (p. 109) Novel (1835) by Théophile Gautier. The preface is the manifesto of the school of 'Art for Art's Sake'.

9. (p. 109) Play (1836) by Alexandre Dumas *père*.

10. (p. 111) Hero of the two novels by Louis Reybaud, *Jérôme Paturot à la recherche d'une position sociale* (1843) and *Jérôme Paturot à la recherche de la meilleure des républiques* (1848). Jérôme Paturot typifies the young petit-bourgeois, ignorant and ambitious.

11. (p. 111) Courtilz de Sandra (1644–1712), novelist.

12. (p. 111) 1797–1871. Humanitarian thinker.

13. (p. 111) Pierre-Joseph Proudhon (1809–65), socialist thinker.

14. (p. 111) Eugène Viollet-le-Duc (1814–79) did much restoration of medieval buildings and churches in France.

15. (p. 112) Étienne Lousteau and Lucien de Rubempré are characters in Balzac's *Comédie humaine*. They appear especially in *Splendeurs et misères des courtisanes* (1839–47) and *Illusions perdues* (1837, 1839, 1843).

16. (p. 113) Arnaud Berquin (1741–91), author of mawkish tales, known as *berquinades*.

17. (p. 113) Jean-Baptiste Auget, Baron de Montyon (1733–1820). Founder of prizes for virtue, distributed annually by the Académie Française.

18. (p. 113) 1804–54. Minister of the Interior in 1851.

19. (p. 114) Baudelaire did not carry out this intention.

4. The Universal Exhibition

1. (p. 115) First published May, June and August 1855; subsequently in *C.e.*

2. (p. 115) 1717–68. German classical archaeologist; helped to bring about the neo-classical revival in Europe in the late eighteenth century.

3. (p. 117) The Sicambri or Sygambri were a powerful Rhineland tribe. They were conquered by Tiberius in the reign of Augustus, and a large number of them were transplanted to Gaul, where they received settlements between the Maas and the Rhine. Thus from enemies of

Rome they became Roman subjects and accepted Roman religion. Baudelaire may have had in mind Horace, *Odes*, IV, xiv, 51-2, where, in praising the Emperor Augustus, he says: *Te caede gaudentes Sygambri compositis venerantur armis* ('The Sygambri who revel in slaughter now lay down their arms and revere you').

4. (p. 122) *c.* 1441–1523. Florentine school.

5. (p. 122) 1441–1524. Umbrian school.

6. (p. 122) Probably an allusion to a passage in *La Grève de Samarez* (Chapter V, pp. 196–9), a philosophic poem by Pierre Leroux; the passage is a diatribe against the cause of 'Art for Art's Sake'. (Crépet)

7. (p. 124) For Guérin, see note 13 on 'The Salon of 1846'. Anne-Louis Girodet (1767–1824), although a pupil of David, tended, by his romantic temperament, to slide away from the staunch classicism of his master. Influenced by Ossian and Chateaubriand, as in, e.g., *Fingal au milieu de ses descendants* and *Atala au tombeau*.

8. (p. 124) The allusion is to the French school of the eighteenth century in general.

9. (p. 124) 1767–1824. Pupil and friend of Louis David, whom he followed as leader of the classical school. Painter of Napoleonic battle scenes.

10. (p. 125) The keepsake was an annual publication of stories, illustrated with steel engravings, of a sentimental and expurgated kind; flourished in the three decades from 1820.

11. (p. 125) Picture inspired by the heroine of Chateaubriand's story (1801)

12. (p. 126) i.e. Louis David, Guérin, Girodet, Gérard, Gros.

13. (p. 126) Both pictures by David.

14. (p. 126) By Girodet.

15. (p. 126) by David.

16. (p. 127) The reference is presumably to the private exhibition held by Courbet in 1855 at the time of the Universal Exhibition, in an attempt to combat official neglect of him; but for Baudelaire to speak of this as Courbet's début appears inaccurate, since in 1849 he had been awarded a gold medal by the Salon.

17. (p. 127) Gustave Courbet (1819–77). In this passage, Baudelaire scarcely seems to appreciate Courbet at what would now be considered his true worth.

18. (p. 127) i.e. Ingres.

19. (p. 131) Writing in the *Journal des Débats*. (Pléiade)

20. (p. 131) The allusion is to Voltaire's *La Pucelle*.

21. (p. 132) Baudelaire here introduces portions of Théophile

Gautier's poem *Compensation* (*La Comédie de la mort*, 1838), but as this adds little to the theme, it has been omitted.

22. (p. 134) 'And when we have turned away from the picture, it haunts and follows us' (from Théophile Gautier's *Terza Rima*, *La Comédie de la mort*). Baudelaire has substituted 'nous' for 'les' both times.

23. (p. 134) Philibert Rouvière (1809–65), painter, turned actor. Baudelaire wrote an article on him (December 1855 or January 1856) and an obituary (October 1865); in both he refers to Rouvière's playing of Hamlet, in a version by Meurice and Dumas *père*.

24. (p. 137) *F. du m.* No. VI, *Les Phares*:

Delacroix, lake of blood, haunted by the angels of evil,
Shaded by a pine wood ever green,
Across which comes, under a lowering sky, the sound of strange fanfares,
Like a muffled sigh from the music of Weber.

25. (p. 139) Charles Lebrun (1619–90), painter in charge of the interior decoration of the Palace of Versailles.

5. Of the Essence of Laughter

1. (p. 140) First published July 1855; subsequently in *C.e.*

2. (p. 141) See note 18 on 'The Salon of 1846'.

3. (p. 141) Originally a character in a melodrama (*L'Auberge des Adrets*, 1823), played by Frédérick-Lemaître; transformed by the caricaturist Daumier into a social type, a modern rogue.

4. (p. 141) François Rabelais (*c.* 1494–1553), creator of Gargantua and Pantagruel; typical Renaissance humanist.

5. (p. 142) Joseph, Comte de Maistre (1753–1821), theocratic political thinker and moralist, much admired by Baudelaire.

6. (p. 142) 1627–1704. Bishop of Meaux; writer, preacher and Catholic polemist.

7. (p. 142) 1632–1704. Jesuit preacher.

8. (p. 144) Heroine of Bernardin de Saint-Pierre's story *Paul et Virginie* (1787).

9. (p. 144) See note 4 on 'The Salon of 1846'.

10. (p. 145) Name of old quarter of Versailles; gave its name to a house situated there, supposedly used by Louis XV to house mistresses.

11. (p. 145) Marie-Antoinette.

12. (p. 147) 1782–1824. Horror novelist, author of *Melmoth the Vagabond* (1820).

13. (p. 154) 1622–73. Comic dramatist.

14. (p. 154) Both these plays (of 1673 and 1670 respectively) have ballet interludes.

15. (p. 154) Jacques Callot (1592–1635), painter and engraver. Spent some years in Italy. A forerunner of Goya in his depiction of the horrors of war (*Les Grandes Misères de la guerre*, 1633).

16. (p. 155) Jean-Baptiste Deburau (1796–1846), famous French mime at the Théâtre des Funambules.

17. (p. 157) First Bishop of Paris, martyred by decapitation. According to the legend, the saint picked up his head and carried it from Montmartre, supposed site of his martyrdom, to the Abbey of Saint-Denis. When Cardinal de Polignac pointed out the distance the saint had to walk with his burden, Madame du Deffand made the remark, since become proverbial, 'Il n'y a que le premier pas qui coûte.'

6. Edgar Allan Poe, his Life and Works

1. (p. 162) *Poésies diverses* (1833–8):

> Seated on his bronze throne, Destiny who rails at them,
> Soaks their sponge in bitter gall,
> And necessity twists them in its pincers.

2. (p. 163) *Ténèbres*:

> To shatter it, the eagle, from the heights of the sky,
> Will drop the tortoise on to their forehead,
> For die they must, inevitably.

3. (p. 163) Alfred de Vigny (1797–1863). The book in question is *Stello* (1832).

4. (p. 164) Baudelaire may have borrowed the expression from a letter of Poe's friend John P. Kennedy, popular novelist. (Crépet)

5. (p. 164) See note 5 on 'Of the Essence of Laughter'.

6. (p. 166) Evidently the novelist George Sand (1804–76).

7. (p. 166) Obscure allusion, perhaps to Émile de Girardin, a publicist much disliked by Baudelaire. (Crépet)

8. (p. 166) From the text, 'paternal' is surely meant.

9. (p. 167) Marie-Joseph, Marquis de Lafayette (1757–1834), French general; fought in the American War of Independence.

10. (p. 167) Sister. (Crépet)

11. (p. 167) 1809, at Boston. (Crépet)

12. (p. 168) This and a number of other biographical details and dates given by Baudelaire appear to be inaccurate in the light of more recent research. (See Crépet.)

13. (p. 171) Originally founded (*c.* 1530) by François I (1515–47), the Collège de France is a quasi-autonomous institution, with chairs in numerous subjects, for the promotion of scholarship and science.

14. (p. 173) Juvenal, *Satire X*, referring to Hannibal. (Crépet) cf. Dryden's translation (lines 271–2):

> Go climb the rugged Alps, ambitious fool,
> To please the boys and be a theme at school.

15. (p. 173) 1850.

16. (p. 174) Gérard de Nerval (1808–55), whose body was found hanging in the rue de la Vieille-Lanterne.

17. (p. 174) The journalist and the pun are lost in oblivion. (Crépet)

18. (p. 178) This and the following extracts from Mrs Osgood's letters are here translated literally from Baudelaire's text, but there are considerable variations from the originals; see, for example, the following note.

19. (p. 178) Baudelaire's text is 'ses yeux . . . dardaient une lumière d'élection, une lumière de sentiment et de pensée . . .'; Mrs Osgood writes: '. . . his dark eyes flashing with the electric light of feeling and of thought . . .'

20. (p. 181) The reference is to Delacroix. See 'The Life and Work of Eugène Delacroix', section VI.

21. (p. 182) Quotation from *Morella*. (Crépet)

22. (p. 186) Delacroix was not flattered by the comparison. (Crépet)

23. (p. 186) cf. *Le Poison* (1857), *F. du m.* No. XLIX.

7. Further Notes on Edgar Poe

1. (p. 188) cf. 'The Painter of Modern Life', section XI *passim*.

2. (p. 191) *Fifty Suggestions*, xlv.

3. (p. 191) *Marginalia*, cxviii.

4. (p. 191) Jacques Cazotte (1720–92).

5. (p. 191) 1772.

6. (p. 191) *Marginalia*, cxciv.

7. (p. 191) ibid., cxxviii.

8. (p. 193) *Eureka*, epigraph. The original text reads: '. . . to . . . those who put faith in dreams as in the only realities'.

9. (p. 193) Perhaps a misquotation of Lamartine's line: 'L'homme est un dieu tombé, qui se souvient des cieux' (*L'Homme, Méditations*). (Crépet)

10. (p. 193) See note 5 on 'Of the Essence of Laughter'. As Baudelaire says a few paragraphs above, the *Colloquy* is in part a diatribe against democracy, progress, civilization, universal equality. This aspect of it would no doubt have 'enchanted' de Maistre, whose views on these subjects were similar to Poe's (and Baudelaire's). The *Colloquy* might also have 'disturbed' him, and anyone else for that matter, by

Monos's description of his passage from mortal life, through death, burial and decay, to the state of disembodied spirit.

11. (p. 193) 1772–1837. Humanitarian theorist; proposed the organization of society on the basis of groups known as 'phalanstères'.

12. (p. 193) 1811–72. American publicist and politician. Founded the *New Yorker* and the *New York Tribune*.

13. (p. 193) 1754–1838. Became Bishop of Autun in 1788, but resigned his bishopric after supporting the Civil Constitution of the Clergy, 1790.

14. (p. 194) Possibly from the newspaper *Le Siècle*. (Crépet)

15. (p. 194) From *Some Words with a Mummy*.

16. (p. 194) Virgil, *Aeneid*, V, 628–9 (Crépet): 'fleeting Italy', i.e. a will-o'-the-wisp.

17. (p. 195) Jean-Jacques Rousseau (1712–78).

18. (p. 195) The quotation comes from Jean-Jacques Rousseau's *Discours sur l'inégalité*, Part II: '. . . l'homme qui médite est un animal dépravé . . .'

19. (p. 195) cf. 'The Painter of Modern Life', section XI *passim*.

20. (p. 195) cf. 'The Painter of Modern Life', section IX.

21. (p. 196) From Poe's *Al Aaraaf*. (Crépet)

22. (p. 196) Aztec God of War. Baudelaire may have derived the allusion from Musset, ms. Dedicatory Epistle to *La Coupe et les lèvres*. (Crépet)

23. (p. 196) A god of some of the primitive Gaulish and Germanic tribes.

24. (p. 198) See *The Poetic Principle*.

25. (p. 199) cf. 'The Salon of 1859', section III.

26. (p. 201) Horace, *Epistles*, I, ii, 2. (Crépet)

27. (p. 201) Poe, *Fifty Suggestions*, xxii.

28. (p. 203) cf. 'Théophile Gautier', section III, where Baudelaire has introduced this and the following four paragraphs, with slight variants.

29. (p. 203) Poe constantly attacked the Boston school. (Crépet)

30. (p. 206) From *The Philosophy of Composition*, but Baudelaire's rendering (here given) varies considerably from the original passage.

31. (p. 206) From *The Philosophy of Composition*, again a rather free rendering of the original.

32. (p. 207) i.e. line with internal rhyme.

8. Some French Caricaturists

1. (p. 209) First published October 1857; subsequently in *C.e.*

2. (p. 209) Antoine Charles ('Carle') Vernet (1758–1835), father of

Horace Vernet, the military painter, whose work Baudelaire so disliked.

3. (p. 209) cf. *Le Jeu*, *F. du m.* No. XCVI.

4. (p. 210) 1794–1872.

5. (p. 210) See note 37 on 'The Salon of 1859'.

6. (p. 211) 1792–1845.

7. (p. 211) See note 18 on 'The Salon of 1846'.

8. (p. 211) Béranger is meant.

9. (p. 212) See *Les Paysans* (1844).

10. (p. 213) The reference is to Auguste Barbier (1805–82), the now forgotten poet of *Iambes* (1831). (Pléiade)

11. (p. 213) Presumably the reference is to *L'Épitaphe de Villon*, better known as *Ballade des Pendus*, but the description does not fit.

12. (p. 214) Horace Vernet.

13. (p. 214) Béranger.

14. (p. 215) 1808–79.

15. (p. 215) Founded in November 1830 by the caricaturist Philipon (1800–1862).

16. (p. 215) Famous caricature of Louis-Philippe by Philipon. The pear is the symbol in French of someone easily taken in, 'roulé'.

17. (p. 217) 1848.

18. (p. 217) That of Louis Bonaparte, December 1848.

19. (p. 218) April 1848.

20. (p. 218) Perhaps Frank-Carré is meant; he was presiding judge at Rouen in April 1848. (Pléiade)

21. (p. 218) Also founded by Philipon, in 1832.

22. (p. 218) 1834.

23. (p. 219) 1741–1801. Swiss physiognomist.

24. (p. 222) Political pamphlet (1594), directed against the Catholic League, at the end of the religious wars.

25. (p. 223) 'Who will deliver us from the Greeks and the Romans?' The line may come from Bernard Clément (1742–1812), critic, or, in the form 'Who will deliver me . . .', from Joseph Berchoux (1765–1839), poet and journalist. (Guerlac, *Citations françaises*)

26. (p. 223) A literary and art fashion attacked by Baudelaire in his article 'L'École Païenne' (January 1852).

27. (p. 224) Which, according to Baudelaire, has its source in the sense of superiority of man over nature. cf. 'Of the Essence of Laughter', section V.

28. (p. 224) 1805–77. Precursor of the Realist school.

29. (p. 225) 1830. M. Joseph Prudhomme is their hero.

30. (p. 225) 1803–47.

31. (p. 227) See note 4 on 'The Salon of 1846'.

32. (p. 227) 1688–1763. Playwright and novelist.

33. (p. 228) 1812–43.

34. (p. 228) 1804–59.

35. (p. 229) 1813–94. As a painter he was a member of the Barbizon school.

36. (p. 229) 1772–1827. Song-writer and vaudevillist, known as the 'Anacréon français'.

37. (p. 231) A character in Paul Scarron's *Roman comique* (1651, 1657): a figure of fun.

9. Some Foreign Caricaturists

1. (p. 232) First published October 1857; subsequently in *C.e.*

2. (p. 233) Murdered in 1817 at Rodez. The trial of his alleged murderers was a Restoration *cause célèbre*.

3. (p. 233) *c.* 1800–1836. Book illustrator. Illustrated the early works of Dickens.

4. (p. 234) 1792–1878.

5. (p. 236) 1767–1851. Spanish statesman.

6. (p. 238) The Musée espagnol consisted of paintings belonging to the d'Orléans family, which were taken back by them. (Pléiade)

7. (p. 239) 1781–1834.

8. (p. 239) Jacopo da Ponte (1510–92).

9. (p. 239) See note 15 on 'Of the Essence of Laughter'.

10. (p. 240) 1794–1835.

11. (p. 241) Pieter Bruegel I (*c.* 1530–69), also known as 'peasant Bruegel', father of Pieter Bruegel II, or 'Hell Bruegel' (1564–1638).

12. (p. 243) The allusion is presumably to the events that occurred at Loudun in the early 1630s, the trial of the priest Urbain Grandier, accused of witchcraft and burned at the stake (1634).

10. *Madame Bovary* by Gustave Flaubert

1. (p. 244) 1821–80. The article first appeared in October 1857; subsequently in *A.r. Madame Bovary* was published in 1856.

2. (p. 245) The allusion is to Flaubert's trial and acquittal (June–July 1857) on a charge of offending public morality and religion in *Madame Bovary*.

3. (p. 245) The novel had been serialized before publication in the *Revue de Paris*.

4. (p. 246) Astolphe, Marquis de Custine (1790–1857), minor Roman-

tic and traveller, best remembered for the record of his journey to Russia: *La Russie en 1839* (1843).

5. (p. 246) Both 1835.

6. (p. 246) Play by Balzac (*c*. 1838–40). The rascally and ingenious financier Mercadet has an ugly daughter, Julie.

7. (p. 246) 1848.

8. (p. 246) 1851.

9. (p. 246) 1854.

10. (p. 246) Jules Husson, known as Champfleury (1821–89), founder of the Realist school.

11. (p. 247) 1822–66.

12. (p. 247) 1817–87. A prolific novelist and dramatist.

13. (p. 247) 1800–1847. Romantic and horror novelist and dramatist.

14. (p. 247) 1804–57. Founder, with *Les Mystères de Paris* (1842–3), of the novel in serialized form.

15. (p. 247) G. W. McA. Reynolds (1814–79) published *The Mysteries of London* (2 vols.) in 1847. Paul Féval's *Mystères de Londres* appeared in 1844, serialized in the *Courrier de Paris*. He appears to have made a play out of it, since Thackeray refers to a play of that name in an article entitled 'Two or three theatres in Paris' (see *Works*, Oxford Edition, Vol. 8, p. 474). Féval's *Le Bossu* appeared in 1858.

16. (p. 247) 1794–1871. Author of light novels, stories, plays in abundance.

17. (p. 248) Overthrown in February 1848.

18. (p. 248) Baudelaire is evidently tilting at the so-called Realist school, whose founder and theorist was Champfleury (see note 10). In the spirit of the Positivist age, the Realists in both literature and painting believed in the dispassionate statement of observed facts.

19. (p. 253) Legendary Queen of Crete and wife of Minos.

20. (p. 253) Carpentras is a small town in the department of Vaucluse, not far from Avignon. A Roman colony existed there. The general sense of the remark is that just as Julius Caesar would have been cramped on such a narrow stage as Carpentras, so Madame Bovary was cramped in her provincial surroundings. But why Carpentras? Perhaps Baudelaire the Parisian is poking fun, as Parisians will, at the Midi and the Meridionals?

21. (p. 253) Joseph-Pétrus Borel (1809–59), lesser romantic poet and writer; nicknamed himself 'le lycanthrope' (werewolf).

22. (p. 253) After his eccentric and flamboyant youth, Pétrus Borel went to Algeria as a Colonial Inspector.

23. (p. 255) The intention was not fulfilled.

11. Théophile Gautier

1. (p. 256) First published in *L'Artiste*, March 1859.

2. (p. 258) Poems (1832, 1838, 1840 respectively).

3. (p. 258) Both were aristocratic and fashionable quarters of Paris.

4. (p. 259) By Lamartine (1820 and 1830 respectively).

5. (p. 259) 1827. Hugo's *Odes*, Book III.

6. (p. 259) 1837. Hugo's *Voix intérieures*. Both odes are inspired by the cult of Napoleon.

7. (p. 259) See note 10 on 'Some French Caricaturists'.

8. (p. 259) *Il Pianto* (1832), a collection of poems on Italy.

9. (p. 259) *Lazare* (1837), a collection of poems on scenes of poverty in England.

10. (p. 262) 1835.

11. (p. 263) 1804–69.

12. (p. 263) 1797–1863.

13. (p. 263) 1606–84. Dramatist; wrote some comedies, but mostly tragedies, notably *Le Cid* (1636) and *Polyeucte* (1643).

14. (p. 263) 1762–94. Poet.

15. (p. 263) King of France 1774–93.

16. (p. 263) 1810–59.

17. (p. 263) 1802–70.

18. (p. 264) Hugo, *Voix intérieures*, XVI, *Passé*: 'Oh vanished splendours, oh sun that has sunk beneath the horizon.'

19. (p. 264) 1799–1850.

20. (p. 264) Name given to the 'lunatic fringe' of the Romantic school, prominent at the time of the 'battle of *Hernani*', 1830 (cf. Gautier, *Histoire du Romantisme*). Gautier had been one of them, but pokes delicate fun at them in his book *Les 'Jeunes-France'* (1833). Other members of the group were Gérard de Nerval, Célestin Nanteuil, Jehan du Seigneur, Pétrus Borel.

21. (p. 264) 'The beauty of the devil.'

22. (p. 264) 1839.

23. (p. 265) Both novels by Balzac (1831 and 1834 respectively).

24. (p. 265) i.e. Calvinistic or puritanical influences.

25. (p. 265) Victor Cousin (1792–1867), and eclecticism.

26. (p. 266) From 'Further Notes on Edgar Poe', section IV.

27. (p. 268) In 'Further Notes on Edgar Poe', section III.

28. (p. 269) Jules Michelet (1798–1874), historian. This comes in *L'Amour* (1858). (Pléiade)

29. (p. 270) 1235–1315.

30. (p. 270) Ridicule has a more cutting edge
 Than the blade of the guillotine.

31. (p. 271) 1852.

32. (p. 271) 1843.

33. (p. 276) 1858.

34. (p. 276) 1844. See also note 70 on 'The Salon of 1859'.

35. (p. 277) *c.* 450–404 B.C. Athenian politician and soldier.

36. (p. 277) From Poe's *To Helen*.

37. (p. 277) Paraphrase of the last lines of *To Helen*.

38. (p. 278) As part of the Universal Exhibition.

39. (p. 278) Claude Gellée or Lorrain (1600–1682). Worked mostly in Italy. Poetic landscapes.

40. (p. 278) Probably Henry Edward Kendall (*c.* 1805–85). His contribution to the 1851 Royal Academy Exhibition was an architect's vision of 'A vast metropolis with glistering spires . . .'

41. (p. 281) 'All wound, the last kills.'

42. (p. 281) Poem from *La Comédie de la mort*.

43. (p. 283) 'I am a man; nothing human is foreign to me.' The poet replies 'Whatever is human is . . .'

44. (p. 284) 1845.

45. (p. 284) 1845.

46. (p. 284) 1845.

12. The Salon of 1859

1. (p. 285) First published June and July 1859; subsequently in *C.e.*

2. (p. 285) Jean Morel.

3. (p. 286) The reference is to the Universal Exhibition of 1855.

4. (p. 286) Charles Robert Leslie (1794–1859) painted scenes from Shakespeare, Cervantes, Molière, Scott, etc.

5. (p. 286) Probably William Henry Hunt (1790–1864), one of the founders of the English water-colour school.

6. (p. 286) Holman Hunt (1827–1910), founder, with Millais and Rossetti, of the Pre-Raphaelite Brotherhood.

7. (p. 286) Daniel Maclise (1806–70), painter of literary and historical scenes; President of the Royal Academy 1865.

8. (p. 286) John Millais (1829–96).

9. (p. 286) John James Chalon (1778–1854).

10. (p. 286) Francis Grant (1803–78): hunting scenes and portraits.

11. (p. 286) James Clarke Hook (1819–1907): literary and historical (mostly Italian) scenes; later, landscapes.

12. (p. 286) Probably Joseph Noel Paton (1821–74), Scottish painter.

13. (p. 286) Henry Fuseli (Füssli) (1741–1825); Swiss by birth, he worked mostly in England; specialized in a visionary type of romantic horror, Blake-ian but on a lower level.

14. (p. 286) George Cattermole (1800–1868).

15. (p. 286) See note 40 on 'Théophile Gautier'.

16. (p. 287) Octavian Penguilly (1811–70), soldier and painter.

17. (p. 287) Eugène Fromentin (1820–76), writer (*Dominique*, 1862), art critic, and painter, especially of exotic scenes.

18. (p. 288) Paul Chenavard (1808–95), pre-eminently a philosophic painter. See Baudelaire's unfinished article 'L'Art philosophique' (*A.r.*).

19. (p. 288) Antoine Préault (1809–79), sculptor, pupil of David d'Angers.

20. (p. 288) Louis Ricard (1823–72): chiefly portraits.

21. (p. 289) Richard Parkes Bonington (1801–28), water-colourist; friend of Delacroix.

22. (p. 289) Émile de Girardin was not dead at the time, despite Baudelaire's assertion.

23. (p. 289) From Virgil, *Georgics*, I, 478. The passage refers to the portents and horrors that occurred at the time of Julius Caesar's death: '. . . and the beasts spoke'. To hear Émile de Girardin speak Latin was, to Baudelaire, a moment of equal horror.

24. (p. 289) See note 36 on 'The Salon of 1846'.

25. (p. 290) Nicolas Bertin (*c.* 1668–1736), painter.

26. (p. 290) Constant Troyon (1813–65), landscape and animal painter; his name is mentioned more than once in Baudelaire's 'Salons', but, as here, with little enthusiasm.

27. (p. 292) This could mean either 'Brutus, cowardly Caesar' (*lâche* as adjective); or 'Brutus, let go of Caesar' (*lâche* as imperative of the verb *lâcher*); or (without the comma) 'Brutus abandons Caesar' (*lâche* as third-person singular of *lâcher* in the sense of 'to let down, betray').

28. (p. 292) 'Love and rabbit fricassee.'

29. (p. 292) 'Misanthropy and Repentance', 1789: play by Kotzebue (1761–1819), German playwright. (Pléiade)

30. (p. 292) 'Monarchist, Catholic and soldier.'

31. (p. 292) 'From Paris to Jerusalem: a travel diary', by Chateaubriand.

32. (p. 292) The title in question had been taken from a speech of Napoleon III. (Pléiade)

33. (p. 293) 'Always and never.'

34. (p. 293) 'Flat to let.'

35. (p. 293) 1492 or 1499–1546. Painter and architect, one of the creators of mannerism.

36. (p. 293) 1493–1560. Florentine painter and sculptor.

37. (p. 293) François-Auguste Biard (1798–1882), prolific and undistinguished painter, much given to the picture that tells a story or amusing anecdote, in the spirit of those Baudelaire has been discussing.

38. (p. 295) Louis Daguerre (1789–1851), inventor, with Nicéphor Nièpce, of photography.

39. (p. 296) The quotations come from Dumas's *La Tour de Nesle* (1832) and Nerval's essay on Cazotte. (Pléiade)

40. (p. 301) Works by Alexandre Dumas (1802–70).

41. (p. 301) See note 20 on 'The Salon of 1845'.

42. (p. 301) Louis Boulanger (1806–67), painter much in vogue during the Romantic period. Friend of Victor Hugo, who dedicated several poems to him.

43. (p. 301) 1802–35. Literary and historical subjects.

44. (p. 301) Horace, *Ars Poetica*: 'The bestower of praise on times past.'

45. (p. 303) By Catherine Crowe, *née* Stevens (1800–1876), novelist, short-story writer, and spiritualist.

46. (p. 303) Delacroix.

47. (p. 303) *Impavidum ferient ruinae* (Horace, *Odes*, III, iii, 8): 'The ruins shall fall upon him but he will remain unmoved.'

48. (p. 305) Baudelaire seems to be foreshadowing the ideas of the Impressionists on the principle of 'divided tones'.

49. (p. 305) See note 21 on 'The Salon of 1846' and note 15 on 'The Salon of 1845'.

50. (p. 308) Main character in Corneille's tragedy of that name (1643).

51. (p. 308) John iii.8: 'The spirit bloweth where it listeth.'

52. (p. 309) There is an untranslatable play on words here, since the French adjective *vert* and adverb *vertement* have secondary meanings: vigorous, tart, harsh, rough, etc.

53. (p. 310) Perhaps Victor Fournel (1829–94), journalist and scholar. (Pléiade)

54. (p. 310) Originally quoted in 'The Salon of 1846', section IV.

55. (p. 310) i.e. Delacroix.

56. (p. 312) Hero of Chateaubriand's 'personal novel' of that name (1802).

57. (p. 312) Ovid.

58. (p. 313) Chateaubriand's translation of a line from Ovid. (Pléiade)

59. (p. 313) Hero of Chateaubriand's *Les Martyrs* (1809).

60. (p. 313) Prose epic by Chateaubriand (1826).

61. (p. 314) Fromentin's name is mentioned at the beginning of this article, but the passage here referred to in section VI has been cut.

62. (p. 315) Term probably borrowed by Baudelaire from his friend Nadar, who used it to denote pedantic authors. (Crépet) Perhaps it was connected in his mind with the word 'pointe' (a conceit), so beloved of the 'Précieuses' in the seventeenth century.

63. (p. 315) Author of *Rome au siècle d'Auguste* (1835).

64. (p. 315) Author of *Le Voyage du jeune Anacharsis* (1789), about life in Greece.

65. (p. 316) In *Whims and Oddities* (1826).

66. (p. 317) 'Love helps to pass the time'; and 'Time puts an end to love'.

67. (p. 317) Author of *Le Vieux-neuf. Histoire des inventions et découvertes modernes* (1856). (Pléiade)

68. (p. 318) Jean Gérome (1824–1904), painter in the academic tradition, which, in its various styles of the day, was decried by Baudelaire.

69. (p. 318) The two differently armed contestants in gladiatorial contests.

70. (p. 319) Legendary king of Lydia (eighth century B.C.).

71. (p. 319) Pierre Antoine Baudouin (1723–69), pupil and son-in-law of François Boucher, the great rococo decorative painter of the age.

72. (p. 321) Isidore Pils (1813–75): mainly historical and religious scenes.

73. (p. 321) See 'Some French Caricaturists'.

74. (p. 321) 1804–60. Prolific draughtsman and lithographer, mainly of battle subjects and military life.

75. (p. 321) See A. Dumas, *L'Art et les artistes contemporains au Salon de 1859*, pp. 58–60. (Pléiade) The point is that if lions could paint they would presumably choose as subjects lions hunting men, not men hunting lions. The moment was not well chosen because after the victories over the Austrians at Magenta and Solferino, patriotic fervour was high.

76. (p. 323) Who admits only one! See *Les Caractères*, 'Des ouvrages de l'esprit', I.

13. Richard Wagner and *Tannhäuser* in Paris

1. (p. 325) First published April 1861; subsequently in *A.r.*

2. (p. 325) 1813–83.

3. (p. 325) 1811–86.

4. (p. 326) 1845.

5. (p. 326) Hector Berlioz (1803–69), composer and conductor.

6. (p. 327) Scudo, music critic. (Pléiade)

7. (p. 327) 1850.

8. (p. 331) *F. du m.* No. IV:

> Nature is a temple from whose living columns
> A sound of confused words comes forth;
> Man walks there in a forest of symbols
> Which look down upon him with familiar glances.
>
> Like echoes which merge in the distance
> Into a unity, dark and deep,
> As measureless as night, or day,
> Scents, colours and sounds correspond

9. (p. 332) 1786–1826.

10. (p. 332) 1770–1827.

11. (p. 333) Three critical writing by Wagner, which appeared between 1849 and 1851.

12. (p. 334) The allusion is to the early years of the Restoration.

13. (p. 335) This publication (? of the middle 1850s) was probably the French translations Wagner had made of his prose poems for the four early operas *Rienzi*, *The Flying Dutchman*, *Tannhäuser* and *Lohengrin*. He was keen to score a success in Paris, which he knew to be the open door, at that time, to acceptance in other European capitals.

14. (p. 335) Christophe Glück (1714–87), German composer; worked for several years in France.

15. (p. 335) Étienne Méhul (1763–1817).

16. (p. 335) Denis Diderot (1713–84), chief architect of the *Encyclopédie*.

17. (p. 337) 1842.

18. (p. 337) 1843.

19. (p. 353) Subject of the Gothic novel *Melmoth the Wanderer* (1820) by Charles Robert Maturin (1782–1824).

20. (p. 354) 1865.

14. The Life and Work of Eugène Delacroix

1. (p. 358) First published, serially, in three sections, September and November 1863; subsequently in *A.r.*

2. (p. 362) See notes 13 and 14 on 'The Salon of 1846' and note 7 on 'The Universal Exhibition of 1855'.

3. (p. 362) James Macpherson (1738–96) published the *Poems of Ossian* (1760–63), a legendary Scottish bard of the third century A.D. Mediocre poet though he was, Macpherson had some influence on early French Romantics.

4. (p. 364) In 'The Salon of 1859', section IV.

5. (p. 367) The next two paragraphs are from 'The Salon of 1859', section V.

6. (p. 368) The following passage originally appeared in an article on Delacroix's mural paintings. (Pléiade)

7. (p. 371) Jean de la Fontaine (1621–95), poet and fabulist.

8. (p. 371) Nicolas Boileau (1636–1711), satirical poet and critic.

9. (p. 371) None other than Baudelaire, perhaps.

10. (p. 371) François de Malherbe (1555–1628), lyrical poet.

11. (p. 372) Ralph Waldo Emerson (1803–82).

12. (p. 372) Charles de Secondat, Baron de Montesquieu (1689–1755), political thinker.

13. (p. 372) 1825–81. Writer and critic.

14. (p. 374) i.e. Jean-Jacques Rousseau.

15. (p. 375) 1801–32. Traveller and naturalist.

16. (p. 375) Prosper Mérimée (1803–70), author of short stories and Inspector of Ancient Monuments.

17. (p. 376) Monsieur de la Palisse was supposedly given to uttering weighty apophthegms of an obvious kind.

18. (p. 376) Giuseppe Ferrari (1812–76).

19. (p. 377) Greek sculptor (fifth century B.C.).

20. (p. 379) Horace, *Odes*, III, i, 1: 'I hate the vulgar crowd . . . and keep at a distance.'

21. (p. 379) The expression comes from a poem by Sainte-Beuve ('Épître à Villemain', *Pensées d'août*) in reference to Vigny.

22. (p. 380) Jacob Jordaens (1593–1678); Flemish school.

23. (p. 381) Niccolò Machiavelli (1469–1527), Florentine historian and political thinker, author of *The Prince*.

24. (p. 383) Presumably the section on Charlet in 'Some French Caricaturists'. See pp. 211–14 above.

25. (p. 384) See note 18 on 'The Salon of 1859'.

15. The Painter of Modern Life

1. (p. 390) This article probably dates from November 1859 to February 1860. (Pléiade) It first appeared on 26 and 29 November and 3 December 1863; subsequently in *A.r.*

2. (p. 390) Debucourt and the three Saint-Aubin brothers were all eighteenth-century draughtsmen and engravers.

3. (p. 393) See *De l'Amour* (1822), Book I, Chapter 17.

4. (p. 393) i.e. their belief in objective standards of beauty and systematic criticism.

5. (p. 393) e.g. in 'The Universal Exhibition of 1855', section I.

6. (p. 394) In 1833 Balzac conceived the idea of giving a framework, to be called *La Comédie humaine*, to all his novels and stories, both those already published and those as yet unborn, so as to make his whole work into a kind of pageant of contemporary French society. In 'Some French Caricaturists' Baudelaire makes the same point as here about Gavarni and Daumier in relation to Balzac (see above, p. 228), but in the passage in question Balzac is stated to have recognized the relationship. That he should have done so seems a reasonable supposition.

7. (p. 394) See note 63 on 'The Salon of 1846'.

8. (p. 394) See notes 33 and 34 on 'Some French Caricaturists'.

9. (p. 395) Constantin Guys (1805–92), born in Holland; was correspondent for the *Illustrated London News* during the Crimean War. See below.

10. (p. 396) i.e. Jean-Jacques Rousseau.

11. (p. 396) Probably in 1859.

12. (p. 397) Aristocratic quarter of Paris. In contrast, the Bréda quarter, which took its name from the owner of the land on which it was developed under the Restoration, had an unsavoury reputation.

13. (p. 397) cf. 'The Salon of 1859', section I *passim*.

14. (p. 397) Edgar Allan Poe.

15. (p. 401) cf. *F. du m.* No. XCV, *Le Crépuscule du soir*.

16. (p. 401) From Rousseau's *Discours sur l'inégalité*.

17. (p. 404) Presumably Catherine the Great of Russia.

18. (p. 405) Term coined *c.* 1840, meaning young woman of easy virtue. 'Doe' ('une biche') has the same meaning, and came into use when 'Lorette' went out of fashion. See also 'Some French Caricaturists', p. 228.

19. (p. 405) Jacques Courtois (1621–76), called 'Borgognone', at Bologna, where he worked for many years: mainly battle scenes, with horses.

20. (p. 405) 1634–90. Flemish origin; attached to the service of Louis XIV. Chronicler in paint of that monarch's campaigns.

21. (p. 408) Probably Ingres.

22. (p. 408) 1800–1876. Known specially for his romantic roles.

23. (p. 408) 1800–1888. Comic actor.

24. (p. 409) i.e. Crimean War. The 'Eastern Question' was in the news at the time, and this may explain why Baudelaire speaks of 'la Guerre d'Orient'.

25. (p. 410) 'Consecration of a burial-ground at Scutari by the Bishop of Gibraltar.'

26. (p. 410) 1806–71. Became Commander-in-Chief of the Turkish army.

27. (p. 411) Turkish irregular troops: Turkish word for 'bad hats'.

28. (p. 411) 1809–95. Marshal of France.

29. (p. 411) 1795–1878. Marshal of France. His service began under Napoleon I and continued until 1870.

30. (p. 411) Turkish Commander-in-Chief.

31. (p. 411) 'Achmet Pasha, Commander-in-Chief, standing in front of his tent, surrounded by his staff, receives two European officers'. Achmet Pasha is presumably Achmet-Kaiserli-Pasha (1796–1881).

32. (p. 412) Eustache Lesueur (1616–55): mostly religious paintings.

33. (p. 413) The two main religious feasts of the Muslim year.

34. (p. 413) 1822–63. Son of Mehemet Ali.

35. (p. 415) Friederich Ludwig (1815–67), second son of Ludwig I of Bavaria. Ascended the Greek throne 1832; deposed 1862.

36. (p. 415) Greek militiamen in the Greek War of Independence; subsequently the word came to be used of any Greek remaining faithful to the traditional customs and national dress.

37. (p. 417) 1821–62. Man of letters and soldier; Crimean War veteran.

38. (p. 418) Presumably after the Italian campaign against the Austrians, with the battles of Magenta and Solferino, in June 1859.

39. (p. 419) Baudelaire prided himself on being a dandy; see Théophile Gautier's essay on him.

40. (p. 419) *c.* 109–62 B.C. Killed after the failure of his conspiracy in 63 B.C.

41. (p. 419) 450–404 B.C. Athenian general; murdered in exile.

42. (p. 419) See note 4 on '*Madame Bovary* by Gustave Flaubert'.

43. (p. 420) The legend of the Spartan who refused to cry out in pain when a fox was gnawing at his vitals reflects the Spartan tradition of rigid fortitude. See Plutarch, *Vita Lycurgi*, Chapter 18.

44. (p. 421) Chief of the Ismaelite sect in medieval Syria.

45. (p. 421) 'As a corpse' (Ignatius Loyola's precept of obedience for Jesuits).

46. (p. 424) 'The world of women.'

47. (p. 424) The Bois de Boulogne, woods on the western outskirts of Paris.

48. (p. 425) Law courts gazette, a daily journal founded in 1826.

49. (p. 430) See La Bruyère's *Les Caractères* (1688), III, 'Des femmes' (Penguin Classics, translated by Jean Stewart).

50. (p. 432) Juvenal, *Satire* VI, 'On Women', line 327: 'the natural woman'.

51. (p. 432) A.D. 15–48. Fourth wife of Claudius I.

52. (p. 435) Jean Moreau (1741–1814), draughtsman and engraver, notably of the French classics.

MORE ABOUT PENGUINS

Penguinews, which appears every month, contains details of all the new books issued by Penguins as they are published. From time to time it is supplemented by *Penguins in Print*, which is a complete list of all available books published by Penguins. (There are well over three thousand of these.)

A specimen copy of *Penguinews* will be sent to you free on request, and you can become a subscriber for the price of the postage. For a year's issues (including the complete lists) please send 30p if you live in the United Kingdom, or 60p if you live elsewhere. Just write to Dept EP, Penguin Books Ltd, Harmondsworth, Middlesex, enclosing a cheque or postal order, and your name will be added to the mailing list.

Note: *Penguinews* and *Penguins in Print* are not available in the U.S.A. or Canada

BAUDELAIRE

EDITED BY FRANCIS SCARFE

A poet whose work is so complex and diverse, though apparently so simple and unified, as Baudelaire's is not to be summarized in any convenient formula. Yet many attempts of this kind have been made; they are useful and have to be taken seriously. A modern Dante? This suggestion, first made in 1857 by Thierry, has been discussed and modified by T. S. Eliot who would be more satisfied with a comparison with Goethe. 'The Swift of poetry,' suggested Lytton Strachey: but they meet only in their disgust, wit, and gloom, and Baudelaire is the bigger of the two. Aldous Huxley called him 'a bored satanist' and Lionel Johnson stated: 'Baudelaire sings sermons.' He has been described as 'the tragic sophist', as 'too Christian', and as a 'Near-Jansenist'.

In this selection Francis Scarfe has placed the poems, for the first time, in a roughly chronological order while trying to preserve the 'cycles' into which they fall. A plain prose translation is appended to each poem.

THE PENGUIN CLASSICS

Some Recent Volumes